THE AFTERLIFE OF THE ROMAN CITY

This book offers a new and surprising perspective on the evolution of cities across the Roman empire in late antiquity and the early Middle Ages (third to ninth centuries AD). It suggests that the tenacious persistence of leading cities across most of the Roman world is due, far more than previously thought, to the persistent inclination of kings, emperors, caliphs, bishops and their leading subordinates to manifest the glory of their offices on an urban stage, before crowds of city dwellers. Long after the dissolution of the Roman empire in the fifth century, these communal leaders continued to maintain and embellish monumental architectural corridors established in late antiquity, the narrow but grandiose urban itineraries, essentially processional ways, in which their parades and solemn public appearances consistently unfolded. Hendrik W. Dey's approach selectively integrates urban topography with the actors who unceasingly strove to animate it for many centuries.

Hendrik W. Dey is an associate professor in the Department of Art and Art History at Hunter College, City University of New York. Previously he held a two-year Rome Prize fellowship at the American Academy in Rome and an Andrew W. Mellon postdoctoral fellowship at the Center for Advanced Study in the Visual Arts of the National Gallery in Washington, DC. He is the author of *The Aurelian Wall and the Refashioning of Imperial Rome, AD 271–855* (Cambridge University Press, 2011) and the coeditor, with Elizabeth Fentress, of *Western Monasticism ante litteram: The Spaces of Monastic Observance in Late Antiquity and the Early Middle Ages* (2011). He has written articles and book chapters for the *Journal of Roman Archaeology*, the *Journal of Late Antiquity*, *Early Medieval Europe*, *Antiquité Tardive*, *The Cambridge History of Western Monasticism*, *Reallexikon für Antike und Christentum* and *Storia dell'architettura in Italia da Costantino a Carlo Magno*, among others.

CAMBRIDGE
UNIVERSITY PRESS

32 Avenue of the Americas, New York, NY 10013-2473, USA

Cambridge University Press is part of the University of Cambridge.

It furthers the University's mission by disseminating knowledge in the pursuit of education, learning and research at the highest international levels of excellence.

www.cambridge.org
Information on this title: www.cambridge.org/9781107069183

First published 2015

Printed in the United States of America

A catalog record for this publication is available from the British Library.

Library of Congress Cataloging in Publication data
Dey, Hendrik W., 1976–
The afterlife of the Roman city : architecture and ceremony in late antiquity and the early middle ages / Hendrik W. Dey, Hunter College, City University of New York.
 pages cm
Includes bibliographical references and index.
ISBN 978-1-107-06918-3 (hardback)
1. Public architecture – Rome. 2. Public architecture – Classical influences. 3. Symbolism in architecture – Rome. 4. Symbolism in architecture – History – To 1500. 5. Cities and towns – Rome. 6. Cities and towns, Medieval. 7. Architecture and state – Rome. 8. Architecture and state – History – To 1500. I. Title.
NA9050.5.D49 2014
722'.7 – dc23 2014025981

ISBN 978-1-107-06918-3 Hardback

Publication of this book has been aided by a grant from the von Bothmer Publication Fund of the Archaeological Institute of America.

THE AFTERLIFE OF THE ROMAN CITY

ARCHITECTURE AND CEREMONY IN LATE ANTIQUITY AND THE EARLY MIDDLE AGES

HENDRIK W. DEY

Hunter College, City University of New York

CONTENTS

FIGURES

PLATES

Plates follow page xvi.

ACKNOWLEDGMENTS

That this book has often been a pleasure in the writing I owe to the many –
surprisingly many – people and institutions whose generosity, hospitality, kind-
ness and interest in me and my project made its writing possible. It began at
the University of Aarhus, where a year-long postdoctoral fellowship in the
Department of Classical Archaeology provided the ideal environment for read-
ing, thinking, conversing and presenting my thoughts, with no intervening
teaching obligations, that led me to conceive of the project and start writ-
ing. Among the many wise and kind colleagues who populated my stint in
Denmark, special thanks are due to Niels and Lise Hannestad, Birte Poulsen,
Troels Myrup Kristensen, Stine Birk and Lea Sterling.

My lucky star thereafter brought me straight from Aarhus to Washington, DC,
and a Mellon Fellowship at the Center for Advanced Study in the Visual Arts at
the National Gallery, an institution that surpasses any reasonable expectations
for what a scholarly nirvana might, in the best of cases, be. It is also where I at
last learned the proper way to cut cheese. To the deans of the Center, Elizabeth
Cropper, Peter Lukehart and Therese O'Malley, as well as the dauntless staff
of the ILL department at the library, my warmest thanks. Not least among the
debts I owe the CASVA deans is their ready acknowledgment that late antiq-
uity is not among the library's many strengths, and their consequent cheerful
willingness to allow me to spend much of my time in one of the great late
antique libraries in the world at Dumbarton Oaks, where I promptly incurred
further debts of gratitude. Margaret Mullet, the director of D.O., not only
warmly received but indeed invited me on more than one occasion, for no
particular reason other than her innate generosity of spirit, as far as I can tell.
Deb Stewart likewise went out of her way to ensconce me comfortably in the
library, as did Columba Stewart (no relation) to provide liquid refreshments
and good company.

Long before I left Washington to begin life at my new home institution,
Hunter College, I was already indebted to Hunter for allowing me to defer
my appointment there in favor of CASVA. I am now further indebted for
the two sabbatical semesters granted me very soon after my arrival, thanks to
which this book has appeared before I go completely grey. The bulk of those

semesters was spent in Rome, where by some grotesque miscarriage of cosmic justice I was neither born nor permanently reside. Most of the writing happened there, in the congenial surroundings of the libraries at the American Academy and the École Française, though a substantial chunk also took shape during a month in Umbria at Civitella Ranieri, which must be both the best and the most beautiful place for writing and thinking in the entire universe; to the director, Dana Prescott, my undying gratitude.

Many of the themes and intuitions explored in the following pages were aired in invited talks at (in no particular order) the Danish Institute in Rome, the University of Aarhus, the National Gallery of Art and the Università degli studi di Sassari, as well as at the 2009 Roman Archaeology Conference in Ann Arbor, the 2010 Theoretical Archaeology Group in Providence and the 2011 Medieval Studies Conference in Kalamazoo. Suggestions and critical feedback from the audiences and organizers at every one of those events led to what I hope are improvements to the book, for which I thank them all.

The work of assembling the illustrations was enormously expedited by the generosity (and prompt responses) of a number of colleagues, who kindly allowed me to reproduce plans and architectural drawings derived from their own published work, and furnished me with several additional, unpublished images. To Slobodan Ćurčić, Charles McClendon, Franz Alto Bauer, Giorgio Bejor, Neil Christie and Federico Marazzi, my warmest gratitude. That some of my illustrations have morphed into color plates I owe to a substantial Publication Subvention Grant from the Archaeological Institute of America, which it is my pleasure to acknowledge here. I must also gratefully acknowledge the support of the Presidential Fund for Faculty Advancement at Hunter College, which furnished me with additional funds for acquiring illustrations and for the preparation of the index.

Norman Clarius and the ILL staff at the Wexler Library at Hunter doubtless grew to dread and loathe the sight of my innumerable requests for books and articles, but worked heroically on my behalf all the same, for which they deserve more than these few words of recognition. Additional thanks go to Beatrice Rehl, her editorial team at Cambridge University Press and the two anonymous readers she enlisted, as well as to Asya Graf, who ably stepped in for Beatrice in the closing stages of the project.

All told, a remarkable amount of time, effort and money provided by others under no appreciable obligation to me whatsoever went into and enabled the realization of this book. I hope the result justifies as much of it as possible. It is all the thanks I have to give.

ABBREVIATIONS

AE	*L'Année épigraphique*
AJP	*American Journal of Philology*
Anejos de AEspA	*Anejos de Archivo Español de Arqueología*
AnTard	*Antiquité Tardive*
ARF	*Annales regni Francorum inde ab a. 741 usque ad a. 829* (F. Kurtze ed.)
AS	*Acta Sanctorum*
BMCR	*Bryn Mawr Classical Review*
BullCom	*Bullettino della Commissione Archeologica Comunale di Roma*
CAH	*The Cambridge Ancient History* (2nd ed.)
CARB	*Corsi di Cultura sull'Arte Ravennate e Bizantina*
CC	*Corpus Christianorum*
CCCM	*Corpus Christianorum. Continuatio Medievalis*
CFHB	*Corpus Fontium Historiae Byzantinae*
CIC	*Corpus Iuris Civilis* (Kunkel ed.)
CJ	*Codex Justinianus*
Dig	*Digestum*
Nov.	*Novellae*
CSHB	*Corpus Scriptorum Historiae Byzantinae*
CSEL	*Corpus Scriptorum Ecclesiasticorum Latinorum*
CTh	*Codex Theodosianus* (Mommsen and Meyer eds.)
DMP	Lactantius, *De mortibus persecutorum* (Creed ed. and trans.)
DOP	*Dumbarton Oaks Papers*
EME	*Early Medieval Europe*
FIRA	*Fontes Iuris Romani Antejustiniani* (S. Riccobono et al. eds.)
GCE	*Die griechischen christlichen Schriftsteller*
ICERV	*Inscripciones cristianas de la España romana y visigoda* (J. Vives ed., Barcelona, 1942)
I.Eph.	*Die Inschriften von Ephesos* (Wankel et al. eds.)

JECS	*Journal of Early Christian Studies*
JLA	*Journal of Late Antiquity*
JRA	*Journal of Roman Archaeology*
JRS	*Journal of Roman Studies*
JSAH	*Journal of the Society of Architectural Historians*
MEFRA	*Mélanges de l'École Française de Rome. Antiquité*
MEFRM	*Mélanges de l'École Française de Rome. Moyen Âge*
MGH	*Monumenta germaniae historica*
AA	*Auctores Antiquissimi*
EP	*Epistulae*
SRG	*Scriptores Rerum Germanicarum*
SRL	*Scriptores Rerum Langobardicarum et Italicarum*
SRM	*Scriptores Rerum Merovingicarum*
PG	*Patrologia Graeca* (Migne ed.)
PL	*Patrologia Latina* (Migne ed.)
PLRE	*Prosopography of the Later Roman Empire* (Jones, Martindale and Morris eds.)
Procopius	
BG	*Bellum Gothicum*
BP	*Bellum Persicum*
BV	*Bellum Vandalicum*
de Aed.	*de Aedificiis*
Hist. Arc.	*Historia Arcana*
Settimane del CISAM	*Settimane di studio del Centro Italiano di Studi sull'Alto Medioevo*
TCCG	*La topographie chrétienne des cités de la Gaule*, Paris, 1980

THE AFTERLIFE OF THE ROMAN CITY

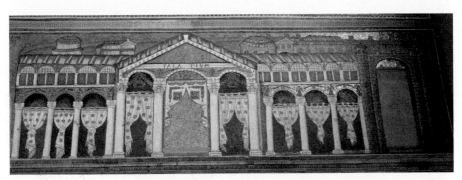

Plate I Sant'Apollinare Nuovo: nave-mosaic showing Ravenna and Theoderic's palace. (Photo: author.)

Plate II 'Italia' in the *Notitia Dignitatum*. (Bayerische Staatsbibliothek BSB-Hss Clm 10291, fol. 214v.)

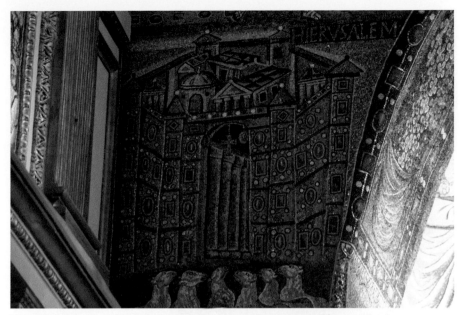
Plate III Jerusalem at Santa Maria Maggiore, Rome, ca. 440 AD. (Photo: author.)

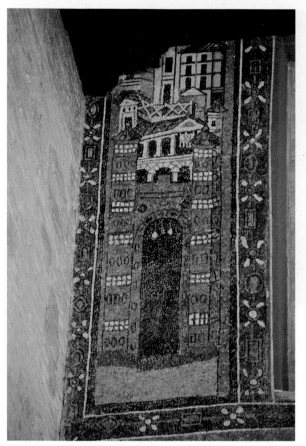

Plate IV Jerusalem in the oratory of San Vincenzo, Rome, 640s AD. (Photo: author.)

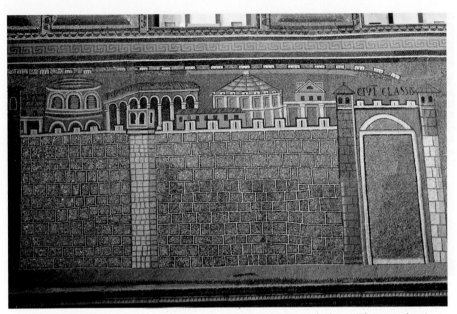

Plate V Sant'Apollinare Nuovo: nave–mosaic showing the port of Classe. (Photo: author.)

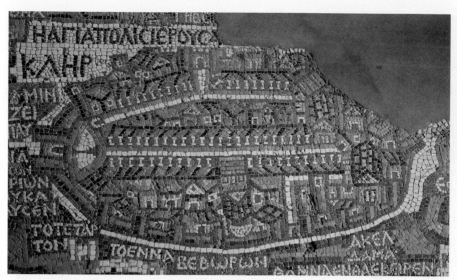
Plate VI The 'Madaba Map Mosaic,' detail of Jerusalem. (Photo: author.)

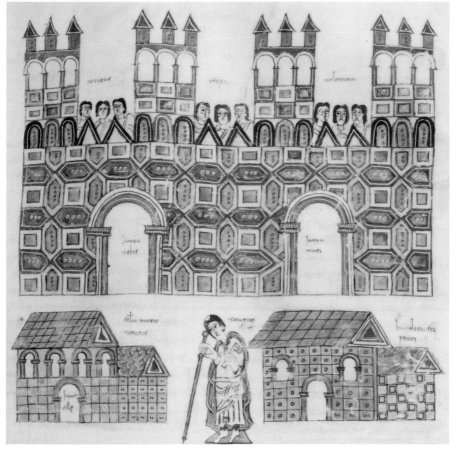

Plate VII The *regia sedes Toletana; Codex Vigilanus* folio 142r. (Biblioteca del Real Monasterio de El Escorial.)

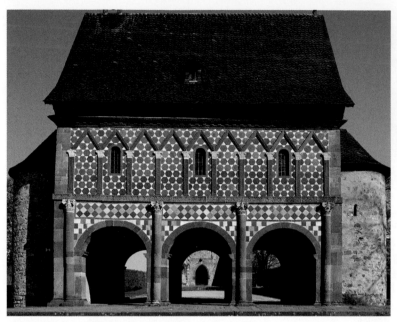

Plate VIII The *Torhalle* at Lorsch. (Photo: author.)

CHAPTER ONE

INTRODUCTION: URBAN LIVING AND THE 'FALL' OF THE ROMAN EMPIRE

I envision the structure of this book as a set of Russian nesting dolls. In its outermost shell, it is a treatment of monumental architecture in cities across the Roman and post-Roman world, roughly from the mid-third century into the ninth. It explores how the types of public buildings and infrastructure that came to predominate beginning in the third century both reflected and actively constituted evolving sociopolitical and spiritual exigencies, chiefly by framing, channeling and preserving for posterity the intricate panoply of ritual and ceremony that underpinned the claims to authority advanced by civic and ecclesiastical luminaries. The underlying silhouette confronts urban topography and traditions of urban living in a broader sense, by seeking to present monumental architecture and the ensemble of ceremony and collective ritual that animated and inspired it as an independent stimulus to the survival of an urban paradigm – what we might call an enduring 'urban habit' – capable of transcending more prosaic economic and demographic realities. The minuscule innermost figure (it is a sparse set of dolls) represents an attempt to provide an alternate lens through which to consider age-old questions of 'decline and fall,' 'Dark Ages,' and (dis?)continuity between the late Roman period and the Middle Ages in both the eastern and western halves of the (former) Roman empire. In my view, the idea of the city developed during the Hellenistic and Roman imperial periods and reforged in the crucible of late antiquity remained remarkably vibrant throughout the 'darkest' centuries following the dissolution of Rome's Mediterranean-wide empire, thus helping both to extend the life of

an essential characteristic of the Greco-Roman Mediterranean cultural *koine*, even as the political and economic collective fragmented, and to stimulate the recrudescence of cities and towns beginning around the ninth century across much of Europe and the eastern Mediterranean alike.

My views on the signal and continuing importance of monumental architecture and urban lifestyles in the cultural matrix of the postclassical period ultimately depend on the premise that urban living was a defining characteristic of Roman, or better Greco-Roman, society. For many centuries before the Roman conquest of the Hellenistic kingdoms of the eastern Mediterranean, and thereafter across the hellenophone East and the increasingly urbanized provinces of the Latin-speaking West, urban centers – and the civic institutions and lifestyles they represented – epitomized what it meant to be civilized. Such a formulation did not wholly exclude rural dwellers from civilization, for a *polis* extended beyond the eponymous city to embrace its surrounding territory: the urban center and the countryside were in fact inseparable, a real and ideal unity effortlessly rendered by the Greek *polis* and its approximate Latin equivalent, *civitas*, which English speakers tend to express with the awkward paraphrase 'city-state.' Ultimately, however, civilized living meant urban living. Urban living framed by well-tended and well-governed countryside, to be sure, but in the end, the country – the Greek *chora* and the Latin *rus* – served the political, economic and ideological ends of the city. It furnished foodstuffs, wood for heating and skins and fabrics for clothing; stone and wood for building; sturdy farmers to take up arms when need arose; raw materials to be 'civilized' into manufactured goods and traded in urban markets; even a pleasant escape for those urbane enough to require periodic retreats to a state of cultured rural tranquility, that *otium rurale* cherished by well-heeled Roman urbanites from Cicero to Sidonius Apollinaris.[1] But the city-center was unmistakably at the head of this complex organism: the *polis* was the only place for the *aner politikos* (the Aristotelian ideal of the socially engaged and politically enfranchised citizen), just as the *civitas* was the epicenter of *civilitas* (society, civility and civilization).[2]

In the West, throughout much of which the urban traditions long characteristic of the eastern Mediterranean were a relative novelty, a single city became an archetype for towns everywhere. Rome was 'the' city, the *urbs* without further qualification, a topographical model and a template for a new way of life that the Romans eagerly put before the eyes of their subjects, current and prospective.[3] So Virgil's Mantuan rustic could only express the glory of Rome to a companion via a series of bucolic analogies to the only city he knew,

[1] Cicero, *de Oratore* 1.224; *Epistulae ad Atticum* 1.7; Sidonius, *Epistulae* 2.2; 8.8, etc.
[2] Cf. Wickham 1984, 15–16; Liebeschuetz 1992, 1–2; Woolf 1998, 125–26; Millar 2006, 25–31.
[3] Cf. Zanker 2000; Ando 2000, 14–15.

Mantua, which like all cities was to the *urbs* itself as are ground-hugging osiers to a soaring cypress.[4] Mantua was the local reality, and Rome the ideal that gave the reality its special, almost mystical significance.

That such a vision was more than a literary topos nurtured by a political and cultural elite is clear from the extent to which 'Romanization' and urbanization went hand in hand in the western provinces of the empire. There was no more effective agent in the diffusion of Roman cultural constructs, and no more visible manifestation of the success thereof – today as well as two millennia ago – than the towns that followed closely in the wake of victorious Roman armies. One of the really remarkable features of the development of Roman provincial society, from Africa to Britain, is the exceptional eagerness newly minted provincials demonstrated in their emulation of Roman urban habits.[5] Usually within a few generations of the Roman conquest, regions with little or no previous history of monumental urbanism witnessed the creation of new towns festooned with more-or-less faithful copies of all the hallmarks of a Mediterranean city in the Greco-Roman tradition: regular street grids, porticoes, forums, baths, atrium houses, basilicas, temples, senate houses, even (in some cases) theaters, arenas and circuses.[6] The speed with which 'native' populations adopted the Roman model, helpfully illustrated for them by the veterans' colonies established in their midst, might have been surprising even to self-identified Romans, had they been less convinced of the manifest superiority of the way of life they championed. In the East, meanwhile, novel forms such as basilicas, circuses and opulent bath complexes heralded the rise of the

[4] *Ecl.* 1.19–25. Four centuries later, Rome's ideological centrality remained unchallenged in the West. Writers of imperial panegyric could think of no better way to exalt new provincial capitals than to compare them with Rome (see, e.g., *Pan. Lat.* 10(2).14.3; 6(7).22.4–5); Ausonius famously called the flourishing provincial capital of Arles, with its unusually rich panoply of monumental public buildings, a 'little Gallic Rome' – *gallula Roma Arelas* (*Ord. nob. urb.* 24.75). Similar examples might be adduced almost ad infinitum.

[5] The bibliography is beyond vast. Accessible recent surveys of provincial urbanization for the regions covered in this study include, on Spain: Kulikowski 2004, 1–38; on Gaul, Woolf 1998, 106–41; Gros (ed.) 1998; on Britain: Burnham and Wacher 1990 and 1995; on Italy: Wallace-Hadrill 2008, 73–143. Wider-ranging overviews include Veyne 1976; Gros and Torelli 1988; Fentress (ed.) 2000; Sewell 2010; Laurence, Esmonde Cleary and Sears 2011.

[6] This is naturally an extreme compression of a very complex process, which often took a century or more to unfold and was characterized both by common internal rhythms and by distinct local and regional particularities. Forums and street grids tended to precede the introduction of baths and entertainment venues, while Roman-style domestic architecture followed still more slowly. In some areas, particular building types never became common: while amphitheaters were often found in the leading towns of Gaul, for example, they were much less common in Britain, where only six examples are known from the whole province, most of which went out of use in relatively short order (Esmonde Cleary 1987, 177; see generally Laurence, Esmonde Cleary and Sears 2011). Further, as Pierre Gros points out, studies of late antique urbanism in particular too often tend to homogenize the period before the later third century into a 'classical' model of provincial urbanism, when in fact cities of, say, AD 50 often looked and functioned very differently than they did a century or two later (Gros 1998).

new power, even as the rhythms of an urban tradition already centuries old remained substantially unaltered.[7]

Of course, much of this necessarily broad-brush *mise-en-scène* might seem a caricature redolent of the comfortable tropes of colonial-era scholarship; and nearly every aspect of my characterization of Roman provincial society has been called into question at one time or another. The whole idea of 'Romanization' has been so successfully problematized that its accompanying quotation marks are now de rigueur,[8] and indeed the very concept of 'cities' and 'urbanism' as both an analytical construct and an historical phenomenon has been stimulatingly, though I think ultimately unconvincingly, challenged.[9] Yet the fact that Roman social, political, economic, religious and juridical institutions took root unevenly and in locally distinct ways does not obscure the fact that a vast sweep of territories was integrated into a supra-regional system of distinctively Roman stamp;[10] nor do the very real difficulties sometimes involved in distinguishing between what is urban and what is not – between towns and cities on the one hand, and villages and rural settlement on the other – fatally compromise the subdiscipline of urban history as a useful lens through which to view broader processes of institutional and cultural development and transformation in the Roman empire and beyond.

Were we to attempt a summary definition of a Roman city in the imperial period (*colonia*, *municipium*, *civitas* or *polis* in the language of contemporaries), we might say that it was an entity with well-defined (though mutable) legal, administrative and sacral boundaries, a distinct juridical status, which included administrative and tax-collecting responsibilities for its dependent territory; a physical presence typically characterized by a pronounced concentration of population and economic activity relative to its surroundings; access to a productive surplus sufficient to allow a sizeable percentage of its inhabitants to engage in activities unrelated to subsistence; and a reasonably homoge

[7] Millar 1993, 225ff.; Boatwright 2000.
[8] Woolf 1998; cf. Wallace-Hadrill 2008, 9ff.; Laurence, Esmonde Cleary and Sears 2011. Among other difficulties, 'Romanization' tends to presuppose the existence of a homogeneous and readily definable Roman cultural archetype, when in fact constructions of Romanness were infinitely varied and constantly evolving over time.
[9] Horden and Purcell 2000, 89–172; contra Wickham 2005, 591 and ff.
[10] The studies of Jacques 1984 and Ando 2000 are fundamental; see now also Noreña 2011. The wider Romanizing picture was always slower to catch on and more tenuous in rural areas, particularly those that were structurally or geographically remote from [the center]; the Isaurians in mountainous southern Anatolia remained effectively autonomous and absolutely hostile to the imperial system as late as the fifth and sixth centuries AD (Lenski 49–50); the African countryside in Augustine's day still swarmed with pagan and seriously disaffected (or heretical) peasants, more than five centuries after the Roman province (Aug. *Ep.* 66.108; cf. Possidius, *Vita Aug.* 9.1ff.); too in Gallaecia, Spain, rural dwellers seem to have clung tenaciously to traditional patterns of social organization through the Roman period and beyond (Díaz and ... 2005).

topographical 'kit' of public buildings and infrastructure.[11] The places that met these standards were recognized as a sine qua non for the conduct of 'civilized' life, and as the pride of their surrounding regions, by a majority of the peoples living within the Roman empire, over a period of several centuries.[12]

Similar views evidently inform the perspective of the many recent scholars who have made cities into a central player in a reanimated and often contentious discussion about how and why the Roman empire turned into its disparate western, Byzantine and Islamic successor polities, or declined and fell, as it is often still – or again – said to have done. On the one hand, late antiquity's coming of age as a scholarly field in its own right in the past two generations has prompted a sweeping revision of old notions of decline and fall. A generation of scholars weaned on the likes of Peter Brown, Glen Bowersock, Walter Goffart and Averil Cameron has tended to stress change, continuity and transformation over collapse,[13] and to question the validity of 'decline' (and other allegedly 'negative' or 'value-laden' terms) as an historical paradigm.[14] Such views have now provoked something of what James O'Donnell aptly called a 'Counter-Reformation,' whose proponents emphatically vindicate the right of historians and archaeologists to talk about decline, and in some cases – now provocatively – to emphasize doom-and-gloom scenarios.[15]

[11] A Roman *civitas*, *colonia* or *municipium* is in fact easier to define than the general concept of an urban center (a town or city as opposed to a village or rural settlement, for example), as the former were reasonably fixed legal constructs (on the legal definitions of urban status prevalent during the imperial period, see, e.g., Wacher 1995, 18–21; Ward-Perkins 1998, 371–73). One way to avoid some of the endless possibilities for wrangling over what is urban and what is not (cf. Gros 1998; Horden and Purcell 2000, 96–105) is to adopt a formulation akin to that proposed some time ago by Martin Biddle, who outlined twelve constituents of urbanism (ranging from city walls to housing types to central place functions), three to four of which together are generally sufficient to qualify a place as urban. Though naturally open to endless debate, Biddle's model still seems as good as any yet proposed (Biddle 1976; for alternative schemes, see, e.g., Kostof 1991, esp. 37–41; Halsall 1996, 236–37). By such criteria, all *civitas* capitals and a substantial number of additional centers would at one time or another have qualified as urban.

[12] Cultural prejudices in favor of cities and city life often seem to grow, if anything, stronger under the late empire and at times even beyond: see, e.g., Amm. Marc. 15.11.7–15; Ausonius, *Ordo nobilium urbium*; Sidonius Apollinaris, *Ep.* 5.20; Procopius, *De aedificiis* 6.6.16. Cf. Loseby 1997 on the urban horizons of Gregory of Tours; Orselli 2006 on sixth-century Italy, and on the East, Millar 2006, e.g., 25: 'In the Greek world of the fifth century cities were, if anything, even more central than they had always been in Greek culture'; see also Jones 1964, 712ff.

[13] Bowersock, Brown and Grabar (eds.) 1999 is a sort of *summum opus* of the 'continuity' school.

[14] Cameron 1993, 128–29; Bowersock 1996.

[15] See Liebeschuetz 2001a, 2001b, 2006; Ward-Perkins 2005; Heather 2005, alongside the outraged response of Fowden 2006 (to Ward-Perkins); and the more measured but still dissenting tones of O'Donnell's review of both Ward-Perkins and Heather (*BMCR* 2005.07.69); for a pair of thoughtful *status quaestionis*, see Wood 2007 and Marcone 2008; cf. also Delogu 2010a.

The more extreme characterizations of the opposing positions proposed by the protagonists in the debate themselves would pit Pollyanna liberal apologists for cultural relativism and political correctness against reactionary conservative cultural imperialists;[16] and cities have become vital testing grounds for the arguments and counterarguments proposed by both sides. Because cities and urban living were central to the configuration of Roman imperial society, the reasoning goes, and because they were again central during the high Middle Ages across much of the erstwhile empire, including western Europe and the surviving Byzantine heartland, the intervening period becomes crucial. For those who want to say that medieval society was born out of rupture and discontinuity with the Roman past, the 'urban habit' disappeared in the interim, while those who favor an uninterrupted evolutionary progression from Roman to medieval stress the continuous occupation of urban sites and the resiliency of a distinctly urban mode of living.[17]

To get a sense of the conceptual divide between the two sides, we might compare the approach taken by Ward-Perkins in his provocatively titled *The Fall of Rome and the End of Civilization* with Michael Kulikowski's book on the cities of late Roman Spain, both of relatively recent vintage.[18] For Kulikowski, invasions and regime changes and famines and plagues and so on are essentially transient phenomena, *évenements* that at best ripple the surface of deeper cultural waters, where change occurs only gradually, over the *longue durée*. Language, spirituality, ethnic identity and the continued inclination to live in nucleated settlements (regardless of how clean the streets, how shiny the dishes, how full of exotic imports the markets) are the resilient strands that connect the Roman world with what came after. Meanwhile, for Ward-Perkins, military instability, social upheavals and eventual political fragmentation in the fifth century irrevocably damaged the interregional networks of communications and trade that had made the Roman empire so unusually prosperous and so distinctly Roman. The gradual disappearance of, for example, high-quality imported pottery in many regions becomes a telling indicator of the disintegration of a whole way of life: as the interconnected economy of the Roman Mediterranean and the intensity of mechanisms of trade and exchange diminished, cities lost their reason for being and the world experienced a sort of rural involution.[19]

[16] E.g., Ward-Perkins 2005 vs. Fowden 2006.

[17] Ironically, as Chris Wickham has pointed out, those on the left of the discussion in modern political terms have tended to emphasize the survival of Roman urban centers and the ongoing ability of their inhabitants to maintain a lifestyle that distinguished them from their rural counterparts, while those on the right have commonly stressed the disintegration of urban structures (physical and social) and the corresponding suffering of the huddled masses left to scrape out an existence amongst the ruins of the past (Wickham 2005, 598–99).

[18] Kulikowski 2004.

[19] Ward-Perkins 2005, 87ff. and passim.

deficient when it comes to accounting for regional differences. Whether one privileges structural upheaval or cultural continuity, one follows a theoretical or methodological trajectory that should, by definition, be universal or at least supra-regional in its application: what is good for the goose in one region should be good for the gander in another. This leaves one to try to squeeze the textual or archaeological data available for any given area into the procrustean bed of one's preferred model of change and historical causation.

In my view, one of the most promising exit strategies for this conceptual impasse requires the reintroduction of people and, more to the point, personalities into the equation, not as an undifferentiated mass quantified in abstract demographic terms, but rather as individuals, as beings with needs and wants and volition and complex cultural and personal agendas. The way cities changed and evolved in different regions of the Roman world over the course of centuries depends to some extent on how people in any of those regions chose to live, beginning with those in the positions of greatest influence, politically, militarily and spiritually speaking.[27] We need, in other words, to account better for human agency when considering why some cities survived and others did not, and to keep in mind that human agents sometimes fail to act in predictable or strictly pragmatic ways.

With regard to the cities that did remain relatively vibrant, one of the primary challenges now confronting scholars is the issue of how and why the urban paradigms that prevailed at the height of the Roman empire came to look so different in the following centuries. Proponents of the idea that the ancient city 'fell' at the end of antiquity often point to the decline of 'classical' urban forms as an indicator of impending doom, and it is true that public spaces such as streets and forums often – but by no means always – grew more crowded with ad hoc structures erected by individual proprietors, while once-essential public amenities such as temples, civic basilicas, *palestrae*, entertainment venues and so on tended to fall into disrepair or to disappear entirely.[28] The crucial point is that in many places, new kinds of constructions supplanted the older forms: churches and other religious foundations, grandiose city walls, opulent palaces and official residences sprang up in impressive numbers and often endured for centuries, while the venerable colonnaded street experienced a startling – and highly underappreciated[29] – renaissance beginning in

[27] This in fact is one of the basic premises of Pirenne's much-maligned *Mahommet et Charlemagne*, one that deserves to be salvaged from the historical wreck made of him by recent scholarship; for a useful historiographical overview, see Delogu 1998. Halsall (2007, 32 and passim) also stresses the need to put individuals back into the study of late antiquity; see also 26–27 for a succinct overview of processual and post-processual trends in late antique historiography.

[28] Liebeschuetz 2001a, esp. 29–103; Saradi 2006, passim; Delogu 2010b, 40ff. For recent overviews of these developments in the West, with a welcome focus on archaeological evidence, see Christie 2011, 112–41; Esmonde Cleary 2013, 97–149.

[29] But see Chapter 3, n. 1 for noteworthy exceptions.

the fourth century and continuing at least through the fifth in the West and the sixth in parts of the East. In the process, both the physical contours of cities and the prevailing idea of what a city should be changed almost beyond recognition, as for example Helen Saradi, Franz Alto Bauer, Neil Christie and Sarah Bassett have all recently helped to demonstrate.[30]

It is my intent to build on the pioneering work of these and other scholars by thinking further about the purpose and inspiration of the new architectural forms that came into fashion beginning around the third century AD, which in my view are neither as fortuitous nor as inevitable as they are often made to seem. Proponents of structural failure stress the straitened economic conditions characteristic of late antiquity,[31] or the declining capacity of city councils to intervene meaningfully in local politics and administration,[32] to arrive at a picture characterized by a sort of creeping entropy. Continuing efforts on the part of civic leaders to maintain walls and main streets and official residences are thus explained away as stopgap measures intended at best to stave off the inexorable decay of the most essential infrastructure. Cultural continuitists in turn tend to concentrate on the vitality of the church and its ability to restructure existing cityscapes with a collection of churches, episcopal complexes, martyrial shrines, monasteries and foundations dedicated to the care of the poor and the infirm. Yet there is an air of inevitability about this picture as well: a triumphant Church opportunistically sought to translate its ascendancy into the realm of constructed space, inserting its edifices rather haphazardly into existing townscapes, and creating in the process a sort of 'alternative city' on the margins of the crumbling classical one, with which it rarely entered into meaningful dialog.[33]

I would say on the contrary that in leading administrative and ecclesiastical centers, urban topography came in late antiquity to be governed by a more coherent spatial logic and a more closely defined ideological agenda than ever before.[34] No longer simply showpieces of 'Romanization' or privileged foci of civilized living endowed with a congeries of characteristically urban features, the surviving urban centers of late antiquity were reengineered to promote the conjoined power of civic and ecclesiastical institutions as effectively as possible, and to translate social hierarchies into a material form capable of reinforcing and propagating those hierarchies over the *longue durée*. Let it be clear that I do

[30] Saradi 1995, 2006; Bauer 1996; Christie 2001, 2006; Bassett 2004.
[31] E.g., Hodges and Whitehouse 1983; Ward-Perkins 2005.
[32] This is a central thesis of Liebeschuetz 2001a; cf. also, e.g., Haldon 1997, chapter 1; Speiser 2001, esp. 13–14.
[33] Cantino Wataghin, Gurt Espaguerra and Guyon 1996, 30–36; Gauthier 1999; Guyon 2006; Saradi 2006, 386–440, esp. 339–40. The comments of Brogiolo and Gelichi 1998, 162 are emblematic in this regard: 'Fino al VII secolo, i luoghi di culto non costituiscono dunque elementi ideologici della topografia urbana.'
[34] *Contra*, e.g., Lavan 2003a, 175 and ff.

not intend here, or subsequently, to set up a dichotomy between 'church' and 'state,' or (worse) between 'religious' and 'secular,' concepts that hardly existed as discrete entities in the premodern world.[35] My occasional binary pairings of such terms should be understood to mean something like 'everyone that mattered,' a shorthand way of alluding to representatives of governmental and ecclesiastical institutions, who (and which) in fact tended to be interpermeable throughout the period under consideration.[36] Beginning with Constantine in the early fourth century, cities became crucial proving grounds on which local and regional variations of a new, Christian world order played themselves out, in the process propelling the Roman world into the early Middle Ages.[37]

The essential point, in any case, is that from the third century on, an enormous portion of the (generally shrinking) resources available for public works was redirected. Urban landscapes traded many of the public amenities of an earlier era, built largely by local citizens for the use and enjoyment of their compatriots, for a constellation of power centers connected and unified by a monumental, sequential 'armature' of walls and colonnaded streets, the vast majority sponsored by the civic and later also the ecclesiastical luminaries who so conspicuously inhabited and animated them.[38] Behind the lofty screens, the living conditions of the masses may well have been considerably reduced, but for the distinguished visitor approaching a city from afar, or processing through the colonnaded avenues that connected the churches and palaces where the Christian god and his earthly representatives – civic and ecclesiastical – resided, the urban spectacle in some respects even grew in magnificence with the passage of time (Figure 1.1).

Written histories, imperial panegyrics and accounts of court ceremony help to fill out the archaeological picture by demonstrating that rulers made ostentatious public displays of themselves in which city walls, gates and colonnaded streets were the preferred backdrops. Precisely the same features appear with striking regularity in the depictions of cities in medieval manuscript copies of the fifth-century *Notitia Dignitatum*, for example, and in a host of mosaics, including the sixth-century 'Madaba Map' in Jordan, and others in numerous Italian churches (in Rome at Sta. Maria Maggiore, S. Lorenzo and the Lateran Baptistery; and in Ravenna at Sant'Apollinare Nuovo and San Vitale). That

[35] See the valuable synthesis of Nongbri 2013.

[36] Indeed, as Durliat has stressed, from Constantine on, churches were public buildings and bishops were public officials; both were primarily subsidized by tax revenues allocated by the state (Durliat 1990, 55–57 and passim).

[37] The point permeates, for example, Peter Brown's important new book (Brown 2012); see also Bowes 2008 for archaeological echoes of competing and, with the breakup of the empire in the fifth century, increasingly localized or regionalized 'Christian' hierarchies.

[38] See Chapter 2. I intend 'armature' in the sense pioneered by MacDonald: urban networks that 'consist of main streets, squares, and essential public buildings linked together across cities and towns from gate to gate, with junctions and entranceways prominently articulated' (1986, 1).

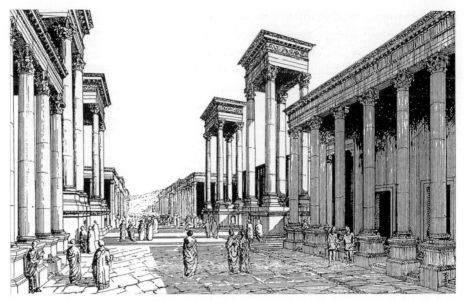

Figure 1.1. Reconstruction of the main street at Jerash in late antiquity, looking toward the tetrapylon. (After Bejor 1999, fig. 47.)

the sizeable corpus of both textual and pictorial sources available for the late antique city focuses with remarkable consistency on precisely the architectural types outlined earlier suggests not that there was an insurmountable gulf between a majestic ideal and an increasingly squalid reality, but rather that a very particular vision of reality came to be privileged, as much in brick, stone and mortar as in the cultural and artistic gestalt of the era.[39]

To cite but one example among the many discussed in more detail in the following chapters, we might take the depiction of Jerusalem in the Madaba Map (Plate VI). The architectural types that dominate this image – a circuit-wall with carefully rendered towers and gates, two main colonnaded streets, and three churches (the Holy Sepulcher complex, the Church of Holy Zion and Justinian's Nea Ecclesia dedicated to Mary) – represent the spaces most frequented by late antique VIPs: the areas of the city in which they put themselves most prominently on display. In this context, we might consider the arrival of an emperor, provincial governor or bishop at Jerusalem in the sixth or early seventh century. He would be greeted by cheering crowds and local dignitaries assembled along the road leading to a gate in the city wall, passage through which marked the culminating point in his *adventus*, and imbued the ceremonial arrival with prepossessing architectural form.[40] He would then process through the main *cardo* of the city, whose receding vistas of colonnades and honorific statues, likewise thronged with crowds, connected the gate in

[39] See Chapter 3.
[40] On *adventus*, see Chapter 2.4 and passim.

the wall with all of his principal destinations: the official residence and seat of administration – the governor's *praetorium* or bishop's palace – and the most prominent sites of Christian cult. All subsequent public appearances he made while in residence would have unfolded in essentially the same places. In a real and underappreciated sense, this living tableau *is* the essence of the late antique city, distilled as it was into a monumental armature that connected focal points, and screened from view all the squalor and filth that may have prevailed elsewhere, hidden behind the turreted façades of circuit-walls and the porticoes lining main thoroughfares. The teeming and often very vocal masses were essential to the spectacle as both audience and participants, but only as a crowd; only when they left their dwellings, assembled *en masse* and brought the public spaces of the late antique city alive.

In my view, then, the city walls, colonnaded streets and official residences that together did the most to shape the 'secular' topography of the late antique city were nearly always calculated to exalt the image of divine majesty that late antique authority figures so carefully cultivated for themselves. Churches and bishops' palaces did the same for members of the ecclesiastical hierarchy, who of course fashioned their public personas in ways that borrowed much from the ceremonial repertoire of the late Roman state.[41] Late antique urban topographies were monumental canvases, or better ornamental backdrops or stage-sets, before which emperors and kings, governors and bishops acted out the pageantry of their own authoritarian spectacle. Rather than as a diffuse collection of edifices representative of an abstract ideal of civilized living, sponsored by private donors who sprinkled their commissions widely across the urban fabric as opportunity and their means allowed, cities increasingly centered around a continuum of dynamic space, a limited series of itineraries designed to connect and frame a few, privileged focal points.

It bears stressing that the individuals at the center of these public displays were the ones responsible for authorizing and financing the structures in front of which they paraded themselves, a point that will be taken up in more detail in the following chapter. Across the empire, private patronage of civic building projects declined steeply over the course of the third century, just before the new forms of monumental public architecture began to predominate.[42] Responsibility for municipal monuments and infrastructure passed increasingly into the hands of the central administration beginning in the later third century,[43] just when Roman sovereigns dropped all pretense of ruling

[41] On the translation of secular ceremonial idioms into ecclesiastical contexts, see, e.g., Dufraigne 1994, 249–325; Humphries 2008.

[42] On the decline of local financing of public buildings, see Ward-Perkins 1984, 3–37; Liebeschuetz 2001a; Kulikowski 2004, 63–85; Marazzi 2006; Noreña 2011, esp. 318–20.

[43] The complex issues relating to the financing of public works and the relative contributions of state and local funds are discussed in greater detail in Chapter 2. For now, suffice it to say that

by consensus and began to style themselves as absolute monarchs, as Western successor kings and Byzantine emperors would continue to do.[44] Thereafter, new constructions were undertaken primarily on the initiative of the ruler and his appointed representatives, who had a powerful vested interest in patronizing buildings that most effectively promoted the vision of commanding presence they sought to project. So too in the case of ecclesiastical building projects, it was the bishops who generally assembled the funds and took responsibility (and credit) for the commissions, in some cases incurring ruinous expenses to erect what some contemporaries chose to portray as needlessly grandiose monuments inspired by lust for worldly glory.[45]

By the later fourth century, the repercussions of the central administration's increasingly pivotal role in the financing of public buildings and urban infra-structure were becoming apparent across the empire. From western Europe to the Levant, the most flourishing cities were those that regularly played host to emperors and their leading subordinates, the imperial and provincial capitals that also underpinned ecclesiastical administration and boasted the most pow-erful and influential bishops.[46] The example *par excellence* is Constantinople, 'founded,' in Jerome's memorable phrase, 'with the stripping of almost all the cities.'[47] Many of the remaining towns, left to the care of an ever-more belea-guered curial class, and at times even denuded of sculpture, building materials and civic funds to supply nearby seats of government, saw their claims to urban status disintegrate in step with their monumental architectural patrimonies.[48]

I would suggest that the political fragmentation of the empire beginning in the fifth century provoked a further winnowing effect, particularly outside of the regions still controlled by Constantinople, where the survival of traditions of urban living largely depended on the cultural sympathies of the new rulers. In those successor kingdoms – Merovingian Gaul, Visigothic Spain, Lombard Italy, even Vandal Africa – deeply invested in usurping the legacy and traditions of imperial Rome, cities remained central to the ordering of society, while in regions occupied by peoples with relatively little exposure to Roman cul-ture and little experience of monumental topography and urban lifestyles in the Greco-Roman mold, cities tended to disintegrate more rapidly and more

from the time of the Diocletianic reforms at the end of the third century, the central adminis-tration played a far more active role in both commissioning and financing public works than ever before: see, e.g., Lepelley 1999; Lewin 2001; Bransbourg 2008. More generally on the bureaucratic apparatus of the late Roman state, see C. Kelly 2004; cf. P. Brown 1992, 17ff.

[44] On the ideology of late antique rulership in theory and in practice, see Alföldi 1970, 6–79; P. Brown 1992; Kolb 2001, 19–58; Potter 2004, 294–98; de Blois 2006; Hedlund 2008; Canepa 2009; Bardill 2012.

[45] P. Brown 1992, 120–21.

[46] On Italy, Marazzi 2006; Fauvinet-Ranson 2006, 197–300; on Spain, Kulikowski 2004, 63–64 and 109ff.; on the eastern Mediterranean, Liebeschuetz 2001a, 170–78; Saradi 2006, 17ff.

[47] Jerome, *Chron.* (*anno* 334, p. 314): *Dedicatur Constantinopolis paene omnium urbium nuditate.*

[48] *CTh* 15.1.14 (of 365, on statues, marble and columns); 15.1.26 (of 390, on civic funds).

completely. Thus, leading regional centers in provinces with strong Roman ties – Cologne, Trier, Carthage, Cordoba, Pavia, for example – were often continuously inhabited throughout the early Middle Ages, while Balkan cities such as Salona, Sirmium and Nicopolis ad Istrum largely fell off the map with the arrival of the Slavs and Avars at the end of the sixth century.[49]

A central thesis of the following chapters will thus be that in those areas where cities remained central to the configuration of society in the post-Roman period, it was in large part because Byzantine emperors, Western kings, bishops and for that matter Umayyad caliphs wanted and needed them to exist, as crucial tokens of the power and patronage that these leaders sought to project. If this is right, narrowly structural or economic arguments for the 'end' of urban living will often fall short of their mark, because the preservation of cities and urban lifestyles was often not a strictly practical matter: the late Roman equation between monumental urban forms and the exercise – and display – of effective temporal and spiritual authority ultimately helped to preserve some cities at a time when they might otherwise have ceased to exist. This 'top-down' approach would then also help to explain why urban infrastructure disintegrated to a greater extent in those regions whose new rulers were relatively disinterested in, or extraneous to, the Greco-Roman urban tradition.

Such a formulation in turn allows cities and monumental architecture to be integrated into recent interpretive structures, broadly characteristic of post-processual (or indeed 'post-post-processual') archaeology and anthropology, which have sought to reintroduce personal agency as an engine of historical causation and cultural evolution, and to recognize that long-term change cannot always be reduced to statistical data, artifact typologies and abstract models of evolutionary processes.[50] Further, it aligns them with current efforts – to my mind so commonsensical that they transcend the more labile world of 'theory' – to highlight the agency of material culture and constructed space, according to which buildings shape the cultural formation and priorities of their inhabitants as much as they passively reflect or embody them.[51]

Seen from this perspective, the enduring presence of a circuit-wall, for example, that most ubiquitous symbol of late antique urbanism, may have become an independent stimulus to continued settlement within its confines, and even incited its inhabitants to comport themselves as urbanites. Hence, when Gregory of Tours and Isidore of Seville presented walls as an essential

[49] Ćurčić 2010, 249ff.; Poulter 2007. See Chapter 4 for a lengthier treatment of these issues.
[50] See, e.g., Hodder and Hutson 2003, 206–35.
[51] Chris Gosden has been particularly influential in shaping my thinking on this topic (Gosden 2004, 2005, 2006), as to a lesser extent has Colin Renfrew's 'material engagement theory' (e.g., Renfrew 2004); cf. also DeMarrais 2004; Leonard 2001 (on evolutionary archaeology); Mithen 2001 (on cognitive archaeology).

token of urban status in the sixth and seventh centuries, respectively, they were not merely propagating an anachronistic fantasy;[52] rather, the presence of the city as a distinct conceptual category remained as real as the walls and cities themselves. It is exactly this kind of thinking – because of its wishful nature and not in spite of it – that helped to ensure the unbroken survival of an urban paradigm into the high Middle Ages, when demographic and economic growth again came to provide a more narrowly functional imperative for the existence of cities across much of Europe and Byzantium.

The vast and multiplying corpus of recent studies on postclassical urbanism aside, my project rests on the insights of a small circle of giants, upon whose shoulders I hope to balance for just long enough to see my way to replacing postclassical cityscapes into the ceremonial and ideological frameworks that did so much to shape them and imbue them with meaning. Andreas Alföldi's work on the regal trappings of Roman imperial rule captured the essence of what made the autocratic stamp of the later empire so qualitatively different from the Principate, even while stressing the basic continuities that link the two periods and tracing the origins of the former in the symbolic repertoire of the latter.[53] The late Sabine MacCormack's *Art and Ceremony in Late Antiquity* did more than any previous study to illustrate the correlation between icon-ographical and textual representations of late antique rulers and the growth of an officially sanctioned vision of triumphal rulership. In a way, this book is an extension of her ideas, among them her precocious sense that written and material culture is as much constitutive of reality as reflective of it, into the realm of architecture and urbanism. For although MacCormack patently recognized the pivotal role of the built landscape in the ideological designs of late antique leaders – at a time when the serious archaeological study of late and post-Roman cityscapes was in its infancy – she left the subject of urban topography largely unexplored.[54] The same is true for Michael McCormick's masterful study of victory ceremonial in late antiquity and the early Middle Ages in both East and West, which also acknowledges that urban topography and monumental architecture furnished the essential backdrop for the large majority of the ceremonial under consideration, without, however, discussing

[52] Isidore began his chapter on public buildings with a lengthy discussion of walls, noting first that 'the walls themselves are the city' (*nam urbs ipsa moenia sunt*; *Etym.* 15.2.1), and later explaining that a town without walls was only a *vicus*, and not a *civitas* (ibid., 15.2.11–12). Gregory of Tours, writing at the end of the sixth century, was at a loss to explain why the town of Dijon, surrounded by an impressive defensive wall that he describes in detail, was known as a *castrum* and not a *civitas* (*HF* 3.19).

[53] The salient elements of the Alföldian corpus are collected in Alföldi 1970.

[54] MacCormack 1981. The idea is most succinctly stated in MacCormack 1976, p. 42: 'As part of imperial ceremonial, [panegyrics] needed a setting, an architectural framework: the extensive imperial building programme of the later Roman empire … can be viewed in the context of imperial ceremonies that stood in need of a back-cloth.'

either architecture or the crucial nexus between urban environments and ceremony in detail;[55] and for Pierre Dufraigne's undercited and underappreciated *summum opus* on that most ubiquitous, majestic and essential element of the ceremonial repertoire, civic and religious, for the centuries of our purview: the *adventus* and its derivatives.[56]

While all of these commentators, in short, recognized that the ritualized elaboration of power, authority and venerability common to temporal sovereigns and ecclesiastics in late antiquity and the early Middle Ages was a quintessentially urban phenomenon, requiring both a crowd of observers and the monumental infrastructure of the late Roman metropolis to be meaningful and effective, they left the profound topographical ramifications of these propositions largely unexplored, as indeed has nearly everyone else, before and since. If it is true that the imperative of auto-representation and -celebration informs much (most?) of the monumental architecture built *ex novo*, as well as that selected for preservation and/or restoration, in both East and West from the third century through the ninth, it follows that the characteristic shape of the postclassical city was largely a product of ceremony. To an extent that has yet to be fully appreciated, the monumental armature – what Krautheimer called the political topography[57] – of leading late antique cities needs to be considered as the translation of ceremonial protocols into the realm of built space.[58] Perceived in this light, the nexus between certain forms of monumental architecture, and indeed between the urban landscape *sensu largo*, and the exercise of sovereign power forged during the third and fourth centuries may indeed become a viable, albeit partial, explanation for the preservation of distinctively urban lifestyles and institutions in much of Europe and Byzantium, even during the darkest of the 'Dark Ages,' as the economic and demographic and political structures that had underpinned the flourishing of Greco-Roman urbanism gave way.

Let us turn finally to the caveats and hedging. The propositions outlined earlier and summarized in the preceding paragraph are largely hypothetical. What follows amounts to an attempt to selectively test my hypotheses on the basis of a series of suggestive vignettes, unabashedly drawn from those sites that seem best to support the case I am attempting to make. The sites chosen for more detailed discussion represent a tiny fraction of the Greco-Roman urban centers for which substantial archaeological and/or textual documentation exists, a fraction made still smaller by my effort to include, at least in theory, the entire

[55] McCormick 1986, 7, 288–89.
[56] Dufraigne 1994. Baldovin 1987 on the urban context of Christian stational liturgies is also extremely important, though he too concerns himself far more with ritual than topography *stricto sensu*, despite recognizing their interpermeation: see esp. 256–57.
[57] Krautheimer 1983, 3–4.
[58] Cf. Carver 1993, 23–25.

range of the empire as it existed ca. AD 250 in my purview. I have done so A) to illustrate the relative cohesiveness of (largely state-sponsored) approaches to public building across much of the empire beginning in the Tetrarchic period and continuing at least through the fourth century, and B) because if my views about the reasons for the persistence of urban habits and urban ideals in some regions are to have any weight, they should also help to explain why cities decayed to a greater extent in other areas. The result is a short book on an enormous topic. Rather than fattening and diluting it by taking a slightly larger (but still minuscule) portion of the relevant data into account, it has seemed best to lay out my central theses; to demonstrate by the use of selected case studies that these theses lie within the realm of the plausible, and indeed work rather well in a select number of contexts; and to leave it to regional experts to explore their applicability to any given area in more detail.

Such an approach naturally risks descending into superficiality and vague generalization, and eliding important differences even between the restricted number of (relative) urban success stories taken into consideration, perhaps above all between places in the 'Byzantine' East and the 'Latin' West. It is traditional to say that a greater number of cities flourished until a later date in the East, where networks of provincial cities remained vital in many areas at least until the period of Persian invasions and subsequent Arab conquests in the first half of the seventh century. There is some truth to the idea: the fifth and early sixth centuries were a period of growing – even unprecedented – prosperity and demographic expansion across much of the eastern empire;[59] and certainly East and West followed increasingly divergent political, religious and social trajectories from the time of the division of the empire between the sons of Theodosius in 395, and especially following the final partitioning of the western empire in the fifth century. To better account for these factors and others (among them the far more ancient roots of monumental urbanism across much of the eastern Mediterranean than in most of the West), it seemed useful to divide the post-imperial Chapter 4 into subsections corresponding with discrete geopolitical entities, a practice I chose not to follow in the preceding chapters, which deal mostly with a unitary 'Roman' empire whose common cultural legacy seems more relevant for present purposes than its manifold regional variations.

It is interesting to note, however, that there has recently been a parallel vogue among scholars of both East and West to place the definitive end of the 'classical' city in the seventh century.[60] Again, there is some truth to the idea, particularly for the East. Of the hundreds of flourishing *civitates/poleis* in existence across the empire in the second century AD, many were more or less

[59] See inter alia Foss 1997; Wickham 2005, 443–65, 609–35; Sivan 2008.

[60] North Africa: Lepelley 2006; Italy: Brogiolo and Delogu 2006, 617–22; Gaul: Guyon 2006, esp. 125; Asia Minor: Whittow 2001, 2003; Syria and Palestine: Foss 1997; Westphalen 2006; see generally also Delogu 2010b, 39–92.

defunct by the seventh century, and many of the rest were considerably smaller and poorer than they had been in their heyday. And to be sure, some combination of political fragmentation, economic involution, civil wars, hostile invasions, natural disasters, famine and recurring outbreaks of plague will largely suffice to explain the reduced fortunes of any given city. Nonetheless, the now popular view that the seventh century represents a period of profound and even definitive rupture with the past, when both the socioeconomic structures and the ideological constructs that had underpinned the primacy of the city in the ancient world became largely irrelevant,[61] is in my view an invitation to throw the urban baby out with the historical bathwater. The more interesting question, surely, is why the ideal, and in some privileged places the reality, of the late antique city did *not* disappear in a world as radically changed as the seventh century in many respects was, in both East and West.

With regard to Byzantium, even if the most pessimistic observers were correct to suggest that Constantinople became the sole metropolis of the 'ruralized' rump of the empire that remained in Byzantine hands following the Arab conquests,[62] its role in propagating the ancient nexus between 'civilization,' authority, ceremony and monumental architecture would be none the less noteworthy.[63] And in fact, as we shall see in Chapter 4, other regional centers, among them Syracuse, Thessaloniki, Corinth and a number of places in Asia Minor such as Ephesus, Nicaea and Amorium continued to maintain distinctly 'urban' concentrations of population, economic activity, and (perhaps most important) monumental topography that still served to frame the exercise of civic and spiritual authority.[64]

In the case of the West as well, too much has been made of the putative ruralization of society in the seventh and eighth centuries.[65] While rural landowners with their retinues of dependents undoubtedly did gain in prominence in, for

[61] Cf. Haldon 1997, 92ff., 1999; Brandes and Haldon 2000, 148–50 and passim. For a useful overview of the economic situation, and the historiography thereof, in both East and West, see Cosentino 2010.

[62] See, e.g., Haldon 1997, 92–124, esp. 115–17 on Constantinople and its unique status in the seventh and eighth centuries; for Haldon, the remaining late antique cities that continued to be occupied in this period were reduced to fortified outposts and administrative centers hardly worthy of consideration as 'cities' in the classical sense, a perspective shared by, e.g., Mango 1980, 73–74; Brandes 1999.

[63] Cf. Wickham 2005, 634–35.

[64] Thessaloniki: Bakirtzis 2003; 2007, 105–13; Asia Minor: Brandes 1989, 124–31; Whittow 2003; Niewöhner 2007; Ivison 2007. Whittow, Niewöhner and Ivison all argue convincingly that Clive Foss overstated the case for seventh-century urban collapse in Asia Minor in his seminal works on the subject (e.g., Foss 1977a). These sites are considered in more detail in Chapter 4.

[65] For example, Liebeschuetz 2001, 129 (postulating a mass movement of western notables to the countryside already in the sixth century, despite the fact that their putative rural dwellings remain archaeologically invisible in areas such as Gaul and Spain, where they have been persistently sought); ibid., 68–70 on the ruralization of society in Anatolia after ca. 550. The

example, Francia and Lombard Italy, as they did in the themes of Byzantium,[66] both governmental and ecclesiastical power structures remained rooted in urban topography – which is to say chiefly in surviving Roman cities – to an extent that needs to be stressed more than it generally has in the past. The political fragmentation of the West may in fact be partially responsible for the relative concentration of 'capital' cities that remained in the seventh and eighth centuries: whereas Constantinople may indeed have tended, by virtue of its status as the undisputed center of the Byzantine world, to attract a disproportionate quantity of resources both human and material unto itself,[67] the western successor kingdoms tended to maintain their own webs of towns that served as political, administrative and spiritual foci. Further, the enduring influence of Byzantium, or a particular vision thereof, on western practices should not be underestimated: Constantinople provided a paradigm of urban grandeur, civility, imperial majesty and court ceremony that Visigothic, Frankish and Lombard rulers drew on for centuries.[68] Rome – itself a provincial Byzantine city into the eighth century – exercised its influence too, furnishing an urban template for generations of western kings and bishops keen to associate themselves with the political and spiritual legacy of the ancient capital.[69]

In any case, in considering the subsequent fortunes of the post-Roman city in both the West (following the dissolution of the empire in the fifth century) and the East (following the upheavals of the early seventh), I hope enough suggestive parallels will emerge to justify the effort – and risk – of examining such a broad cross-section of the erstwhile Roman empire. In a sizeable number of urban landscapes scattered across western Europe, Byzantium, and for that matter the Islamic world, from Damascus to Cordoba, an ember of the late antique city, that last flowering of the 'classical city,' remained alive for many centuries. The extent to which that ember helped spark a new explosion of urbanism in the high Middle Ages is both debatable and the subject of another book entirely. In what follows, however, we might at least show that something of the late antique city lived on long enough in both the minds and the daily experience of enough of the powerful – and by extension their subjects – to make the likelihood of such a connection inherently plausible.

same might be said about the alleged flight of leading families from cities to rural villas in the fourth and fifth centuries.

[66] On the west: Wickham 1984; 2005, 168–232; T. S. Brown 1984, 190ff.; on the East: Haldon 1997, 92–172; Dagron 2002.

[67] Cf. Wickham 1984, 33–36; Saradi 2008, 319ff.

[68] Cf. McCormick 1986, at, e.g., 288–89; 303–04; 364–65; Zanini 2003.

[69] Cf. Graf 1882–83, Vol. 1, 1–43; Settis 2001.

CHAPTER TWO

NEW URBAN FORMS FOR A
NEW EMPIRE: THE THIRD CENTURY
AND THE GENESIS OF THE LATE
ANTIQUE CITY

2.1 PHILIPPOPOLIS

A lone reference in the *Liber de Caesaribus* informs us that the newly minted emperor Philip ('the Arab'), shortly after his elevation to the purple in 244 following the murder of Gordian III, founded a new town bearing his name in his native province of Arabia, before heading west to Rome.[1] Philip's eponymous urban project is identified beyond reasonable doubt with the mid-third-century remains of a city planted in the rocky hills of modern Syria on the site of an existing village where Philip was likely born, some miles from the stretch of the Via Traiana Nova that links Bostra and Damascus.[2]

Philippopolis is enclosed by a bulky circuit-wall of large, well-cut stone blocks ca. 3500m in length, in the form of an irregular quadrilateral whose contours, particularly in the southwest, are determined by the undulating topography of the rocky upland plain where it sits (Figure 2.1). The curtains

[1] Aurelius Victor, *de Caes.* 28: *Igitur Marcus Iulius Philippus Arabs Thraconites, sumpto in consortium Philippo filio, rebus ad Orientem compositis conditoque apud Arabiam Philippopoli oppido Romam venere.*

[2] For reliable, recent overviews of the site, see Darrous and Rohmer 2004; Oenbrink 2006. Cf. also (less reliably) Segal 1988, 75–100; 1997, 13–15. Darrous and Rohmer provide the most accurate and detailed site-plan yet produced. On the remains of the older village and the probability of its association with the birthplace of Philip, see Darrous and Rohmer 2004, 17ff.; Oenbrink 2006, 248–53.

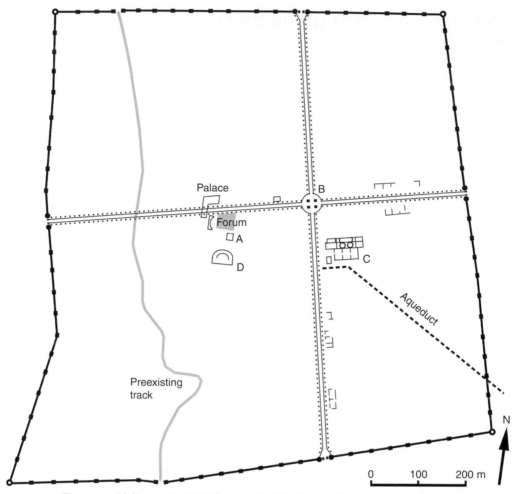

Figure 2.1 Philippopolis. A: 'Philippeion' (*boule*?); B: tetrapylon; C: baths; D: theater. (Author.)

are studded with numerous square towers, projecting from both faces of the wall, at frequent intervals generally ranging between 40 and 50m. In addition to two small posterns presumably built to accommodate the older track running past the existing village in the western sector of the perimeter, the circuit is pierced by four identical gates, each with a central archway flanked by two smaller arches.[3] These gates opened onto the main *cardo* and *decumanus* of the new city, both fully 15m wide, paved in slabs of basalt, and lined along their full extent by continuous, covered porticoes 5m deep, such that the full width of the streets and their flanking colonnaded galleries approached 25m.[4] The two streets intersect at right angles at a circular plaza ca. 60m in diameter,

[3] Segal 1988, 82–83.
[4] Darrous and Rohmer 2004, 9–10; Oenbrink 2006, 253–54.

punctuated at its center by an imposing *quadrifrons* archway.[5] Due particu-
larly to the displacement of the main *cardo* toward the east, perhaps to avoid
bisecting the existing settlement nucleus in the west, the result is an intramu-
ral area divided into four quadrants of varying size. While a grid of roughly
quadrangular blocks delineated by secondary streets has been detected in spots,
particularly along both sides of the *cardo* and in the eastern sector of the city,
the majority of the street grid seems never to have been finished; and with
the exception of a number of important public buildings located in close
proximity to the two main streets, the rest of the intramural area was left empty,
almost certainly as a result of Philip's murder in 249, at which point construc-
tion seems to have ceased almost entirely, leaving imposing edifices such as the
public baths east of the *cardo* unfinished.[6]

With the exception of the baths, the rest of the attested monumental archi-
tecture closely straddles the western stretch of the *decumanus*, centered on what
appears to have been a small forum surrounded by colonnades, possibly located
on the site of an existing public space.[7] The principal adjacent structures
include a theater;[8] portions of what may have been an official residence or pal-
ace;[9] the 'Philippeion,' a building embellished with statues of the emperor and
his family that is more likely to have been a senate house or *bouleuterion* than
an imperial mausoleum and shrine;[10] a temple; and perhaps a civic basilica. The
new foundation was thus furnished from its inception with a schematic ver-
sion of the essential kit of urban amenities characteristic of an important city
anywhere in the empire, including also an aqueduct to furnish water for the
baths and an adjacent nymphaeum facing onto the *cardo*.

What is particularly noteworthy about the ensemble of public edifices
erected in the five brief years of Philip's reign is its interconnectedness and
basic cohesion. All of the principal public buildings are more or less directly
linked to the two major colonnaded streets, themselves connected to the four
gates in the imposing circuit-wall. The result is a kind of distillation of the
image of a well-appointed city, a robust urban skeleton that stands essentially
independent of the remainder of the intramural space. To be sure, the impres-
sion is heightened by the arrested development of the peripheral quarters, yet

[5] Ibid.
[6] Segal 1988, 83–87, Darrous and Rohmer 2004, 26–27.
[7] Darrous and Rohmer 2004, 11–17; Oenbrink 2006, 255–57.
[8] Coupel and Frézouls 1956.
[9] Segal 1988, 79–80.
[10] For the traditional identification of the building as a mausoleum and shrine to the imperial
cult, see Amer and Gawlikowski 1985; the presence of two tiers of seats arranged in a horse-
shoe shape around the interior of the building, sufficient to accommodate ca. 100 people
(the standard number for a Roman-style *curia*) and other factors lead Darrous and Rohmer
(2004, 12–15) convincingly to suggest the alternate interpretation; on the several inscriptions
from statue bases commemorating members of the imperial family found in the complex, see
Segal 1988, 98–100.

for contemporaries who beheld the city wall from the outside, or experienced its interior from the perspective of the grand avenues that greeted anyone traversing the gates, the image of the place would have remained precisely the same regardless of the condition of the neighborhoods behind the main streets, screened from view as they were by the covered colonnades. It appears that Philip's architects gave first priority to the structures that most effectively and succinctly captured the vision of the imperial showpiece that their patron manifestly sought to create, leaving the less visible and less frequented zones for a later date that largely never arrived, though the place lived on for centuries after the death of its founder.[11]

It is a schematic blueprint that bears witness to the development of a new urban paradigm, conceived and financed by and on behalf of the sovereign of the Roman world, which placed unprecedented weight on two colonnaded thoroughfares and their associated monuments, as Giorgio Bejor has seen so well: 'Philippopolis marks the change in significance of the colonnaded street from a representative image of the city, which it maintained in the foundations of Hadrian, Antoninus Pius and then Septimius Severus, to that of an element directly connected with the imperial will. While local euergetism entered its final decline, the continuity of the [colonnaded] paradigm appears to have been ever-more connected to the direct intervention of the central government.'[12] Indeed: and beginning four decades later, the distinguishing characteristics of Philippopolis would reappear, on an empire-wide scale, in a spate of new urban and quasi-urban projects sponsored by Diocletian and his colleagues, autocrats possessed as never before of the funds, the sheer political and administrative muscle, and the will to transform the architectural language of the classical cityscape into a new urban paradigm, tailored to serve the political and ideological ends of the emperors and their agents. Before turning to the architecture, however, we ought first to address the political and administrative evolution – or revolution – of the later third century that made the state into the primary architect of urban topography and arbiter of architectural décor.

[11] Houses with opulent mosaics of the highest quality continued to be built in the fourth century; a church was erected – again facing directly onto the *decumanus* – in perhaps the fifth century, and continued in use in the sixth, when a chapel was added; and local notables are epigraphically attested through the fifth and sixth centuries. On the mosaics, see Balty 1995, 141–48; on the church and the inscriptions, Darrous and Rohmer 2004, 28–30 and 36–37, respectively.

[12] Bejor 1999, 99: 'Filippopoli segna il passaggio di significato della via colonnata da immagine rappresentativa della città, che già aveva nelle fondazioni di Adriano, di Antonino Pio e poi di Settimio Severo, a elemento strettamente connesso con la volontà imperiale. Mentre sta definitivamente tramontando l'evergetismo locale, la continuità del genere sembra sempre più legata al diretto intervento del potere centrale.' Cf. Darrous and Rohmer 2004, 38–39.

2.2 CITIES AND THE REORGANIZATION OF THE
LATE ROMAN STATE

Diocletian (r. 284–305) is undoubtedly the pivotal figure who set the political, military, economic and administrative structures of the late Roman state on a dramatically new course, for all that a number of his innovations were partially anticipated by his predecessors, and continually developed, augmented and codified under his successors throughout the course of the fourth century and beyond. Baldly put, the Diocletianic program was designed vastly to increase the size, complexity and reach of the central administration, such that it might better insinuate itself into every corner of the empire and exercise an unprecedented degree of control over all aspects of defense, taxation and civil administration.[13] The size of the standing army was dramatically increased – perhaps doubled – and divided first into two essentially independent commands with the institution of the Diarchy in 286, and then four with the creation of the First Tetrarchy in 293. The number of salaried professional administrators likewise rose precipitously: if MacMullen's figure of 300 senior civil servants for the mid-third century (not including some thousands of slaves and freedmen allocated to clerical tasks) falls anywhere near the mark, perhaps by a factor of twenty or more.[14] The number of provinces was approximately doubled, from ca. 50 to ca. 100, with each province overseen by an imperially appointed governor assisted by a large bureaucratic staff; and the provinces were themselves grouped into twelve dioceses, each under a *vicarius* with his own dedicated retinue of civil servants, who in turn answered to the praetorian prefect(s), themselves served by yet another coterie of professional bureaucrats.[15] These innovations alone were sufficient to provoke a dramatic increase in government expenditures, both in kind (particularly for the troops) and in specie, which was in turn underwritten by a drastic overhaul of the fiscal apparatus of the state, focused above all on the means by which taxes were collected and the quantity of the exactions, a process considerably facilitated by the division of the provinces into smaller administrative units.

[13] The bibliography on Diocletian and his reforms is gargantuan: valuable overviews include Seston 1946; Jones 1964, 37–76 and passim; Barnes 1982; Williams 1985; Matthews 1989, 252–62; Chastagnol 1994a, 1994b; Kuhoff 2001, esp. 327–410; Porena 2003, esp. 152ff.; Potter 2004, 280–90; Boschung and Eck (eds.) 2006.

[14] MacMullen 1988, 164. For the numbers from Diocletian on, see, e.g., Jones 1964, 50–52 (for an estimate of the equivalent of two legions' worth of officials added) and 367; Smith 2011, 135–36.

[15] Barnes (1982, 225) believes that the provincial reorganization occurred in one fell swoop in 293; for other perspectives, see Chastagnol 1994b, 237–54; Kuhoff 2001, 329–70, esp. 338ff. On the changing character and new responsibilities of the praetorian prefecture from the late third century, see esp. Porena 2003.

Given that it is these financial initiatives that most immediately affected the fortunes of cities and the mechanics of public building across the empire, very simply by determining where and in whose hands the money available for costly urban interventions resided, they require a closer look. As the topic is vast, and continues to consume oceans of scholarly ink in the discussion of its particulars and its practical repercussions, a resume of the most relevant and reasonably uncontroversial points will have to suffice.

Modern accounts understandably tend to depart from the colorful testimony of Lactantius,[16] whose narrative, tendentious as it is, remains the best contemporary source for what transpired under Diocletian and his colleagues:

> The number of recipients [of revenues derived from taxes] began to exceed the number of contributors by so much that, with farmers' resources exhausted by the enormous size of the requisitions, fields became deserted and cultivated land was turned into forest. To ensure that terror was universal, provinces too were cut into fragments; many governors and even more officials were imposed on individual regions, almost on individual cities, and to these were added numerous accountants, controllers, and prefects' deputies. The activities of all these people were very rarely civil; they engaged only in repeated condemnations and confiscations, and in exacting endless resources – and the exactions were not just frequent, they were incessant, and involved unsupportable injustices.[17]

A. H. M. Jones, himself prefacing his discussion with Lactantius, arrived at the following conclusions regarding the situation of cities in the fourth century, in the wake of the processes set in motion at the end of the third:

> As the councils lost their richest and most enterprising members, as their revenues were curtailed, and as civic patriotism decayed, the cities lost initiative and vitality. Whether through genuine poverty or lack of public spirit the councils became increasingly reluctant to undertake any action which would involve expense. This encouraged growing interference in civic affairs by the provincial governors. Such interference was most marked in the capitals of provinces, where the governor normally resided and where he was particularly anxious to make himself popular.[18]

While Jones' views have been considerably nuanced in the ensuing half-century, above all by Delmaire's *magnum opus* on late imperial finances,[19] they remain as good a point of departure as any.

We begin with the loss of civic revenues, the funds raised and administered by individual city councils (*curiae/boulai*), through taxes and rents on civic lands,

[16] Cf. Delmaire 1989, 589; Durliat 1990, 14ff.; Lepelley 1996, 219; Kuhoff 2001, 329–30.
[17] *DMP* 7.3–4; trans. Creed 1984, 13.
[18] Jones 1964, 757, citing Lactantius at 46–47.
[19] Delmaire 1989. See also Durliat 1990, 11–94; Carrié 1994; Lepelley 1996; Kuhoff 2001, 483–514; Bransbourg 2008.

and through voluntary contributions by local euergetes – chiefly the *decuriones* who made up the local *curiae*, who also paid the *summa honoraria* upon taking up office – which had sufficed to finance the great majority of civic building projects undertaken during the early and high empire.[20] Beginning with Diocletian, the growing demands of the state translated into higher exactions of taxes, which will by definition have left fewer resources in the hands of provincial populations, rich and poor alike.[21] Further, Diocletian's scheme vastly improved the efficiency of tax collection by instituting a regular census of all persons and property in the empire at five-year intervals,[22] and by simplifying the procedure by which taxes were reckoned. Instead of the poll tax (*tributum capitis*) and land tax (*tributum soli*), formerly collected separately and assessed differently in different regions,[23] an abstract unit was introduced, often called the *jugum* (but apparently also, at various times in different parts of the empire, a *millena, iulia, sors, caput, klèros, zygon*). People, assets and land were all converted into a fixed number (or fraction) of *juga* or its equivalents: persons of different age, sex and condition (servile or free) could be calculated in varying fractions of a *jugum*, likewise with livestock, and so too with land of differing quality and devoted to particular types of use or cultivation (steep or flat; forage or crops; grapes, grain or olives, and so on).[24] Each household – and each city – was thus valued at a certain number of *juga*, with the actual quantity of taxes owed each year in cash and in kind determined and assessed per *jugum*. The administration calculated the revenues it required each year, divided the requisite amount by the number of fiscal units tallied on the census rolls for the whole empire, city by city, and collected the share required from each *civitas/polis*.

Fiscal evasion – or better the possibility of fiscal shortfalls – was likewise curtailed. The *decuriones* remained responsible for collecting taxes, they were compelled to raise unprecedented sums on a yearly basis, and they were held liable for any shortfalls.[25] They thus had to squeeze the taxpayers under their jurisdiction harder than ever before, as those who failed to collect the amount required from their city will have suffered financially, all of which made service in municipal *curiae* considerably more onerous, and led to a spate of fourth-

[20] See, e.g., Ward-Perkins 1984, 3–37; 1998; Jacques 1984, 687–765; Corbier 1991, esp. 654ff. On the *summa honoraria*, see also Duncan Jones 1982, 108–10; 147–55.

[21] See n. 19.

[22] Lactantius' description of the census undertaken in 306 under Galerius is the most graphic ancient account of the hardships the new census provoked (*DMP* 23). See generally Jones 1974, 83–89; Barnes 1982, 226–37; Chastagnol 1994b, 373–74.

[23] For a succinct overview of the high imperial system, see Corbier 1991; Potter 2004, 50–60.

[24] The late fifth-century Syro-Roman Law Code is the best source for the details of the new system, which it explicitly attributes to the initiative of Diocletian (*FIRA*, vol. 2, 121 at pp. 795–96). See generally Jones 1964, 453–54; 1974, 280–92; Hendy 1985, 371ff.; Williams 1985, 118–25; Durliat 1990, 16–30; Carrié 1994; Chastagnol 1994b, 364–82; Bransbourg 2008, 269–73.

[25] Jones 1964, 728–29; Delmaire 1996; Kuhoff 2001, 395–96; Bransbourg 2008, 273–77.

century legislation that first bound *decuriones* and their heirs to their posts in perpetuity, and subsequently strove to curb all efforts to escape service in the councils.[26] To further ensure prompt and full payment from each city in the empire, greatly enhanced powers were attributed to the *curator civitatis/curator rei publicae* (*logistes* in Greek), an official charged with supervising civic finances and ensuring responsible fiscal behavior, attested sporadically from the time of Trajan on.[27] Beginning with Diocletian, a *curator* was assigned to each city in the empire, whose responsibilities included, in addition to regulating civic spending and tax collection, maintaining public order and – interestingly enough – supervising civic building projects.[28] While usually drawn from the local aristocracy, these *curatores* were appointed by, and answered directly to, the emperors;[29] their intimate knowledge of local affairs must indeed have made them particularly effective in executing their charge.[30] The possibilities for local corruption and peculation remained legion, and even grew, and the heaviest financial burden no doubt often fell on the ranks of the humble and defenseless;[31] all the same, the government guaranteed itself a predictable sum from all cities in the empire, to the peril of their leading citizens if annual obligations were not met.

Yet these measures, draining as they were, did not impinge on the right of cities to collect local taxes – indirect levies such as sales taxes and customs dues (*vectigalia*), and above all the rents from civic lands, buildings, shops and public spaces leased to or otherwise occupied by tenants – and administer them as they saw fit.[32] Over the course of the fourth century, however, cities everywhere lost control of the majority of their revenues, including of course those available for building projects, which passed under the direct control of the state. The chronology and the details of this radical fiscal realignment, illuminated as they primarily are by a series of rather inscrutable – to modern eyes – laws in the Theodosian Code, continue to provoke scholarly debate, but the essential fact that city councils were progressively deprived of the right to dispose freely of their yearly tax intake seems quite certain.[33]

[26] See esp. Laniado 2002, 3–26; cf. Bransbourg 2008, 278–79. For a concise overview of the reams of legislation in the Theodosian Code aimed at *decuriones*, Jones 1964, 743ff.

[27] On the origins and development of the position in the second and third centuries, see Jacques 1983; 1984, 115–317.

[28] Jones 1964, 726–27; Lepelley 1996, 215–17; 1999, 241–42.

[29] Along with Jacques (n. 27), see also Durliat 1990, 71.

[30] By the fourth century, the *curatores* were joined by yet more officials charged with extracting taxes from cities, the suggestively named *exactores* and *compulsores*, the latter always dispatched directly from the palatine ministry in cases of suspected noncompliance, with authority over decurions and even governors (Delmaire 1996, 63–66).

[31] Cf. MacMullen 1988; Carrié 1994, 63–64; Delmaire 1996, esp. 64.

[32] On the various kinds of *vectigalia*, Delmaire 1989, 275–312; on civic lands and properties, ibid., 641–57; cf. Jones 1964, 732–37.

[33] *Pace* Durliat (n. 43). In what follows, I rely largely on Delmaire (1989, esp. the sections cited in the preceding note), whose account of the fiscal structure of the late empire remains

The famous inscription of 331 from Orcistus in Asia Minor suggests that already at that date, the state-appointed *rationalis* of Asia controlled the allocation of local *vectigalia*,[34] while *CTh* 9.17.2 (of 349) indicates that governors were expected to finance public building projects undertaken under their supervision *ex vectigaliis vel aliis titulis*, which is to say with the proceeds from both indirect taxes and those derived from municipal properties.[35] The properties themselves possibly still belonged to the cities until the reign of Valentinian I, but the proceeds deriving from taxes and rents imposed thereupon went increasingly to the imperial treasury (*aerarium*).[36] Whatever money was returned to the cities for the upkeep of urban infrastructure and new construction came directly under the control of governors, *rationales* and *curatores* who answered directly to the central administration,[37] thus bypassing the city councils entirely. Such was apparently the situation in 358, when Constantius II remitted a quarter of annual tax revenues 'to the cities and provincials of Africa, so that from these [*vectigalia*, probably including both rents and indirect taxes] public buildings may be restored.'[38] In 362, Julian went a step further and returned the entirety of their *vectigalia* and *fundi* (rents) to all the cities of the empire,[39] but upon his death, cities were again deprived of their revenues,[40] with undoubtedly grave consequences for the maintenance of urban infrastructure, leading Valentinian to restore a third of the revenues from municipal lands to the control of local *curiae* in 374.[41] While the system remained subject

to my mind unsurpassed, notwithstanding the important modifications proposed in, e.g., Bransbourg 2008 and 2009. See also the sources cited at n. 19.

[34] Delmaire 1989, 276; generally on the inscription, Chastagnol 1981.

[35] *Sed si ex praecepto iudicum monumenta deiecta sunt, ne sub specie publicae fabricationis poena vitetur, eosdem iudices iubemus hanc multam agnoscere; nam ex vectigalibus vel aliis titulis aedificare debuerunt.*

[36] Whether civic lands and properties had been appropriated to the fisc already under Constantius II (Jones 1964, esp. 415; Delmaire 1989, 648ff.), or merely an increasing proportion of the rents derived therefrom (Bransbourg 2008) need not concern us here: the effect on municipal coffers will have been much the same.

[37] On the office of the *rationalis*, a diocesan-level functionary, Hendy 1985, 376–77; Matthews 1989, 265; Chastagnol 1994b, 379–81.

[38] *CTh* 4.13.5: *Divalibus iussis addimus firmitatem et vectigalium quartam provincialibus et urbibus Africanis hac ratione concedimus, ut ex his moenia publica restaurentur vel sarcientibus tecta substantia ministretur.*

[39] *CTh.* 10.3.1 (a. 362): *Possessiones publicas civitatibus iubemus restitui ita, ut iustis aestimationibus locentur, quo cunctarum possit civitatium reparatio procurari*; Amm. 25.4.15: *vectigalia civitatibus restituta com fundis, absque his, quos velut iure vendidere praeteritae potestates*. Bransbourg (2009, 155) plausibly suggests that this passage suggests rather that cities had sought to privatize lands that had become subject to an intolerable tax burden; again (cf. n. 36), the effect on civic coffers would have been nonetheless dramatic, whence Julian's decision to restore full tax immunity to civic lands (Bransbourg 2009, 157).

[40] On the definitive confiscation of most civic lands/revenues under Valentinian I (probably in ca. 364–66), Bransbourg 2008, esp. 290–91; 2009, 157; it had unquestionably occurred by 371, on the evidence of an inscription from Ephesus (*AE* 1906, 30), analyzed at length in Chastagnol 1986.

[41] *CTh.* 4.13.7, with Delmaire 1989, arguing that this rescript pertained only to the West, while more variable sums were allotted to cities in the East. The repercussions of Julian's initiative are

to frequent tweaking thereafter, until Justinian permanently arrogated all civic revenues to the state,[42] city councils never again controlled more than a small fraction of their annual fiscal intake. In short: from the mid-fourth century at the latest, the large majority (never less than two-thirds, with the exception of the brief parenthesis under Julian) of the local rents and taxes once controlled by city councils, much of which had been devoted to the construction and maintenance of public buildings and infrastructure, went directly to the imperial treasury. More to the point (for the actual sums allocated to urban upkeep will never be known, and can be endlessly disputed, and may indeed have been quite substantial), a large portion of whatever funds were returned to cities for the maintenance of their architectural patrimony was controlled by imperially appointed officials, the governors on the provincial level and the *curatores* on the municipal level.[43]

Still more money – in specie – passed out of the hands of provincial populations and into the imperial coffers in the form of new or enhanced taxes, beginning in the late third/early fourth century. Early in Constantine's reign at the latest, the *chrysargyron* or *collatio lustralis* was assessed on those deriving cash profits from commercial transactions at five-year intervals, a measure that will by definition have hit urbanites particularly hard.[44] Again starting with Constantine, senators were required to pay the *collatio glebalis* (or better *follis* or *gleba*) to the *aerarium*, a substantial sum assessed yearly according to their landed wealth, along with yet another new levy, the *aurum oblaticium*.[45] As senators were consequently exempted from the traditional burden of the *aurum coronarium*, this now fell squarely on the shoulders of the decurial classes, straining their resources yet further.[46] Presumably to ensure the efficient collection of all these new cash levies, yet another new group of officials attached to the palatine administration, called *largitionales urbium* and serving under the *comes sacrarum largitionum*, was dispatched to cities throughout the empire in the fourth century.[47]

evident in a spate of epigraphically attested building in cities across the empire, from ca. 364 to 367, after which there is again a precipitous decline, evidently as the result of Valentinian's re-appropriation of civic revenues (Lepelley 1979, 67–72; Delmaire 1989, 651–52).

[42] At least according to Procopius, *Hist. Arc.* 26.6–11.

[43] Durliat, for example, has argued that the fourth-century texts actually indicate that cities enjoyed a remission of one-third of their *total* annual tax burden to the state for the upkeep of public buildings, and thus that a great deal of money continued to be available for construction (1990, 43–45); even were this the case, the point nonetheless stands that these funds were administered primarily by imperial appointees, as opposed to local *curiales*.

[44] Delmaire 1989, 354–71; cf. Jones 1964, 431–32; Chastagnol 1994b, 374–75.

[45] Delmaire 1989, 374–86 and 400–09, respectively; see also Jones 1964, 431; Durliat 1990, 31–33; Potter 2004, 397–98.

[46] Delmaire 1989, 387–400; cf. Chastagnol 1994b, 374–75.

[47] Jones 1964, 429; Delmaire 1989, 127ff.

Jairus Banaji has recently enriched and nuanced this picture of the decline of local aristocracies in important ways, drawing extensively on the papyrological evidence from Egypt, which shows the estates of city-based *curiales* shrunken and divided by the fourth century, following generations' worth of partitioning among multiple, often competing heirs.[48] Thus diminished in landed wealth and resources, these local notables were ripe for displacement by those with connections to the imperial administration, in whose hands honors and titles, political influence, and resources, both in land and gold, more and more resided by the later fourth century. This disparity in wealth and influence between a new, empire-wide 'service' elite on the one hand, and local nobles without government connections on the other, was compounded by the vast fiscal advantages enjoyed by the former, who were paid in gold *solidi*, the only stable and truly liquid currency of the age, while local landowners were at the mercy of the vicissitudes of the market for their crops, all the more so as the increasingly gold-based fiscal structure of the post-Constantinian empire required them to commute tax payments once made in kind into specie.[49] In this process of *adaeratio* the local landowners, sitting on perishable harvests and in need of ready cash to pay their taxes, were at the mercy of upper-level imperial bureaucrats and commanders, flush with gold and able to negotiate or impose advantageous prices at their leisure, all the while accumulating and investing additional assets in hard currency.[50]

Thus, as Banaji convincingly shows, there were actually plenty of fantastically wealthy people, particularly in the eastern Mediterranean, from the fourth century through the seventh, when the quantities of gold in circulation indeed seem to have steadily increased.[51] Unlike the *decuriones* of the high empire, however, these new service aristocrats invested little in their home cities, largely because – I presume – they saw little to gain in currying favor with urban constituencies, in a period when wealth, power and prestige derived chiefly from tenure of government offices and investment in large rural estates.[52] When they did sponsor urban architecture, either with public money or their own, it was

[48] Banaji 2007, 102–15.

[49] Ibid., 115–70. For the growing dominance of this service aristocracy in the fourth-century West, see also P. Brown 2012, 3–30.

[50] Banaji 2007, 49–57; see also 216: 'As large sums of gold were accumulated through these various mechanisms in a late-Roman equivalent of "primitive accumulation" that appeared to contemporaries as the unbridled dominance of public officials, a new aristocracy emerged out of the expanded governing class of the fourth century, no longer merely an "aristocracy of office," though it always was that as well, but an economically powerful and socially dominant group of businesslike landowners who dominated their respective regions.'

[51] Ibid., 57–65 and passim. The steady growth and monetization of the Mediterranean market economy in late antiquity is powerfully – and provocatively – argued throughout Banaji's opus.

[52] Cf. Heather 2005, 440.

chiefly on the grander political stage of the provincial and imperial capitals where they performed their official duties.[53]

While the relative weight of all these factors will remain debatable, some combination thereof undoubtedly tended to leave provincial elites disempowered, demoralized and often impoverished, at least relative to their condition under the high empire. Hence, private building patronage too – as opposed to municipal initiatives – collapsed throughout the Roman world. The most compelling testament to this last observation is the stunning fact that from 305 to 361, there is barely a single inscription commemorating an act of civic euergetism by a local donor anywhere in the empire, a phenomenon that Bransbourg has recently invoked in support of his argument that the Diocletianic reforms had a greater negative impact on municipal finances than any of the confiscations of civic revenues enacted in the fourth century (which he is inclined to minimize for the period before Valentinian I).[54]

In any case, there is no doubt that the reign of Diocletian marks the beginning of a process whereby the central administration came to retain a large and growing majority of the funds once raised and administered by individual cities, above all for the maintenance and embellishment of their architectural patrimony. At the same time, as curial service became increasingly onerous, and the possibilities for gaining wealth, power and social advancement came to be concentrated in the imperial administration, both at court and at the provincial level, more of the wealthiest and most ambitious men in the provinces left their cities and entered government service.[55] Thereafter, these were the individuals with the means, the motive and the institutional backing to undertake important public works, as the epigraphic record clearly demonstrates: beginning – precisely – with the reign of Diocletian, provincial governors, along with the emperors themselves, came to predominate in building inscriptions throughout the Roman world.[56]

In their ensemble, these developments provoked a revolutionary shift in the mechanics of building patronage, which saw the erection and maintenance of monumental architecture become almost the exclusive prerogative of the emperors and high government officials, later joined by Christian bishops in their new guise as civic leaders and patrons in their own right. Urban topography consequently became an extension and a mirror of the political, ideological and ceremonial agendas championed by this rarified circle of the ruling elite, possessed as it was of an unprecedented share of the resources available for building, as well as the institutional mandate to dispose of those resources as it saw fit. The disposable wealth of all the *civitates/poleis* in the empire was

[53] See n. 57.
[54] Bransbourg 2008, 287 and passim; 2009, 154–56; see also Lepelley 1999.
[55] Cf. Jones 1964, 69–70; Matthews 1975, 41–48; Millar 1983, esp. 91–96; Laniado 2002, 7–8.
[56] Lepelley 1996, 217–18; 1999; Lewin 2001.

thenceforth channeled primarily into the capitals where these rulers most often resided and exercised their public functions, leaving many of the former to decay even as the latter metamorphosed into showpieces dedicated to a newly ostentatious vision of absolute temporal sovereignty. This trend is already apparent in the plethora of imperial residences patronized by Diocletian and his Tetrarchic colleagues, the examples *par excellence* of places shaped according to the imperial will and financed by the productive surplus of the empire as a whole, as Lactantius bitterly remarked apropos of Diocletian himself and his preferred seat of Nicomedia in particular.[57]

2.3 URBAN ARCHITECTURE UNDER DIOCLETIAN AND THE TETRARCHY: PALACES AND CAPITALS

Lactantius' claim that Diocletian and his colleagues embarked on a spate of costly building initiatives is fully borne out by a range of literary and archaeological sources, particularly with regard to the capital cities and palaces where first two, and then four imperial courts based themselves at various times. Existing cities such as Trier, Milan, Thessaloniki, Sirmium, Nicomedia and Antioch were extensively remodeled, often with the addition of extensive urban agglomerations that became veritable 'new cities' annexed to the older urban nuclei.[58] They were joined by *ex novo* foundations, the most famous and best-studied examples of which are Diocletian's palace-city at Split, and Galerius' at Gamzigrad, as well as other sites known through vague textual references and yet to be conclusively identified, such as *Diocletianopolis* in the Balkans.[59] Looming embodiments of the power and prestige of the resurgent imperial regime, testaments to the desire of the Tetrarchic emperors to present themselves as city founders on (*inter alia*) the model of Alexander the Great and his successors,[60] these projects are remarkable – *pace* Noël Duval[61] – for the consistency of the architectural language they employ, which extends not only to the types of buildings singled out for inclusion, but also to the topographical sequences in which they were arranged. A sampling of the sites that can be adequately reconstructed on the basis of surviving material or textual evidence will suffice to illustrate the basic parameters of the architectural

[57] *DMP* 7.8–10: *Huc accedebat infinita quaedam cupiditas aedificandi, non minor provinciarum exactio in exhibendis operariis et artificiis et plaustris, omnibus quaecumque sint fabricandis operibus necessaria … Ita semper dementabat Nicomediam studens urbi Romae coaequare.* On the preceding points, in addition to the discussion later in this chapter and in Chapter 3, cf. Delmaire 1989, 585–90; Liebeschuetz 2001, 12ff., 137–68; Marazzi 2006.

[58] For a very useful overview of the Tetrarchic imperial residences, see von Hesberg 2006.

[59] At present, Hissar in Thrace is the best candidate for identification with *Diocletianopolis*; see n. 150.

[60] Cf. Jones 1964, 719; Ćurčić 2010a, 22.

[61] E.g., Duval 1979.

vision promulgated by the members of the First Tetrarchy, and inherited by their successors for centuries to come.

We begin in the East with Antioch, the greatest city of the Levant, capital of the diocese of *Oriens* and frequent residence of both Diocletian and Galerius, whence they launched their campaigns against the Persians in 296–98. During the last decades of the third century, the island in the Orontes River adjacent to the city, home to a palace and hippodrome by the second century AD, was extensively re-edified.[62] While scattered vestiges of this 'new city' came to light during the excavations of the 1930s, the principal source for its configuration is Libanius' Oration 11, the *Antiochikos*, a lengthy encomium on the orator's home city composed around 360:[63]

> The new city stands on the island which the division of the river formed ...The form of this new city is round. It lies in the level part of the plain, the whole of it in an exact plan, and an unbroken wall surrounds it like a crown. From four arches which are joined to each other in the form of a rectangle, four pairs of stoas proceed as from an omphalos, stretched out toward each quarter of the heavens, as in a statue of the four-handed Apollo. Three of these pairs, running as far as the wall, are joined to its circuit, while the fourth is shorter but is the more beautiful just in proportion as it is shorter, since it runs toward the palace which begins hard by and serves as an approach to it. This palace occupies so much of the island that it constitutes a fourth part of the whole. It reaches to the middle of the island, which we have called an omphalos, and extends to the outer branch of the river, so that where the wall has columns instead of battlements, there is a view worthy of the emperor, with the river flowing below and the suburbs feasting the eyes on all sides.[64]

The key points that can be deduced from Libanius' description of the 'new city' in the midst of the Orontes, lucidly outlined by Ćurčić, can be summarized as follows.[65] The new palatial quarter was roughly circular in form,

[62] Malalas (*Chron.* 9.21 [Dindorf 225]) says that the Roman proconsul Q. Marcius Rex rebuilt a palace and hippodrome upon his visit to Antioch in 67 BC. The hippodrome in question may be that on the island in the Orontes; although the extant remains have been dated to the early second century AD at the latest, the existence of an earlier hippodrome on the same site is not impossible (Humphrey 1986, 455–57). While there are hints of new construction beginning in the time of Valerian and Gallienus (Malalas, *Chron.* 12.36 [Dindorf 306]; cf. Saliou 2009, 239), the transformation of the island into a cohesive monumental ensemble, with the essential topographical parameters it maintained until the sixth century, surely dates primarily to the time of Diocletian (Downey 1961, 317–27, with the articles of Poccardie cited in the following note). The palace itself seems to have been largely complete by ca. 305 (Saliou 2009, 243).

[63] On the date of composition, see Downey 1959, 652–53; on the archaeological remains, see the overviews of Poccardie 1994 and 2001; for an overview of the textual sources, see Saliou 2009.

[64] *Orat.* 11.203–06; trans. Downey 1959, 674–75.

[65] Ćurčić 1993, 68–69.

and surrounded by a continuous circuit of walls. The palace proper occupied a quarter of the intramural area, which was in turn traversed by two principal colonnaded avenues that intersected at right angles at a quadrifrons archway near the geographical center of the island, in front of the entrance to the palace. Three of the streets led to gates in the fortified perimeter, themselves presumably connected to three of the five bridges spanning the river subsequently mentioned by Libanius,[66] while the fourth, shorter section was particularly grandiose and led directly to the palace. Pointed references in several later sources testify to the continuing centrality and visual *éclat* of these streets. Theodoret of Cyrrhus informs us that the porticoes connected to the palace were – like the final stretch of the Mese leading to the imperial palace at Constantinople – two stories high, and departed from a gate in the city wall with 'two lofty towers.'[67] For Malalas, this grand approach to the palace was – exactly as at Constantinople – called the Regia, and departed from an archway known as the tetrapylon of the elephants, presumably because of its sculptural decoration (an elephant-drawn quadriga?), surely on the spot of Libanius' *omphalos*.[68]

The excavations of the 1930s, coupled with aerial photographs taken at the time, allow us to fill in some of the spaces surrounding the colonnaded thoroughfares that occupy so much of Libanius' attention (Figure 2.2). One of the largest hippodromes in the Roman world (the arena measures 492.5m long by 75m wide) ran roughly north-south just west of the main north-south street; the colonnade of red-granite columns that ran along its eastern flank may indeed have been those lining the street itself.[69] The extant structures, originally built in the second century, appear to have been remodeled in or shortly after the time of Diocletian, probably in the first half of the fourth century.[70] The *carceres* of the hippodrome, flanked on both ends by towers adjacent to the two main entrances to the complex, would thus have been located just to the northwest of the tetrapylon.[71] Continuing west from the

[66] *Orat.* 11.208; Downey 1959, 675. Cf. Poccardie 1994, 997.

[67] *Hist. Ecc.* 4.26.1–2; cf. also 5.35.4; Evagrius Scholasticus, *Hist. Ecc.* 2.12.

[68] *Chron.* 13.19 (Dindorf 328); cf. Saliou 2009, 241–42 (who notes the triumphal associations elephant-drawn chariots took on in late antiquity). Malalas says that Julian posted his *Misopogon* ἔξω τοῦ παλατίου τῆς αὐτῆς πόλεως εἰς τὸ λεγόμενον Τετράπυλον τῶν ἐλεφάντων πλησίον τῆς Ῥηγίας. On the Regia at Constantinople, *Chron.* 13.8 (Dindorf 321), with Chapter 3.3.

[69] On the colonnade, Humphrey 1986, 451; on the dimensions of the circus, ibid., 445.

[70] Notably the colonnade and the adjoining street, which the excavators tentatively dated to the fourth century, along with extensive repairs to the foundations of the *cavea*: see Humphrey 1986, 455.

[71] Humphrey 1986, 452. On the towers, which are said to have fallen in an earthquake in 458, see Evagrius Scholasticus, *Hist. Ecc.* 2.12 (whose description indeed implies a close connection between the tetrapylon, its adjoining colonnades and the entrance to the circus): Κατέρριψε δὲ καὶ τὰς στοὰς τὰς πρὸ τῶν βασιλείων καὶ τὸ ἐπ'αὐταῖς τετράπυλον, καὶ τοῦ ἱπποδρομίου δὲ τοὺς περὶ τὰς θύρας πύργους, καί τινας τῶν ἐπ'αὐταῖς στοῶν.

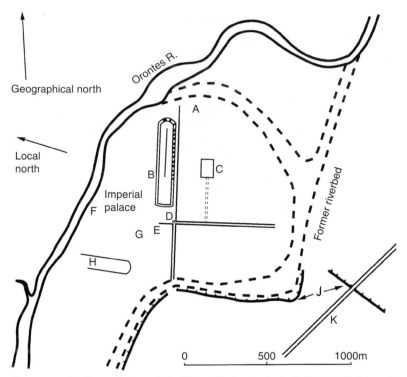

Figure 2.2 Conjectural plan of the 'New City' at Antioch. A: Bath E; B: hippodrome; C: temple; D: Tetrapylon; E: Bath B; F: Bath A; G: Bath D; H: 'Byzantine Stadium'; J: walls of Old City; K: main *cardo* of Old City. (Redrawn from Poccardi 2001, with changes.)

hippodrome, in the vicinity of the palatial quarter, the remains of two baths and an opulent residential complex, all on the same orientation as the hippodrome, may also belong to the Diocletianic building campaign.[72]

The depiction of Antioch on the topographical border of the fifth-century 'Megalopsychia Hunt Mosaic' from the suburb of Yakto (Figure 2.3) appears to depict a suggestively similar ensemble of monuments, as Poccardi has argued.[73] If we imagine the mosaic representing a perspective from the old city, looking north across the river to the island and along its principal north-south avenue, the monuments depicted would read as follows, from left (west) to right (east): a bridge across the river; a bath-complex; a sort of hippodrome-garden or practice track, corresponding with the remains of a fifth-century(?) structure found in the western part of the island;[74] and a palace just left (west) of the crossing

<hr/>

[72] Bath B; Bath D; and House A; the mosaic floors of Bath D are dated to ca. 300 or just after: see Poccardie 1994, 1004; 2001, 164; also Malalas, *Chron.* 12.38 (Dindorf 307–08) (five baths attributed to Diocletian).

[73] Poccardi 1994, 1005–08; 2001, 158; also Uggeri 1998, who proposes a similar scheme for the placement of the palace, hippodrome and main streets of the 'New City.' On the mosaic, see also Lassus 1934; Downey 1961, 346–48; Dunbabin 1999, 180–83.

[74] On this feature, which has no provision for seating (like the structure shown in the mosaic, with a lone rider in its midst), see Humphrey 1986, 458–59.

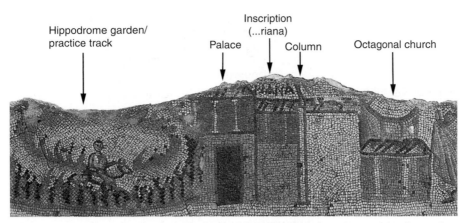

Figure 2.3 The 'New City' at Antioch, detail of the Megalopsychia Hunt Mosaic from Yakto. (Hatay Archaeological Museum, Antakya, inv. 1016; Photo: author.)

of two perpendicular streets, the intersection of which is marked with a column, perhaps a simplified substitute for the tetrapylon/*omphalos*. The structure identified as the palace has a large gateway opening onto the intersection, as well as an upper story composed of a colonnaded gallery, whence it broadly conforms with Libanius' description.[75] The Regia would thus have run west from the column/tetrapylon to the façade of the palace, while the three longer sections of street departing from the central intersection would have extended toward gates in the circuit in the north, south and east.[76] The street running north, past the hippodrome, would have reached the island from the old city across the river via the Porta Tauriana, which may indeed be indicated by the fragmentary label [TAU?]PIANA on the mosaic.[77] Just to the east/right of the crossing, the mosaic shows an octagonal building flanked by a single figure inclined in a position of prayer, which thus very likely represents the famous octagonal cathedral erected by Constantine and Constantius II between 327 and 341. The best assumption is thus that when the cathedral was constructed,

[75] Cf. Poccardie 2001, 158.

[76] For this reconstruction, which I find considerably more convincing than earlier attempts that placed the palace to the north of the intersection of the colonnaded streets (not least because it conforms much better with the archaeologically attested remains), see Poccardie 1994, 1020 and passim; 2001, 161–67.

[77] Downey 1961, 347–48 (but note, with Poccardie [*locc. cit.* in the preceding note], that Downey's 'west,' which reflects the local sense of the cardinal points in effect amongst the Antiochenes, is actually geographical south). The Porta Tauriana clearly did directly abut a bridge across the Orontes (Theophanes, *Chron.* [*anno* 5758 = 385/86 AD], de Boor [ed.] p. 70); the evidence marshaled by Saliou (2000, 218ff.) to argue that it need not have been a bridge to the island in fact better suggests that it was precisely that, as the passage of Theophanes itself indicates by juxtaposing the account of an extension of the bridge with a description of a church pointedly said to have been built – by contrast – in the 'old city': Τούτῳ τῷ ἔτει ἐν Ἀντιοχείᾳ ἐπεκτίσθη ἐν τῇ Ταυριανῇ λεγομένῃ πύλῃ προσθήκη εἰς πλάτος τῆς γεφύρας καὶ ἐπεστεγάθη · ἐπεκτίσθη δὲ καὶ μικρὰ βασιλικὴ ἐν τῇ παλαιᾷ πλησίον τῆς μεγάλης.

it was integrated into the monumental armature of the Diocletianic palatial quarter, directly in front of the palace and facing onto one – or two, if immediately adjacent to the tetrapylon – of the main colonnaded arteries.[78]

Many of the details of the proposed reconstruction remain hypothetical, but the ensemble of archaeological, iconographical and especially literary evidence makes it clear that the two intersecting colonnaded streets, the city gates connected to them and the grand public buildings located in their immediate vicinity dominated the topographical panorama of the 'new city,' in the form it took beginning with Diocletian and Galerius. Thereafter, almost immediately upon the advent of Antioch's first Christian emperor (a scant three years after the city entered Constantine's dominions in 324), the new epicenter of Christian cult was integrated into this imperial capital within an imperial capital, joining the existing gates and colonnaded avenues that served, above all, to frame the approaches to the palace (and its public or semi-public appendages, such as the hippodrome and likely one or more bath complexes), where Constantine and his successors would continue to reside for generations to come during their frequent stays in Antioch.[79] But given the sparseness of the extant remains, we might best apprehend the form and function of the island at Antioch by comparison with other Tetrarchic projects that have left more physical traces, beginning with Thessaloniki, where Galerius spent much of his reign and launched a particularly ambitious building project.

Galerius' grand scheme envisioned nothing less than the transformation of the entire southeastern section of the city into a sprawling palatial quarter, stretching over 800 meters from the harbor in the south to the famous rotunda ('of St. George,' after a nearby chapel) in the north, and straddling the principal thoroughfare in city, which ran from the Cassandreotic Gate in the east, past the agora and on to the Golden Gate in the west.[80] While the function and chronology of the various components of the palace remain intensely debated, the essentials of its layout and the initial phase of construction clearly belong to the reign of Galerius, though work undoubtedly continued well after his death in 311, and

[78] Downey 1961, 342–49; Ćurčić 1993, 68 and n. 16; Poccardie 1994, 1009–12; *contra* Deichmann 1972. While the cathedral is frequently mentioned in the literary sources (e.g., Eusebius, *V. Const.* 3.50; Malalas, *Chron.* 13.17 (Dindorf 325–26), its location is never specified. Saliou 2000 thus argues that there is no proof for locating the church on the island. Very well: the burden of proof nonetheless remains with those who would argue both that the Yakto mosaic does not represent the topography of the island (as Saliou 2000 223ff. attempts to do), and that Constantine and Constantius would have preferred to locate the cathedral anywhere other than in the immediate vicinity of the palatial quarter, as they did at Constantinople.

[79] On the lengthy stays in Antioch of Constantius II, Gallus, Julian and Valens, see Downey 1961, 342–73; 380–96; 400–03.

[80] Useful overviews of topography and monuments of the city in late antiquity (none, however, definitive) include Speiser 1984; Torp 1993; Hattersley-Smith 1996, 118–70; Meyer 2002, 39–68; Nasrallah 2005; Ćurčić 2000; 2010a, 19–22, 100–10; 2010b.

indeed sporadically through the fourth century and beyond.[81] The bulk of the palace lay to the south of the road, in a salient perhaps added to the existing city walls specifically to accommodate the new structures,[82] beginning with the hippodrome hard against the circuit in the east, and continuing to the west with a series of courtyards, built on the same axis as the circus and flanked by imposing edifices, notably the great domed octagon, an apsidal audience hall and a bath complex.[83] Like the massive rotunda across the street to the north, these features all began, at least, to take shape under Galerius,[84] who indeed seems to have envisioned himself as the founder of another 'new city' (Figure 2.4).[85]

From the outset, the complex as a whole strove bodily to impose itself on anyone traversing the city along its grandest and busiest thoroughfare: the Mese, as it were.[86] Beginning with Galerius, this street was monumentally re-edified with continuous colonnades along its northern and southern flanks, which converged from east and west on the twin façades of its most visible and ostentatious feature, the massive Arch of Galerius, simultaneously a triumphal monument and the entrance-vestibule or propylaeum of the palace proper.[87] While the arch began life as a simple tetrapylon, two lower, lateral bays were soon added on its north and south sides (perpendicular to the direction of the Mese), thus integrating the structure more closely with the palace proper to the south and the rotunda to the north.[88] Thenceforth, anyone seeking to enter the palace, or the hippodrome, or simply to pass through the city, was channeled past the three bays of the arch, dedicated in 303 and covered with reliefs commemorating Galerius' victorious Persian campaign of 297–98, which together comprised an extensive,

[81] The initial construction campaign likely belongs more specifically to the period between ca. 298 and 311, during much of which (ca. 299–303 and 308/09 until his death in 311) Galerius resided in the city. On the dates of his residence, see Barnes 1982, 61; on the 'long' chronology of the various components of the palace, see esp. Mentzos 2010.

[82] On the various positions adopted regarding the chronological relationship between the (Galerian) circus and the section of city wall abutting its eastern flank, see Duval 2003, 286–87.

[83] On these structures, see esp. Mentzos 2010.

[84] As most scholars now agree, with the recent exception of Ćurčić (e.g., 2000, 11–14; 2010a, 53–54), who wants to date the rotunda to the reign of Constantine.

[85] A small 'triumphal arch' found ca. 40m south of the octagon bore twin clipeate portraits of Galerius and a city tyche, suggestively echoed by similar fragments from the column capitals of the octagon itself: see Vickers 1973, 111, 117–18; Ćurčić 2010a, 22; the most exhaustive publication of the arch is Stephanidou-Tiberiou 1995. On the 'new cities' of Gamzigrad and Split, see later in this chapter.

[86] Cf. Nasrallah 2005, 474–75. On *the* Mese in Constantinople, see Chapter 3.

[87] On the archaeological remains of the marble colonnades lining both flanks of the Mese in the vicinity of the Arch, see Torp 2003, 247–48. The covered galleries were 5.5m wide, and the total width of the street, measured from the rear walls of both colonnades, in the vicinity of 28m. On the dating of the colonnades, ibid., 256–57.

[88] On the phases of the Arch, see Torp 2003, 268–69: the northern bay appears to have been added after the southern one, probably still under Galerius. On the monumental structures connected to it, see later in this chapter.

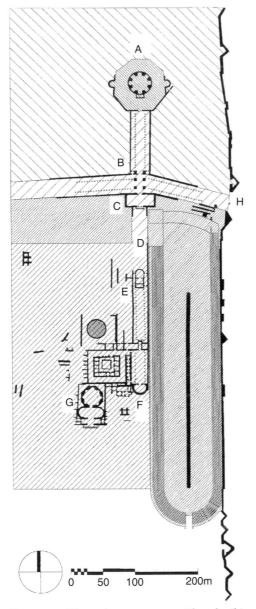

Figure 2.4 The palace-quarter at Thessaloniki.
A: Octagon; B: Arch of Galerius; C: vestibule;
D: colonnaded walkway?; E: small apsidal hall;
F: large apsidal hall; G: Octagon; H: Cassandreotic
Gate. (After Ćurčić 2010, fig. 2, with changes.)

even overwhelming visual manifesto of Tetrarchic ideology: 'no land can
escape the imperial gaze; peace comes through military force; the gods and
emperors support each other; and the known world, the *oikoumene*, is coter-
minous with and celebrates the Roman empire.'[89] The *carceres* − and thus

[89] Nasrallah 2005, 480; see also Canepa 2009, 83–99.

quite certainly the main entrances – of the hippodrome, meanwhile, stood just east of the arch and south of the Mese,[90] thus requiring crowds bound for that most ceremonially and ideologically charged of all public gathering places to pass through this same monumental nexus.

Branching off the domed interior of the central tetrapylon, the entrances to the northern and southern wings of the palace opened up, via the lateral bays of the arch, onto two processional spaces receding perpendicular to the line of the Mese, which between them comprised a single axis of communication between the rotunda in the north, with its south-facing entrance, and the grand (ca. 67 × 27m) apsidal audience hall in the south, the entrance of which in turn faced north.[91] The southern passage was accessed from an opulent vestibule, measuring 42.7m by 17.65m, lavishly adorned with *opus sectile* wall revetment and polychrome floor mosaics, opening off the southern flank of the arch via a doorway 5m wide.[92] An ornate marble staircase, 18m wide, descended from the south wall through an archway nearly as wide as the staircase onto a grand corridor,[93] which I presume to have been lined with columns receding toward the entrance to the audience hall, a fitting background for what was evidently both the main entrance to the residential wing of the palace in the south, and a kind of ceremonial corridor focused on the rotunda to the north for those coming from the residential quarters.[94]

Approximately midway between the vestibule and the audience hall stood another sizeable apsidal hall (24.3 × 13.45m), perhaps a *triclinium*, or a place for official receptions (a function encompassed by the term *triclinium* in late antiquity), finished on its interior with polychrome marble revetment, which turned its apsidal 'back' on the vestibule and faced south toward the entrance to the audience hall; Motsopoulos proposed that the intervening space comprised a kind of colonnaded processional way linking the two halls.[95] Just east of the

90 Meyer 2002, 57; Torp 2003, 245–46, 269–70.

91 On the audience hall, which closely resembles the Constantinian basilica at Trier in both size and configuration, see recently Meyer 2002, 44–47; Mentzos 2010, 352–54.

92 Torp 2003, 248–68 (esp. 257–67 on the mosaics); cf. Nasrallah 2005, 476–77 and n. 26.

93 Torp 2003, 250–55; the massive opening seems to have been fronted on the south side, at the head of the steps, by a tetrastyle protyron, a configuration that immediately recalls the façade of Diocletian's palace at Split, which was also accessed via a colonnaded passageway (see later in this chapter).

94 While the elaboration of the connecting spaces between the arch/vestibule and the audience hall may date slightly later, the integration of arch, audience hall, rotunda and hippodrome was manifestly projected from very early on; on the general coherence of the ensemble, as well as the issues over dating, see esp. Mentzos 2001–02, 57–61; Torp 2003, 256–57; 269–71; Ćurčić 2010a, 19ff; Duval (2003, 286) is, predictably, more skeptical. On the likely presence of columns lining this passageway, cf. Speiser 1984, 101–04; Torp 2003, 272; their presence is suggested by the columns lining the northern branch of the 'ceremonial way' leading to the rotunda of Galerius (see later in this chapter), as well as by analogy with the entrances to the palaces at, e.g., Antioch (see earlier in this chapter) and Split (see later in this chapter).

95 See Motsopoulos 1977, esp. plate X, with Torp 2003, 244–45, also on the possible identification of the *triclinium*. On the semantic evolution of the term *triclinium*, see Speiser 1984, 119–20 (who proposes its use in relation to the southern octagon).

'*triclinium*' stood a square annex projecting from the west flank of the hippodrome, measuring 10.3m by 10m, plausibly identified by Dyggve as the imperial box (*pulvinar*), which would thus have been intimately linked to the main, north-south processional axis of the palace complex, and perhaps explains the presence of the apsidal triclinium in the midst of that axis.[96]

The original appearance of the northern branch of the passage connecting the arch with the rotunda itself is impossible to determine; in the late fourth century, it was widened and embellished with, again, colonnades along both flanks, leading from the arch to the polygonal precinct surrounding the rotunda, presumably at the time when the rotunda itself was reconfigured as a church.[97] The result was a configuration with striking similarities to the 'new city' at Antioch, comprising a unified ensemble of perpendicular colonnaded axes departing from a four-sided triumphal arch, and connecting in turn with a hippodrome, baths, the principal entrance of the palace proper and (as we shall see) a central-plan church. Also as at Antioch, the rear of the palace in the south appears to have faced directly onto the water: though the area immediately adjacent to the seafront has not been excavated, the grand vestibule of the octagon faces in this direction, and special attention was given to the marble revetment of south-facing walls in this sector, all of which suggests that a second principal entrance was oriented in the direction of the harbor, to which the palace very probably extended.[98]

With the advent of Constantine and his Christian successors, the most profound modifications to the architectonic configuration of the palatial quarter were provoked by the installation of churches, which – yet again as at Antioch – were seamlessly and very prominently integrated into the monumental armature inaugurated by the Tetrarchs. With regard to the rotunda along the northern axis of the Arch of Galerius, we have already noted the installation of the wide, porticated avenue in the intervening space, which seems to have occurred when the rotunda was converted into a church with the addition of its famous mosaics in the dome, an ambulatory, and a more lavish entrance porch opening onto its colonnaded approaches.[99] The project may well belong to the time of Theodosius I, who spent extended periods in the palace in the 380s, though it might conceivably date a generation or

[96] See Torp 2003, 244–46 (reporting on Dyggve's largely unpublished excavation notes of 1939), who notes also the close correspondence with the configuration of the closely contemporary Villa of Maxentius at Rome, where the *pulvinar* of the circus was also linked via a long corridor with the apsidal audience hall. Cf. Speiser 1984, 112–13; Duval 2003, 281–84.

[97] On the conversion of the rotunda see n. 99.

[98] Vickers 1973, 112–13; cf. Nasrallah 2005, 477 and n. 26.

[99] Generally on the modifications and additions to the rotunda during its transformation into a church, see Torp 1991, 15ff.; Ćurčić 2010b, 217–22. The function of the building in its original phase continues to spark controversy; it is at any rate much more likely to have been intended as a temple, perhaps to the supreme patron of the Tetrarchic emperors, Jupiter, than a mausoleum: see Mentzos 2001–02, 60–61.

two later; in any case, the crucial point, as Nasrallah aptly put it, 'is that the early Christian Rotunda in the first phase of its transformation was linked to a functioning imperial palace, continuing the Roman imperial tradition of sacred space related to and/or bound into a palace complex via a processional way.'[100]

The second major Christian cult center located in the environs of the palace lies just to its west, on axis with the modern Pringhipis Nikolaou street. In the fifth century, the gargantuan, five-aisled cathedral of Hagia Sophia was erected on the site, the dimensions of which (53m wide by 93m long, stretching to 175m with the narthex and atrium) recall those of the greatest Constantinian churches in Rome, and surely testify to imperial patronage, as Torp has noted.[101] The church was built over some 3m of fill, which itself covered structures dating to ca. 300; within the fill, sections of wall on the same alignment as the later church were found, which must thus represent an intermediate phase, very possibly associated with an earlier, fourth-century church.[102] The underlying remains of ca. 300 are in turn connected with two parallel walls, 40m apart, running east from beneath the apse of the later church toward the palace; extended as far as the hippodrome, they would have terminated just in front of the apsidal triclinium and – more strikingly still – the entrance to the *pulvinar* of the hippodrome.[103] If Torp's appealing suggestion that they represent the remains of a colonnaded street leading to another entrance of the Galerian palace is correct,[104] it would appear that perhaps as early as the fourth century, and certainly by the later fifth, the cathedral of the city was placed directly in front of this entrance to the palace,[105] of which it would have constituted in effect a second monumental appendage dedicated to Christian cult.

Like the rotunda-church, Hagia Sophia too was also only a single city block removed from the Mese, which remained the privileged focus of the evolving Christian topography of the city: its two other greatest churches, the Acheiropoietos and St. Demetrios, both probably datable to the second half of the fifth century, were both built in the immediate vicinity of the road (one and two *insulae* away, respectively);[106] all four, along with the street, remained in constant use in what continued to be the busiest and most densely populated

[100] Nasrallah 2005, 383; for the (often, but not universally accepted) Theodosian dating, see Torp 1991, esp. 17–22; Ćurčić 2010b, 217–22.

[101] Torp 1993, 124–26.

[102] Ibid., 126.

[103] Remains of this street, which appears to have been colonnaded, have indeed been found inside the palace complex, in connection with a gate on the western edge of the palace, facing the church: see Mentzos 2010, 342–43.

[104] Ibid.

[105] Remains of the presumed palace gate itself have recently been discovered (Mentzos 2010, 343).

[106] Speiser 1984, 164–214; Ćurčić 2010a, 106–09; 2010b, esp. 222–31.

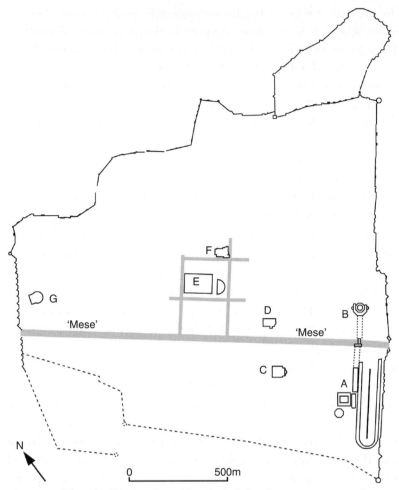
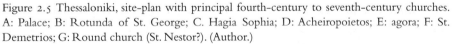

Figure 2.5 Thessaloniki, site-plan with principal fourth-century to seventh-century churches. A: Palace; B: Rotunda of St. George; C. Hagia Sophia; D: Acheiropoietos; E: agora; F: St. Demetrios; G: Round church (St. Nestor?). (Author.)

sector of the city until the Turkish conquest in the fifteenth century.[107] Finally, another round church, perhaps a martyrium dedicated to St. Nestor, was added at the western extremity of the Mese in the fifth century, in exactly the same position relative to the street as the Galerian rotunda in the east.[108] The Mese was thus bracketed by two major shrines located just inside the western and eastern gates in the walls, the twin poles of what manifestly remained the primary processional route through the city, and the epicenter of intramural life for a millennium to come (Figure 2.5).

Turning to the northwestern provinces, there are similar signs that imperial – and provincial – capitals, rejuvenated beginning in the Tetrarchic period by

[107] Bakirtzis 2003, esp. 49–58; cf. Hattersley-Smith 1996, 187–95.
[108] Torp (1993, 127–28) prefers the second half of the century; Ćurčić (2010a, 104–05) the first.

the stable presence of a locally resident emperor and his court, were reengineered to embody a new infrastructure of power, conceived and sponsored by the central government itself: a porticated thoroughfare, often the intramural extension of a principal axis of long-distance communications, which connected the most frequented gates in the city walls with the intramural structures most closely associated with the ruling establishment – palaces with their associated baths, audience halls and circuses, and later episcopal residences and cathedrals as well.

This phenomenon is – based on the extant evidence – best attested at Trier, the city that rapidly evolved into the premier imperial residence north of the Alps, beginning soon after Maximian's promotion to co-*augustus* in 286. Over the course of the next three decades, Trier served first as the principal residence of the *caesar* Constantius Chlorus (293–306), and then of his son Constantine, from the time of his imperial coronation by the army at York in 306 until about 316.[109] During this period, a concerted effort was made to transform an entire sector of the city into an imperial quarter, a grand urban showpiece that proclaimed the ascendency of the ruling sovereign and the resurgent strength and majesty of the Roman state, as it emerged from the tumults of the preceding decades.

The principal components of the palace were arrayed along the eastern flank of the main north-south road (*cardo maximus*) in the city, just south of the point where it entered the northern flank of the circuit-wall at the Porta Nigra (Figure 2.6). The northernmost section of the palace comprised an extensive sweep of residential quarters, spread over at least two city blocks and facing directly onto the road. Apparently following the deposition and murder of Constantine's son Crispus along with his mother, Fausta, in 326, this prime location was ceded to the church, and the existing structures razed to make way for the episcopal complex, centered on two parallel basilicas that rose over the foundations of the halls presumably once occupied by the unfortunate Crispus and his mother.[110] To the south lay the imposing Constantinian basilica (the imperial audience hall),[111] and beyond that, at the intersection with the perpendicular road that connected the city center with the west bank of the Moselle via the massive stone bridge (the *Römerbrücke*) spanning the river, the imperial bath complex (the *Kaiserthermen*).[112]

[109] Generally on the historical context of Trier's transformation into an imperial residence, see Wightman 1970, 58–62; Heinen 1984; Cuppers 1992; Mayer 2002, 34–38. In the course of Diocletian's remodeling of the administrative apparatus of the provinces, Trier became the capital of the province of Belgica I, and of the vicariate of northern Gaul, whence it hosted resident governors and *vicarii* as well as the imperial court and the praetorian prefect of the Gauls. On the dates of Constantine's stays in Trier, see Barnes 1982, 68–69.

[110] Heinen 1985, 268–75; TCCG Vol. I, 21–25; Cuppers 1992, 229ff.

[111] Wightman 1970, 103–09; Heinen 1985, 275–76.

[112] Heinen 1985, 276–78; Gros and Torelli 1988, 312–16.

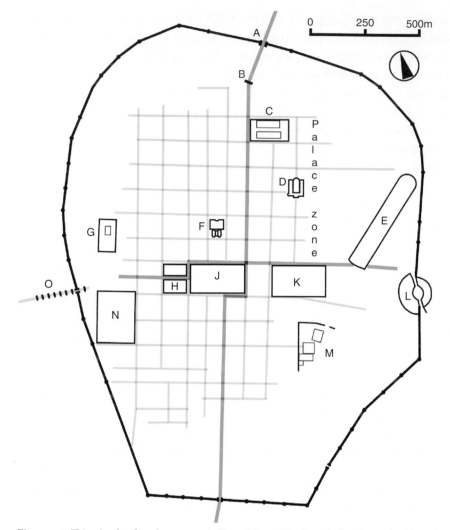

Figure 2.6 Trier in the fourth century. A: Porta Nigra; B: triumphal arch; C: double-cathedral complex; D: Constantinian audience hall; E: Hippodrome; F: Viehmarkt Baths; G: Temple of Asclepius; H: high-imperial *praetorium*; J: Forum; K: Kaiserthermen; L: amphitheater; M: Altbachtal sanctuary-complex; N: Barbarathermen; O: stone bridge over Rhine. (Author.)

The section of the street flanked by the palatial quarter, from the Porta Nigra south to its intersection with the road leading east from the bridge, was thus transformed into the principal axis of late antique Trier, a sequential progression of imperially sponsored monuments lining the route followed by anyone bound to or from the palace and the episcopal complex, as well as by all long-distance traffic arriving at the city center from the north.[113] Like the east-west road, it was lined on both sides with continuous porticoes, apparently

[113] Cf. Cantino Wataghin 1992, 176.

dating to the period before the arrival of the emperors, though they may well have been refurbished in the course of the imperial building campaign; at any rate, there is clear evidence for repaving of the roadbed with limestone slabs in the fourth century.[114] These porticoes framed the approaches to the various components of the palatial quarter, and bound them together with the Porta Nigra – whose continuous superimposed registers of arched windows framed by pilasters prefigured the arcaded vista that opened off the rear of the gate – into a cohesive architectural ensemble, a single, privileged urban itinerary that became the inevitable backdrop for the public appearances of the emperors, praetorian prefects, *vicarii*, provincial governors and bishops based in the edifices fronted by the eastern portico.

That the topographical evolution of Trier reflects the influence of an emerging urban paradigm centered on an interconnected axis of city gate, porticated street and locus of imperial power is strongly suggested by the example of the nearby city of Autun, *civitas*-capital of the Aedui in the province of Lugdunensis I, which was extensively reconstructed beginning at the very end of the third century under Constantius Chlorus, following its destruction at the hands of the Gallic emperor Victorinus in 270. The imperially sponsored re-edification of Autun is closely contemporary with Trier's transformation into an imperial capital; and the architects of the project manifestly aimed to reshape the principal axis of movement in the city into a monumental itinerary effectively identical in conception to the plan of the *cardo maximus* at Trier. The *cardo maximus* at Autun, the intramural tract of the important north-south highway straddled by the city, was elevated into a grand processional avenue with the construction – or reconstruction – of continuous porticoes along both sides of its entire 1570m length.[115] This newly aggrandized thoroughfare, the architectonic centerpiece of the urban plan as a whole, led, exactly as at Trier, directly to the *palatium*, the official residence of the leading imperial official – perhaps a *procurator* – stationed in the city, where Constantine concluded his *adventus* into Autun in 311, according to a remarkable passage in the panegyric delivered to Constantine in that year by a native of Autun, come to Trier to convey his city's gratitude for its restoration at the hands of the reigning emperor and his father.[116]

Greeted by cheering throngs headed by the massed ranks of local dignitaries, Constantine entered the city through one of its two principal gates

[114] Wightman 1970, 119; Christie 2011, 127.

[115] Olivier and Rebourg 1985; Rebourg 1998, 173–75; cf. Frakes 2009, 341–42. The colonnades are datable on stratigraphic grounds to ca. 300, and thus to exactly the period of the reconstruction of the city by Constantius Chlorus and Constantine commemorated in the panegyric of 311 cited later in this chapter (*Pan. Lat.* 5[8]; the orator attributes Autun's renewal to Constantine and his father at 5[8].4.4).

[116] While the location of this palace remains unknown, it is best imagined in the vicinity of the forum, which clearly lay along the main *cardo*: for a resume of the indications for the

(the northern one, if he came directly from Trier), the threshold of which marked the culminating point of his *adventus*, the moment when the emperor's divine presence rose like the sun over the community blessed with his arrival: 'Immortal Gods! What a day dawned upon us then, when you, in what was our first sign of salvation, entered the gates of that city! [Autun], which seemed to receive you in their inward-curving fold, with towers projecting on both sides, in a kind of embrace.'[117] The panegyrist concluded his account of Constantine's arrival by evoking the scene that greeted the emperor inside the city, as he processed down the teeming expanse of the *cardo* en route to his final destination at the palace: 'We adorned the roads that lead to the palace, albeit with poor decorations, but we brought forth all the standards of the *collegia*, all the statues of our gods; we circulated our few musical instruments of clear tone by means of shortcuts so that they might appear before you frequently.'[118] For the panegyrist of 311, the physical essence of his native city, the parade route followed by its illustrious imperial benefactor on the day of his epiphany before the rejoicing populace of Autun, was encapsulated in the image of an uninterrupted armature comprising the city gate, the local center of imperial administration, and the intervening stretch of processional thoroughfare, its twin colonnades festively adorned for the occasion.[119] The image is particularly apposite given that many of the surrounding neighborhoods never recovered from the ruin of 270:[120] in its post-Tetrarchic incarnation, the city's remaining pretentions to urban grandeur lodged as never before in the colonnades and associated structures of its central processional thoroughfare, embellished and aggrandized at the expense of the rest.

As at Trier, where the resident emperors undoubtedly displayed themselves with similar pomp on a much more regular basis,[121] the imperial intervention in the cityscape at Autun turned the most visible, frequented street in the city into a monument to the prestige and patronage of the ruling establishment,

placement of the forum, with the best hypothesis advanced to date for its location (in the eastern part of the place du Champ-du-Mars), see Rebourg 1998, 180–86.

[117] *Pan. Lat.* 5(8).7.6: *Di immortales! Quisnam ille tum nobis inluxit dies … cum tu, quod primum nobis signum salutis fuit, portas istius urbis intrasti! – quae te habitu illo in sinum reducto et procurrentibus utrimque turribus amplexu quodam videbantur accipere.*

[118] *Pan. Lat.* 5(8).8.4: *Exornavimus vias quibus in palatium pervenitur, paupere quidem supellectili, sed omnium signa collegiorum, omnium deorum nostrorum simulacra protulimus, paucissima clarorum instrumenta modulorum per compendia saepius tibi occursura produximus.*

[119] Cf. the discussion in Dey 2010, esp. 23–27.

[120] Byhet 2001–02, 31; cf. Rebourg 1998, 220–21.

[121] Though no surviving descriptions comparable to the account of Constantine's *adventus* at Autun, or the procession of Diocletian and Maximian through Milan in 291 (*Pan. Lat.* 11(3).10–11) exist for Trier, the panegyrist of 311's sense of the city as the showpiece in front of which the emperor displayed himself to the subjects of his realm is palpable at *Pan Lat.* 5(8).2.1: *Nunc itaque cum in hac urbe,* [Trier] *quae adhuc adsiduitate praesentiae tuae prae ceteris fruitur … totus tibi amicorum tuorum comitatus et omnis imperii apparatus adsistat, cum omnes homines omnium fere civitatum aut publice missi aut pro se tibi supplices adsint…*

a grand succession of public buildings, linked by continuous porticoes, that stood ready to 'embrace' the emperors and their leading subordinates, whenever they chose to grace the city with their presence. The construction of the porticated avenue sufficed to cast Autun in the image of the imperial capital on the Moselle, the 'city above all which you [Constantine] have begun to make her [Autun] resemble.'[122] Both cities, retrofitted, like Thessaloniki, with the seminal elements of the 'architecture of power' developed *ex novo* at Philippopolis and at the 'new city' at Antioch, were thus integrated into the emerging architectural *koine* of the increasingly authoritarian, bureaucratized and 'ceremonialized' empire taking shape under Diocletian, his colleagues and his successors.

There is more to be said about the elaboration of ritual, ceremony and the protocols of hierarchy from the later third century on, but first, we conclude our excursus on the urban template disseminated so widely and consistently by the Tetrarchs with a pair of newly founded 'palace-cities,' sites where, as at Philippopolis two generations earlier, the leaders of the Roman state had carte blanche to shape an urban – or 'urbanizing' – environment according to their desires and aspirations.

The first is Diocletian's 'palace' at Split, the quasi-urban foundation *par excellence*, and much the best preserved of the Tetrarchs' large-scale building initiatives. Ćurčić's characterization of the site as a (very) 'small city' is apt, though best accompanied with the clarification that we are dealing not so much with a minuscule town as with a sort of scale model of a major city, complete even with its own aqueduct.[123] Without belaboring basic points – and counterpoints[124] – already made by many others, we might simply say that Libanius' description of Diocletian's 'new city' at Antioch applies almost verbatim to the remains at Split, with the lone important exception that the

[122] *Pan. Lat.* 5(8).1.1; trans. Nixon and Rodgers 1994, 264.

[123] Ćurčić 1993; cf. also Bejor 1999, 100. Other useful discussions of the complex include Wilkes 1993; Marasović and Marasović 1994; McNally 1989; *ead.* 1996; Meyer 2002, 69–79; Ćurčić 2010, 26–29, 32–40; Nikšić 2011. On the 9.7km-long aqueduct, see Wilkes 1993, 63–64.

[124] I am – again, see nn. 61 and 94 – particularly unsympathetic to N. Duval's effort to stress the nonurban, nonpalatial character of the site, and the extent of its alleged differences from, e.g., Antioch, which seem to me far less compelling than its patent formal similarities (*inter alia* Duval 1961–62; cf. also Wilkes 1993, 65–77). Indeed, while Dyggve's (1941) seminal work on late antique palaces needs to be (and has been) nuanced and corrected in many respects (not least of them the chimera of the 'basilica ipetrale'), his perception of the remarkably homogenous architectural underpinnings of these structures, and the inspiration thereof in the exigencies of court ceremonial, remains to my mind prescient and compelling; cf. also, in a similar vein, L'Orange 1965, 69–76. Further, while Diocletian resided at Split (presumably) only when 'retired' after 305, his manifest attachment to the trappings of court ceremony, coupled with his retention of the title *augustus*, make it – I think – very likely that a ceremonial regime on the imperial model, albeit on a reduced scale, was practiced at Split, the architecture of which lent itself so well to the public exaltation of its august founder (see later in this chapter).

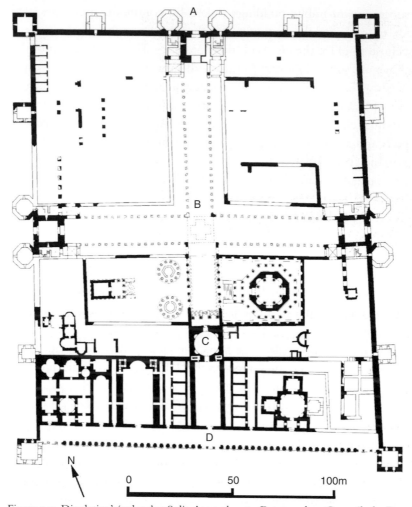

Figure 2.7 Diocletian's 'palace' at Split. A: north gate; B: tetrapylon; C: vestibule; D: colonnaded gallery. (After Ćurčić 2010, fig. 14.)

perimeter of the latter is quadrangular instead of circular.[125] There is an impos-ing circuit-wall bristling with closely spaced towers, traversed by three gates with oversized flanking towers, opening onto wide (just over 10m), straight avenues once lined by continuous colonnades that intersected at (nearly) right angles at a central tetrapylon (Figure 2.7).

From the fourth (south) side of the tetrapylon, there is a truncated section of colonnaded avenue, 27m long by 13.5m wide, with higher columns and arcades instead of trabeated lintels, "more beautiful just in proportion as it is shorter, since it runs toward the palace which begins hard by and serves as an approach

[125] The close correlation is noted by L'Orange 1965, 69ff.; Ćurčić 1993, 68–69; Poccardie 1994, 2008–12, among many others.

Figure 2.8 The 'Regia' and *protyron* at Diocletian's 'palace' at split. (From Kowalczyk 1909.)

to it."[126] This main approach to the palace – the Regia, as it were – did double duty as a grand forecourt, recessed by three steps along its long sides that would have provided an optimal place for ascending ranks of spectators at ceremonial occasions, and as the axial prolongation of the north-south colonnaded street, a kind of triumphal way bracketed by the (triumphal) tetrapylon to the north and the (triumphal) entranceway in the palace-façade to the south.[127] The eastern colonnade fronted a rectangular courtyard enclosing two small *tholoi* and a rectangular temple, while the western one gave directly onto the stairway leading to Diocletian's octagonal mausoleum. Between the mausoleum and temple precincts to the north and the façade of the palace to the south lay two small baths to the east and west of the street, which recall the positioning of the (public?) baths located in the vicinity of the palace at Antioch, and the Baths of Zeuxippos that would later rise by the entrance to the palace at Constantinople.[128] The 'Regia' terminated at the palace-façade, accessed via twin marble staircases ascending to an elevated protyron consisting of a tetrastyle porch surmounted by an arcuated pediment: a sort of triumphal arch, in short, meant to frame the epiphanies of the living god who resided within (Figure 2.8).[129]

[126] Libanius, *Orat.* 11 (on the palace at Antioch), cited at n. 64; on the dimensions, Wilkes 1993, 41–42.

[127] Wilkes 1993, 41–46. For a summary of the varying interpretations of the function and significance of this space, see McNally 1989, 17–21.

[128] Wilkes 1993, 56–58; McNally 1994, 114–16; McNally (*loc. cit.* 117) suggests that the eastern bath may have been 'more public,' while the western one was perhaps accessible only from the palace. On Antioch, see earlier in this chapter; on Constantinople, see Chapter 3.

[129] This tetrastyle façade topped by an arcuated pediment is strikingly similar to the architectural backdrop surrounding the enthroned emperor on the famous missorium of Theodosius, as many others have noted (e.g., Wilkes 1993, 66; Ćurčić 2010, 36–37); it also closely resembles

Behind the protyron lay a circular vestibule with a golden dome, leading to a large, rectangular hall behind it.[130] This central unit, on axis with the colonnaded forecourt, the tetrapylon and the north gate of the circuit beyond, was in turn flanked to the east by a central-plan triclinium, and to the west by an apsidal audience hall and a residential suite.[131] A colonnaded gallery rose above the wall at the rear of the palace, overlooking the water just like its counterpart at Antioch (and, one might assume, at Thessaloniki, and later – with some supporting evidence – at Constantinople too).[132] And again as at Antioch, the main body of the palace occupied approximately a quarter of the intramural area, and was fronted by connected but presumably more publicly accessible buildings, such as the temples, the mausoleum and the baths, branching off the arcades of the 'Regia.'

While the southern half, and especially quarter, of the site was clearly devoted to structures directly connected to Diocletian's official persona as ruler of state and divine patron and companion, the remains of the northern half, which are much more lacunose and largely obscured by subsequent residential and utilitarian structures, remain difficult to interpret.[133] The relative lack of original construction and the subsequent occupation history of this zone may indeed be the best evidence in favor of Ćurčić's suggestion that the area was from the outset intended as a token residential area, included to add a further element of urban verisimilitude;[134] the personnel required to staff the complex and to serve and guard the retired emperor might at any rate just as well have lived here as anywhere else. For that matter, as these spaces were hidden from view by the colonnaded streets that comprised the public face of the intramural area and led to all its attested 'public' or 'representational' or religious foci, the issue becomes almost academic. To my mind, the crucial point that transcends all matters of semantics and terminology is that every one of the discrete elements of the complex might just as well be described as 'token,' given the dwarfish dimensions of the place in its entirety (barely more than 200m north to south, and under 200m east to west).[135] Even if we

the proposed reconstruction of the south façade of the vestibule at Thessaloniki (n. 93). On the increasingly strident claims to divinity made by emperors beginning in the later third century, see Dey 2010, 21–22, with the sources cited at n. 50.

[130] Ćurčić 1993, 68–69; Wilkes 1993, 56.
[131] Wilkes 1993, 59–62.
[132] Wilkes 1993, 28–29. On the presence of a gallery overlooking the sea at Constantinople, see Dagron 1974, 93–94; Ćurčić 1993, 71.
[133] On the finds, which clearly testify to the continuous residential occupation of the site from late antiquity through the Middle Ages (and beyond), see Wilkes 1993, 88–91; McNally 1975; ead. 1994, esp. 114; on the architectural remains, see also Wilkes 1993, 37–41; Marasović and Marasović 1994, 96–97.
[134] Ćurčić 1993, 69.
[135] The east and west walls are 215.5m long; the north 175m; the south 181m, for a total area of 3.8ha (Wilkes 1993, 25–27).

prefer to call the whole thing a 'palace' or a 'villa,' the obvious fact remains that Diocletian did his utmost to create his retirement home in the image of a city, and more to the point an imperial capital, complete with all the features and amenities (albeit in schematic, reduced or 'symbolic'[136] form) most characteristic of the new urban quarters at Antioch, Thessaloniki and Trier, and presumably Milan, Sirmium and Nicomedia too.[137] Diocletian's 'palace' is a miniaturized urban archetype in every detail, right down to the juxtaposed clipeate busts of himself and a tyche (complete with mural crown) in the interior of the octagon, which unambiguously proclaimed him the founder of this new 'city,' the name of which alone, among its most strident pretentions to urbanity, escapes us.[138]

Thanks to an inscription reading FELIX ROMULIANA found on the site in 1984, the name of another minuscule Tetrarchic 'city' at Gamzigrad in eastern Serbia is confirmed beyond doubt: Romuliana, the place that, according to the *Epitome de Caesaribus*, Galerius founded on the site of his birth and named after his mother, where he was subsequently buried.[139] Thanks to excavations carried out in the 1980s and 1990s, the chronology and architectural contours of the site are now reasonably clear.[140] Two primary phases of construction are apparent, the first of them begun shortly after Galerius became *caesar* in 293. The circuit-wall of the first phase was almost immediately replaced – still during the lifetime of Galerius – with a second that can only be described as a sort of melodramatic urbanizing fantasy. Seen straight on, almost half the visible wall surface was composed of gigantic, polygonal projecting towers, nearly 23m in diameter and spaced at ca. 30m intervals; the four corner towers were larger

[136] Cf. Ćurčić 1993, 72; on the terminological issues, see also Meyer 2002, 69–71.

[137] I omit these important sites from the discussion because of the relative scarcity of archaeological and literary evidence pertaining to their Tetrarchic phases; all the available indicators nonetheless place them directly in the mold of the other Tetrarchic capitals, from their new or restored city walls, to the juxtaposition of palaces and hippodromes attested at all three. On Milan, see Humphrey 1986, 613–20; Duval 1992; Meyer 2002, 31–34; on Sirmium, see V. Popović 1971; Humphrey 1986, 606–13; I. Popović 2011; on Nicomedia, see Humphrey 1986, 581–82, 633–34; Meyer 2002, 29–31.

[138] Cf. Ćurčić 1993, 69, who is surely right that the female figure with the mural crown can only be a tyche, and hardly – both logically and iconographically speaking – a female member of the imperial family, *contra*, e.g., McNally 1996, 59–60. We would discard as anachronistic the testimony of Constantine Porphyrogenitus, writing in the tenth century, at our peril (*De administrando imperio* 29.237–40; trans. Jenkins 1967, 137): 'The *city* of Spalato, which means "little palace" was *founded* by the emperor Diocletian; he made it his own dwelling-place, and *built within it a court and a palace*, most of which has been destroyed' (Italics mine).

[139] *Epit. de Caes.* 40.16: *Ortus* [Galerius] *Dacia Ripensi ibique sepultus est; quem locum Romulianum ex vocabulo Romulae matris appellarat.* On the inscription, see Srejović 1993, 35–39; the *Epitome's* mention of Galerius' burial has likewise been confirmed by the discovery of two mausolea and associated funerary pyres on a nearby hilltop, which surely belong to Galerius and his mother, Romula: see esp. Srejović and Vasić 1994, 127–41.

[140] See esp. Srejović 1993, 31–53; Srejović and Vasić 1994; Vasić 2007; also see Meyer 2002, 79–91; Bülow 2011.

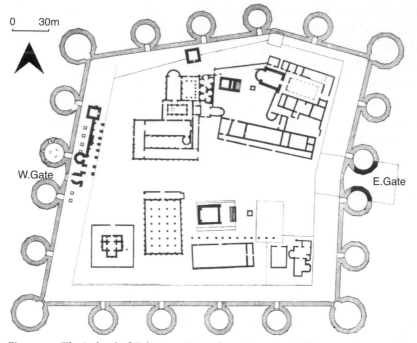

Figure 2.9 The 'palace' of Galerius at Romuliana/Gamzigrad. (After Curcic 2010, fig. 8.)

still, with an external diameter of ca. 26m (Figure 2.9).[141] The irregular polygon traced by this later circuit was pierced on the east and west sides by two facing gates, one of which is sufficiently preserved to allow a partial reconstruction.[142] Its single arch was bracketed by two closely spaced towers, separated by a concave curtain wall pierced by rows of superimposed arcades above the gateway, themselves recalling the Porta Nigra at Trier, in a configuration strongly reminiscent of the gate at Autun that received Constantine in its 'inward-curving fold, with towers projecting on both sides, in a kind of embrace' (Figure 2.10).[143] The two gates faced each other across a wide, open stretch of the intramural enclosure where the one main street of the 'city' – the *decumanus maximus*, as it were – evidently ran.[144] While no remains of its architectural décor have been found, we might even imagine the presence of continuous colonnaded arcades on both sides, fronting the dense clusters of buildings situated north and south of the street. As monolithic columns would presumably have been first to be carted off for reuse during the later phases of occupation, which continued well into the Middle Ages, their removal would hardly be surprising.[145]

[141] On the first circuit, Srejović (ed.) 1993, 119–25; on the second, ibid., 125–27; see also Ćurčić 2010, 22–24.

[142] Ibid.

[143] *Pan. Lat.* 5(8).7.6 (quoted at n. 117); on the gate arcades, see also Breitner 2011, 144–45.

[144] Cf. Srejović 1993, 45; Bülow 2011, 155–56.

[145] On the later phases of occupation, see Petković 2011.

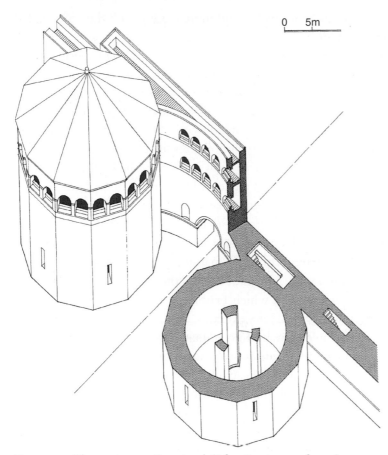

Figure 2.10 The west gate at Gamzigrad. (After Curcic 2010, fig. 10.)

The arcaded theme of the gate-façades was in any case reprised elsewhere inside the enclosure, where the two rectangular buildings that faced each other across the expanse of the *decumanus*, inside the western gate, both featured continuous blind arcades on their exterior walls, including those of the monumental, apsidal audience hall in the northern palace complex, which thus bears a striking resemblance to the closely contemporary audience halls at Trier and Thessaloniki.[146] One might wonder whether this novel Tetrarchic predilection for blind arcades in imperially sponsored edifices was not intended consciously to echo the arcades of nearby street porticoes, thus visually and symbolically linking the structures most representative of the impe-

[146] Ćurčić 2010, 38. Generally on the palace complex, which occupies most of the northern half of the enclosure, see Srejović (ed.) 1993, 128–39; Bülow 2011, 157–59. On the southern rectangular hall, the function of which remains unclear, see Srejović (ed.) 1993, 145–46; here, the external pilasters may have been topped with trabeated entablatures instead of arcades.

rial majesty – notably audience halls – still more closely with the colonnaded avenues that led to them.[147]

Hardly larger than Diocletian's 'palace' at Split, the result of Galerius' effort to put his natal soil on the map was a complex with equally manifest urban pretensions, fully consonant with the efforts both emperors made elsewhere to present themselves as founders of cities, from the 'new city' at Antioch, to the new urban quarter at Thessaloniki, complete with its triumphal arch featuring twinned busts of Galerius and the tyche of (presumably) the 'new' city that rose up on the periphery of the old, to Split itself, furnished with its own set of clipeate portraits of 'founder' and tyche in Diocletian's mausoleum.[148] And again, even if we wish to imagine Romuliana functioning primarily as a kind of rural palace or 'villa,' the fact remains that there is not another freestanding private residence in the Roman world with a circuit-wall as imposingly grandiose as the one at Romuliana. It is manifestly in the image of the new circuits erected around innumerable cities across the empire beginning in the second half of the third century, which bristled as never before with closely spaced, projecting towers, thick, lofty curtains, and awe-inspiring gateways.[149] Like the rest of the complex, the wall is simultaneously a spatially compressed and formally grandiloquent evocation of the urban paradigms promulgated by the Tetrarchs in the greatest imperial capitals of the age.[150]

Underlying all of the urban and quasi-urban showpieces engineered by Diocletian and his colleagues there remained, of course, the specter of Rome, itself recently refortified by Aurelian with the longest circuit of walls anywhere in the empire and still much the largest city in the Roman world, and its only titular capital. Contemporaries both hostile and sympathetic to the Tetrarchic regime were quick to note the emulation of the old *caput mundi* in the new capitals and imperial residences;[151] and basic formal similarities are immediately apparent, notably in the provision of new or restored walled circuits, and

[147] The main, north gate at Split likewise featured blind arcades, which in this case clearly did presage the arcades fronting the palace proper (Wilkes 1993, 32–37); see also earlier in this chapter on Trier.

[148] On the clipeate portraits at Thessaloniki and Split, see nn. 85 and 138.

[149] A quick troll through Rodríguez Colmenero and Rodá de Llanza (eds.) (2007) will make this last point abundantly clear.

[150] Cf. Ćurčić 2010, 24: 'With the second phase of fortifications at Romuliana, then, we see the emergence of a trend in late antique architecture in which compactness of design and boldness of form begin to "allude to" rather than simply to "represent"'; also Bülow 2011, 157–59. Crow's objection to the characterization of Split and Romuliana as 'miniature cities' (2012, 970) is unconvincing, though he usefully calls attention to yet another probable Tetrarchic palace-city at Hissar in Thrace, best identified as the ancient *Diocletianopolis*, which also boasts an imposing circuit-wall and ornate gateway.

[151] Trier, for example, is compared favorably with Rome by the Gallic panegyrists: see *Pan. Lat.* 6(7).22.4–5; 10(2).14.3, with Dey 2011, 123–24; the unrelentingly hostile Lactantius took Diocletian to task for foolishly (and ruinously) 'trying to make Nicomedia the equal of Rome' (*DMP* 7.10: *Ita semper dementabat Nicomediam studens urbi Romae coaequare*).

in the juxtaposition of palaces and hippodromes on the model of the Palatine
and Circus Maximus. Yet the new palatial quarters and 'palaces' also differed
from the imperial seat at Rome in important respects, notably in the con-
nective armatures of majestic, colonnaded avenues around which every one
of the examples discussed earlier gravitated, with the possible exception of
Romuliana. While Rome was graced with monumental colonnaded streets,
among them the Via Sacra in the Forum,[152] the palace itself, risen helter-skelter
over the course of centuries in a jumble high up on the Palatine, possessed no
comparable internal colonnades, nor were its approaches closely integrated
with the colonnaded streets below.[153] I would argue that the Tetrarchic colon-
nades were thus the single most significant morphological development of
their time, the spinal column of the new architecture of imperial majesty that
came into its own beginning with Diocletian. They organized architectural
space – and the experience thereof – along one or two primary axes of move-
ment; they defined the physical relationship between the various components
of the palaces and their surrounding and associated monuments; they deter-
mined the sequence in which those components were perceived and encoun-
tered, and constituted the inescapable backdrop against which all movements
between them occurred, above all in the course of public processions and
ceremonies. Moreover, they permitted and indeed often demanded the regular
presence of the urban masses, channeled as they inevitably were along the main
streets in the heart of existing cities where these palaces rose up, where their
entrances loomed and their venerable inhabitants appeared, and from which
their associated hippodromes, baths and – later – churches were accessed.[154]

2.4 *PRAESENS DEUS*: IMPERIAL CEREMONIAL
AND URBAN ARCHITECTURE

This last point leads, finally, to the question of why the Tetrarchic emper-
ors, newly empowered by the pervasive bureaucratic apparatus that they had
laboriously assembled, and possessed of a growing proportion of the surplus
capital produced by all the *civitates* in their dominions, devoted themselves
so assiduously to the elaboration and diffusion of the particular architec-
tural paradigms outlined earlier. In my view, the single most important factor
behind the realignment of the most important metropolises of the late Roman
empire around a restricted core of porticated avenues is to be identified in
the ensemble of public ceremonial and ritual employed to redefine the pub-
lic persona of the leaders of the Roman world following the tumults of the

[152] See Chapter 3.
[153] On the imperial palace at Rome, see Hoffmann and Wulf (eds.) 2004; Wulf-Rheidt 2011.
[154] Cf. Mayer 2002, 15–18; and (specifically on Antioch) Saliou 2009, 245.

mid-third century. Beginning in the later third century, emperors, praetorian prefects, vicars, provincial governors (and later, bishops as well) made ever more elaborate, stylized processions a key component of their effort to bring the awe-inspiring spectacle of themselves and the institutions they strove to embody before the eyes of their subjects.[155] The public, processional ceremony *par excellence* was the *adventus*, the elaborate welcome accorded to emperors and other eminent public officials upon their entry into a city, the inhabitants of which would line the arriving dignitary's route, grouped according to rank and station, chanting acclamations and brandishing a panoply of torches, banners, *signa* and garlands, as they did at Autun in 311.[156]

The leaders of the empire had been feted with pomp and ceremony (*adventus* included) long before Diocletian, of course, and the decades preceding his accession had already borne witness to an increasingly hieratic and authoritarian trend in the presentation of the imperial office, yet as in so many other respects, his reign marks a watershed.[157] It is surely significant that both contemporaries and later, fourth-century chroniclers so frequently identified Diocletian (or occasionally another Tetrarch) as the primary innovator in cloaking the persona of the Roman emperor in the 'eastern' trappings of absolute monarchy, and indeed of divinity incarnate, chief among them the wearing of gold, gems and a jeweled crown or diadem, and the rite of proskynesis or the 'adoration of the purple' (*adoratio purpurae*), which required those admitted to the imperial presence to abase themselves and kiss the hem of the sovereign's robes.[158] The

[155] Salient contributions to the vast corpus of relevant bibliography include Alföldi 1970, 88–100; MacCormack 1972; *ead.* 1981, 17–61; McCormick 1986, esp. 84–92; Dufraigne 1994, 151–233; Kolb 2001, 38–46.

[156] See the sources cited in the preceding note. On Autun, see nn. 117–18.

[157] Generally on imperial ceremonial up to the mid-third century, see the compendious overview in Fishwick 1987–2005, esp. vol. 2.1; on signs of ideological and ceremonial change under Diocletian's predecessors, Alföldi 1970; de Blois 2006; Noreña 2011, 236–43; 283–97; specifically on *adventus* from the Republic through the Severan period, Koeppel 1969; Dufraigne 1994, 15–92. For the innovations of the Tetrarchic period, which seem to represent a pronounced intensification of existing traditions more than a reinvention of ceremonial protocols *ex novo*, see, e.g., Williams 1985, 111–14; Kolb 2001, 25–58; Kuhoff 2001, 382–410; Canepa 2009, 79–99. On the (near) divinity of the emperors, with regard to which the Tetrarchs again built on the initiatives of their immediate predecessors, see Nock 1947; Kolb 2004.

[158] Amm. 15.5.18: *Diocletianus enim Augustus omnium primus externo et regio more instituit adorari, cum semper antea ad similitudinem iudicum salutatos principes legerimus;* Eutropius, *Brev.* 9.26: *diligentissimus [Diocletianus] tamen et sollertissimus princeps et qui imperio Romano primus regiae consuetudinis formam magis quam Romanae libertatis invexerit adorarique se iussit, cum ante eum cuncti salutarentur. Ornamenta gemmarum vestibus calciamentisque indidit. Nam prius imperii insigne in chlamyde purpurea tantum erat, reliqua communia;* Aurelius Victor, *de Caes.* 39.2–4: *quippe qui [Diocletianus] primus ex auro veste quaesita serici ac purpurae gemmarumque vim plantis concupiverit … Namque se primus omnium Caligulam post Domitianumque dominum palam dici passus et adorari se appellarique uti deum.* The more closely contemporary Lactantius makes Galerius, the object of his most pointed vitriol, the innovator (*DMP* 21.2): *Nam post devictos Persas, quorum hic ritus, hic mos est, ut regibus suis in servitium se addicant et reges populo suo tamquam familia utantur, hunc morem nefarius homo in Romanam terram voluit inducere, quem ex illo tempore victoriae sine pudore laudabat.*

adventus, too, was fundamentally a proclamation of divinity – or near divinity – and legitimacy, the latter often confirmed by victory over enemies foreign and domestic: the honorand was, by definition, anointed by the gods – or later the Christian god – from whom the ultimate and irrevocable sanction for the title and honors of the protagonist were held to derive.[159] For a sense of the full awe-inspiring potential of an *adventus* at one of the great imperial capitals, Ammianus Marcellinus' famous, albeit critical description of Constantius II's entry into Rome in 357 will suffice.[160] As the profound symbolic and cultural significance of *adventus* in the later empire has been thoroughly explored in several landmark studies,[161] we may limit ourselves to an outline of a few points most relevant to the deep symbiosis between this most ubiquitous of all public ceremonies and the urban architectural backgrounds in front of which it was – very deliberately – intended to occur.

As with mentions of innovations in imperial costume and deportment, *adventus* appears often enough in written and iconographic sources, beginning in the late third century, to indicate that it became the preferred means of putting the majesty of the honorand most visibly on display before the largest possible number of beholders. Even if the lack of extant mid-third-century sources makes the subsequent rash of descriptions and depictions of *adventus* stand out all the more starkly, beginning with the series of imperial panegyrics preserved from the year 289 on, it is nonetheless clear that contemporary observers began to notice and attend to imperial arrivals, and the magnificence thereof, as never before, a trend doubtless encouraged by the emperors themselves.[162] Already in the panegyrics delivered to Maximian, Constantius Chlorus and Constantine, arrivals greeted by festive, cheering crowds became a – perhaps the – preferred literary device for establishing the divinely ordained legitimacy of the ruling sovereign, a trend that continued unabated in the fourth century.[163] Ammianus

When late antique chroniclers invoke another emperor as the primary innovator, they tend nonetheless to identify one of Diocletian's immediate predecessors: so, e.g., the *Epitome de Caesaribus* on Aurelian (35.5): *Iste primus apud Romanos diadema capiti innexuit, gemmisque et aurata omni veste, quod adhuc fere incognitum Romanis moribus visebatur, usus est.* Useful modern discussions include Matthews 1989, 244–49; R. B. E. Smith 2011, esp. 138–39; see also R. B. E. Smith 2007 for a valuable overview of the imperial court in the late empire.

[159] Cf. MacCormack 1972, 727ff.; *ead.* 1981, 23ff.; for Ammianus' repeated expression of these themes, see n. 166.

[160] Amm. 16.10.

[161] MacCormack 1981 (also *ead.* 1972 and 1976); McCormick 1986; Dufraigne 1994.

[162] In addition to the sources cited at n. 155, see MacCormack 1976 with particular reference to the Latin Panegyrics; for several conspicuous iconographic parallels, see Dey 2010, 24–27, 33–34.

[163] In addition to the example of Autun (*sup.* n. 117–18), see, e.g., *Pan. Lat.* 8(5).19 (Constantius Chlorus in Britain in 297); 7(6).8.7–8 (Maximian to Rome in 307); 12(11).7.5–7 (Constantine to Milan in 312); 12(11).19 (Constantine to Rome in 312). In every case, the *adventus* serves to proclaim the legitimacy of, and overwhelming popular support allegedly expressed for, the honorand in the wake of a civil conflict or disputed accession to the purple.

Marcellinus, for example, was continually at pains to depict the consensus and outpouring of joy that attended his hero Julian's arrival in leading cities, a tactic all the more necessary to establish the unimpeachable credentials of, and overwhelming support expressed by gods and men for, the erstwhile usurper. Hence the *adventus* that Ammianus says occurred at Sirmium in 361, the first capital ('the populous and celebrated mother of cities') in Constantius II's domains that Julian entered on his way east: 'heading for the city which he presumed surrendered, he [Julian] approached with hastened steps; as he drew near the extensive and far-reaching suburbs, a crowd of soldiers and all the people, with much light and flowers, and favorable acclamations, proclaiming him Augustus and lord, led him to the palace.'[164] There has been much debate about whether any such *adventus* happened upon the first incursion of the rebel *caesar* into territory loyal to Constantius.[165] What counts is that Ammianus claims it did, by way of establishing Julian's manifest right to rule in Constantius' stead, a right that, in Ammianus' literary construction of reality, is cleverly established by the reception Julian is said to have received at Sirmium.[166]

The ample, additional literary testimonia aside, the surge in the visibility and political centrality of *adventus* from the end of the third century was undoubtedly favored by the simple reality that, beginning with Diocletian, the available opportunities for welcoming emperors and other dignitaries increased dramatically. The presence of first two, and then four emperors resulted in a commensurate multiplication of imperial arrivals, the more so given that the Tetrarchs (and their fourth-century successors) were so frequently on the move, as they strove both to secure the frontiers and to assert their authority more visibly and effectively over their own dominions, whence potential rivals and usurpers continued to spring with alarming regularity.[167] Further, the redoubling of the provinces of the empire and the creation of the dioceses greatly increased the number of regional seats of government, along with the cadre of ranking

[164] (21.10.1) ...*civitatem, ut praesumebat, dediticiam petens citis passibus incedebat eumque suburbanis propinquantem amplis nimiumque protentis militaris et omnis generis turba cum lumine multo et floribus votisque faustis Augustum appelans et dominum duxit in regiam*; cf. *Pan. Lat.* 3(11).6.2ff.

[165] See most recently Fournier 2010 for an overview of the views expressed on both sides of the question. For Fournier, the episode is not entirely fanciful, though it is undoubtedly employed to construct a particularly favorable literary picture of Julian.

[166] For Ammianus, indeed, Sirmium was to set the example for all the lesser towns Julian subsequently approached (21.10.2): *ubi eventu laetus et omine firmata spe venturorum, quod ad exemplum urbium matris populosae et celebris per alias quoque civitates ut sidus salutare susciperetur...* The themes of divine sanction, popular support and unimpeachable legitimacy recur with striking consistency in Ammianus' depictions of Julian's arrival at Vienne at 355, immediately after his promotion to *caesar* (15.8.21–22); at Constantinople in 361 (22.2.4); and at Antioch in 362 (22.9.14–16), all of which diverge markedly in tone from his scornful portrayal of Constantius II's arrival at Rome in 357. Also noteworthy is Ammianus' predilection for focusing on *adventus* that occurred in the leading capital cities of the empire.

[167] Dey 2010, 22; cf. McCormick 1986, 120–30; 231.

imperial representatives (governors, *vicarii*) stationed therein, direct proxies of the emperor himself who were thus entitled to their own *adventus*, both in their capitals and in the other cities they entered in the course of their yearly rounds, as I have stressed elsewhere.[168] *Adventus* thus became a recurring and ever-more dramatic part of the experience of urban dwellers across the Roman world, the means *par excellence* by which they were physically and symbolically implicated in their adherence to the imperial regime.

In short: these processions were a quintessentially urban phenomenon; they occurred most frequently in the capital cities regularly occupied by their protagonists; and they usually unfolded along a – or the – main colonnaded street, which almost invariably led from a principal point of entry (a city gate or a port) to a final destination at an official residence (an imperial palace, the *praetorium* of a prefect or governor, and later also a bishop's palace or – in the case of relics or icons – a church).[169] Particularly noteworthy is the concerted effort made to transform the architectural backdrop of the processional route into a festive protagonist in its own right via the *coronatio urbis*, the adornment of the city gate and the streets leading to the palace through which the honoree was to pass. We have seen it already at Autun in 311; we see it again, for example, during the *adventus* of Theodosius I into Emona in 388, immediately following his victory over the usurper Maximus:

> Why should I recall … *the gates crowned with green garlands* and the main streets waving with tapestries, and the day prolonged with blazing torches? Why recount the crowds pouring out of their houses into the public places, old men congratulating themselves on their years, youngsters pledging long service upon your behalf, joyful mothers and girls without a care? You had not yet brought the whole war to an end and you were already celebrating a triumph.[170]

Eleven years later, Rome would repeat the performance for Stilicho as he came to take up his consulship, in Claudian's artful anticipation of the scene:

> How many thousands will jam the Via Flaminia! How many times, O, will the lying dust delude bated love, when you (Stilicho) will be thought

[168] Ibid. On the *adventus* of governors, see Menander Rhetor, 378–81; McCormick 1986, 252–56; P. Brown 1992, 13–15; Slootjes 2006, 105–28.

[169] When an intramural destination for an arriving emperor is specified in the late antique written sources, it is inevitably a *palatium*. The panegyrist of 291 focuses closely on the veneration Diocletian and Maximian received at the palace upon their arrival in the city (*Pan. lat.* 11[3].3.1): *Quid illud, di boni! quale pietas vestra spectaculum dedit, cum in Mediolanensi palatio admissis qui sacros vultus adoraturi erant conspecti estis ambo et consuetudinem simplicis venerationis geminato numine repente turbastis!* See also Ammianus on Julian's *adventus* to Sirmium (21.10.1): *Augustum appelans et dominum duxit in regiam*; and Antioch (22.9.15): *Quod amplam urbem principumque domicilium introeunte imperatore…*

[170] *Pan. Lat.* (12(2).37.4: *Quid ego referam … portas virentibus sertis coronatas? Quid aulaeis undantes plateas accensisque funalibus auctum diem? Quid effusam in publicum turbam domorum, gratulantes*

to arrive with every hour! The avid mothers will look on and *all the road will be sprinkled with flowers* when you pass the Pincian heights, a lofty consul, the Roman image of the ancient senate.[171]

The personification of the city, so common in late antique panegyrics,[172] is itself personified by the depiction of the triumphal route, its grand architectural contours further accentuated by flowers and garlands, as yet another festively adorned witness to the majesty of the arriving dignitary. The spectacle was unthinkable, and un-describable, without its urban backdrop.

As the emperors no longer took the field with their armies and generally traveled less after the death of Theodosius I in 395, the spectacle of the triumphal imperial *adventus* became considerably rarer, at least outside of the cities (Constantinople, Ravenna and Rome) where the emperors primarily resided in the fifth century.[173] Yet governors and other august representatives of the state continued, like Stilicho, to be greeted in the traditional manner,[174] as did the imperial portraits sent out to cities across the empire upon the accession of a new emperor, and thereafter on significant occasions, regnal anniversaries and the like, which received an *adventus* appropriate for the emperor himself.[175] Further, the spectacle of the *adventus* gained a new lease on life in the hands of the Church, which adopted the ceremonial protocols of *adventus* for use in its own festive arrivals, which featured not only bishops but also – manifestly on the example of imperial *simulacra* – relics and images, all of which begin to appear regularly in the sources in the later fourth century.[176] By the 390s, Victricius of Rouen would not hesitate to compare explicitly the arrival of a shipment of relics to Rouen to the arrivals of Roman sovereigns, and indeed to privilege the *adventus* of the former, as both more spectacular and infinitely more significant for the aura of sanctity and ascetic charisma with which it

annis senes, pueros tibi longam servitutem voventes, matres laetas virginesque securas? Nondum omne confeceras bellum, iam agebas triumphum. Trans. Nixon and Rodgers 1994, 504, slightly modified (*platea* is a principal – wide – street, not a 'square' as Nixon and Rodgers have it: see Spanu 2002 and below, passim); italics mine.

[171] *De Consulatu Stilichonis* 2.397–402: *quae tum Flaminiam stipabunt milia vulgi! / fallax o quotiens pulvis deludet amorem / suspensum, veniens omni dum crederis hora! / Spectabunt cupidae matres spargentur et omnes / flore viae, superes cum Pincia culmina consul / arduus, antiqui species Romana senatus.* Italics mine. For other mentions of *coronatio urbis*, see Chapter 3 on Constantinople and Ravenna; also see John Chrysostom, *Hom.* 21 (PG 49, col. 220) on Antioch.

[172] Cf. Roberts 2001.

[173] Cf. McCormick 1986, 47; 91ff. On Rome's return to prominence as an imperial residence, alongside Ravenna, see Gillett 2001.

[174] In addition to Stilicho's *adventus* at Rome in 400 (*sup.* n. 171), see Claudian, *Bellum Geticum* 455–62 on his arrival at Milan in 402, following the repulse of Alaric at Pollentia.

[175] On the use of portraits and other imperial images in processions, see Fishwick 1987–2005, vol. 2.1, 550–66, esp. 552–53 on arrivals of such images; for the continuation of the practice in late antiquity (and beyond), see McCormick 1986, 234, with Chapter 4.

[176] For an exhaustive survey of the textual sources, see Dufraigne 1994, 249–318; cf. also MacCormack 1981, 64ff.

was imbued.[177] The significance of the procession, nonetheless, as well as the terminology used to describe it – Victricius' speech indeed accompanied the *adventus*, just as the imperial panegyrics did – would have been immediately recognizable to anyone with experience of the arrival of a temporal sovereign.[178] So too would the final destination of the relics at a monumental basilical *aula*; not the reception hall of an imperial palace, of course, but rather a church newly built by Victricius.[179]

And of course, *adventus* was only the most conspicuous component of a much broader range of ostentatious public displays invoked by the mighty in late antiquity. Every public appearance made by late antique emperors could indeed become the occasion for a captivating *mise-en-scène*, beginning from the moment they issued forth from their palaces, accompanied by a glittering retinue of attendants and guards.[180] The panegyrist of 291 captured what must, from an official perspective, have been the desired effect of such imperial epiphanies, both within the confines of the palace and without:

> What a spectacle your [sc. Diocletian and Maxentius] piety created, when those who were going to adore your sacred features were admitted to the palace in Milan you both were gazed upon and your twin deity suddenly confused the ceremony of single veneration! … Yet this private veneration, as if in the inner shrine, stunned the minds only of those whose public rank gave them access to you. But when you passed through the door and rode together through the middle of the city, the very buildings, I hear, almost moved themselves, when every man, woman, tiny child and aged person either ran out through the doors into the open or hung out of the upper thresholds of the houses. All cried out for joy, then openly without fear of you they pointed with their hands: 'Do you see Diocletian? Do you see Maximian?'[181]

The divinity of the sovereigns; the active 'beholding' and eager assent of the spectators; the architectural backdrop that becomes a protagonist in its own right; we have here in its essence – regardless of what actually transpired during the visit of Diocletian and Maximian to Milan – the vision of imperial majesty that the Tetrarchs and their successors sought to propagate, a condensed

[177] *De laude sanctorum*, esp. 12.15–42, with Dufraigne 1994, 303–08; cf. also Clark 2003. The arrival of the relics, some perhaps sent by Ambrose (*De laude* 2.1), likely occurred in 396.

[178] Cf. Dufraigne 1994, 306–08. For Victricius' characterization of a secular *adventus* – including a prominent reference to the *coronatio urbis* – as a foil for the arrival of the relics, see 12.15–17 and ff.: *Si quis saecularium principum nostram nunc viseret civitatem, protinus sertis spatia omnia redimita riderent, matres tecta conplerent, portae undam populi vomerent…*

[179] *De laude* 12.113–14: *Divinis pateat aula martyribus*; Victricius excuses his presumption in building the new church (without knowledge of the relics) by the subsequent desire of the relics to inhabit it (ibid., 119–20): *Ipsi sibi aulam parari occulta desiderii mei ratione iusserunt.*

[180] Cf. Dagron 1974, 95 on Constantinople.

[181] *Pan. Lat.* 11(3).11.1–4; trans. Nixon and Rodgers 1994, 95–96.

evocation of the inspiration for their architectonic reimagining of palaces and urban infrastructure in their primary residences.[182]

Nor should we forget the spectacles in the hippodrome, which over the course of the fourth and fifth centuries became the preferred meeting point for the emperors and the urban masses in their capitals, wherein lies much of the explanation for the increasingly close integration of hippodromes into the palatial 'architecture of power' outlined earlier in this chapter, beginning in the Tetrarchic period.[183]

But the elemental symbiosis between architecture and ceremony, both civil and ecclesiastical – the distinction is effectively meaningless in late antiquity – is best seen in the continued evolution of the paradigmatic urban backdrop forged by the imperial establishment at the end of the third century, which indelibly conditioned the parameters of cityscapes and public ritual alike for centuries to come. We thus turn to ceremonial armatures, centered on colonnaded avenues, over the *longue durée*.

[182] For my views on the (very close) correlation between the 'official' self-fashioning of the Tetrarchic imperial persona and the tenor of the panegyrics composed at the time, see Dey 2010, 23 and n. 57.

[183] On the growing role of the circus/hippodrome as the primary point of encounter between the emperors and the masses, where the triumphal ideology promulgated by the former was most prominently on display, see McCormick 1986, 92ff. and passim; on Constantinople in particular, see also Dagron 2011, esp. 229–51.

CHAPTER THREE

CEREMONIAL ARMATURES: PORTICATED STREETS AND THEIR ARCHITECTURAL APPENDAGES

3.1 PROLEGOMENA TO PORTICATED STREETS

Albeit with notable exceptions, modern scholars have tended to underestimate the importance of colonnaded (or porticated) streets in the urban fabric of late antique cities, particularly in the West.[1] Even with regard to the East, where the majestic colonnaded avenues still visible in cities such as Palmyra, Apamea and Ephesus bring the monumental presence of these prepossessing features powerfully to life, there is nonetheless a continued inclination (again with notable exceptions) to propose their de-monumentalization by the later sixth century at the latest, following what remains a hallowed *locus communis*, the metamorphosis of the grand colonnaded thoroughfare of antiquity into the pullulating chaos of the medieval *suq*. Jean Sauvaget's schematized

[1] Giorgio Bejor, for example, consistently downplays the role of colonnades in the urban fabric of Western cities; with regard to Italy in late antiquity, he cites Milan as the only example of a place embellished with an important colonnaded street, thus like Mundell Mango (*inf.* n. 12) ignoring the important evidence for colonnaded streets in – inter alia – Rome discussed later in this chapter (Bejor 1999, 105–06). In recent years, many more scholars have begun to recognize their importance and ubiquity in late antiquity, though more often than not in passing: see, e.g., Crawford 1990, 124; Mundell Mango 2001; Speiser in Morrisson (ed.) 2004, 279; Saliou 2005; Wickham 2005, 634; Tabaczek 2008, 106; Lavan 2009, esp. 805 and 808–09; Niewöhner 2011, 112. Lavan 2012 is excellent on the East, though he too paints too bleak a picture of the West after the fourth century, and the East after the early seventh; see now also Jacobs 2013, 111–204.

diagram representing the chronological (d)evolution of the colonnaded street in his study of Laodicea of 1934,[2] still often cited and reproduced, has become emblematic of the idea that even before the Arab conquest in the seventh century, colonnaded streets had seen their pristine monumentality compromised by the encroachment of shops and residences haphazardly built into the spaces between the columns and thence outward onto the paving of the streets themselves. Hugh Kennedy's influential article of 1985 translated Sauvaget's diagram into a paradigm more generally applicable to the cities of the Levant, which in his formulation were well on their way to becoming the teeming bazaars characteristic of the medieval period by the later sixth century;[3] and Helen Saradi has recently further extended the presumed range of the phenomenon to the 'Byzantine city' of the sixth century in general.[4]

As we shall see, this perspective requires substantial modification. At least as late as the fifth century in the western Mediterranean and the sixth in the East, porticated streets were either refurbished or built anew with remarkable frequency, joining city walls and churches as much the most prolific monumental architectural forms of the era. Further, the partition walls and structures in generally irregular masonry or more perishable materials that ultimately did come to encroach on the intercolumnar spaces and sometimes – more to the point – the roadbeds of so many colonnaded streets are often extremely difficult to date even for methodologically advanced archaeologists. As the majority of the extant remains were uncovered before the widespread use of rigorously stratigraphic excavation techniques in the past few decades, the essential question of chronology remains very much open. Much of the encroachment once dated to the sixth century largely on the basis of a priori notions about the inexorable decline of the classical townscape already in that period may well belong to the ninth century or later.[5] There are indeed a number of tantalizing indicators of the continued vitality of some streets, in both East and West, into the seventh and eighth centuries, when they apparently continued to frame the unfolding of urban ceremony in ways that suggest that their accessibility and their imposing architectural presence had not been fatally compromised either by unchecked decay or by the installation of shops and other commercial establishments, which had indeed been a ubiquitous presence in porticated

[2] Sauvaget 1934, 100.

[3] Kennedy approvingly cites Sauvaget's diagram (Kennedy 1985, 12), though interestingly, Sauvaget himself proposed that the blocking of the street at Laodicea occurred only in the tenth century.

[4] Saradi 2006, 186–208; 259–94; Sauvaget's diagram of Laodicea is reproduced at p. 189. In a similar vein, cf. Haldon 1999, esp. 4 and 8–9.

[5] Cf. Ward-Perkins 1996, 148–52 (with a highly effective critique of Kennedy's attempt to date large-scale 'encroachment' on colonnaded streets to the later sixth century); also Walmsley 2007, 37–39; Lavan 2009, esp. 808–09; 2012 (esp. 333–36 for a useful historiographical and methodological *status quaestionis*); Avni 2011b.

streets throughout late antiquity, as we shall see, and for that matter under the high empire as well.[6]

Before proceeding, there is a brief matter of terminology and definitions to clear up. Strictly speaking, a colonnade is composed of columns, bearing either a flat (trabeated) entablature, or a series of arches (an arcade). In the West more often than the East (where the proximity of good sources of marble permitted a ready supply of monolithic columns), the trabeated and arcaded structures flanking streets were often supported by pillars of masonry or even wood, whence they cannot properly be called colonnades.[7] Hence, I will hereafter prefer 'porticated streets' as a catchall designator for all such structures, and 'colonnaded streets' in the more restricted sense of the term. There is the further issue of what exactly constitutes a porticated street: my discussion of these structures will focus on streets lined by lengthy porticoes of relatively uniform aspect, as opposed to streets flanked by buildings with their own irregularly sized and spaced porticoes giving onto the roadbed, which will have presented a more heterogeneous and discontinuous appearance. A porticated street constitutes a cohesive architectural scheme that transcends the character of the individual structures situated behind the porticoes, imbuing the street as a whole with an architectonic identity essentially independent of the adjacent buildings, for all that these buildings are often directly connected to the porticoes.[8]

It should also be stressed that such streets started to proliferate long before late antiquity, beginning in the first century AD. The longest and perhaps the earliest of all is the *cardo* at Antioch, repaved and widened by King Herod at the turn of the millennium and lined on both sides, for its entire length of 2,275m, with continuous files of columns by the mid-first century AD.[9] By the later second century, extensive colonnades lined both sides of one or more principal streets at cities across the eastern Mediterranean and North Africa, as well as at Rome itself and at a number of sites in western Europe (e.g., Lincoln, Reims, Italica), though the Eastern exemplars usually receive considerably more attention, as they tend to be both more monumental and better preserved.[10] It was

[6] Cf. Segal 1997, 10; Saliou 2005.

[7] For the use of wood in street porticoes in early imperial Gaul, v. Frakes 2009, 97–103 and passim.

[8] Similar distinctions (often with considerably more technical nuances and categorical subdivisions) have appeared in much of the specialized literature on porticated streets: see MacDonald 1986, 33 and ff.; Bejor 1999, 9–10; Frakes 2009, esp. 5–9. The streets under consideration here correspond with MacDonald's types 5 and 6: 'covered porticoes ... carried on columns or piers and interposed between the pavement and the buildings ... (forming) a continuous colonnade at least several blocks long,' on one or both sides of the street (p. 33).

[9] Bejor 1999, 10–15; Segal 1997, 9.

[10] See generally MacDonald 1986, 33–51; Segal 1997, 5–54; Bejor 1999, passim; for the underappreciated colonnades in northwest Europe, see Lehmann-Hartleben 1929, 2109–10; Bejor 1999, 89–91; Byhet 2007, 427–28. On Lincoln, see Wacher 1995, 120–37; Reims: Byhet 2007,

only with the imperially sponsored urban or quasi-urban foundations of the third century, however, that the colonnaded or porticated street came into its own as an indispensable element in the architectural language of imperial power, East and West, from Philippopolis in the 240s to the palace-city complexes erected by the Tetrarchic emperors, as we saw in the preceding chapter.

Thereafter, porticated streets became (with the exception of city walls) the most ubiquitous, expensive and ambitious form of secular monumental architecture erected from the later third century through the sixth, leaving an indelible stamp on the greatest cities of the late Roman – and post-Roman – world, and many others besides. The majority of the most extensive and costly street porticoes either restored, extended or constructed *ex novo* were located in prominent centers of civic and ecclesiastical administration, provincial and imperial capitals above all,[11] which increasingly tended to gravitate around the colonnades that framed and connected the palaces and churches where rulers and bishops lived and performed their public duties.

Hence, an inquiry into the question of why the civic and, to a lesser extent, ecclesiastical authorities responsible for the most ambitious interventions in the urban topography of late antique cities devoted such a considerable portion of their limited resources to porticated streets should have much to reveal about the ways power and authority were enacted, publicized and given architectural form in the late Roman world. It should also help to explain the motives behind the development of the porticated street into the 'imperial' architectural feature *par excellence* in the third century, and the surprising persistence of these streets, and – more to the point – the ceremonial and commemorative praxis associated with them, through the sixth century and beyond in both East and West. Hence, the function of these grand avenues will concern us at least as much as their form. Our focus will be on the period ca. 300–600, which is rich enough in literary, epigraphic, archaeological and iconographic evidence to permit a relatively detailed perspective on the activities and ideological constructs that animated these streets and made them such indispensable features of the greatest cities of the epoch.

3.2 IMPERIAL CAPITALS IN ITALY: ROME AND MILAN

In a fine recent article on colonnaded streets in Constantinople in late antiquity, it is stated that the city of Rome differed markedly from Constantinople in that it had no colonnaded streets worth speaking of in late antiquity.[12] In reality,

433; Italica: Bejor 1999, 89. In addition to true colonnades, many more Western cities featured street porticoes of varying degrees of monumentality supported by pillars in masonry or wood: for numerous examples in Gaul, see Byhet 2001–02, 2007; Frakes 2009.

[11] Cf. Bejor 1999, 104–05; Saradi 2006, 291.

[12] Mundell Mango 2001, 29.

Rome had long featured extensive street porticoes. The most ideologically charged route in the city, the Triumphal Way followed by returning conquerors since the early days of the Republic, came to be lined by covered stone arcades over much or all of its urban tract, from the Bridge of Nero in the Campus Martius, through the Circus Flaminius and the Forum Boarium, and on past the Circus Maximus to the Forum Romanum.[13] Elsewhere, following the catastrophic fire of AD 64, a number of principal thoroughfares in the devastated city center were reconstructed as wide, porticated avenues, which imbued the imperial capital with a stately veneer reminiscent of the royal capitals of the Hellenistic eastern Mediterranean.[14] Nero's gargantuan new palace, the *domus aurea*, gravitated around a triple portico said by Suetonius to be a mile long;[15] and Nero's architects encased the nearby Sacra Via – the final stretch of the Triumphal Way running through the forum to the Capitoline Hill – within lofty, arcaded porticoes at the same time.[16]

But the most extensive evidence for the erection of monumental street porticoes at Rome comes from late antiquity, beginning in the later fourth century, when several of the busiest and most symbolically charged axes of communication in the city were embellished with extensive porticated façades. Indeed, one of the most significant architectural interventions witnessed in Rome in the second half of the fourth century involved the erection of new porticoes along what was then becoming one of the very most important roads in the city, the street leading north through the Campus Martius to the Pons Aelius, the bridge leading to the mausoleum of Hadrian, and from there onward to St. Peter's. As the evidence for the monumentalization of this street has been presented elsewhere,[17] a resume of the salient points will suffice.

At the time of or soon after the construction of the Aurelian Wall in the 270s, the Pons Neronianus, the old Neronian bridge that served as the principal connection between the northern Campus Martius and the west bank of the Tiber, went out of use.[18] Thereafter, all traffic on the two main roads in the area,

[13] See, e.g., E. La Rocca 1984, 65ff., with prior bibliography; remnants of what must be the arcades of this *porticus triumphi* remain visible in the Forum Boarium, near the church of S. Nicola in Carcere (Coarelli 1988, 394–97).

[14] Tacitus, *Annales* 15.43, stressing both the utility (*utilitas*) of the new streets in preventing future catastrophic fires, and their impressive appearance (*decor*); cf. MacDonald 1982, 25–31; Bejor 1999, 9–10, 82–83.

[15] Suetonius, *Ner.* 31; MacDonald 1982, 31ff.

[16] Van Deman 1923, esp. 415–19; generally on the location and evolution of the Sacra Via, Coarelli 1986, esp. 11–26.

[17] Dey 2011, 174–80, 304–09.

[18] As the bridge cannot plausibly be connected with any of the bridges mentioned in the exhaustive list given in the Regionary Catalogues of the early fourth century, it was almost certainly defunct by this point. The *terminus ante* is given by the earlier of the two lists, the *Curiosum*, which is best dated to the early part of Constantine's reign at the latest (*Codice topografico della città di Roma*, vol. I, 66ff.).

the so-called Via Recta (the modern Via dei Coronari) leading east through the Campus Martius past the Baths of Nero and on to the Via Lata, and the Via Tecta, the porticated road running northwest from the Circus Flaminius, effectively the urban continuation of the ancient Via Triumphalis (the modern Via dei Banchi Vecchi), was diverted northward to the bridge leading to the Mausoleum of Hadrian, which subsequently became the sole crossing point in the northern Campus Martius. The decision to privilege the previously little-frequented Pons Aelius over the Pons Neronianus was presumably conditioned by defensive considerations, as the mausoleum was admirably suited to function as a fortified bridgehead on the far bank of the Tiber, allowing access to the bridge to be strictly controlled in a way that would have been impossible at the Pons Neronianus without the addition of substantial new structures at its western approaches. Traffic on the 'Via Recta' and Via Tecta was subsequently diverted north to the Pons Aelius along the modern Via del Banco Santo Spirito, as can be deduced in part from the fact that almost no traces of the paving of the 'Via Recta' and Via Tecta have been discovered between the point where they converged on the road leading to the mausoleum and the Pons Neronianus;[19] the paving of these streets may indeed have been reused to monumentally re-edify the tract of road leading to the Pons Aelius, as may the columns from the tract of the Via Tecta situated between the intersection with the Via del Banco Santo Spirito and the Pons Neronianus, which had become a blind alley with the closure of the bridge (Figure 3.1).[20]

While this last point may be considered speculative, it is clear that the road leading to the Pons Aelius did indeed come to be flanked by impressive porticoes, which seem to have been installed, apparently for the first time, in the later fourth century. The key piece of evidence is the lost inscription from the triumphal arch of Valentinian, Valens and Gratian, completed ca. 380 athwart the southern approaches to the Pons Aelius, which survives in a ninth-century transcription: 'Our lords, emperors and caesars Gratian, Valentinian and Theodosius, pious, fortunate and eternal *augusti*, commanded that (this) arch to conclude the whole project of the *porticus maximae* of their eternal name be built and adorned with their own money.'[21] In addition to providing a firm date for the arch, the inscription strongly implies that the *porticus maximae*, which must refer to porticoes along the street leading to the arch, was realized in connection with, or shortly before, the arch itself, in what was clearly perceived as a unified architectural scheme, for which

[19] Cf. E. La Rocca 1984, 65–66.

[20] The matter is discussed in detail in Dey 2011, Appendix D.

[21] *CIL* 6, 1184: *Imperatores caesares ddd nnn Gratianus Valentinianus et Theodosius pii felices semper Auggg arcum ad concludendum opus omne porticuum maximarum aeterni nominis sui pecunia propria fieri ornariq. iusserunt.* The inscription is transcribed in the so-called Einsiedeln Itineraries, a ninth-century compilation of guided walking tours through the city of Rome.

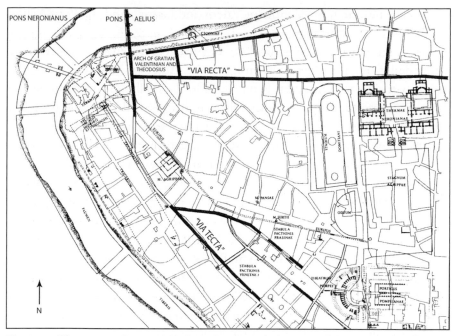

Figure 3.1 The western Campus Martius in Rome, with the route of the *porticus maximae* to the Pons Aelius and the arch of Valentinian, Valens and Gratian. (After Dey 2011, fig. 4.1.)

the arch served as the final and concluding element (*arcum ad concludendum opus omne porticuum maximarum*). The best conclusion is that the new porticoes extended the existing colonnades of the Via Tecta along the stretch of road leading to the only surviving river crossing in the area, which in turn provided access to St. Peter's, one of the crucial nodes in Rome's emerging Christian topography.[22]

The centrality of St. Peter's in the spiritual and ceremonial life of Rome was further accentuated by the construction of an additional covered colonnade on the far side of the Tiber, flanking the road leading from the mausoleum of Hadrian to the church. While it is first securely attested in the *Gothic War* of Procopius, written in the mid-sixth century, the colonnade was likely built rather earlier, perhaps indeed shortly after or in connection with the *porticus maximae*, to which it would effectively have formed the extra-urban continuation, creating a nearly continuous colonnaded panorama stretching all the way from the Via Tecta in the intramural heart of the

[22] One telling indicator of the new centrality of the Pons Aelius comes from an allusion in the *Peristephanon* of Prudentius (written ca. 400), for whom 'Hadrian's bridge' was the preferred (and almost certainly only) means of access to St. Peter's from the Campus Martius: *ibimus ulterius qua fert via pontis Hadriani* (*Peristephanon* 12.61); in one of Augustine's newly discovered sermons, the emperor Honorius clearly crossed the Tiber via the same bridge on his way to St. Peter's in 404 (see Dolbeau 1996, 266).

city, via the new arch of Valentinian, Valens and Gratian and the Pons Aelius, all the way to the Vatican.[23]

The other two most substantial street porticoes erected in late antique Rome led from the Porta Ostiensis in the Aurelian Wall along the Via Ostiensis to the church of St. Paul's outside the walls; and from the Porta Tiburtina along the Via Tiburtina to the basilica of San Lorenzo. While they too are only known from later sources (of the mid-sixth and eighth centuries, respectively),[24] both structures may well date as early as the later fourth century. They likely belong to approximately the same period as the portico leading to St. Peter's, as the similarities in form and function common to all three suggest that they were conceived as interrelated parts of a unitary architectural scheme designed to connect the suburban shrines of Rome's three most venerated martyrs with the Aurelian Wall, and thus with the city center. In the case of the portico to St. Paul's, a date in the 380s appears especially likely, as it was in precisely this period (beginning in ca. 383–84) that the Constantinian church on the site was replaced by a massive new basilica sponsored by Valentinian II,[25] the same Western emperor under whom, it should be remembered, the triumphal arch and the *porticus maximae* leading to the Pons Aelius were erected. It is surely as good a hypothesis as any that the imperial authorities, presumably working in concert with Pope Damasus (366–84), sought to monumentalize the route to the new St. Paul's and link the church to the city center during or soon after its construction, by means of an imposing portico that mirrored the extra-mural extension of the *porticus maximae* leading to St. Peter's. Damasus, of course, is best known for his tireless efforts to restore and popularize the suburban shrines of Rome's leading martyrs,[26] whence the temptation grows powerful to imagine that he actively collaborated in a scheme to anchor the devotional circuit of the Roman periphery he did so much to promote on three porticated 'access roads' leading to the shrines of Rome's three greatest martyrs.

By the sixth century, when the annual liturgical calendar of the Roman church was largely complete, the three churches of St. Peter's, St. Paul's and San Lorenzo remained the only extramural shrines regularly visited by the popes

[23] Procop. *BG* 1.22.21; generally on the topography and ceremonial importance of the route to St. Peter's, see Liverani 2007. Liverani (2007, 93) imagines that the extramural colonnade was built rather later, ca. 500, but acknowledges that the proposal is – necessarily given the state of the evidence – purely speculative.

[24] St. Paul's: Procopius, *BG* 2.4.9; S. Lorenzo: *Liber Pontificalis* I, 396 and 508.

[25] In 383–84, we see Symmachus in his capacity as *praefectus urbi* of Rome communicating with the reigning emperors Valentinian II, Theodosius and Arcadius, who were responsible for allocating the funds for the new construction; in practice, Valentinian II, from his capital at Milan, will have been the prime mover in the new project: see *Collectio Avellana*, 3 (*CSEL* 35, pp. 46–47), with Chastagnol 1960, 349–50.

[26] See Saghy 2000, with extensive prior bibliography; cf. also Pietri 1961, esp. 303–04.

in the course of the stational processions that increasingly came to define the sacred topography of the city.[27] The porticated avenues thus provided a grandiose architectural framework for the ceremonial processions led by the popes to the three great extramural sanctuaries in the course of the annual liturgical cycle.[28] The prominence of these processional routes in the topographical horizons of the city and the ideological agendas of its bishops was such that they continued to be maintained for centuries, often at enormous cost. In the late eighth century, Pope Hadrian I (772–95) restored all three porticoes, in the case of the route to St. Peter's allegedly by reusing 12,000 tufa blocks taken from the embankments of the Tiber to complete the project.[29]

But while the popes may have been unusually successful in preserving the grand processional ways marked out in Rome in late antiquity into the early Middle Ages, similar porticoes once dominated the cityscapes of other Western capitals in late antiquity, notably those that superseded Rome as preferred imperial residences.

In Italy, Milan served as the primary seat of government from 286 until 402, during which time it too saw the erection of an architecturally prepossessing porticated avenue. As excavations undertaken in the 1980s during the construction of the MM3 underground line demonstrated, the new street took shape in ca. 375–80, and thus at almost exactly the moment when the *porticus maximae* at Rome were built, under the patronage of the same Italian emperor, Valentinian II. The Milanese porticoes were two stories high, and extended for nearly 600m along both sides of the road leading to Rome, beginning from the Porta Romana in the circuit-wall and terminating, again like the Roman exemplar, with a triumphal arch.[30] Moreover, just as at Rome, the colonnades were linked to an especially prominent extramural church, the new Basilica Apostolorum built by Bishop Ambrose between 382 and 386 at the midway point of the newly aggrandized street (Figure 3.2).[31] In light of the new evidence for dating the porticoes scant years before the appearance of the church, there is now better reason than ever to imagine – as past scholars operating under the assumption that the rebuilt street dated to the third century were already tempted to do[32] – that the proximity of the imperial triumphal way was a determining factor in Ambrose's decision to situate the first

[27] Baldovin 1987, 143–66, esp. 155; Chavasse 1993, 231–46.
[28] Cf. Dey 2011, 225–28; Fiocchi Nicolai 2000, 229.
[29] *Liber Pontificalis* I, 507–08.
[30] Caporusso 1991, 251–57.
[31] Bovini 1961; Lewis 1969a; *ead.* 1969b, 83–92; Krautheimer 1983, 80.
[32] E.g., Lewis 1969b, 92: 'Indeed, the large-scale demolition of tombs to clear the site for construction would suggest that the prestige of the imperial porticoed street may have been the overriding factor in Ambrose's choice of this spot, not its function as a Christian burial ground'; cf. Lewis 1969a, 217–18.

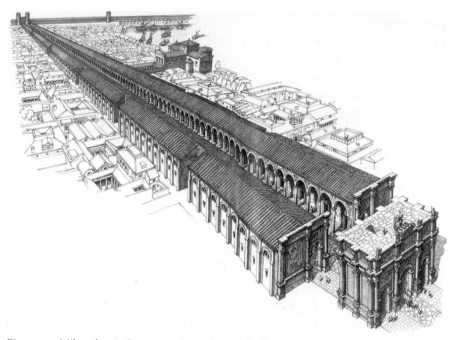

Figure 3.2 Milan: the via Romana colonnades and the Basilica Apostolorum. (Francesco Corni/ Civico Museo Archeologico di Milano.)

and most prestigious of his three (or four) great extramural churches adjacent to its porticoes.[33] In so doing, Ambrose – surely consciously – reproduced the topographical relationship between St. Peter's and the Via Triumphalis at Rome, and also, as we shall see, between a principal Constantinopolitan triumphal avenue and the city's own church of the apostles, the Apostoleion, whose unusual cross-shaped plan directly inspired the cruciform layout of the Ambrosian Basilica Apostolorum.[34] So too at Trier, the east end of the cathedral – suggestively dedicated to St. Peter and rebuilt under Valentinian and Gratian (364–83) – featured a twelve-sided aedicula enclosed within a massive square precinct, another Apostoleion in miniature that was, moreover, directly accessible from the porticated *cardo* departing from the Porta Nigra.[35] In each

[33] Cf. McLynn 1994, 232. The other extramural foundations are the Basilica Ambrosiana-Basilica Martyrum-S. Ambrogio; the Basilica Virginum-S. Simpliciano; and – perhaps – the vanished Basilica Salvatoris, attested in the later Middle Ages as S. Dionigi: on the case for S. Dionigi as an Ambrosian foundation, v. Cattaneo 1974; on the other suburban churches, Krautheimer 1983, 77ff.; McLynn 1994, 226–37. The relative prestige of the Basilica Apostolorum is amply attested by the outstanding importance of the relics it was built to house, from which it took its name, for all that these may have been *brandea* (contact relics) rather than physical remains; for diverse views on the nature, provenance and importance of the relics, v. Lewis 1969b, 93; Krautheimer 1983, 80; McLynn 1994, 230–32.

[34] Lewis 1969a, 209; Krautheimer 1983, 80; McLynn 1994, 232. On the location and dating of the Apostoleion in Constantinople, see later in this chapter.

[35] TCCG Vol. I, 24–25.

case, we see civil and ecclesiastical authorities effectively collaborating in the creation of new, monumental urban itineraries, punctuated by imperially sponsored street porticoes, triumphal arches and city gates that provided a suitably grandiose setting for the formal processions that dominated the ceremonial repertoire of both church and state.[36]

The dedication of the Milanese church of the Apostles on May 9, 386 culminated with the translation and installation under the high altar of the relics of John the Baptist and the Apostles Andrew and Thomas, doubtless conveyed to the church in a festive procession along the Via Romana arcades.[37] The event indeed left such an impression on the Christian faithful that when Ambrose later consecrated the Basilica Ambrosiana, the assembled crowd loudly demanded that he consecrate the new church with relics, as he had the *basilica in Romana*.[38] The Basilica Apostolorum, that is, derived its vulgar name from the porticated (*via*) *Romana* whence it was accessed, which in the popular imagination – as well as in material reality – was inextricably connected with the church itself, as was the memory of the relic procession that accompanied its dedication. Motivated by the prompting of the crowd, Ambrose exhumed the bones of the local martyrs Gervasius and Protasius, which he conveyed to the Ambrosiana in a triumphal procession directly inspired by the protocols governing secular *adventus*.[39] Nine years later, when Ambrose sought to exalt the remains of Nazarius, another local martyr, he sent them to the extramural church best architecturally equipped, by virtue of its monumental access road, to host yet another triumphal entry of relics: the *basilica in Romana* Basilica Apostolorum, thereafter known also as S. Nazaro.[40]

The chronology of the monumental porticoes built along the approaches to several of the leading churches in Rome and Milan in the 380s is particularly noteworthy given that evidence of imperial participation in processions held to

[36] It is noteworthy that the Basilica Apostolorum was also the Ambrosian foundation most closely associated with high-ranking members of the imperial court. Leading members of the secular élites were buried there; and in 395, Stilicho's wife, Serena, sponsored the new pavement of Libyan marble installed around the relics of Nazarius, including in her dedicatory inscription a prayer for Stilicho's return from campaigning (Lewis 1969b, 96–97; McLynn 1994, 363–64). As McLynn has seen so well, the Basilica Apostolorum, privileged as it was by its relationship to the main *adventus*-route, was in effect the state church of the city, 'a place within Christian Milan for the newly arrived imperial entourage' (1994, 232).

[37] The date is given by the *Martyrologium Hieronymianum*, which reports the arrival of the relics at the Basilica Apostolorum on May 9 thus (*AS* Nov. 2.2, p. 241): *Mediolani de ingressu reliquiarum apostolorum Iohannis, Andreae et Thomae in basilicam ad portam Romanam.*

[38] Ambrose, *Ep.* 77.1, with McLynn 1994, 209–15.

[39] Ambrose, *Ep.* 77.2ff., with Dufraigne 1994, 301–02.

[40] For Ambrose's biographer Paulinus, whose account establishes the date of the translation shortly after the death of Theodosius in 395, the church is again inseparable from its flanking street, the 'Romana' (*Vita S. Amb.* 32): *Quo in tempore sancti Nazarii martyris corporis, quod erat in horto positum extra civitatem, levatum ad basilica apostolorum, quae est in Romana, transtulit.* Cf. McLynn 1994, 363–64.

mark the translation of relics begins with the reign of Theodosius I (379–95).[41] According to Sozomen, in 391 Theodosius solemnly carried the head of John the Baptist to his new church dedicated in the martyr's name, located outside the Golden Gate at the Hebdomon, the same place from which newly raised emperors departed on their ceremonial entrance into Constantinople.[42] In 406, Theodosius' son Arcadius joined the Patriarch of Constantinople and members of the Senate in transporting the relics of Samuel into the city.[43] In 411, these relics were deposited outside the new city walls at the church of St. John *iucundianae* at the Hebdomon, which took its name from the imperial palace of the same name located nearby.[44] During the reign of Theodosius II (408–50), the emperor and members of the imperial family regularly participated in translations of relics, as when, in 421, the remains of Stephen were paraded through the city, in a style befitting of an imperial *adventus*, on their way to their final resting place at the oratory of St. Stephen, newly built inside the imperial palace itself, at the eastern extremity of the Mese, the main processional artery in the city.[45] With the installation of the relics of both John the Baptist and Samuel at the Hebdomon, and those of Stephen at the palace inside the city, the starting and ending points of the imperial triumphal route along the Mese were bracketed by collections of newly installed relics, in the translation of which the imperial family had, moreover, actively participated. At San Nazaro, meanwhile, the relics of the eponymous martyr were ensconced in a chapel decorated with Libyan marble at the behest of the *magister militum* Stilicho's wife, Serena, who prayed for her husband's safe return from campaigning in the dedicatory inscription.[46] Thus, at Milan, too, the church that seems to have become the preferred stage for the display of court-sponsored patronage of the cult of relics was the one most closely connected with the monumental route (the very road, perhaps, along which Serena hoped to see her husband return in triumph?) followed by imperial processions.

Beginning in the later fourth century, then, the rulers of the empire were evidently increasingly eager to link their public personae with the triumphs

[41] Dufraigne 1994, 299; Klein 2006, 82–83.

[42] Sozomen, *HE* 7.21.4–9; *Chronicon Paschale*, p. 564.

[43] *Chronicon Paschale*, p. 569.

[44] *Chronicon Paschale*, pp. 570–71; the palace is named by Procopius (*De aed.* 1.11.16) in his account of Justinian's reconstruction of the complex.

[45] The arrival of these relics at the church is (probably) the subject of the famous relief on the 'Trier Ivory,' most plausibly interpreted to represent the emperor's sister Pulcheria Augusta awaiting their arrival before the entrance to the still-unfinished church: see n. 146. More broadly on relic translations into the capital and its environs under Theodosius II, v. Klein 2006, 84–86.

[46] McLynn 1994, 363–64. The inscription reads: *Qua sinuata cavo consurgunt tecta regressu / sacrataque crucis flectitur orbe caput / Nazarius vitae immaculabilis integer artus / conditur; exultat hunc tumuli esse locum; / quem pius Ambrosius signavit imagine Christi / marmoribus Libycis fida Serena polit; / coniugis ut reditu Stiliconis laeta fruatur, / Germanisque suis pignoribus propriis* (transcribed in Lewis 1969b, n. 47).

of the Christian church, and they actively collaborated with church leaders in the celebration, veneration and architectural framing of the martyrs who, in triumphing over death, had preserved orthodoxy and placed the Christian Roman empire over which they presided under divine protection.[47] Ambrose himself, like many of his contemporaries, leaves no doubt that the arrival of relics was a triumphal occasion, best presented in the trappings of triumphal imperial *adventus* that would have been immediately familiar to the inhabitants of any imperial capital.[48] Enthroned on the four-wheeled cart (*plaustrum*) used to convey arriving emperors in the fourth century, preceded by torches and standards, and hailed by the acclamations of the masses, the bones of the illustrious Christian dead were greeted with reverence otherwise reserved for reigning emperors.[49] The transfer of relics to churches connected to the principal porticated streets of a late antique capital such as Milan could subsequently unfold in the same spaces used by the emperors for their own triumphal arrivals: a church procession through the porticoes of the Via Romana would inevitably have called to mind imperial processions along the same street. The connection between imperial and ecclesiastical ceremony thus received its definitive and lasting stamp in the realm of architectural space, in the form of a monumental processional way jointly exploited by civic luminaries and bishops. When the emperors themselves participated in translations of relics, the circle was closed: state and church triumphed together, as the representatives of each basked in the reflected glow of their counterparts. The imperial presence ennobled the ecclesiastical ceremony and proclaimed the unity of bishops and Christian sovereigns in the governance of the empire. The emperors themselves grew in the eyes of the Christian faithful, as the patrons and colleagues of the holy men tasked with stewarding the bones of the martyrs and mediating the access of the faithful to this most precious of all forms of spiritual currency.

3.3 CONSTANTINOPLE

The topographical nexus between imperial and ecclesiastical authority was nowhere more fully realized than in Constantinople, the ideal laboratory for the testing and elaboration of the urban paradigm envisioned by the first

[47] There are of course exceptions to the rule of collaboration between emperors and bishops, notably the violent conflict between the partisans of Arcadius and John Chrysostom that led to the deposition of the latter, on which see recently Andrade 2010.

[48] Victricius of Rouen, for example, is particularly explicit in comparing the arrival of relics to the *adventus* of emperors: v. *De laude sanctorum* 12, 15–42 and passim, with Dufraigne 1994, 303–07; cf. also Clark 2003.

[49] According to Ambrose, the relics of Felix, Nabor and Victor, soldiers martyred in 304, were conveyed in triumph into Milan during the episcopate of Maternus (316–28), borne on a 'triumphal cart' (*Hymn.* 10, 29–32): *sed reddiderunt hostias rapti quadrigis corpora revecti in ora principum plaustri triumphalis modo.* For the use of similar vehicles (often described with the traditional term *currus*) in the *adventus* of fourth-century emperors, McCormick 1986, 87–88.

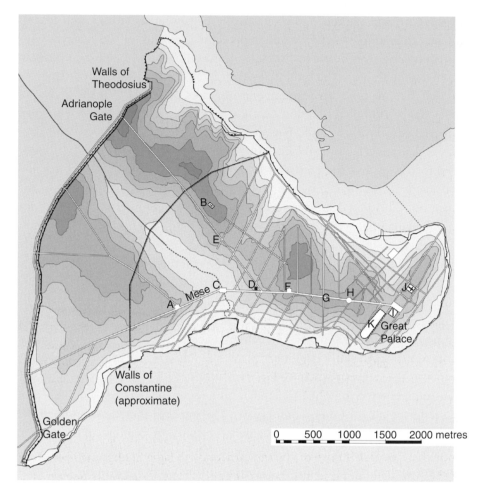

Figure 3.3 Constantinople. A: Forum of Arcadius; B: Apostoleion; C: Forum of the Ox/*forum bovis*; D: Philadelphion; E: Forum/column of Marcian; F: Forum of Theodosius; G: tetrapylon; H: Forum of Constantine; I: Baths of Zeuxippos; J. Hagia Sophia; K: hippodrome. (Wikimedia Commons/Cplakidas, modified.)

generations of Christian emperors. Officially inaugurated on May 11, 330, the birthday of its founder and namesake, the new city afforded Constantine and his successors in the fourth and fifth centuries a sort of architectural blank slate, onto which they were free to delineate an ideal vision of an imperial capital, largely unencumbered by the constraints of preexisting urban topography. In Constantine's day, the new city center, built over and around the much smaller existing town of Byzantium, gravitated around an architectural core based on a single colonnaded main street, the Mese, that comprised the final tract of the principal land route leading to the city from Greece and the West, the Via Egnatia (Figure 3.3).[50] After traversing the Golden Gate in the new land

[50] Generally on the components of the Constantinian building program outlined in the following section, see Krautheimer 1983, 46–56; Mango 1985, 23–36; Bauer 2001, 30–32; 2008, 195.

walls, the visitor approaching from the west arrived first at the Capitol – prime symbol of the 'old' Rome and so too of Constantine's 'new' Rome[51] – and the nearby precinct of the Philadelphion, a colonnaded square filled with statues and commemorative monuments to the emperors (among them the porphyry Tetrarchs now in Venice).[52] From the Philadelphion, the Mese continued to the east, lined with majestic two-story colonnades, as far as the circular forum of Constantine, itself surrounded by colonnades two stories high, and graced at its center by a porphyry column topped by a gilded statue of Constantine.[53]

The two-story colonnades of the Mese thence continued east toward the *milion*, the Constantinopolitan equivalent of the *umbilicus* in the Roman Forum, marked by a monumental arch, likely a *quadrifrons*, spanning the street, just behind which stood a statue of an elephant, the very symbol of imperial triumph that adorned the *quadrifrons* arch at Antioch.[54] To the north and south, the colonnades of a second avenue running perpendicular to the Mese converged on the archway, which thus stood, as at Antioch, Thessaloniki and Split, at the intersection of four radiating colonnaded axes, the shortest of which – again – led straight to the palace. This final stretch of the Mese, now wider and grander still and called – again – the Regia, stretched eastward from the *milion* to the main gate of the palace, known by the fifth century as the Chalke.[55] The form of the gate appears to have been rectangular, with a domed central chamber straddling the axis of the Regia and two lower flanking bays, very much like the Arch of Galerius at Thessaloniki.[56] North of the Regia stood the Augusteion, a colonnaded square flanked by a second senate house, joined under Constantius II (337–61) by the cathedral of Hagia Sophia and the palace of the patriarchs along its northern extremity.[57] The Constantinian cathedral of the city, Hagia Eirene, lay just beyond to the northeast.[58] To the south, the southern colonnade of the Regia gave onto the Baths of Zeuxippos and the *carceres* of the hippodrome, both rebuilt by Constantine and directly connected to the imperial palace itself, which sprawled south and east toward the shores of the Sea of Marmara (Figure 3.4).[59]

[51] Dagron 1974, 43–47.

[52] Bauer 1996, 228–33; on the numerous questions that remain about the Capitol and its sculptural decoration, Meyer 2002, 161–68.

[53] Bauer 1996, 167–87; Meyer 2002, 93–97; on the statue, see esp. Bardill 2012, 28–36; 104–09.

[54] Mango 1959, 48–49, 78–81; Müller-Wiener 1977, 216–18.

[55] The colonnades lining the Mese between the forum and the palace are singled out for mention by Malalas, *Chron.* 13.8 (Dindorf 321), and the *Chronicon Paschale*, p. 528, both of which state that this portion of the Mese was called the Regia.

[56] On the Chalke, see esp. Mango 1959.

[57] For the Augusteion and its surrounding monuments, Mango 1959, 42–72; Bauer 1996, 148–67; on Hagia Sophia, Müller-Wiener 1977, 84–96; on the episcopal palace, Mango 1959.

[58] Müller-Wiener 1977, 112–17.

[59] Bauer 1996, 148–67; on the hippodrome and the baths of Zeuxippos, see also Müller-Wiener 1977, 64–71 and 51, respectively.

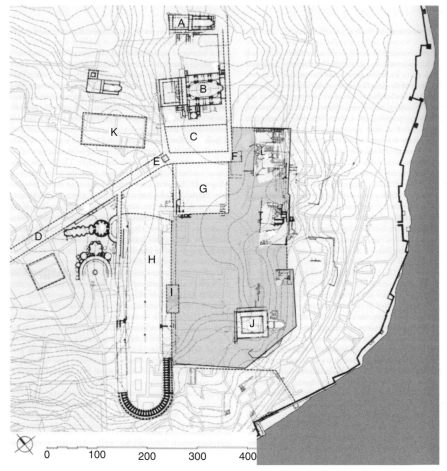

Figure 3.4 The area of the Great Palace in Constantinople. A: Hagia Eirene; B: Hagia Sophia; C: Augusteion; D: Mese; E: *Milion*; F: Chalke Gate; G: Baths of Zeuxippos; H: hippodrome; I: *pulvinar*; J: Peristyle Court; K: Yerebatan cistern; L: Palace of Lausos. (After Ćurčić 2010, fig. 190.)

While the archaeological evidence is scanty and leaves infinite scope for haggling over the details, the basic contours of the palatial quarter in Constantinople as it took shape beginning under Constantine are clear enough.[60] The complex gravitated around the Regia, itself framed at the west by the *milion* and at the east by the principal gate of the palace, the Chalke. The hippodrome and the greatest baths in the city (of Zeuxippos) stood just off the Regia, in the immediate vicinity of the entrance to the palace, and both in fact communicated directly with the palace to the rear, while their public entrances lay just off the colonnades of the street.[61] By

[60] Useful overviews of the palace include Müller-Wiener 1977, 229–37; Kostenec 2004.

[61] On the connection between the residential wing of the palace and the *kathisma* on the eastern (palace) side of the hippodrome, see Dagron 1974, 36, 320–47; Müller-Wiener 1977, 64–65; on the baths, which communicated with the palace via a side door in the fourth century, see Mango 1959, 40.

the fifth century (and probably earlier), the palace was also bodily attached to the cathedral of Hagia Sophia, via – yet another – colonnaded passageway, an elevated loggia by the sixth century, which connected the northern bay of the Chalke with the south flank of the church.[62] Baths, hippodrome, arches, the imperial palace and the cathedral, all linked by the armature of a single, extraordinarily grandiose colonnaded avenue and further colonnaded extensions thereof: it is the culmination of the 'imperial' architectural paradigm that took shape in the third century, a cohesive ensemble that need not have exactly 'copied' any existing foundation to nonetheless reprise the essential features of all the imperial capitals and residences discussed in the preceding chapter, insofar as these can be known or surmised on the basis of the available evidence.

Later sources are surely right to suggest that already at the time of the dedication of the new capital in 330, the Mese with its associated monuments was conceived as a grand triumphal route. According to the eighth-century *Parastaseis Syntomoi Chronikai*, the founding ceremony on May 11 witnessed the transfer of a gilded statue of Constantine from the Capitol to the forum of Constantine, where it was laboriously raised, in front of the assembled people and dignitaries of the new city, up to its final resting place atop the porphyry column.[63] In the words of Franz Alto Bauer, 'The transfer of the statue to its new location appears to have been staged as a triumphal entry of the emperor into the city. An escort wearing white *chlamydes*, holding candles, accompanied the statue, which stood erect in a chariot, from the Philadelphion to the Forum of Constantine. Thus was staged the *adventus* of the emperor who, present in his statue, proceeded along the main street of Constantinople and finally reached "his" forum.'[64]

But while the transfer of the statue to the column was a one-time event, Constantine also made provision for a more lasting commemorative *adventus*, to be staged every year on the occasion of his birthday and the founding of the city. Again, the protagonist was (yet another) gilded statue of the emperor, ordinarily kept in a repository on the north side of the forum of Constantine, which every May 11 left the forum mounted on a triumphal chariot and processed down the Mese and into the hippodrome, where it made a lap of the track and came to rest in front of the imperial box (*kathisma*) to receive the obeisance of the reigning emperor.[65] 'By means of this ritual, therefore, the memory of the founding emperor was awakened in the consciousness of the populace; gilded, like the statue on the porphyry column ...

[62] Mango 1959, 85–92.
[63] *Par.* 56; see Cameron and Herrin 1984, 131–33.
[64] Bauer 2001, 33–34; cf. also Dagron 1974, 37–42.
[65] The best description of the ceremony is given by John Malalas (*Chron.* 13.8 [Dindorf 321–22]); see also the very similar account in the *Chronicon Paschale*, pp. 528–30.

He received the acclamation of the populace, the aristocracy and the emperor, before returning to the Forum of Constantine.'[66]

For more than a century following the death of Constantine in 337, succeeding emperors made it their task to extend the monumental framework of the Mese with a series of imperial forums and triumphal monuments arrayed along the main axis of the street. Theodosius I (379–95) built his forum between the forum of Constantine and the Capitol; the forum of Arcadius (395–408) took shape still farther to the east; and that of Theodosius II (408–50) rose between the old Constantinian walls and the new land walls of the city, built between 405 and 413.[67] There, the road exited the city via the Porta Aurea, much the most magnificent gate in the new circuit, which took the shape of a triumphal arch dedicated to Theodosius II.[68] New colonnades rose along the Mese in correspondence with the new forums, linking them all together in an unbroken progression of symbolically charged spaces designed to exalt the memory of their individual founders and propagate the timeless ideology of imperial victory upon which their claims to legitimacy and unchallenged sovereignty rested.[69]

At the Philadelphion, the main tract of the Mese on its way to the Porta Aurea diverged from a second colonnaded avenue, which angled northwest toward the Charisios (or Adrianople) Gate in the Theodosian walls. The centrality of this northern branch of the Mese in the landscape of the new city had been proclaimed already under Constantine himself, who erected his mausoleum just to the north of the road shortly before it traversed the Constantinian walls.[70] The mausoleum, final resting place of the emperors through the reign of Anastastius I (d. 518),[71] was flanked by the cruciform church of the apostles, the Apostoleion, probably begun in the 350s by Constantius and consecrated in 370.[72] The fame of this church was such that Ambrose based the cruciform plan of his own

[66] Bauer 2001, 35; see also Bardill 2012, 151–58.

[67] On all of these complexes, in addition to the individual entries in Müller-Wiener 1977 (esp. 250–65), see Mango 1985, 37–50; 2000; Bauer 1996, 187–212; 2001, 37–40; Meyer 2002, 105–74.

[68] Bardill 1999 (who thinks it a triumphal arch originally built for Theodosius I, subsequently incorporated into the walls of Theodosius II); Mango 2000.

[69] Dagron 1974, 92–102; Bauer 2008, 197 and passim.

[70] On the problem of the precise location of the Apostoleion and its relationship to the northern branch of the Mese, v. Berger 1997, 398–402.

[71] Grierson 1962.

[72] With regard to the date of the Apostoleion and its relationship to the mausoleum, I follow Mango 1990 (contra, e.g., Krautheimer 1983, 56–60), who makes a convincing case that Constantine erected only the mausoleum (albeit as a shrine to the twelve apostles and above all to himself in the guise of the thirteenth apostle), leaving it to Constantius II to commission the cruciform church, in part to alleviate the embarrassing theological problems provoked by Constantine's subordination of the cenotaphs of the apostles to his own tomb in the mausoleum. This would then be the structure said in the Chronicon Paschale (p. 559) to have been dedicated in 370.

Basilica Apostolorum at Milan on the Constantinopolitan exemplar;[73] and the location of Ambrose's church at the midway point of the Porta Romana colonnade strongly implies that the Milanese bishop was attempting more broadly to replicate the architectonic context of the Apostoleion and to ensure that his new foundation was similarly privileged by virtue of its physical proximity to the main ceremonial thoroughfare of the city.

In the mid-fifth century, when all of the prime locations along the southern branch of the Mese had been occupied by imperial monuments, the emperor Marcian (450–57) was compelled to establish his own forum along the northern extension of the Mese, between the Philadelphion and the Apostoleion.[74] Thus, by the time of Marcian's death, the architectonic imprint of the capital was largely complete. The most magnificent public buildings and forums in the city, as well as the churches of Hagia Sophia, Hagia Eirene and the Apostoleion, were either bisected by or proximate to the trunk of the Mese in the east and its two principal continuations in the west.[75] These expansive, colonnaded thoroughfares were the spinal cord of the city as a whole, the architectural profile that imprinted itself on the consciousness of visitors and residents alike, and the repositories of the institutional memory encoded in their flanking monuments. The Mese anchored the ceremonial processions that gave tangible form to the ascendancy of Constantinople's civic and ecclesiastical authorities, and at the same time channeled the flow of quotidian life and commerce through the most ideologically charged spaces in the city, the forums and commemorative columns bedecked with statues, reliefs and inscriptions that inevitably called to mind the mighty who had commissioned them, and who animated them on important occasions with their superhuman presence.[76]

When newly crowned emperors made their triumphal entrance into the city, as Leo I did in 457, or returned from extended absences, as Justinian did in 559, the entire population of the city, arranged sequentially and hierarchically according to rank and station, lined these streets and chanted their acclamations to the passing imperial cortege. On the most important days in the annual liturgical calendar, ecclesiastical processions followed the same route on their way to the leading shrines in the city.[77] When relics arrived, such as those of Samuel in 406, Stephen in 421, and John Chrysostom in 438, these too made

[73] See n. 34.
[74] Bauer 1996, 213–15.
[75] Bauer 1996, 379–83; Bejor 1999, 101–06; Berger 2000; Mundell Mango 2001, 30–33 and 44–46. More generally on the layout of the street grid in Constantinople in the first century following its foundation, v. Berger 1997, 395–411.
[76] Cf. Bauer 1996, 385–88. The stretch of the Mese between Hagia Sophia and the forum of Constantine was by far the most frequently traversed of all the routes in the city; fully forty-six of the sixty-eight processions mentioned in the tenth-century *Typikon* of Hagia Sophia passed through the latter: see Baldovin 1987, 197, 212.
[77] See, e.g., Bauer 2008, esp. 203–05.

their *adventus* into the city along the Mese and its northern and southern extensions, conveyed in regal splendor by patriarchs and reigning emperors, whose joint participation in these processions ostentatiously proclaimed the ideal unity of church and state in a polity in which these two institutions grew ever more inseparable.[78]

Already in ca. 400, the presence of the emperor Arcadius and his wife Eudoxia featured prominently in the sermon John Chrysostom delivered upon the arrival of the relics of the Pontic martyr Phocas to Constantinople, in which, moreover, the physical essence of the city was distilled into a vision of its grand colonnades: 'The city became splendid yesterday, splendid and illustrious, not because it has columns, but because it hosted the parade of the arriving martyr, who came to us from Pontus.'[79] The newly arrived relics may have glorified the city as the colonnades alone never could have, but it was nonetheless the image of the colonnaded street that provided, in the mind of the bishop, the essential architectural backdrop for the solemn festivities that bound Arcadius and Eudoxia together with the clergy and the urban masses in joint veneration of Phocas' mortal remains.[80]

3.4 PORTICATED STREETS AND THE LITERARY IMAGE OF LATE ANTIQUE CITYSCAPES

One of the great strengths of porticated streets was their capacity to channel the flow of both quotidian and ceremonial life within their confines: to direct movement along a limited number of privileged itineraries designed to highlight key civic monuments and connect them with grand colonnaded façades in a seamless topographical ensemble. The scattered civic monuments of the high imperial period, many of them falling into disrepair, and the teeming residential neighborhoods of the lower classes could be selectively filtered from view behind the lofty screens of porticoes lining the main streets of the late antique city. The testimony of contemporaries writing in the fourth and fifth

[78] Bauer 1996, 383–85; 2008, 205–06; Diefenbach 2002; Klein 2006; cf. also Baldovin 1987, 185–89, 211–12. For the sources relating to the translations of Samuel and Stephen, see nn. 43–45. On the return of Chrysostom's remains, which were deposited in the Apostoleion with the participation of both Theodosius II and the Patriarch Proclus, see Socrates, *HE* 7.45; cf. Marcellinus Comes, *Chron.* a. 438 (ed. Mommsen, p. 79).

[79] *de s. hieromartyre Phoca, PG* 50, col. 700: Λαμπρὰ γέγονεν ἡμῖν χθὲς ἡ πόλις, λαμπρὰ καὶ περιφανὴς, οὔκ ἐπειδὴ κίονας εἶχεν, ἀλλ' ἐπειδὴ μάρτυρα πομπεύοντα ἀπὸ Πόντου πρὸς ἡμᾶς παραγενόμενον. For Chrysostom's similar take on street colonnades at Antioch, see n. 91.

[80] 'Indeed the emperors sing choruses together with us. What indulgence [for absenting themselves from the celebration], then, should private individuals receive, when the emperor and empress leave the royal palace, and seat themselves at the sepulcher of the martyr? So wonderful is the virtue of the martyrs that it enmeshes not only private people, but also those who wear the diadem' (*Ibid.*).

centuries indicates that the urban experience was increasingly coming to be distilled into the visual and spatial parameters delineated by porticated avenues, which had become the essence of urban grandeur, the token by which a great city could be recognized and most succinctly defined.

One such indicator comes from the *Notitia Urbis Constantinopolitanae*, the extensive catalogue of urban topography in Constantinople compiled by an anonymous author writing ca. 425. While street colonnades are punctiliously listed in all of the fourteen chapters devoted to the various regions of the city, particularly evocative is the description of the seventh region, located in the ceremonial heart of the city, extending north from the Mese, between the forum of Theodosius and the forum of Constantine, as far as the shores of the Golden Horn. The summary description of the region that precedes the detailed listing of its component structures reads thus in its entirety:

> In comparison to the previous one, the seventh region is flatter, though it too on its far extremity slopes steeply to the sea. From the right side of the column of Constantine all the way to the forum of Theodosius, it extends flanked by continuous colonnades, with other similar colonnades extending along the side streets, and continues, leaning downward as it were, all the way to the sea.[81]

For all that the seventh region was populous and densely built, it is the colonnaded sweep of the Mese between the forums of Constantine and Theodosius I, with its colonnaded cross-streets, that dominates the topographical panorama sketched by the author, and shapes the visual profile of the region as a whole. Visitors and residents alike might traverse the entirety of this central district of the capital without experiencing it as anything other than a continuous succession of stately colonnaded façades; the glorious illusion would give way to a more jumbled and heterogeneous reality only for those whose business carried them beyond the main roads.[82]

In his list of the twenty greatest cities of the empire, written ca. 380, Ausonius includes a similarly succinct description of the city of Milan, which concludes with reference to 'her colonnades (*peristyla*) all adorned with marble statuary, her walls piled like an earthen rampart around the city's edge.'[83] The juxtaposition between city wall and colonnades is particularly striking, as it was the gates in the wall that framed the principal streets in the city, including the Via Romana with its grand new arcades, themselves under construction

[81] *Not. Urb. Const.* 8, lines 2–9: *Regio septima in conparatione superioris planior, quamvis et ipsa circa lateris sui extremitatem habeatur a mare declinior. Haec a parte dextera columnae Constantini usque ad forum Theodosii continuis extensa porticibus et de latere aliis quoque pari ratione porrectis, usque ad mare velut se ipsam inclinat et ita deducitur.* Cf. Berger 1997, 365–67.

[82] On the literary and archaeological evidence for the non-monumental quarters of the city, see Dark 2004.

[83] *Ordo Nobilium Urbium* 7, lines 9–10.

or very recently completed at the time when Ausonius was writing. For the visitor approaching from the south, Milan will indeed have been experienced precisely as the intersection of the porticated street and the city wall, which between them channeled the flow of traffic onto a single axis and screened from view all of the less monumental quarters of the city.

The predominance of porticated vistas in the imagination of late antique writers appears to herald a real shift in prevailing views, or mental images, of urban topography, for all that a similar inclination to condense the essence of urban civilization into colonnaded streets occasionally occurs earlier, notably in Achilles Tatius' second-century description of Alexandria.[84] In his lament for the martyrs of the Diocletianic persecution in Palestine in 309, Eusebius turns the morning dew on the colonnades of Caesarea into tears of sorrow wept by the city for its fallen: 'The air was clear and bright and the appearance of the sky most serene, when suddenly throughout the city from the pillars which supported the public colonnades (stoai) many drops fell like tears; and the marketplaces and streets (agorai te kai plateiai), though there was no mist in the air, were moistened with sprinkled water.'[85] For Eusebius, the columns of the street colonnades were evidently the most pervasive and characteristic feature of the cityscape, the architectural element best suited to express the mourning of the entire city: they were the eyes and the wounded heart of Caesarea personified. So too in the mind of the anonymous mid-fourth-century author of the *Expositio totius mundi et gentium*, the grandeur of Carthage is apparent in its regular grid of streets, which in their ordered symmetry called to his mind the image of an orchard.[86] The columns lining the streets make the metaphor: in the urban orchard of Carthage, the rows of columns take the place of trees as the dominant visual element. Likewise in the imagination of

[84] Tatius' erotic novel *Leukippe and Kleitophon* is now generally assigned a date in the second century: see the *OCD*, 3rd ed., *s.v.* Achilles Tatius (2). Upon arriving in Alexandria after a three-day journey, Tatius' hero Kleitophon proclaims (5.1): 'I entered it (Alexandria) by the Sun Gate, as it is called, and was instantly struck by the splendid beauty of the city, which filled my eyes with delight. From the Sun Gate to the Moon Gate – these are the guardian divinities of the entrances – led a straight double row of columns, about the middle of which lies the open part of the town, and in it so many streets that walking in them you would fancy yourself abroad while still at home. Going a few stades further, I came to the quarter called after Alexander, where I saw a second town; the splendor of this was cut into squares, for there was a row of columns intersected by another as long at right angles' (Trans. S. Gaselee, *Achilles Tatius*, Loeb Classical Library [London, 1917], p. 237, slightly adapted); cf. Haas 1997, 29–31.

[85] Eusebius, *Mart. Pal.* 9.12: αἰθρία ἦν καὶ λαμπρὸς ἀὴρ καὶ τοῦ περιέχοντος κατάστασις εὐδινοτάτη εἶτα ἀθρόως τῶν ἀνὰ τὴν πόλιν κιόνων οἳ τὰς δημοσίας ὑπήρειδον στοάς, δακρύων τινὰ τρόπον οἱ πλείους σταλαγμοὺς ἀπέσταζον, ἀγοραί τε καὶ πλατεῖαι, μηδεμιᾶς ψεκάδος ἐξ ἀέρος γεγενημένης, οὐκ οἶδ' ὁπόθεν ὕδατι ῥανθεῖσαι καθυγραίνοντο, cf. Sivan 2008, 322; Holum 2009, 199.

[86] Ed. Rougé, p. 61: *Quae dispositione valde gloriosissima constat, etenim ordinem arborum habet in vicos aequales* (Rougé, p. 19, dates the text to 359).

John Chrysostom, as we have seen, the columns of Constantinople became a synecdoche for the architectural grandeur of the city as a whole.[87]

But by far the longest and most explicit surviving account of the place of colonnaded streets in the physical, social and mental geographies of the late antique metropolis comes in Libanius' Oration 11, the *Antiochikos*.[88] The text concludes with a topographical excursus on the city that runs to some ten pages in Downey's edition, nearly half of which centers on the form, the beauty, and the function of the city's colonnaded avenues, its grand central axis above all.

> (196) And now it is the proper time to describe the situation and size of the city, for I think that there can be found none of those which now exist which possesses such size with such a fair situation. Beginning from the east it stretches out straight to the west, extending a double line of stoas. These are divided from each other by a street, open to the sky, which is paved over the whole of its width between the stoas … (201) The stoas have the appearance of rivers which flow for the greatest distance through the city, while the side streets seem like canals drawn from them … (212) As you go through these stoas, private houses are numerous, but everywhere public buildings find a place among private ones, both temples and baths, at such a distance from each other that each section of the city has them near at hand for use, and all of them have their entrances on the stoas.[89]

For Libanius, Antioch is a great city above all because of its colonnaded streets, which are both beautiful and the essence of civic life.[90] The main street is quite literally the architectural centerpiece of the city, the conduit that in turn leads to its grandest public buildings, all directly accessible from its flanking colonnades.

Nor was Libanius alone in judging Antioch's wide, colonnaded streets the epitome of its urban glory. When John Chrysostom was still a priest at Antioch, he delivered a sermon during the 'affair of the statues' in 387, while the Antiochenes were anticipating with dread Theodosius' response to their destruction of imperial images near the palace on the Orontes. In what was almost certainly a conscious evocation of his despised former teacher Libanius' *Antiochikos*, Chrysostom pointed out to his congregation that the true beauty of their city, whatever became of it as a result of the emperor's wrath, lay not in its wide, colonnaded streets, but rather in the virtue and piety of its (Christian) inhabitants.[91] As with his later sermon on the arrival of Phokas'

[87] *Sup.* n. 79.
[88] See Downey 1959.
[89] Trans. Downey 1959, 673–75.
[90] Cf. Lassus 1972; Pullan 1999.
[91] *Hom.* 17 (*PG* 49, col. 176): Ἀλγεῖς ὅτι τὸ τῆς πόλεως ἀξίωμα ἀφῄρηται; μάθε τί ποτέ ἐστι τῆς πόλεως ἀξίωμα, καὶ τότε εἴσῃ σαφῶς, ὅτι ἐὰν οἱ οἰκοῦντες αὐτὸ μὴ προδῶσιν, οὐδεὶς

relics at Constantinople, what Chrysostom's effort to subordinate colonnaded streets to the greater glories of the Christian faith really shows is just how synonymous these streets had become, by the later fourth century, with the concept, the idea and the reality, of a leading Mediterranean metropolis.

But to return to Libanius, his lengthy encomium is also noteworthy for being the only extant account that makes a concerted effort to explain why colonnaded streets were so central to the configuration of the ideal cityscape:

> (213) What then is my purpose in this? And the lengthening of my discourse, entirely about stoas, to what end will it bring us? It seems to me that one of the most pleasing things in cities, and I might add one of the most useful, is meetings with other people. That indeed is a city, where there is much of this … (216) while the year takes its changes from the seasons, association is not altered by any season, but the rain beats upon the roofs, and we, walking about in the stoas at our ease, sit together where we wish.[92]

Rather than treating them only as essential elements of urban décor, that is, Libanius considered the *stoai* of Antioch in terms of their functionality; of the uses to which they were put, and the activities that unfolded within and around them.

In addition to keeping the winter rains off the Antiochenes and allowing all members of the urban collective to mingle and conduct business even in the depths of winter, Libanius' colonnades were the teeming commercial heart of the city, packed with industrious craftsmen and vendors who filled the spaces between the columns and spilled out onto the street:

> (254) The cities which we know pride themselves especially on their wealth exhibit only one row of goods for sale, that which lies before the buildings, but between the columns of the stoas no one works; with us, however, even these spaces are turned into shops, so that there is a workshop facing almost each one of the buildings.[93]

His words are a valuable reminder that colonnaded streets were lived space, fulcrums of everyday living, as much as settings for grand displays on special occasions. Antioch's main roads were both beautiful and bustling, grand

ἕτερος ἀφελέσθαι δυνήσεται ἀξίωμα πόλεως. Οὐ τὸ μητρόπολιν εἶναι, οὐδὲ τὸ μέγεθος ἔχειν καὶ κάλλος οἰκοδομημάτων, οὐδὲ τὸ πολλοὺς κίονας, καὶ στοὰς εὐρείας καὶ περιπάτους, οὐδὲ τὸ πρὸ τῶν ἄλλων ἀναγορεύσθαι πόλεων, ἀλλ' ἡ τῶν ἐνοικούντων ἀρετὴ καὶ εὐσέβεια (emphasis mine). See also ibid., col. 178: οὐδὲν γὰρ ἡμᾶς ὠφελῆσαι δυνήσεται κατὰ τὴν ἡμέραν ἐκείνην, τὸ μητρόπολιν οἰκεῖν, καὶ στοὰς ἔχουσαν εὐρείας καὶ τὰ ἄλλα ἀξιώματα τὰ τοιαῦτα. ('It will be of no help to us on that day [of judgment], that we live in a metropolis with wide porticoes and other such adornments.') On the strong probability that Libanius taught Chrysostom in his youth, see J. N. D. Kelly 1995, 6–8. For the 'affair of the statues,' see also Libanius, *Or.* 19–23.

[92] Trans. Downey 1959, 675–76.

[93] Ibid., 679.

architectonic vistas and the center of daily life. Here is the death knell for attempts to apply Sauvaget's vision of the 'devolution' of the colonnaded street into the *suq* to the end of antiquity:[94] long before the alleged disintegration of effective civic government and the 'privatization' of public spaces in the sixth century, the colonnaded thoroughfares of the great cities of the eastern Mediterranean already teemed with shops and commercial activity.[95] Indeed, it was their mundane role as much as their ceremonial profile that made such streets so desirable in late antiquity, and led them to become more prominent than ever before on the urban landscape.

3.5 COMMERCE, COMMEMORATION AND CEREMONY IN THE COLONNADES OF THE EASTERN MEDITERRANEAN

Even if Libanius' hyperbolic assertion that Antioch was unique for the amount of activity in its colonnades were true, his depiction of the throng of shops filling the intercolumniations of Antioch's main streets would be nonetheless noteworthy. Antioch was the capital of the diocese of *Oriens* and seat of both the Praetorian Prefect of the East and the *comes orientis*, a place where the reach of the imperial administration and the ceremonial regime governing the public deportment of high officials were particularly robust.[96] A perusal of Libanius' voluminous corpus suggests that work on street colonnades at Antioch was almost the exclusive preserve of ranking members of the imperial administration, chiefly serving governors or ex-governors of proconsular rank resident in the city, who in fact seem to have made colonnaded streets their first priority in the realm of public building.[97] The crucial point is that, their immense prestige value aside,[98] these colonnades were envisioned from their inception as grand commercial arcades, useful for producing revenues for the imperial servants who built them as well as ennobling the spaces where they paraded about. When the ex-governor Florentius widened a street and lined it with a colonnade in 392,

[94] See n. 2. Cf. Saliou 2005, esp. 210–11, 220–21.

[95] And, for that matter, in the West too – see, e.g., Byhet 2001–02 on Gallic cities, and esp. 17–18 on Flavian Rome.

[96] Liebeschuetz 1972, 208–19; cf. Saliou 2005, 212–14.

[97] See esp. Liebeschuetz 1972, 132–36 (from whose thorough perusal of the Libanian corpus the following citations derive). Modestus, governor in 358–59, erected a sumptuous new street colonnade with the compulsory labor of the urban *collegia*, whose members were taxed nearly to the breaking point by the demands of the project, among them the need to ferry columns from as far away as Seleucia, according to Libanius (who discussed this project in more detail than any other); see *Ep.* 196 and 242 (both of 358–59); and 617 (of 361). Among the building projects of the *praefectus urbi* Proculus, Libanius mentions only work on a theater, a bath complex and – again – the paving and colonnades of streets (*Or.* 10; *Ep.* 852).

[98] Libanius in fact admonishes Modestus to take care lest his stoa become the subject of vitriol rather than praise in the future (*Ep.* 617.3; its prestige value is also a prominent theme in *Ep.* 196).

he expected to recoup his costs (and far more, according to the hostile Libanius) from the rents of the shops located behind the columnar façade.[99] When the provincial governor Tissamenes had a street colonnade repainted (!), he rewarded the painters and defrayed his own costs by compelling the commercial tenants of the structure to have their shop signs done by the same painters, presumably at substantial cost.[100] Far from a symptom of the collapse of effective civic authority, then, the 'encroachment' of commercial activities on the public colonnades of Antioch is better construed as an indicator not only of economic vitality, but also of the immense power and local influence of the imperial representatives who built and maintained the colonnades. It is also a sure sign that there was no profound incompatibility between the dual roles of Antioch's stoas as lived space on the one hand, and ceremonial space on the other.

Further, it turns out that the situation in Antioch was far less anomalous than Libanius would have us believe. Both archaeological and textual evidence makes it clear that in other provincial and imperial capitals in the eastern Mediterranean, the colonnades of the main streets were similarly packed with vendors' stalls and workshops, and continued nonetheless to preserve the monumental profile upon which their role as privileged theaters of ceremonial life depended.[101] In the fifth century, we find the central administration in Constantinople legislating with the express intent of reconciling the exigencies of commerce with the equally pressing need to maintain the architectural decorum of the Mese: a decree addressed by the emperor Zeno to Adamantius, *praefectus urbi* of Constantinople in 474–79, prescribes in minute detail the proper configuration of shops along the colonnades of the Mese, from the *milion* at its eastern extremity as far as the Capitolium.[102] The façades of the intercolumnar stalls were to be no more than six feet wide and seven high, and to be revetted with marble on their exterior facings, 'that they may be an adornment for the city and a source of pleasure for passersby.'[103] Zeno's special concern for the principal ceremonial avenue in the city, the route indelibly associated with his public appearances, is manifest in the further specification that the disposition of shops in all other city colonnades fell under the purview of the city prefect.[104] The décor of the city's 'imperial' street alone required the direct supervision of

[99] Libanius, *Or.* 46.44.

[100] Libanius, *Or.* 33.34.

[101] E.g., Petra (Fiema 2008); Scythopolis (Segal 1997, 28–30; Agady et al. 2002); Sardis (Crawford 1990; Harris 2004); for further examples, see the useful overview in Crawford 1990, 107–25, and especially Lavan 2012.

[102] *CJ* 8.10.12.6a–b.

[103] Ibid., 8.10.12.6b–c: ὥστε κάλλος μὲν διδόναι τῇ πόλει, ψυχαγωγὴν δὲ τοῖς βαδίζουσι. For other examples of the (voluminous) laws issued in connection with the regulation of private occupation of colonnades in Constantinople, see *CTh* 15.1.39 (of 398); 15.1.50 (of 412); 15.1.52 (of 424); 15.1.53 (of 425); see also Patlagean 1977, 59–61; Ward-Perkins 1996, 152; Saliou 2005, 214–18; Saradi 2006, 194.

[104] *CJ* 8.10.12.6c. Cf. generally Mundell Mango 2000, esp. 194–97.

the emperor himself. Archaeology reveals that similar aesthetic concerns prevailed at Ephesus, where the shop fronts installed in the intercolumnations of the main processional way (the Embolos) were covered with marble veneer on their external facings in the fifth and sixth centuries.[105]

Ephesus in fact provides, I would suggest, the closest thing possible to a canonical example of the intertwining of social and economic imperatives with ceremonial agendas in the topographical evolution of a late antique metropolis in the eastern Mediterranean. Capital of the diocese of Asia after Diocletian and later seat of a metropolitan bishop, it is one of the best excavated and most thoroughly studied of the empire's leading cities. Its extant remains furnish an unusually detailed perspective on the evolving patterns of human activity, and even of the changed *mentalités* underlying them, that so profoundly conditioned the physical parameters of the urban environment and imbued them with their characteristically late antique features, chief among them a colonnaded street and its associated monuments.

Between the fourth century and the seventh, the city gravitated ever more closely around a single main street, composed of three intersecting segments on different orientations, flanked along nearly all of its length by colonnades built in the fourth and fifth centuries (Figure 3.5). Throughout this period, the majority of investment in public architecture and urban infrastructure occurred in the environs of this central axis, beginning with the paving and colonnades of the road itself, and extending to the public monuments – squares, triumphal arches and columnar monuments, nymphaea, the theater – and the opulent private houses that lined its course.[106] Those approaching the city center from the direction of the harbor (as most distinguished visitors arriving from afar will have done) first embarked on the Arkadiane, the wide, straight promenade between the harbor and the theater, which was monumentally re-edified ca. 400 with 600 meters of continuous colonnades along both sides of the street, sponsored by Emperor Arcadius, from whom it took its name.[107] A sharp right at the theater led to the 'Marble Street,' running past the scaena of the theater and the lower agora and on to the old library of Celsus, rebuilt as a grand nymphaeum, also ca. 400; there, the road turned sharply again to become the Embolos (or 'Curetes Street'), leading upward from the façade of the nymphaeum toward the upper agora, beyond which lay the principal gate in the land walls, the Magnesian Gate (Figure 3.6).[108] As with the Arkadiane, the

[105] Bauer 1996, 278–79.

[106] Foss 1979, 47–84; Bauer 1996, 269–99; cf. Scherrer 1995, 20–23.

[107] Bauer 1996, 271–74.

[108] Bauer 278–93; see also the contributions of Roueché, Auinger, Quatember et al., Iro et al. and Schindel in Ladstätter (ed.) 2009, all of which make it clear that the Embolos rapidly lost its monumental character in ca. 616, very possibly in connection with the Persian invasion of western Asia Minor in that year; generally on 616 and its aftermath at Ephesus, see also Foss 1979, 103–15.

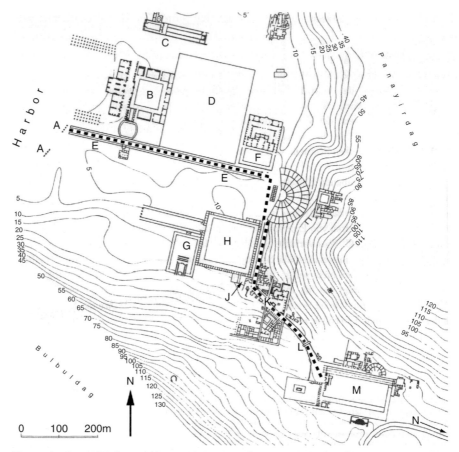

Figure 3.5 Central Ephesus in late antiquity. A: Harbor-Gate; B: Baths of Constantius; C: Church of Mary; D: palace; E: Arkadiane; F: Theater Gymnasium; G: Temple of Serapis; H: Lower Agora; J: Library of Celsus; K: Embolos; L: Gate of Herakles; M: Upper Agora; N: to Magnesian Gate. Dotted line marks course of the Arkadiane-Embolos route. (After Bauer 1996, modified.)

Marble Street and the Embolos were maintained in grand style into the early seventh century: the solid pavers of the roadbed were kept whole and unobstructed, the colonnades assiduously restored whenever necessary, the floors of the covered sidewalks repaved with new mosaics and sumptuous marble panels, the shop fronts revetted with marble.[109]

This continuous monumental armature comprising the three sections of the road and its associated structures attained unprecedented heights of architectural grandeur, beginning in the fourth century, because the governors who thenceforth controlled the funds available for building chose to make it the architectural showpiece of the city as a whole, and to recognize its de facto role as the epicenter of civic life. As Franz-Alto Bauer has shown, by the fifth century, the Arkadiane–Marble Street–Embolos axis had largely supplanted

[109] Bauer 1996, 278–93.

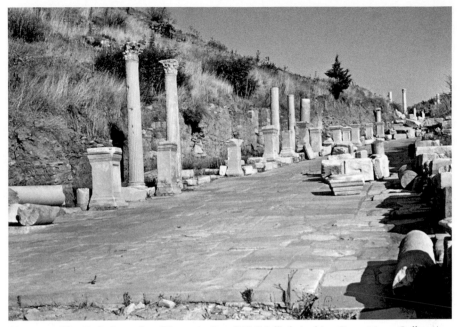

Figure 3.6 The Embolos today. (Photo: ArtStor IAP/Mellink Archive, Bryn Mawr College.)

traditional civic spaces, such as the upper and lower *agorai*, as the venue of choice for the display of statues and inscriptions honoring the leading patrons and benefactors of the city and the late Roman state.[110] City councilors and private *euergetes* are almost nonexistent: the dedicatees of the dozens of fourth-to-sixth-century statues and inscribed bases found among the colonnades and along the street overwhelmingly represent the emperors and members of the imperial family on the one hand, and governors and other representatives of the central administration on the other.[111] This is of course to be expected, given that imperial agents were chiefly responsible for the upkeep of public architecture and infrastructure from the fourth century on.[112] What is remarkable is the extent to which the colonnades and other monuments flanking the road were preferred to all other buildings in the city for the display of honorary monuments. That they were so privileged strongly suggests that there was no better place to be honored and immortalized for posterity, and thus that the city's main processional avenue had become the heart of the urban collective, the place where the images of the emperors and their local delegates were most effectively brought before the eyes of the urban populace as a whole;

[110] Ibid., esp. 296ff.; Aurenhammer and Sokolicek 2011, esp. 59, 65–66.

[111] Bauer 1996, 284–90, 297; Roueché 2006, 251–52; *ead.* 2009; cf. also Auinger 2009.

[112] The same trend is evident at, for example, Aphrodisias, where from the Tetrarchic period on, honorary statues and inscriptions (including those that relate specifically to building activities) focus almost entirely on members of the imperial establishment, while local city councilors largely vanish: see esp. Smith 1999; also Smith 2002, 146–48; Roueché 2004, passim.

where the ubiquitous presence of the imperial establishment was driven home
in the constant succession of honorary inscriptions and stone faces gazing out
from the shadow of the colonnades.

Beginning in the fourth century, these porticoes also became the venue
in which the will of the state was made manifest in a more immediate and
explicit way, in the form of the laws and edicts promulgated by the emperors
and their representatives, as Denis Feissel has shown. Until the third century,
the inscribed texts of such decrees were regularly displayed at the locations
where the popular assembly and city council met: the theater, the odeon, the
bouleuterion and the upper agora.[113] After the third century, there is not a sin-
gle example of an official decree posted at any of these places, a clear indication
that the traditional organs of civic government were no longer responsible for
their publication.[114] Of the twenty-five inscribed edicts datable between the
mid-fourth century (the earliest belongs to the reign of Constantius II) and the
end of the sixth whose original location is well established, fourteen adorned
the columns, balustrades and walls of the colonnades lining the Embolos and
the Marble Street.[115] Feissel's meticulous study even suffices to trace the migra-
tion of newly inscribed acts over time: by the sixth century, when the available
surfaces of the Embolos were evidently jumbled with official documents, the
inscribers moved on to the adjacent stretch of the Marble Street, covering its
porticoes too with a dense patchwork of documents.[116] In the process, the col-
onnades were transformed into an indelible testament to the pull of the impe-
rial will on the lives of the Ephesians, an archive of centuries' worth of official
pronouncements imposed on the consciousness of the masses who traversed
the high street of the city on a daily basis.[117]

The commemorative monuments and legal texts clustered along the Marble
Street and Embolos, taken in their entirety, testify eloquently to the centrality
of this axis in the minds of the authorities responsible for commissioning them.
The profusion of shops in the colonnades indicates that, as at so many other
late antique cities, the main street was bustling with commercial activity.[118]
The numerous game boards inscribed in the pavements of the colonnades at
Ephesus and numerous other cities reveal them as places of leisure and social

[113] Feissel 1999, 122–23.
[114] Ibid.
[115] Ibid., 125–27.
[116] Ibid., 125.
[117] Antioch provides a suggestive parallel: there, official proclamations seem to have been
displayed on the Tetrapylon of the Elephants, where Julian posted his *Misopogon* (Saliou 2009,
247–48); Ausonius likewise depicts the colonnades at Milan as the place where imperial
decrees were posted in his speech of thanks for the consulship of 379 (*Gratiarum Actio*, 10.50):
*has ego litteras tuas si in omnibus pilis atque porticibus, unde de plano legi possint, instar edicti pendere
mandavero, nonne tot statuis honorabor, quot fuerint paginae libellorum?*
[118] Crawford 1990, 108–11.

gathering as well.[119] The colonnades of the main street at Ephesus, in short, had become the most frequented space in the city, a development that also helps to explain why they were the preferred location for conspicuous forms of epigraphic and artistic display.

But why? Why, when emperors and their representatives became the prime movers behind the shaping of urban infrastructure at Ephesus in the fourth century, did they so assiduously maintain and embellish the architectural décor of a single colonnaded thoroughfare, which progressively subsumed so many of the commercial, commemorative and administrative functions previously more widely diffused throughout the markets, *agorai*, assembly halls and entertainment venues of the high imperial city?

As at the imperial capitals – Trier, Rome, Milan, Thessaloniki, Constantinople – discussed earlier, so too at Ephesus, I think the answer lies to a considerable extent in the exigencies of public ceremony. The colonnaded processional way was the conduit through which the authoritarian juggernaut of the late Roman state could most visibly and efficiently permeate the heart of the urban center. Not merely grand architectural statements punctuated by honorary monuments to the ruling establishment (which they certainly were), these streets became the main stage for the living tableaux placed before the urban populace, dutifully assembled and arrayed along the porticoes on, for example, the several occasions each year when an incoming governor either made his first *adventus* into the city, or returned from regular visits to the rest of the province.[120] It is for these ephemeral activities, so memorable for participants and so hard for modern scholars to trace in the material record, that the rich corpus of epigraphic evidence from Ephesus is so unusually revealing.

Dozens of extant inscriptions datable from the fifth century into the seventh contain verbatim transcripts of acclamations shouted out by the crowds lining the processional route on special occasions. Like the inscribed edicts discussed earlier, they cluster almost exclusively along the Marble Street and the adjacent section of the lower Embolos. 'Many years for Christian emperors and Greens!' 'Many years for pious emperors!' 'Many years for Heraclius and Heraclius, our god-protected lords, and for the Greens!' 'Heraclius and Heraclius, our god-protected lords, the new Constantines!' '[Lord] help Phokas, crowned by God, and the Blues!'[121] As Charlotte Roueché has said, many of these inscriptions

[119] The extant examples found at Ephesus are heavily concentrated along the Arkadiane: see the catalogue in Schädler 1998, nos. 2–4, 11 (and passim for a useful catalogue of game boards from other sites in Asia Minor). For late antique game boards on the main colonnaded street at Sagalassos, see Lavan 2008, 207; for additional exemplars at Aphrodisias, see Roueché 2007.

[120] Roueché 2006, 252; *ead.* 2009, 158; Ladstätter and Pülz 2007, 402–04.

[121] Roueché 1999a, respectively catalogue nos. 1a: Χριστιανῶν βασιλέων κ(αι) Πρασίνων πολλὰ τὰ ἔτη; 1b: εὐσεβων βασιλέων πολλὰ τὰ ἔτη; 2: Ἡρακλήου καὶ Ἡρακλήου τῶν θεωφυλάκτων

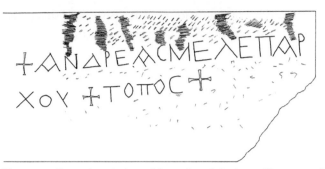

Figure 3.7 Topos-inscription of the *meleparch* Andreas. (Courtesy of F. A. Bauer.)

must reproduce the wording of real chants, and they should often be under-stood to mark the very spot where the recorded words were uttered on one or more occasions, in addition to the identity of the speakers:[122] a group of supporters of the Green faction very likely filled the colonnades of the Marble Street where their acclamations are incised, for example, just as the Blues who supported Phokas must have done along the lower Embolos where their chant appears.

A particularly eloquent evocation of a particular time and place in the ceremonial life of the city comes from an inscribed block reused in the paving of a platform leading to the northwest entrance to the theater, recently pub-lished by Roueché, which preserves the roar of the crowd as it hailed the *adventus* of the new proconsular governor of Asia, Phlegethius, into the city around the year 500: 'Enter, Lord Phlegethius, into your city!'[123] The position of the reused block near the intersection of the Arkadiane and the Marble Street sug-gests that it originated along one of the two streets, and thus on the route the entering governor would have taken on his way into the city from the harbor at the foot of the Arkadiane, where those who uttered the acclamation stood.

Another inscription preserved in situ within the colonnades of the lower embolos, just past the nymphaeum at the library of Celsus, graphically illus-trates the rootedness of specific individuals in the ceremonial topography of the processional way: '(this is) the place (*topos*) of the *meleparchos* Andreas' (Figure 3.7).[124] Similar *topos*-inscriptions are attested in late antique urban

ἡμῶν δεσποτῶν καὶ τῶν Πρασίνων πολλὰ τὰ ἔτη; 6: Ἡρακλήου καὶ Ἡρακλήου τῶν νέων Κωνσταντίνων τῶν θεοφυλάκτων ἡμῶν δεσποτῶν; 11: Φωκᾷ τῷ θεοστεφῇ ἡμῶν δεσπ(οτῇ) καὶ Βενέτοις [Κ(ύρι)ε βο]ήθcον. Inscriptions 1a, 1b, 2 and 6 come from the Marble Street, 11 from the lower Embolos.

[122] Roueché 1999a, esp. 162; *ead.* 1984, 196 and passim (the latter on the remarkable series of acclamations honoring the *clarissimus* Albinus from the columns of the west stoa of the agora at Aphrodisias, which he restored in – probably – the first half of the sixth century).

[123] ἔνβα κύρι Φλεγέθι [ἐc] τὴν πόλιν c[ου]: see Roueché 1999b.

[124] *I. Eph.* 1374.2: Ἀνδρέας μελεπάρχου τόπος. I thank Franz Alto Bauer for calling my atten-tion to this inscription, and for providing a drawing of the text, which allows the Ἀνδρέα

contexts elsewhere in the eastern Mediterranean, where they are generally interpreted as place markers for shopkeepers and other purveyors of services, some of whom are clearly identified as such in the texts.[125] In this case, however, the mention of Andreas with his official government title (*meleparchos*) suggests another interpretation: this is the spot where Andreas, in his capacity as a representative of the civic administration, took his place on ceremonial occasions, when the ranks of spectators arrayed themselves along the parade route according to their rank and station. Whatever the precise duties of the 'meleparch' (a *hapax*, as far as I know), it is evidently the title of a representative of the urban administration, whose official quarters are unlikely to have been sandwiched in among the shops adjacent to the place along the Marble Street where his inscription occurs. We might speculate further: the urban prefects of Constantinople were later known as eparchs; their responsibilities included oversight of all the logistical arrangements necessary for triumphal processions;[126] and the tenth-century *De caerimoniis aulae byzantinae* places the eparch and his staff (the *taxis eparchou*) along the route of Justinian's *adventus* of 559.[127] It is thus tempting to imagine that in sixth-century Ephesus, the meleparch was involved in the organization of urban processions, whence it would be particularly appropriate that his 'place marker' lies along the heart of the processional route.

The wording of the inscription is suggestively echoed in a sermon delivered by Bishop Proclus of Constantinople (434–46), whose passing reference to the protocols surrounding imperial *adventus* constitutes the most explicit extant testimony to the existence of what we might call stational chants:

> Among the citizens of this world, when they prepare for the arrival of the temporal sovereign, they prepare the way, they crown the city gates, they decorate the city, they thoroughly prepare the royal halls, *they arrange choruses of praise, each in its proper location.* In these ways the entry of a temporal sovereign into any city is made manifest.[128]

given in the *I.Eph.* transcription to be amended to Ἀνδρέας. A second graffito on the same stone invoked divine aid for the same Andreas (*I.Eph* 1374.1): κύριε βοήθηϲον το δούλο ϲου Ἀνδρέᾳ. The editors wonder if this individual is perhaps the proconsul of the same name attested in *I.Eph.* 1301 and 1355, an intriguing possibility.

125 For such inscriptions on the main colonnaded avenues at Sagalassos and Perge, see Lavan 2008, 206–07; one inscription from the principal thoroughfare at Perge marks, for example, the *topos* of an eating establishment (*thermopolium*; ibid., n. 42); for the numerous *topos*-inscriptions from Aphrodisias, see Roueché 2004, nos. 187–211; nos. 189–91 name a trouser maker, cloakroom attendant and barber, respectively; other examples occur at the market gate in Miletus (Maischberger 2009, 114–15); for additional examples, see Lavan 2012, 338–40.

126 McCormick 1986, 204–05 and passim.

127 *De caer.* 498, 3–4; on Justinian's *adventus* of 559, see later in this chapter; the passage is quoted in full at n. 130.

128 Proclus, *Or.* 9 (*In ramos palmarum*; *PG* 65, col. 773a): Ἐν κοσμικοῖς πολίταις, ὅτε προσκαίρου βασιλέως εἴσοδον περιμένουσι, τὴν ὁδὸν ὁμαλίζουσι, τὰ προπύλαια στεφανοῦσι, τὴν πόλιν ἐξαλλάττουσι, τὰς βασιλικὰς αὐλὰς πανταχόθεν καθαίρουσι, χοροὺς ἐγκωμίων κατὰ

For Proclus, particular locations along the processional route were associated with specific chants, each of which, like the *meleparchos* Andreas himself at Ephesus, had its proper place (*kata topous*). The further implication is that these chants were voiced by discrete subgroups among the urban populace, each of which had its assigned place along the Mese on those occasions when official processions passed along its colonnades.

So much is in fact clear from the literary sources, which show that at Constantinople and elsewhere, the citizenry assembled along the processional route, subdivided by rank and profession, according to a prescribed sequence. According to Libanius, when a new governor made his *adventus* to Antioch, his route as far as the city gate was lined by senators and ex-governors, current members of the governor's staff (*officiales*), local city councilors, and then lawyers and teachers, in that order. Upon traversing the gate, he received the acclamations of the masses, doubtless including the proprietors of the shops lining the street, who thronged the colonnades along his route to the palace on the Orontes.[129] When Justinian made his triumphal entrance into Constantinople after the retreat of the marauding Kotrigurs in 559, the Mese from the Capitol all the way to the palace was lined with various corps of government officials, followed by 'the silversmiths and all the artisans, and every guild.'[130] In the tenth century, shopkeepers and craftsmen still clustered according to profession along the colonnades of the Mese, which they presumably helped to decorate on ceremonial occasions.[131]

The example of Constantinople thus suggests also a substantial degree of interpenetration between ceremonial and commercial topography: the ranks of shops, revetted in marble and decorated by their proprietors on festive occasions, must also – at least in some cases – have been the very place where their occupants stood and voiced their acclamations to passing dignitaries. The section of the Mese called the 'portico of the silversmiths,'[132] then, would not merely have been where the silversmiths plied their trade, but also the place where they participated, as a corporate entity, in events such as the arrival of Justinian in 559, where they feature so prominently in the description preserved in the *De caerimoniis*.

τόπους συνφαίνουσιν ἐν τούτοις γὰρ ἡ τοῦ προσκαίρου βασιλέως εἴς τινα πόλιν εἴσοδος γνωρίζεται. Cf. McCormick 1986, 212.

[129] *Or.* 56, with Liebeschuetz 1972, 209 and ff.

[130] *De caer.* 497.20–498, 6: ὡς δὲ εἰσῆλθεν (Justinian) εἰς τὴν μέσην, ὑπήντησαν δομέστικοι πρωτίκτορες, αἱ ἑπτὰ σχολαὶ καὶ μετ' αὐτους τριβοῦνοι καὶ κόμητες, πάντες μετὰ λευκῶν χλαμιδίων καὶ κηρῶν δεξιὰ καὶ ἀριστερὰ ἱστάμενοι, καὶ μετ'αὐτους μαγιστριανοί, φαβρικήσιοι, τάξις τῶν ἐπάρχων καὶ τοῦ ἐπάρχου, ἀργυροπρᾶται καὶ πάντες πραγματευταί, καὶ πᾶν σύστημα, καὶ ἁπλῶς ἀπὸ τοῦ καπιτωλίου μέχρι τῆς χαλκῆς τοῦ παλατίου πάντα ἐπεπλήρωτο.

[131] McCormick 1986, 206–08; cf. Mango 2000, 202–05.

[132] The name refers to the colonnades along the Mese east of the forum of Constantine: see *Chronicon Paschale*, p. 623.

Serious consideration might then be given to the idea that some of the many *topos*-inscriptions identifying individuals by name, with or without further information about their rank and profession, may relate to their placement on ceremonial occasions. The *phylarch* Eugraphius and the 'most eloquent John,' for example, whose *topos*-inscriptions appear on the north portico of the South Agora at Aphrodisias,[133] seem more likely to have laid claim to this space in their capacity as distinguished representatives of their city than as permanent occupants of the colonnade. Similar concerns may also better explain the function of the many inscriptions located in close proximity to circles inscribed on pavements at both Ephesus and Aphrodisias, which Roueché has already been inclined to link to the positioning of spectators in attendance at public ceremonies.[134] The circles, after all, have no appreciable connection to any sort of commercial activity, but would serve admirably to delineate the space to be occupied by a single, standing individual.[135] A remarkable graffito found near the tetrapylon at the crossing of two main roads at Aphrodisias indeed appears to show a figure with one foot in such a circle, arms raised in what might be a gesture of acclamation.[136]

In any case, while the function(s) of such *topos*-inscriptions remains open to question, the large corpus of inscribed acclamations alone suffices to demonstrate the transformation of the Arkadiane-Marble Street-Embolos route at Ephesus into a living archive, a repository of institutional memory that ensured that the echo of the ephemeral chants voiced from its colonnades never died away. The memory of the choruses that accompanied the arrivals and other public appearances of the mighty was encoded in the fabric of the street itself, which proclaimed itself, in the voices of the people who assembled there to salute their rulers, a triumphal monument to the imperial establishment. Numerous inscribed acclamations documented at other sites, such as those present on the tetrapylon and adjacent colonnades at Aphrodisias, for example, and others by the propylon at Magnesia-on-Meander, and still others at Phrygian Hierapolis indicate that the main streets of regional centers across the eastern Mediterranean (and almost certainly beyond) experienced a similar transformation in late antiquity, for all that most of the evidence is either irretrievably lost, or awaiting identification by researchers more sensitive to its presence.[137] Traces of much more ephemeral painted texts of acclamations, moreover, indicate that the extant inscriptions represent merely the tip of an

[133] Roueché 2004, nos. 201 and 205, respectively.

[134] Roueché 1999a, 164; *ead.* 2007, 100.

[135] On the diameter of the inscribed circles, which is often in the range of 50–60cm, see the catalogue entries in Roueché 2007.

[136] Roueché 2007, 103, no. 9. A large number of inscribed circles clusters along both streets leading to the tetrapylon, the primary ceremonial axes in the city (*ibid.*, 102, no. 8).

[137] Aphrodisias: Roueché 2004, nos. 184–85; Magnesia: Bingöl 1998, 41–43; Hierapolis: Miranda 2002 (thanks to Prof. Francesco d'Andria for this last reference).

immensely larger iceberg: by the sixth century, the porticoes along principal urban thoroughfares must have teemed with writing to an extent that is today almost unimaginable.[138]

The processional avenues that bisected the heart of the leading political and administrative centers of the late empire became, in short, the single most potent architectural manifestation of an ideal consensus between rulers and ruled. They were the stage that framed and reified the social order of the urban collective, its constituent parts hierarchically arranged – and perhaps even prescriptively oriented by inscribed place markers – festively attired, chanting pledges of allegiance to the emperor, the governor, Christian orthodoxy, Christ, Mary, their bishop, their circus-faction and/or the fortune of their city.[139] When the residents of a late antique metropolis lined the colonnades along the main processional way to witness the passage of their leaders, they intermingled with the statues of generations of emperors and imperial officials, whose edicts and proclamations peppered the columns, interspersed among the acclamations voiced by the citizenry in honor of these officials on innumerable past occasions, the cumulative legacy of which was evoked by, and integrally connected with, the procession unfolding before their eyes. On all the other days of the year, the profusion of written texts and honorary monuments served as a constant reminder for all comers of those special days when the leaders of the late Roman state put the spectacle of their might and the grandeur of the institutions of government they represented most visibly on display to their assembled subjects, by day and even – perhaps to a still greater extent – by night. The brilliant lighting of the main streets at (inter alia) Antioch, Ephesus and Constantinople must only have increased their relative prominence in the cityscape, and enhanced their propensity to attract and direct the flow of passersby.[140]

The closely linked imperatives of commemoration, display and ceremonial praxis, in short, deserve pride of place in any attempt to explain why colonnaded streets were so privileged relative to other types of public building in late antique cities, and why, beginning in the Tetrarchic period, imperial and provincial capitals witnessed so much more building activity than the cities that remained more peripheral to the administrative apparatus of the state. Grand

[138] For numerous examples at Aphrodisias, see Roueché 1984, 196; several columns from the colonnade just east of the theater preserve signs of multiple layers of painted inscriptions; the overpainting of earlier texts might suggest that the columns came to be completely covered, to the extent that little blank space remained for new texts.

[139] All feature among the inscribed acclamations from Ephesus transcribed in Roueché 1999a, 1999b.

[140] For illumination at Antioch, Amm. 14.1.9: ...ubi pernoctantium luminum claritudo dierum solet imitari fulgorem; Libanius, Or. 11, 267; on Ephesus, where inscriptions demonstrate that the Arkadiane–Embolos axis was likewise lit with a profusion of lamps, see Feissel 1999; on Constantinople, see Foss 1979, 56–57.

processional avenues proliferated in large part for their unique capacity to transform urban landscapes into scenic backdrops, majestic tableaux expressly intended to enhance the public appearances of emperors and their provincial representatives who commissioned and – directly or indirectly – funded them, and to distill the topographical profile of the places they inhabited into a narrowly circumscribed monumental itinerary.

With the growth of the Christian church, the wealthiest and most influential bishops, who themselves tended to be based in the secular capitals in which the metropolitan structure of the church was rooted,[141] came almost inevitably to treat these porticated armatures as the preferred venue for the expanding battery of liturgical ceremony over which they presided, and often to annex the churches and episcopal residences they commissioned to the same streets.[142] In the fifth and sixth centuries, when bishops took an increasingly active interest in the infrastructure and architectural patrimony of their cities, colonnaded streets indeed featured prominently in the list of construction projects they sponsored. Theodoret, for example, when listing the most significant architectural commissions he undertook as bishop of Cyrrhus in the second quarter of the fifth century, twice cited colonnaded streets in the first place, followed by mention of two bridges, baths and an aqueduct, all underwritten with money from church coffers.[143] While the colonnades will undoubtedly have pleased the shopkeepers and passersby who frequented them, and proclaimed the bishop's stature as a leading patron of his city, one wonders whether Theodoret did not also hope to endow the rather mediocre capital of his remote provincial see with a more distinguished architectural profile, one better suited to magnify the public appearances of a leading figure in the ecclesiastical politics and theological controversies of the age.[144] Similar motives may also help to explain why other fifth- and sixth-century bishops chose to embellish their cities with street colonnades; their evident predilection for such structures surely suggests that church dignitaries, like their counterparts in the imperial administration, considered them key features of the urban landscapes they inhabited.[145]

[141] Already in canons 4 and 5 of the Council of Nicaea of 325, the sees of metropolitan bishops were understood to be based in provincial capitals, an arrangement that remained substantially unaltered for centuries thereafter; see Mansi (ed.), vol. II, 679, with Flusin 2004, 119ff.

[142] The examples of Milan, Rome and Constantinople discussed earlier all illustrate this trend: Ambrose placed the Basilica Apostolorum along the colonnades of the Via Romana at Milan; at Rome, Pelagius II (579–90) constructed the new basilica of San Lorenzo at the extremity of the colonnade leading to the existing fourth-century church on the site; and at Constantinople, the Mese was bracketed at its west end, outside the city walls, by the early fifth-century Church of St. John Hebdomon, and in the east by the fourth-century churches of Hagia Sophia and Hagia Eirene.

[143] *Ep.* 79, Azéma (ed.), vol. 2, p. 187; *Ep.* 81, ibid., p. 197.

[144] Cf. *Ep.* 139, Azéma (ed.), vol. 3, p. 147.

[145] Avramea 1989; Di Segni 1999, esp. 157.

Figure 3.8 The 'Trier Ivory.' (Photo: author.)

The extant image that perhaps best captures the role of colonnaded streets as the vibrant center of public life in the late antique city in fact depicts a religious procession, with two bishops for protagonists. This is the 'Trier Ivory,' a relief panel from a reliquary produced in Constantinople, variously dated between the fifth century and the ninth (Figure 3.8).[146] The event depicted on the panel has been interpreted most plausibly to represent the translation of the relics of the protomartyr Stephen, discovered near Jerusalem in 415 and triumphantly carried into Constantinople in 421, where they were installed in a new church built inside the imperial palace and dedicated to the saint whose remains it was to house.[147] Two bishops mounted on a chariot at the left of the panel convey the reliquary casket toward a church that workers are scurrying to complete, before the doors of which a bejeweled woman of imperial rank waits to receive them.[148] The center of the scene, however, is dominated by the profile of a two-story colonnade, packed with ranks of spectators gazing at the procession unfolding before them. Whether the colonnades represent the final section of the Mese, or the interior of the palace (or perhaps a conflation of the two),[149] they are manifestly the glue that holds the image together: for the creator(s) of the casket, the physical fabric of the city condensed itself into the image of a processional way; its inhabitants to the multitude that filled both levels and the roof

[146] See Holum and Vikan 1979; Brubaker 1999, 70–77 (the latter arguing for a ninth-century date, though acknowledging that the subject may nonetheless be the translation of 421).

[147] Holum and Vikan 1979, 127ff.

[148] If the subject is the translation of 421, the two bishops might be Atticus, Patriarch of Constantinople, and St. Passarion, bearer of the relics from Palestine to Constantinople, according to Theophanes; the woman at the door of the church would then surely be Pulcheria Augusta, the sister of Theodosius II: see Holum and Vikan 1979, 127–32.

[149] Cf. Holum and Vikan 1979, 124–26.

of the colonnade.[150] In both architectural and human terms, 'Constantinople' is epitomized by the vision of a colonnaded street filled to bursting with beholders, without whose presence the elaborate spectacle engineered by the leaders of church and state would have been an exercise in futility.

3.6 THE LONG SHADOW OF CONSTANTINOPLE, I: NEW CITIES AND OLD TRADITIONS IN THE SIXTH-CENTURY EAST

A particularly telling indicator of the enduring prominence of colonnaded streets in the minds of the leading architects of early Byzantine urban topography – again, chiefly the emperors and their provincial representatives – comes from the various cities founded *ex novo* as late as the sixth century, which, like Constantinople, afforded their designers extensive freedom to map out the contours of an ideal cityscape in a single, cohesively planned and executed initiative. Among the dozens(!) of examples of new cities founded in the eastern Mediterranean between the reigns of Anastasius and Justinian,[151] Zenobia stands out for the quality of its extant remains, which furnish a reasonably complete picture of its basic configuration. Located along the Euphrates, on the strategically vital frontier with Sassanian Persia, the city took shape in the 530s and 540s under Justinian, though work may have begun already under Anastasius.[152] The topographical imprint of the site leaves no doubt about the vision of urban infrastructure shared by the planners tasked by the central administration in Constantinople with designing it, whom Procopius names as John of Byzantium and Isidore of Miletus the younger.[153] The city gravitates around two continuous, colonnaded streets that lead directly from the main gates in the city walls to a central crossing point, punctuated by a tetrapylon, where they meet at right angles (Figure 3.9).[154] The principal churches and the *praetorium* are located in close proximity to these streets. The result was yet another urban armature made up of a continuous sequence of monumental architecture centered around colonnaded thoroughfares. All comers approaching from

[150] It is worth noting that the colonnades along the Mese were not only two stories high, but also had a walkway above the roof of the second level (Mango 1959, 88–89), thus providing for exactly the three superimposed levels of spectators seen on the Trier Ivory.

[151] Zanini (2003, 201) puts the number of such foundations identifiable in literary and epigraphic sources alone near thirty.

[152] The definitive study of the history and topography of the site is Lauffray 1983–91; see also the lengthy description of Procopius, *De aed.* 2.8.8–25.

[153] *De aed.* 2.8.25. Generally on the crucial role played by the authorities in Constantinople in the planning of new cities in the sixth century, see Zanini 2003, esp. 218–20; 2007, 186ff. According to Zacharias Rhetor (*HE* 7.6), who describes the foundation of the nearby city of Dara at length, plans and sketches drawn up on site were brought to Constantinople, where Emperor Anastasius himself and his advisors, among them professional architects, drew up the plans for the new city.

[154] Cf. Zanini 2003, 202–06.

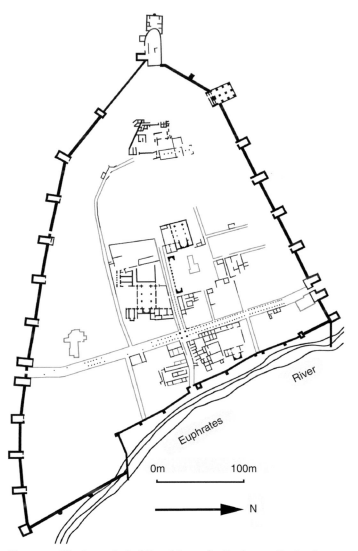

Figure 3.9 The 'new city' of Zenobia on the Euphrates. (Author.)

the outside experienced Zenobia first as an uninterrupted panorama of walls
and towers, converging on the massive fortified gate through which they were
required to pass; upon traversing the gates, they were funneled onto one of two
wide, colonnaded streets that in turn led directly to the intramural foci of civic
and ecclesiastical life. The most distinguished residents and visitors presumably
need not have seen much of anything else, either during the course of their
arrival/*adventus* or at any point thereafter.[155]

Another example of sixth-century urban planning that merits particular
attention is the site of Justiniana Prima, the new city erected by Justinian on

[155] The humbler neighborhoods in the peripheral quarters of the city were, however, well served
by a dense network of secondary streets, which has yet to be adequately studied.

the site of his birthplace at Caričin Grad, in modern-day Serbia. The tiny size of the intramural nucleus — it is some 600 meters in length, barely more than 100 meters wide over much of that extent, and encloses an area of about 7ha — belies its immense institutional prestige: by 535, Justinian had made it the capital of an independent archbishopric covering the northern half of the prefecture of Illyricum,[156] and probably the seat of a praetorian prefect as well.[157] The city proper is formed of three interconnected, walled nuclei perched along a narrow spit of elevated terrain: a roughly circular citadel enclosing the cathedral, baptistery, episcopal audience hall and perhaps residence; an upper city that contains at least three churches and a number of administrative buildings; and a lower city with several more churches, a bath complex and a tiny residential quarter (Figure 3.10).[158] The full length and breadth of the intramural space was traversed by a total of two streets, lined along their full extent with arcaded porticoes, which converged at an oblique angle on a circular plaza in the upper city.[159] The enclosed perimeter was so narrow that there was generally room for only one rank of sizeable structures in the space left between the circuit-wall and the rear of the porticoes, whence all of the principal buildings fronted one of the two streets.

The walled center of the city, in other words, primarily consisted of two porticated streets, along with the single files of large, solidly built complexes — almost exclusively pertaining to government and church — visible and directly accessible from those streets.[160] It was a processional itinerary with a stately façade, artfully arranged to appear larger and more 'urban' than it really was. Both streets made a slight bend about midway along their course, making it impossible to see how short they really were, and providing the illusion of endlessly receding arcades. From the outside, the walled profile of the city likewise appeared to extend indefinitely for anyone approaching from the south, along the principal road that connected it with the outside world: on both sides of the narrow façade of the lower city wall, comers saw only the swelling profile of the upper city and citadel, their bristling walls sweeping upward and outward along the crest of the hill, giving no sign that the enclosed space ended

[156] *CIC, Nov.* 11; cf. *Nov.* 131. See also Procopius, *De aed.* 4.1.17–27.

[157] So much is strongly implied at *CIC Nov.* 11.1–3; Procopius states outright that it became the (civil) metropolis of its surrounding region, as well as the ecclesiastical capital (*De aed.* 4.1.24–25).

[158] A good recent overview is Bavant 2007, with prior bibliography; see also inter alia Duval 1996; Bavant and Ivanišević 2003; Ćurčić 2010, 209–14.

[159] Vasić 1990.

[160] On the administrative buildings, Duval 1996, 331ff.; Bavant 2007, 361–67; on the churches, Duval 1984; on the citadel, Duval and Popović 2010. All of the monumental structures in the city, including the city walls, were constructed in the alternating bands of brick and well-cut stone characteristic of contemporary architecture in Constantinople and across the Byzantine dominions, doubtless by craftsmen imported from afar, perhaps the capital itself (cf. Zanini 2007, 398–99).

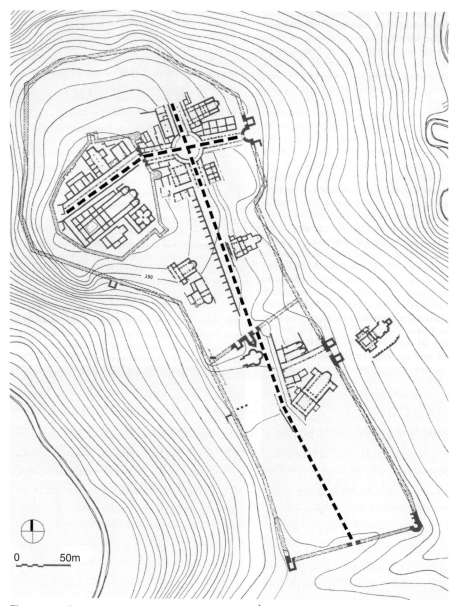

Figure 3.10 Justiniana Prima (Caričin Grad). (After Ćurčić 2010, fig. 217.)

just past the point where the circuit reached its greatest breadth. The presence of three distinct circuits and, more to the point, three sets of gates along the main axis of traffic is also remarkable, the more so if the wall of the lower city was an original part of the city plan, as Bavant has proposed, and not a later addition.[161] Regardless, anyone bound for the citadel occupied by the newly

[161] Bavant 2007, 353–61. If the lower wall is a later addition, it was erected scant years after the rest.

created metropolitan archbishop of northern Illyricum would have traversed three bristling city gates in the space of some 500 meters. The considerable ceremonial potential of so many gates aside, the effect was surely to make the city seem far larger, grander and more impregnable than it was, a fiction that will have been far more convincing when experienced from street level than on the modern observer's scaled city plan.

'Small, fortified, Christian and imperial,'[162] Justiniana Prima embodies the essential characteristics of the new cities founded on orders from Constantinople in the sixth century, though it is dominated to an unparalleled extent by the profile of its porticated armature, to which the entirety of the built space inside the walls is little more than an appendage. It is unlikely to be pure coincidence that the one sixth-century city destined from its inception to attain the highest rank in the administrative hierarchy of empire and church was also the one designed to be little more – and no less – than a parade route situated in the midst of what, at first glance, might plausibly have been a great city.[163] The population that filled the neighborhoods flanking the Mese at Constantinople – the epitome of a great city – was almost nonexistent within the walled confines of Justiniana Prima,[164] yet from street level, the difference will hardly have been apparent; the absence of the masses was as effectively concealed by the porticoes of Justiniana Prima as was their teeming presence by those of Constantinople. In reality, the inhabitants of Justinian's magniloquent urban gesture were almost all required to live outside the walls, where other churches, baths and traces of a defensive palisade hint at the sweep of a sprawling suburban neighborhood substantially larger than the area enclosed within the walls.[165] 'The people' were thus very literally peripheral to the urban showpiece of the walled center, for all that they were indispensable on those occasions when the archbishops and praetorian prefects required living, chanting spectators to transform the colonnades along the processional route into a plausible facsimile of the cosmopolitan city that the dignity of their offices required them, as much as ever, to inhabit.

The ruling establishment's continued fascination with colonnaded streets in the sixth century is equally manifest at Antioch, which Justinian was compelled to rebuild practically from scratch after it had first been devastated by a series of earthquakes and fires in the 520s, and then disastrously sacked by the Persians in 540.[166] The Persians had no sooner retreated than the

[162] Zanini 2003, 214.

[163] Cf. Duval 1996, 329–30, with further reference to previous 'ceremonial' interpretations of the urban layout.

[164] Intramural housing is concentrated in a section of the lower city that Bavant estimates to have contained no more than thirty dwellings, presumably occupied primarily by military and administrative officials (Bavant 2007, 367–71).

[165] Kondić and Popović 1977, 349–57; Popović 1990, 303–06; Bavant 2007, 371–72.

[166] Downey 1961, 520–71.

emperor launched a massive reconstruction effort, focused first and foremost on reconstructing the city wall and restoring the colonnades along the main intramural thoroughfares.[167] Over a layer of rubble more than two meters thick in places, Justinian's architects rebuilt the colonnaded backbone of the city's main *cardo* to nearly the size and width of its predecessor, lining it with thousands of new columns along the two kilometers and more of its intramural sweep.[168] Looming over the blasted ruins of a city that would never fully recover, the stately ensemble of walls and colonnades screened the devastation from view behind a plausible monumental façade, ready outwardly to proclaim the resurgence of the greatest metropolis of the Levant, and to dignify the public appearances of its governors as they struggled to reassert the authority of the central administration in the devastated province.

3.7 THE LONG SHADOW OF CONSTANTINOPLE, II: RAVENNA

The fifth century is now quite universally recognized as a period of relative peace and prosperity, indeed of economic and demographic expansion, across most of the eastern half of the empire. Institutional change came slowly, and generally flourishing cityscapes did not transform radically, though naturally urban topography is never static.[169] In the West, however, the disintegration of the empire and its partitioning into 'barbarian' successor kingdoms provoked more serious shifts in the ordering of government and society. The causes of the western empire's dissolution in the fifth century continue to provoke lusty debate, and need not be rehashed here, except insofar as they relate to the condition of cities and towns.

An important point of convergence in much of the best recent work on the breakup of the western empire is, precisely, fragmentation. The western provinces, always a multicultural, multiethnic hodgepodge, embarked on diverging regional, and even micro-regional, trajectories with surprising alacrity, centrifugally spinning off from the center in Italy with a momentum that the advent of barbarian rulers does not entirely suffice to explain. To be sure, the arrival of large numbers of unsubdued peoples inside the empire, beginning with Adrianople in 378 and continuing through the collapse of the Rhine frontier ca. 406, was an historical watershed. But as (for example) Peter Brown and Guy Halsall have stressed, the really remarkable thing is how quickly Roman

[167] Procop. *De aed*. 2.10, esp. 2.10.19–22. After work on the wall and the colonnades was at least well under way, Procopius implies, efforts turned to hydraulic infrastructure, sewers, theaters, baths and 'all the other public buildings through which the good fortune of a city is customarily shown.'

[168] Foss 1997, 191–93; Bejor 1999, 14–15.

[169] A small sampling of recent perspectives: Millar 2006; Banaji 2007; Sivan 2008; Dally and Ratté (eds.) 2011.

provincials, beginning with the landed aristocracy, reached an accommodation with Gothic, Burgundian, Frankish and Vandal rulers, recognizing in their local courts the best and most immediate source of protection and patronage available, and eagerly vying to serve there.[170] While the fourth century had witnessed the rise of a mobile service aristocracy of supra-regional scope and ambitions, empowered and enriched by their imperial connections, their fifth-century descendants in North Africa, Spain, much of Gaul and eventually Italy too continued to work for local rulers in similar capacities, but in (relative) mutual isolation.[171] Their horizons contracted dramatically, in a manner reminiscent of the mid-third century, when the empire fragmented into *Teilreiche,* in part because in difficult times provincials preferred to serve, and gain advancement from, a nearby court rather than a remote and distant emperor.

The result was a constellation of what Brown has called 'little Romes,' regional kingdoms under Germanic rulers that modeled themselves on imperial precedent, adopted Latin as the language of law, administration and diplomacy, and were largely staffed by native 'Romans.'[172] The royal seats of these early successor kingdoms were consistently city based, resulting in a profusion of regional capitals: Vandal Carthage; Burgundian Geneva and Lyon; Visigothic Bordeaux, Toulouse and Barcelona; sub-Roman Soissons; Frankish Cologne, Trier and Tournai, and so on.[173] Further, as Halsall has suggested apropos of Spain and Gaul, the breakdown of Roman central authority and the generally unsettled conditions of the fifth century frequently made even non-'regal' *civitates* more central than ever to the ordering of local society, as the sole remaining stage upon which ambitious aristocrats and clergy could hope to act.[174] As imperial control wavered and receded, in other words, the *civitas* was frequently all that remained. While the West was undoubtedly poorer in absolute terms than the East in the fifth century (and after), the working hypothesis that we will seek

[170] Halsall 2007, 19: 'the key factor in the break-up of the Empire was the exposure of a critical fault-line between the imperial government and the interests of the regional élites,' quoted approvingly at P. Brown 2012, 393.

[171] On provincial cooperation with new, non-Roman overlords, see also (in addition to the sources cited in the preceding note) Heather 2005, 415–25; 432–43, though Heather concentrates on the period following the final dissolution of the western empire in the 470s, in part because he is inclined to place more stress than Halsall and Brown on the barbarian incursions of the early fifth century as the proximate cause of the end of Roman rule, and less on the localizing proclivities of regional Roman élites. On Africa, where despite acute tensions, religious differences and occasional persecution, cooperation between local élites and Vandal overlords increasingly prevailed, see now Conant 2012, esp. 142–59; also Hen 2007, 59–93.

[172] P. Brown 2012, 392–94, at 393: 'In effect, barbarian kings and their armed retinues offered the regional elites a Rome at home. These little Romes were largely run by local Romans. They drew to themselves courtiers and litigants from the region. They proved more accessible as a source of justice and wealth than was the increasingly impoverished *Respublica* – the legitimate empire that now ruled Gaul from a distance, across the Alps in Ravenna and Rome.'

[173] Gurt and Ripoll (eds.) 2000; on Vandal Africa, also Conant 2012, 49; 132–33.

[174] Halsall 2007, 480–82.

to develop, first in relation to Ravenna, and in the next chapter to a number of other places in the West, is that a substantial group of leading urban centers continued to absorb and retain a relative preponderance of the resources available, as the cream of local society and the clergy joined their new rulers in working, spending and displaying themselves there.

The continuing capacity of the urban paradigm incarnated by (inter alia) Constantinople to reach even beyond the regions under the direct control of the eastern emperors is best exemplified at Ravenna, the last imperial capital in the West, later the first city in the realm of that most Romanized (or Byzantinized) of post-Roman sovereigns, Theoderic. As the most ambitious example of urban remodeling undertaken in the Latin West in the fifth and sixth centuries, Ravenna deserves consideration at some length. It offers crucial insights into the architectural vernacular shared by its rulers and archbishops, a vocabulary of power in which central porticated thoroughfares seem to have featured as prominently as they did in the greatest cities of the eastern Mediterranean.

Following Honorius' transfer of the imperial court from Milan to Ravenna in 402, the western scions of the Theodosian dynasty clung to Constantinople both as the buttress of their faltering hold on power, and as the urban template for the transformation of their new capital into an imperial residence worthy of comparison with the New Rome on the Bosporus.[175] Honorius himself spent much of his youth in Constantinople. His sister Galla Placidia and nephew Valentinian III (western emperor 425–55) came directly to Ravenna from Constantinople in 425, following the deposition of the usurper John, effected with the help of troops dispatched from Constantinople by the young Valentinian's cousin, Theodosius II.[176] Theoderic, who perhaps did more, over the course of his long reign (493–527), to shape the monumental infrastructure of Ravenna than any other resident ruler, had likewise spent some ten years of his youth as a hostage at the imperial palace in Constantinople, an experience that manifestly shaped his vision of the magnificent capital – a sort of 'New Constantinople,' as it were – he wished Ravenna to be.[177] Following the Byzantine conquest of the city in 540, links between Ravenna and Constantinople remained strong for the following two centuries of Byzantine rule, though building activity trailed off considerably from the later sixth century.[178]

With the exception of the surviving churches of fifth- and sixth-century date, our knowledge of the topographical contours of the imperial (and later

[175] For a comprehensive introduction to late antique Ravenna, see now Mauskopf Deliyannis 2010; on the fifth century, see esp. 41–105.

[176] Cf. Farioli Campanati 1992, 139–41; Blockley 1998, 135–37.

[177] Ensslin 1959, 7–57; Johnson 1988; Farioli Campanati 1992, esp. 145ff.

[178] Though the imposing basilica of San Severo in Classe was begun at the very end of the sixth century, as recent excavations have shown (Augenti 2010, 148–54, with prior bibliography); more 'late' examples of monumental projects may await discovery.

regal and exarchal) capital that Ravenna became after 402 is unfortunately
rather vague. Excavations, limited by the dense fabric of the modern city, offer
only tantalizing glimpses of the ancient city, widely scattered and of limited
extent, amongst which the most significant is the section of Theoderic's palace
excavated between 1908 and 1914, to the east of the modern Via Roma and
behind the church of Sant'Apollinare Nuovo.[179] The textual record is similarly
lacunose, and the *Liber Pontificalis* of Andreas Agnellus, much the longest and
most detailed source available, was compiled only in the mid-ninth century.
While Agnellus' text is replete with topographical references and descriptions
of important monuments, many of the edifices he mentions were ruinous or
wholly vanished in his day, and his sense of fifth- and sixth-century chronol-
ogy is vague at best, and often badly confused.[180]

The broad outlines of Ravenna's urban plan as it evolved in the two cen-
turies after 402 can nonetheless be reconstructed with some confidence. The
monumental framework of the new imperial capital arose to the east of the
rectangular perimeter of the old city center, in a neighborhood that came
to be extensively reconfigured beginning soon after the arrival of the impe-
rial court.[181] The fulcrum of the new 'imperial' quarter, the *regio Caesarum* of
later sources, was the *platea maior*, the urban tract of the road that led through
the suburb of Caesarea and on to the port of Classe, which entered the city
through the Porta San Lorenzo/S. Laurentii in the new circuit of walls, them-
selves apparently erected during the reign of Valentinian III, though work may
have begun already under Honorius and continued into the latter part of the
fifth century.[182]

During the fifth century, a contiguous series of palace complexes arose
on both sides of the road. A brief synopsis of centuries' worth of debated
issues might run something like this: when Honorius moved to Ravenna, he
occupied an existing, previously extramural residential complex, possibly the
residence of the *praefectus classis ravennatis*, located on the site of the exca-
vated portions of Theoderic's palace, where the existing structures of the first
century AD were restored and embellished with new mosaics and *opus sectile*
pavements around the beginning of the fifth century.[183] Valentinian III is the

[179] Ghirardini 1917; Augenti 2007.
[180] Agnellus' text at last has the definitive modern edition it deserves (Mauskopf Deliyannis
2006).
[181] On the 'refoundation' of Ravenna in the fifth century as an imperial capital, see recently
Augenti 2010. Other useful overviews of the topography of the city in the fifth and sixth
centuries include, in addition to Deichmann's five-volume *magnum opus* (Deichmann
1969–89), Farioli Campanati 1989; *ead.* 1992; Gelichi 1991; Ortalli 1991; and esp. Mauskopf
Deliyannis 2010.
[182] On the new circuit of walls, see Christie and Gibson 1988; Christie 1989.
[183] Deichmann 1989, 60ff.; Augenti 2007, 435–38. Generally on the topography and evolution of
the palatial quarter in the fifth and sixth centuries, see De Francovich 1970; Deichmann 1989,
49–70; Ortalli 1991, 172ff.; Farioli Campanati 1992; Baldini Lippolis 1997.

first emperor credited in the textual record with the construction of a palace *ad Lauro/ad Laureta*, located to the south of the later palace of Theoderic, stretching along both sides of the *platea maior* toward the Porta S. Lorenzo. Agnellus, clearly relying on an earlier source, puts the murder of Odoacer at the hands of Theoderic in 493 in the palace *ad lauro*;[184] he goes on to describe the complex at some length in a passage that contains a number of noteworthy observations: Valentinian III built a 'lofty palace' in a place called *ad Laureta*, a toponym that Agnellus associates with past triumphal victory parades based on the triumphal associations of the laurel; he goes on to say that the emperor constructed palace buildings on both sides of the *platea* (a point of exceptional importance, too often overlooked by modern scholars),[185] and marvels at the metal clamps, evidently visible in his day, used to reinforce the masonry in these buildings, before passing on to the city walls (which ran quite close to the palace *ad Laureta*), which he attributes to the same emperor.[186]

In the early sixth century, Theoderic made extensive repairs and additions to the existing imperial palace(s), traces of which appeared in Ghirardini's excavations of the complex north of the palace *ad Laureta*. Colonnades were added to the internal courtyard, new mosaics installed in the covered walkways of the quadriporticus, and an audience hall opening onto the northern flank of the colonnaded courtyard was enlarged and adorned with new

[184] *LP* 39.312–14: *Post paucos dies occidit Odovacrem regem in palatio in Lauro cum comitibus suis.*

[185] But see Farioli Campanati 1992, 144. That most essential adjunct to any late antique imperial residence, the circus, was almost certainly located to the west of the road, where by the tenth century its memory was preserved in the name of the Via del Cerchio. The circus was surely an integral component of the palace *ad Laureta* (the toponym itself manifestly evokes the name given to the nucleus of the Constantinian palace at Constantinople, the Δαφνή, with its adjacent hippodrome; cf. Farioli Campanati, 1992, 141), and may indeed have been built or much restored during the building of the palace; Sidonius Apollinaris' lengthy description of a chariot race held under Valentinian III (*Carm.* 23.307–427) reveals a fully functional complex. Johnson's (1988, 87) failure to grasp that Valentinian's palace was built on both sides of the *platea* led him to propose that the name originally referred to a square in front of Theoderic's palace, and only came to be extended to the road in the early Middle Ages, when the palace *ad Laureta* was theoretically in ruins, an interpretation already highly implausible on linguistic grounds alone because the term *platea* quite unambiguously meant 'street' in the fifth and sixth centuries (Spanu 2002).

[186] *LP* 40.359–80: *Celsam etenim Valentinianus illo in tempore Ravennatis tenebat arcem, regalemque aulam struere iussit in loco qui dicitur ad Laureta. Ideo Laureta dicitur quia aliquando triumphalis victoria facta ibidem fuit … Et in ipsa domo regia multo tempore Valentinianus commoratus est, et hinc atque inde ex utraque parte plateae civitatis magnis moenibus decoravit, et vectes ferreos infra viscera muri claudere iussit … Qui etiam istius muros civitatis multum adauxit; cingebatur autem antea quasi una ex oppidis. Et quod priscis temporibus angustiosa erat, idem augustus ingens fecit, et iussit atque decrevit ut absque Roma Ravenna esset caput Italiae.* Further evidence for the location of the palace *ad laureta* just south of the *Theodericanum* (the nucleus of Theoderic's palace just west of Sant'Apollinare Nuovo) appears in Agnellus' description of the route followed by the abbot Iohannis, come from Classe to present himself to the Exarch during the episcopate of Damianus (692–708): *Alia autem die lustrata Caesarea egressus est et a Wandalariam portam, quae est vicina portae Caesarea, relicto Laurenti palatio, Theodoricanum ingressus est, iubetque se exarcho praesentare (LP 132.301–04).*

floor mosaics.[187] To the west, just off the *platea maior*, Theoderic constructed a new, Arian palatine chapel dedicated, like the fourth-century church in the palace at Constantinople, to Christ the Savior (today's Sant'Apollinare Nuovo).[188] The principal entrance to the palace lay off the *platea maior* in the immediate vicinity of the church, in a spot called *ad Calchi* (*vel sim.*) in later sources, a clear reference to the monumental entrance vestibule of the palace at Constantinople, the Chalke.[189] Porticoes were added to the exterior façade of the palace along the *platea maior*, flanking the entrance, as well as to the remaining three sides of the palace.[190] Thus, just as the colonnades along the final tract of the Mese at Constantinople led to the Chalke gate of the palace, so too at Ravenna, by Theoderic's time at the latest, the principal entrance to the palace opened off the porticoes of the *platea maior*, which likely continued as far south as the walls at the Porta S. Lorenzo.[191] With the construction of the Arian cathedral, baptistery and bishop's palace along the west side of the *platea maior*, just north of the palace, the principal axis of Theoderic's royal capital was complete: visitors arriving from the port at Classe, upon entering the Porta S. Lorenzo, found themselves invited to traverse a receding vista of porticoes, leading directly to the Calchi gate of the palace, the palatine chapel of the Savior/Sant'Apollinare Nuovo, and the Arian episcopal complex.

A second porticated avenue very probably intersected the *platea maior* at right angles just north of Sant'Apollinare Nuovo, along the line of the modern Via Mariani.[192] This street would have connected the area of the palace with the one topographical focal point of the late antique city established before the arrival of the imperial court, the orthodox episcopal complex with its cathedral, baptistery and palace, which began to take shape under Bishop Ursus at the end of the fourth century.[193] It may indeed have been the first street to be

[187] Johnson 1988, 80–92; Deichmann 1989, 64ff.; Baldini Lippolis 1997, 14–28; Augenti 2007, 438–41.

[188] Deichmann 1969, 171–200.

[189] See, e.g., Agnellus, *LP* 94.26, with Deichmann 1989, 153–54; Farioli Campanati 1992, 143.

[190] Such at least appears to be the sense of *Anonymous Valesianus*, 12.71: *palatium usque ad perfectum fecit* [Theodericus], *quem non dedicavit. portica circum palatium perfecit.* The porticoes along the *platea maior* are evidently the subject of the references cited in the following note.

[191] Two sixth-century documents make conspicuous mention of what are clearly public porticoes situated in close proximity to Theoderic's palace, which almost certainly refer to the section of the *platea maior* (along which the mint cited in one of the documents was also located) giving onto the principal entrance of the palace *ad Calchi*: See *Anon. Val.* 14.84: *item mulier pauper de gente Gothica, iacens sub porticu non longe a palatio Ravennati, quattuor generavit dracones* (the surely credible topographical detail will have lent an air of plausibility to the miraculous event); and the subscription of a papyrus dating to 572, written by a public notary based in the porticoes separating the palace proper and the mint, which is to say those along the *platea maior: Fl(avius) Iohannis, for(ensis) huius splendedissimae [sic] urbis Ravennatis, habens stationem ad Monitam auri in porticum Sacri Palati, scriptor huius instrumenti* (Tjäder 1955–82, vol. II, p. 35, lines 87–90). Cf. Zirardini 1762, 174–80; Ortalli 1991, 174; Farioli Campanati 1992, 144.

[192] Verzone 1966, 440–41; Mazzotti 1968–69; Farioli Campanati 1989, 142–43.

[193] Deichmann 1974, 1–47, 193–208.

monumentalized after 402, as the connector between the twin poles of secular and ecclesiastical government, an architectonic extension of the intertwining of civic and ecclesiastical authority so essential to the vision of a Christian Roman empire championed by Theodosius I and his heirs. This road, the principal east-west axis in the late antique city, was the urban extension of the old highway leading to Rome, the Via Popilia, which entered the city through a monumental gateway erected under the emperor Claudius, itself included in the fifth-century circuit of walls and renamed — in all probability in the fifth century — the Porta Aurea, in memory of the gate in the new Theodosian land walls of Constantinople.[194] From the episcopal complex, the road proceeded across the River Po on a bridge identified in later medieval sources as the 'covered' bridge (*pons copertus*),[195] past the imperial mint for gold coinage (the *moneta aurea*) located just north of the point where it crossed the *platea maior*,[196] on past the orthodox palatine chapel of Saint John the Evangelist, constructed during the reign of Valentinian III,[197] and finally on — very possibly in a direct line — to the gate in the eastern flank of the late antique circuit called the *porta palatii*.[198] Its porticoes, or the memory thereof, would endure for close to a millennium: in the tenth and eleventh centuries, when the road again connected the episcopal complex with the seat of civic government at the palazzo comunale, the two churches of *S. Georgio de porticibus* and *S. Giustina in capite porticus*, situated between the episcopal complex and the *platea maior*, still derived their popular designations from the porticoes lining the street, which remained the center of civic life in the medieval city (Figure 3.11).[199]

By the time of Theoderic's death in 527, then, the 'topography of power' assembled over the 125 years since the arrival of the imperial court and the resulting elevation of Ravenna to a position of ecclesiastical and administrative preeminence was largely complete. The orthodox and Arian episcopal complexes, the sprawling palatial quarter with its associated palatine churches, royal mint and monumental entrance vestibule *ad Calchi*, were all directly

[194] Farioli Campanati 1989, 140; *ead.* 1992, 139–40; cf. Christie and Gibson 1988, 163. The road through the Porta Aurea did not lead directly to the episcopal complex, but will nonetheless have comprised the first segment of the urban itinerary followed by anyone entering the city along the Via Popilia, bound for the nearby episcopal complex and/or the palatial quarter beyond.

[195] Mazzotti 1971, 374–75.

[196] Caroli 1974, 140ff.; Deichmann 1989, 54–56; Augenti 2010, 345–46; the first phase of the complex likely dates to the first half of the fifth century; it was restored in the first half of the sixth.

[197] Deichmann 1974, 91–124; Farioli Campanati 1992, 137–38.

[198] Farioli Campanati 1992, 137. The precise location of the *Porta Palatii* is unknown, and unlikely to be discovered because of the almost complete disappearance of the walls in this sector of the city; it may possibly have lain just south of the street in question, in line with the parallel road running past S. Apollinare Nuovo.

[199] Mazzotti 1968–69; 1971; Farioli Campanati 1989, 142–43.

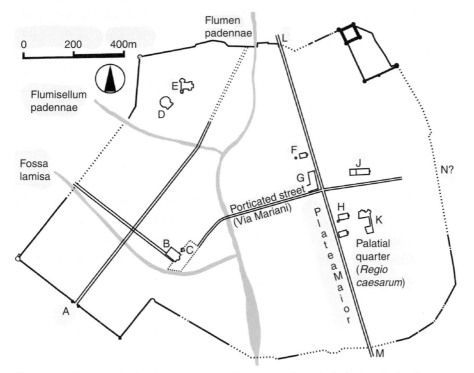

Figure 3.11 Ravenna in the sixth century. A: Porta Aurea; B: cathedral; C: orthodox baptistery and episcopal complex; D: San Vitale; E: Santa Croce; F: Arian cathedral and baptistery; G: mint; H: Sant'Apollinare Nuovo; J: S. Giovanni Evangelista; K: Theoderic's palace (1917 excavations); L: Porta Serrata; M: Porta S. Lorenzo; N: *Porta Palatii*? (Author.)

accessible from, and linked to each other by, the converging axes of two prin-cipal streets. These streets, architectonically elevated above the rest by their flanking porticoes and connected to the principal gates in the circuit-wall, structured and defined the urban experience of Ravenna, channeling the flow of traffic and majestically framing the approaches to those buildings that most visibly and effectively proclaimed the ascendancy of their inhabitants and the institutions of church (orthodox and Arian) and government (western impe-rial, Gothic, and Byzantine) they championed. As at Constantinople, which the architects of Ravenna's transformation strove so diligently to emulate, the monumental core of the city was engineered to compress the experience of a much larger, more chaotic and undoubtedly less architecturally distinguished urban conglomeration into an architectonic *mise-en-scène*, a city within a city that translated the language of temporal and spiritual sovereignty into the realm of built space.

And as at all of the other late antique capitals hitherto discussed, so too at Ravenna, that language of power was never more ostentatiously proclaimed, nor more integrally connected with its architectural context, than during those moments of ceremonial high drama when bishops and rulers paraded

in majesty through the main streets of the city. While we know relatively little of the particulars of the ceremonies that unfolded at Ravenna, both regarding recurring events such as liturgical processions, and exceptional occasions such as *adventus* and victory celebrations, it is beyond doubt that Ravenna's porticated avenues regularly hosted processions similar to those attested at, for example, Rome and Constantinople. Much of what is known comes from Agnellus, whose repeated evocations of the gates and main streets, bedecked with flowers and tapestries to receive the protagonists at the heart of defining moments in Ravenna's storied past, reveal, if nothing else, the extent to which the decaying monumental contours of the ninth-century city continued to resound with the echoes of celebrations long past.

In his account of the negotiations that led to Attila's decision to spare the city from destruction in ca. 450, Agnellus has Attila depart amidst general rejoicing, hailed for his clemency by the crowds lining his route: 'Therefore the king went out from the city; [the people of Ravenna] went before him with great acclamations, with all the streets adorned and the city decorated with all manner of flowers.'[200]

When Maximian entered the city in 546 to be consecrated archbishop, following bitter disputes over the episcopal succession, 'all set out in unanimity, as though one person, and opening the gates of the city, with crosses and signs and banners and praises they honorably conducted him inside this city of Ravenna; and they kissed his feet and adorned the streets of the city with various ornaments. All the buildings were crowned [bedecked with flowers], and there was public rejoicing among the contending parties.'[201] Two centuries later, when a Byzantine attack was repulsed on the feast day of John and Paul, the people of Ravenna began to mark the anniversary 'almost as though it were the holy festival of Easter, adorning the streets of the city with many tapestries, and setting out in a liturgical procession (*lethaneis*) to their [*sc.* John and Paul's] church.'[202] It might also be recalled that the site of Valentinian's palace *ad Laureta* was, for Agnellus, entwined with the memory of a 'triumphal victory once celebrated in that place,'[203] an association that evokes shades of the triumphal processions

[200] *LP* 37.250–52: *Igitur rex egressus extra civitatem, magnis laudibus ante eum praeibant, ornatasque cunctis plateis diversisque floribus civitas decorata.*

[201] Ibid., 71.78–83: *Tunc surgente aurora ierunt unanimes omnes quasi vir unus, et aperientes portas civitatis cum crucibus et signis et bandis et laudibus introduxerunt eum honorifice infra hanc civitatem Ravennae, et osculaverunt pedes eius et ornaverunt plateas civitatis decoratas diversis ornatibus. Omnesque coronantur aedes, fiebat militantibus laetitia.*

[202] Ibid., 153.78–81: *Hoc autem factum est in die sanctorum Iohannis et Pauli, et coeperunt agere diem istum quasi diem festum paschae, ornantes plateas civitatis cum diversis palleis et letaneis ad eorum ecclesiam gradientes.* The church in question was built in the sixth century, near the *posterula S. Zenonis* in the western flank of the city wall.

[203] Ibid., 40.360–62: *[Valentinianus] regalemque aulam struere iussit in loco qui dicitur ad Laureta. Ideo Laureta dicitur quia aliquando triumphalis victoria facta ibidem fuit.*

that subsequently unfolded along the stretch of the *platea maior* – the Mese or Regia, as it were, of late antique Ravenna – in the midst of the palace.

Whatever the relationship between Agnellus' visions of past urban ceremony and the reality they purport to represent (and he likely did draw some of his information from earlier sources that have since perished), his sense of the city's monumental infrastructure as the stage upon which marvelous pageants were enacted is noteworthy. Agnellus' continued inclination to perceive his surroundings as processional space, and to imaginatively layer crowns of flowers and teeming multitudes over a backdrop of city gates, streets and crumbling palaces, suggests something of how successful Ravenna's fifth- and sixth-century rulers were in creating a physical landscape infused with the memory of their public appearances, a space capable of invoking an aura of the very epiphanies it was designed to facilitate. Agnellus, in other words, seems to have perceived the cityscape and the semiotics of power encapsulated therein in much the way Theoderic, for example – whom we know best of all Ravenna's late antique rulers – intended it to be perceived.

Agnellus' famous description of Theoderic's palace indicates that the pediment of the main entrance to the palace *ad Calchi* was decorated with a mosaic depicting the king on horseback, armed with lance and shield, surrounded by personifications of Rome and Ravenna.[204] A second equestrian portrait, this the famous statue later taken by Charlemagne to Aachen, stood in front of the entrance.[205] The equally famous mosaic depiction of Ravenna at Sant'Apollinare Nuovo in fact shows what must be the Calchi, in the form of a tetrastyle entrance porch surmounted by a triangular pediment (bearing the designation PALATIUM) that once contained an equestrian portrait, surely an echo of the mosaic described by Agnellus (Plate I).[206] The entrance is flanked by lower, arcaded colonnades, which may have been meant to represent – or better, to call to mind – the colonnaded façade of the palace along the *plateia maior*, in the midst of which the Calchi was indeed located, and which Theoderic is said to have built.[207] Yet the presence of a city gate, bearing

[204] *LP* 94.20–34: *Post vero depraedata a Langobardis Tuscia; obsiderunt Ticinum, quae civitas Papia dicitur, ubi et Theodericus palatium struxit, et eius imaginem sedentem super equum in tribunalis camerae tessellis ornatam bene conspexi. Hic autem similis fuit in isto palatio quod ipse aedificavit, in tribunale triclinii quod vocatur Ad mare, supra portam et in fronte regiae quae dicitur Ad Calchi istius civitatis, ubi prima porta palatii fuit, in loco qui vocatur Sicrestum, ubi ecclesia Salvatoris esse videtur. In pinnaculo ipsius loci fuit Theoderici effigies, mire tessellis ornata, dextera manu lanceam tenens, sinistra clipeum, lorica indutus. Contra clipeum Roma tessellis ornata astabat cum hasta et galea; unde vero telum tenensque fuit, Ravenna tessellis figurata, pedem dextrum super mare, sinistrum super terram ad regem properans.*

[205] *LP* 94.36–43.

[206] The silhouette of the figure excised when the mosaics were reworked in the 560s, preserved in the mortar backing of the mosaic, is clearly in the shape of a mounted rider; see, e.g., Deichmann 1974, 143–45; Baldini Lippolis 1997, 16–19. On the historical context of the reconfiguration of the mosaics, see nn. 224–26.

[207] See nn. 189–91; Cf. Deichmann 1989, 75.

the legend CIVITAS RAVENN(AS), shown directly abutting the outermost column of the arcade on the right side of the image, demonstrates that the vignette as a whole is highly schematic.[208] While its bearing on the topography of the 'real' city can be (and has been) endlessly debated,[209] the image is sufficiently illuminating when taken purely on its own terms, as a visual compression of the elements considered most essential to the presentation of Theoderic's capital. Seen in this light, the message seems quite clear: the palatial quarter of the city, the *regio Caesarum*, was to be understood, epitomized, symbolized as a city gate, opening onto an arcade – a porticated street – that in turn led directly to the entrance of the palace itself, the seat and embodiment of Theoderic's rule, the 'fair face of *imperium*,' as Cassiodorus put it.[210]

The figures originally present in the intercolumniations of the palace façade, hands raised to acclaim Theoderic as he processed to or (more likely) from the palace,[211] provide a crucial interpretive key to the mosaic's selective distillation of urban topography: the gates, colonnaded *platea* and palace are the essence of the city, insofar as they constituted the monumental backdrop that underpinned the ceremonial processions of the king, and proclaimed his capital a locus of rarified temporal power. Such is precisely the sequence of monuments that Theoderic would have traversed when approaching or leaving the main entrance of his palace, via the porticated expanse of the *platea maior* and the gates that bracketed its northern and southern extremities, the Porta Serrata and the Porta S. Lorenzo, respectively. The placement of Theoderic's equestrian statue, and the closely related mosaic on the façade of the Calchi, at the juncture where the arcades of the *platea* opened onto the entrance to the palace, marked the culmination of the triumphal itinerary, the very spot shown at the center of the urban vignette at Sant'Apollinare Nuovo, where the reproduction of the equestrian portrait on the Calchi stood in suggestive visual counterpoint to the depiction of the king in the act of processing through the city. Like Justinian's equestrian statue in the Augusteion by the entrance to the palace at Constantinople,[212] these images permanently embedded the

[208] Cf. Baldini Lippolis 1997, 18–19.

[209] For a convenient summary of the principal points of discussion, see Deichmann 1989, 70–75.

[210] Cassiodorus, *Var.* 7.5.1: *Formula curae palatii: Haec nostrae sunt oblectamenta potentiae, imperii decora facies, testimonium praeconiale regnorum: haec legatis sub ammiratione monstrantur et prima fronte talis dominus esse creditur, quale eius habitaculum comprobatur.*

[211] The acclaiming figures seem to have been facing toward the viewer's left, the direction taken by a procession, presumably led by the king himself, shown exiting the city and processing toward the representation of Christ in majesty still visible at the far (east) end of the nave arcade; the processing figures were replaced in or shortly after 560 by the file of Byzantine saints that currently occupies the register immediately above the arcades of the nave; see the sources cited at nn. 224–25.

[212] Cf. Bauer 2001, 49.

presence of the sovereign in the heart of the most symbolically charged real estate in the city, as a constant reminder of those moments when he appeared in person among his subjects, processing amongst them on horseback in full martial regalia.

Under Theoderic, then, topography and iconography combined to transform Ravenna into a vessel for the triumphal epiphanies of the king. In constructing (or reconstructing) the exterior colonnades of the palace and thereby framing the Calchi gate and integrating its approaches into the porticoes of the *platea maior*, Theoderic reified the nexus between city gates, porticated street and royal dwelling that defined the architectural language of temporal rule in the early sixth century, and remade Ravenna in the image of the greatest capital of the age, Constantinople. The ultimate confirmation of the cohesiveness of the urban template envisioned by Theoderic relates not to Ravenna, however, but to Verona, the second city (along with Pavia) of the realm. Immediately after describing the porticoes erected around the palace at Ravenna, the author of the *Anonymous Valesianus*, Theoderic's younger contemporary, turned to Verona, where the king 'Likewise (my emphasis) at Verona built baths and a palace, and constructed a portico from the city-gate as far as the palace.'[213] To transform Verona from a provincial center into a seat of power, what was needed was a palace, connected to a city gate by a porticated street: an urban armature, that is, fit for the arrival of a king, particularly a king as steeped in the traditions of late Roman triumphal ideology as Theoderic manifestly was.[214]

3.8 THE INTERSECTION OF 'REAL' AND 'IDEAL': CITIES DEPICTED

Nowhere is the capacity of these porticated armatures to streamline and condense the physical and ideological components of the urban experience more apparent than in the extant depictions of cities produced in both the eastern and western Mediterranean in the fifth to eighth centuries. Rather than seeking to produce comprehensive plans of cities, late antique artists strove to capture the idea of 'city'; to imply the whole through a limited canon of

[213] *Anon. Val.* 12.71: *hic* [Theodericus] *aquae ductum Ravennae restauravit, quem princeps Traianus fecerat, et post multa tempora aquam introduxit. palatium usque ad perfectum fecit, quem non dedicavit. portica circum palatium perfecit. Item Veronae thermas et palatium fecit et a porta usque ad palatium porticum addidit. aquae ductum, quod multa tempora destructum fuerat, renovavit et aquam intromisit. Muros alios novos circuit civitatem. item Ticino* [Pavia] *palatium thermas amphitheatrum et alios muros civitatis fecit.*

[214] Generally on Theoderic's appropriation of the imperial language of triumphant sovereignty, see MacCormack 1981, 229ff; McCormick 1986, 267–84; on his triumphal *adventus* to Rome, celebrated in rigorously traditional, even archaizing fashion, see Fraschetti 1999, 242ff.

representational tropes centered on the features most readily associated in the minds of viewers (or patrons, or artists) with the concept of *polis* or *civitas*.[215] It is thus the more noteworthy that after city walls, porticated streets are perhaps the single most distinctive feature of the cityscapes depicted in extant manuscripts and mosaics commissioned under the aegis of church and state, which is to say by the same class of patrons responsible for reshaping real cities into visual panoramas largely defined by walls and colonnades.

The most salient examples in the manuscript tradition appear in the *Notitia Dignitatum*, a detailed catalogue of the administrative subdivisions of the empire compiled around the beginning of the fifth century, preserved in a sixteenth-century copy that seems to reproduce quite faithfully the illustrations – at one remove – of a late antique exemplar.[216] Two sections of the 'western' half of the document, both devoted to the commands of officials stationed in Italy, contain especially valuable illustrations. The image accompanying the list of forces at the disposition of the *Comes Italiae* depicts the fortified passes of the Alps, at the base of which stands a city, labeled 'Italia,' that stands in for the region as a whole (Plate II).[217] An almost identical cityscape represents the provinces of Apulia and Calabria, joined under the governorship of the *Corrector Apuliae et Calabriae*.[218] Both images are dominated by the profile of a hexagonal city wall, the three visible faces of which occupy approximately half of the urban vignettes as a whole. A centrally placed gate in the façade of the wall opens onto a single dominant intramural feature, an arcaded street colonnade, roofed with vivid red tiles, that departs from the gate at an oblique angle, bends sharply off to the right and continues as far as the receding profile of the wall, presumably to connect with another city gate.

This remarkable compression of the urban image into a schematized ensemble of city wall, gate and colonnaded street finds its closest parallels in a number of mosaics datable between the fifth century and the seventh, all of them, interestingly enough, from Italy. The earliest are the representations of Jerusalem and Bethlehem on the spandrels of the triumphal arch at Santa Maria Maggiore at Rome, built under Pope Sixtus III (432–40). Here, too, the contours of the cityscape are defined by the profile of a hexagonal city wall, in this case bedecked

[215] See Dey 2014.

[216] This copy, now at the Bayerische Staatsbibliotek (BSB-Hss Clm 10291; online in its entirety at: http://daten.digitale-sammlungen.de/~db/bsb00005863/images/index.html), was made for the Elector Palatine of the Rhineland, Otto Heinrich, in 1542; at his express request, the illustrations of the now lost original were copied exactly, without the addition of any modernizing anachronisms (see the preface of Seeck's 1876 edition, at ix–x and ff.). The lost manuscript, evidently a very close copy of a late antique manuscript, dates after 825. For an up-to-date summary of the questions regarding the dating and historical context of the *Notitia* itself, see Neira Faleiro (ed.) 2006.

[217] *N.D. Occ.* 24; Seeck (ed.), p. 173.

[218] *N.D. Occ.* 44; Seeck (ed.), p. 222.

with jewels in a fashion recalling the description of Celestial Jerusalem in the Book of the Apocalypse (*Apoc.* 10: 10–21),[219] above which only the roofs of a few intramural structures are visible. The gate in the wall opens onto the receding profile of a monumental street colonnade, which joins the wall as the most visually arresting component of the scene (Plate III). The iconographical signposts used to convey all the physical and spiritual grandeur of Jerusalem and Bethlehem, in their quality as superlative embodiments of the (Christian) metropolis, boil down to an interlinked armature of city wall and colonnaded street. It is precisely the vision that would have confronted real visitors as they approached the walls and passed through the gates of the urban showpieces of late antiquity, from Constantinople, to Justiniana Prima, to – as we shall see – Jerusalem itself.

More than two centuries later, in the oratory of S. Vincenzo, annexed to the Lateran Baptistery in the 640s under popes John IV and Theodore I, Jerusalem would again be signified by the image of a wall, a gate and a two-story colonnade (Plate IV). While the form of the cityscape – which appears in the same position on the spandrel of the triumphal arch as the example at Sta. Maria Maggiore – was doubtless inspired by earlier precedents, the fact remains that in the seventh century as much as the fifth, the essence of the Christian city was best conveyed to a Roman audience by the vision of a wall and a gate opening onto a colonnaded street.

Elsewhere in Italy, there is the representation of the port city of Classe, located above the nave arcade in Theoderic's new palace-church of Sant'Apollinare Nuovo, built adjacent to the royal palace in Ravenna in ca. 500.[220] Once again, the predominant feature is the city wall, flanked on the right by a gate and on the left by a view of the port itself. Above the wall, the view of the interior of the city centers on the profile of two large, round buildings, never convincingly identified, which are connected by the unmistakable silhouette of a porticated street, the arcades and tile roof of which closely resemble the examples depicted in the *Notitia Dignitatum* (Plate V).[221] Whatever the two buildings represent, the intramural topography of Classe is epitomized in the form of a single monumental itinerary, a colonnaded avenue linking the most imposing structures in the city, the rightmost of which may in turn be connected to the city gate by the suggestion of an additional, trabeated colonnade.

In the more famous vignette of Ravenna, located *en pendant* just across the nave, the colonnaded façade of Theoderic's *palatium* abuts a city gate,

[219] Cf. De Seta 1989, 11ff.; Farioli Campanati 1999.
[220] Generally on the date and location of the church, see Deichmann 1974, 127–30.
[221] Deichmann 1969, 172–73 (with Abb. 260), suggests that the round building on the left may be a theater or amphitheater; the second round structure is heavily restored (ibid.); cf. Deichmann 1976, 145–46. While much of the porticated street is likewise restored, enough remains to show it was there from the beginning.

almost certainly the *Porta S. Laurentii*, through which the road leading through the suburb of Caesarea and on to Classe entered the city (Plate I). Thus, the principal ceremonial axis of the city, from the *Porta S. Laurentii*, along the – colonnaded – *platea maior* and thence to the royal palace, becomes a binary pairing of gate and palace, joined by a colonnade that likely recalled the intervening street as much as the façade of the palace itself.[222] Just as Theoderic's royal capital at Ravenna was to be experienced in a stately progression of monuments linked by a colonnaded avenue, so was the adjacent port of Classe, both in mosaic and, in all probability, in reality: excavations undertaken in Classe in the 1970s and 1980s in fact uncovered a lengthy tract (running for ca. 500m) of what was almost certainly the main street leading away from the harbor; the street was repaved, provided with new sewers, and lined on both sides with porticoes supported by brick pilasters at the end of the fifth century, scant years before the execution of the mosaics at Sant'Apollinare Nuovo.[223]

The markedly ceremonial character of the topography represented in the images of Ravenna and Classe was further accentuated by the presence of King Theoderic and his entourage, who almost certainly appeared in both cityscapes, filling the intercolumniations of the palace façade in the depiction of Ravenna (much like the onlookers in the Constantinopolitan 'Trier Ivory'), and silhouetted against the walls of Classe.[224] The fundamental nexus between (urban) architecture, ceremony and the construction of regal legitimacy would have gone unrealized without the presence of the king, who animated the monumental armature of Ravenna and Classe with his public appearances, and maintained its architectural decorum with his patronage. Hence, following the Byzantine reconquest of the city in 540, all trace of human presence was expunged from both cityscapes, when the formerly Arian palace-church was rededicated to St. Martin of Tours under Archbishop Agnellus (ca. 557–70).[225] Bereft of the ceremonial pageantry that had proclaimed the regal status of the city and the glory of its (Arian) Gothic ruler,

[222] It has indeed been suggested that the image represents an attempt at a perspectival rendering of the final stretch of the colonnaded avenue (the Regia) leading to the Chalke gate: v. Deichmann 1974, 144, with the discussion in n. 191.

[223] Maioli 1980; 1983, esp. 67–69 and 73–74. The street was again repaved with large blocks of basalt in the mid-sixth century, shortly after it passed back into Byzantine hands, a costly initiative that tends to support the identification of this porticated avenue as the principal thoroughfare in the city.

[224] The scholarly consensus now leans heavily in favor of identifying the effaced figures in the intercolumniations of the palace at Ravenna with Theoderic and members of his court, along, perhaps, with the Arian bishop of the city. The hands of the figures, still silhouetted against the columns, suggest that the protagonists of the scene were shown making a gesture of acclamation, almost certainly to hail the arrival (or departure) of the king himself: see Bovini 1966; Deichmann 1974, 144–45; MacCormack 1981, 237; and – more cautiously – Wood 2007b, 252–60.

[225] Agnellus, *LP* 86–88; Farioli Campanati 1992, 145–48.

the architectural background remained, innocuous, generic, shorn of royal pretensions, befitting the administrative seat of a peripheral and humbled province of the Byzantine empire.[226]

Turning to the eastern Mediterranean, the best-known depiction of a late antique cityscape in the region is undoubtedly the image of Jerusalem placed at the center of the Madaba Map Mosaic, a tesselated floor-pavement from the church of St. George in Madaba, Jordan, that depicts the geography of the Levant, from Egypt in the south to the borders of Asia Minor in the north (Plate VI).[227] The centerpiece of the whole composition, the city of Jerusalem is shown larger and in considerably more detail than any of the other cities on the map. The ovoid periphery of the city wall, rendered in bird's-eye perspective, circumscribes an ensemble of intramural topography dominated by the contours of two colonnaded streets, both of which depart from a roughly semi-circular plaza located just inside the northern gate of the city, today's Damascus Gate. The two most monumental structures depicted both connect directly to the colonnades of the central *cardo*: the Church of the Holy Sepulcher, placed farther south than its actual location to lie in the very center of the city, and thus the map as a whole, and Justinian's new church of the Virgin Mary, the *nea ecclesia*, at the southern extremity of the same street (its dedication in 542/43 provides the *terminus post* for the mosaic). A third monumental structure, probably the Church of Holy Zion, lies just beyond and to the west of the point where the street terminates.[228]

While the focus is clearly on the religious topography of the city, the monumental armature remains firmly in the mold of the late antique capital. A central core of colonnaded streets connects the principal gates in the city wall with the most prominent focal points of intramural life, presented in the form of three preeminent churches.[229] The mosaicist's vision indeed closely mirrors that of Justinian himself, whose most salient intervention in the topography of the real city aimed precisely at accentuating the architectonic profile of the *cardo maximus*, the colonnades of which were extended for hundreds of meters south of the tetrapylon at the crossing of the *cardo* and *decumanus*, as far as the façade of the newly completed Nea church.[230] The principal colonnaded thoroughfare of the city, nearly doubled in length, was thenceforth bracketed by the Church of the Holy Sepulcher in the north, and Justinian's

[226] Cf. Baldini Lippolis 1997, 127–28; Urbano 2005, 92–98.

[227] The map has been the subject of a vast amount of scholarship; for a comprehensive overview, see the various contributions in Piccirillo and Alliata (eds.) 1999.

[228] For these identifications, and generally on the topographical configuration of the city as it appears in the mosaic, see Tsafrir 1999; Pullan 1999; Dey 2014; on the *nea ecclesia*, see also Avigad 1993.

[229] Cf. Pullan 1999.

[230] This section of the street was either built for the first time, or otherwise reconstructed *ex novo* in monumental form under Justinian: see Avigad 1993; Tsafrir 1999, 160–62.

massive new church in the south.[231] These twin poles, connected by an unbroken line of colonnades, anchored the ceremonial topography of a city that, for the first time since its elevation to patriarchal rank at Chalcedon in 451, boasted an architectural centerpiece worthy of its lofty status, a space in which the patriarchs of Jerusalem could be seen to rival their colleagues in Rome, Constantinople, Antioch and Alexandria.[232]

The visual perspective of the mosaic is thus clearly rooted in contemporary reality, for all that the representation of Jerusalem is hardly a faithful rendering of its architecture and topography. The irregular profile of the city wall is depicted as a perfect oval; side streets are nonexistent, as is the Temple Mount; and the majority of the buildings that fill the interstices between the wall and the colonnaded streets are schematically rendered and difficult to identify. Yet the diverging profile of the two colonnaded streets shown on the map squares remarkably well with their actual configuration, still preserved in the contours of the two modern streets that faithfully follow their course, the Tariq Khan ez-Seit and the Tariq el-Wad (Figure 3.12).[233] A comparative glance at Plate VI and Figure 3.12 will make this point best: by far the closest correspondence between the mosaic and the real city occurs in the profile of the two colonnaded streets, the (real) spaces that surely not coincidentally did most to define the experience of the city for those who saw it firsthand, from – naturally – street level.

In condensing the symbolic hallmarks of the city into an ensemble of colonnaded streets and grand churches, which corresponded in its essentials with the disposition of those monuments on the ground, the makers of the mosaic succeeded in creating a vision of Jerusalem that would have been as edifying for the residents of Madaba who saw it on the floor of the church as it would have been plausible for those who regularly traversed the city center, or participated in the processions between the three churches that anchored the liturgical topography of the city and proclaimed its unique place at the epicenter of the Christian cosmos. The monumental corridor in the midst of the city, expanded and embellished by Justinian, was simultaneously a reality susceptible to (near-) cartographic reproduction, and an ideal landscape designed to convey the essence of Jerusalem as the Christian capital *par excellence*.

That the archaeological map of Jerusalem on the one hand, and its features as shown on the Madaba Map on the other, correspond most closely in the positioning of the two colonnaded streets and the principal edifices attached to the central *cardo* is compelling testimony to what all of the 'western' images

[231] Cf. Pullan 1999, 167ff.
[232] For examples of processional ceremonies in Jerusalem that unfolded in these spaces, some of which continued long after the city passed under Muslim rule, see Baldovin 1987, 61–63, 78, 100–02.
[233] Tsafrir 1999, 159.

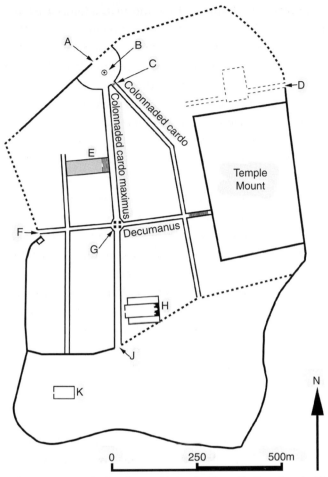

Figure 3.12 Jerusalem in late antiquity. A: Neapolis Gate (just inside modern Damascus Gate); B: open plaza and column; C: arch; D: Eastern Gate/Lion Gate; E: Holy Sepulcher complex; F: Western Gate; G: tetrapylon; H: Nea Church; J: Nea Gate; K: Church of Holy Zion. (Author.)

discussed earlier already strongly suggest: the story of the late antique metropolis is not – not always, in any case – characterized by a profound divergence between 'image' and 'reality,' a widening chasm between rosy, anachronistic literary and artistic tropes applied to ever-more squalid cityscapes, but rather by the methodical privileging of a very selective reality.[234] The Madaba Map's Jerusalem translated the material essence of the city in its 'Justinianic' form into an iconic panorama, a visual itinerary that closely mirrored the ensemble of gates, colonnaded avenues and churches consciously designed to define the experience of the real city. The images of Ravenna and Classe at

[234] These points are made in more detail in Dey 2014, which includes several additional examples of city vignettes focusing on central colonnaded armatures that correspond closely to reality, such as the image of Alexandria from the Church of St. John the Baptist at Madaba, dedicated in 531.

Sant'Apollinare Nuovo functioned in much the same way, adding only the palace that proclaimed Ravenna the seat of an earthly monarch. In sum: the colonnaded streets, with their associated gates, churches and palaces, that loomed so large in the civic and religious life – and ceremonial – of the late antique capital were as real and imposing as ever in the sixth century, present-ing the same exemplary urban façade that artists captured in their depictions of cities, both real and, in the case of Celestial Jerusalem, imagined.

3.9 CONCLUSIONS

Porticated streets, then, were the places where the dominant personalities in late antique society most effectively displayed themselves to the urban masses, where they acted out their status as civic and/or religious leaders, and drove home the majesty of their offices to the largest possible number of people. The unfolding of ceremonial processions brought together all members of the urban populace, framed by stately lines of receding columns, in a seamless blend of architecture and bodies that came to stand for, and in a sense to be, the city as a whole. As long as there was a processional way and people to fill it, there was in a real sense a city, regardless of the condition of the neighbor-hoods behind the porticoes, some still teeming with life in the sixth cen-tury (Constantinople, Ephesus, Ravenna); some ruined (Antioch); some almost nonexistent (Justiniana Prima). In condensing the architectural, commercial and symbolic essence of the city into the profile of a porticated street and its associated monuments, emperors, governors and bishops achieved a kind of architectural shorthand, a relatively economical means of preserving the appearance of capital cities and ensuring that the urban spectacle lived on.

Yet perhaps the strongest testament to just how powerful the physical, con-ceptual and functional legacy of these central urban itineraries ultimately became is the signs of their continuing relevance even in the seventh century and later, in a definitively post-Roman world in which the social, political and economic structures that had underpinned the flourishing of 'classical' urbanism had changed almost beyond recognition, as had the cities themselves, when they survived at all. It is to this changed world of the seventh to ninth centuries, the darkest of the 'Dark Ages,' that we now turn, in an effort to trace further the nexus between urban topography and what we might call spatial praxis – the use and experience of lived space – in the crucial transitional cen-turies between late antiquity and the early Middle Ages.

CHAPTER FOUR

'DARK AGES' AND THE AFTERLIFE
OF THE CLASSICAL CITY

4.1 CITIES, THE SEVENTH CENTURY AND THE BEGINNING
OF THE MIDDLE AGES

The passages in Agnellus' *Liber Pontificalis* cited in the preceding chapter,
steeped as they are in the urban and symbolic legacy of Ravenna the imperial,
Ostrogothic and exarchal capital, might be dismissed as the product of
antiquarian nostalgia or as a tendentious attempt to bolster the prestige of
a city that had been politically marginalized since the end of the Byzantine
exarchate in 751. And it is undoubtedly true that Ravenna had changed greatly
since its sixth-century heyday, as indeed had cities across the full extent of the
former Roman empire, albeit in different ways, and for different reasons. The
chronology and causes of the process whereby the public buildings, atrium
houses and *insulae* characteristic of cities in the second century AD lost their
pristine monumentality and often indeed disappeared entirely vary immensely
from one region to the next. Thus, while a 'Roman' (or Greco-Roman) urban
paradigm applies, albeit again with infinite regional variations, from one end
of the empire to the other, there is no single 'early medieval' paradigm that can
remotely capture the variety of urban contexts that prevailed across the same
geographical sweep in the seventh and eighth centuries.[1] Had Agnellus been

[1] For a sense of the range of urban possibilities in the early Middle Ages, Wickham's survey will
suffice (Wickham 2005, 591–692).

writing in England or the Balkans, for example, we would probably have to dismiss as pure fantasy his sense that his ninth-century surroundings descended in a direct and unbroken continuum – in both physical and conceptual terms – from their late antique incarnations.

In Britain, the disintegration of any form of effective central authority upon the departure of the Roman legions at the beginning of the fifth century, followed by the arrival from the Continent of peoples mostly innocent of Roman urban culture, provoked a relatively profound rupture in patterns of urban settlement over the course of the fifth century. Many towns that had continued to vaunt conspicuous elements of monumental infrastructure during the fourth century – new or repaired city walls, streets, forums, temples, basilicas, and so forth – were completely abandoned, while those that remained inhabited seem to have been given over to essentially anarchic patterns of occupation: to habitation, that is, by populations that apparently had neither much interest in maintaining existing civic infrastructure, nor the will – and thus the capacity – to effect significant topographical interventions in a coherent, or 'communal,' manner.[2] While there is continuity of occupation on some sites, there is, it seems, very little in the way of functional or institutional continuity.[3] In the absence of a conscious effort to preserve elements of the Roman urban heritage, the Romano-British city ceased to be relevant, both as a cultural institution and as a built reality.

While the Balkan peninsula also suffered – like the rest of the Roman West – the effects of repeated invasions and the breakdown of Roman territorial control over the course of the fifth century, the really profound rupture seems to have occurred there only from the end of the sixth century, when Slavs and Avars overran the entirety of the region, with the exception of scattered coastal enclaves and the metropolis of Thessaloniki.[4] As in the case of Britain, the most significant factor in the disappearance of an urban way of life appears – to me – to have been the disinclination of the new occupiers to see cities as places worthy of preservation, or indeed as culturally relevant entities. Existing urban populations either fled (many to Thessaloniki and Constantinople) or fell into the hands of the invaders, who made no archaeologically visible effort

[2] On both continued investment in monumental architecture and the maintenance of urban infrastructure in the fourth century – which, as elsewhere, appears to have depended primarily on state-sponsored initiatives – and the near-total disappearance of such initiatives in the fifth century, see Esmonde Cleary 1987 and esp. *id.* 1989; Wacher 1995, esp. 408–21; Faulkner 2000; Halsall 2007, 357–68.

[3] Wroxeter is one case where habitation continued from the Roman period at least into the seventh century (White 2000), though even here, as Halsall (2007, 359) has noted, the exiguous traces of occupation – in a place excavated to exceptionally meticulous standards – in crumbling Roman buildings hardly make a strong case for Wroxeter as 'something that we could call a town'; for further examples of continued habitation in some form (e.g., London, Canterbury), see Rogers 2011.

[4] Useful overviews include Poulter (ed.) 2007; Bowden 2003, 2010; Heinrich-Tamáska (ed.) 2011; cf. also Rizos 2013, 903, for interesting synthetic remarks on the relative deurbanization of the erstwhile Danube frontier from the fifth century.

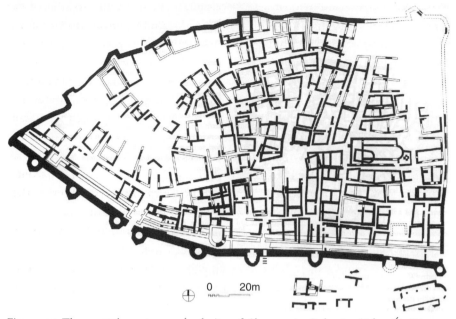

Figure 4.1 The seventh-century upland site of Shumen in Bulgaria. (After Ćurčić 2010, fig. 224.)

to establish themselves amidst the blasted ruins of the *civitates* that had continued to figure prominently in the social and administrative horizons of the region while it remained under Byzantine rule.[5]

If the example of Justiniana Prima illustrates the extent to which the authorities in Constantinople remained attached to the physical form and the ideological centrality of the late antique capital in the sixth century, its decay and abandonment by the seventh are equally indicative of the new conditions that prevailed with the end of Byzantine dominion.[6] Thereafter, the role of the cities as both showpieces and centers of provincial administration seems effectively to have ceased, a dramatic cultural reorientation best captured in the contours of the new sorts of nucleated settlements that took shape in the region from the end of the sixth century, such as Shumen and Sadovets in Bulgaria (their ancient names are – not insignificantly – unknown). With the exception of their solid, and surely very necessary, defensive circuits, these tiny, upland residential clusters betray no traces of coordinated urban planning, much less anything in the way of a monumental armature or public/ceremonial spaces (Figure 4.1).[7] They are dense clusters of haphazardly built houses separated

[5] See the sources cited in the preceding note. The brevity of the chapter devoted to the seventh and eighth centuries in Ćurčić's recent survey of architecture in the Balkans (2010a, 249–62) is particularly revealing; with the (partial) exceptions of Thessaloniki and, of course, Constantinople, there is very little to speak of in the way of monumental architecture anywhere in the region.

[6] The site seems to have been abandoned by ca. 615: see Bavant 2007, 337–38.

[7] On both, see Ćurčić 2010a, 214–16; also Kirilov 2007, 10–11.

by narrow alleys, composed of a few contiguous rooms with no sign of the atria typical of domestic architecture in the preceding period. In both form and function, in other words, such settlements are worlds away from Justiniana Prima, and from the late antique city in general.

In hindsight, then, Justiniana Prima appears a kind of wishful anachronism, a futile urban gesture soon swept away by transcendent historical forces. For the next two centuries, until the gradual Byzantine reconquest of the Balkans in the later eighth and ninth centuries, there was evidently nobody in the region, outside of the surviving coastal enclaves under Byzantine control, with either the means or the will to preserve and privilege late antique urban sites as monumental foci of settlement, administration and display.[8] Much the same can be said for early Anglo-Saxon England. Yet to my mind, cases such as these are more the exception than the rule: by showing what might so easily have happened more widely, they provide a revealing foil for the more numerous regional examples in which the striving after an urban habit, the effort to showcase an ideology of urbanity in tangible form, epitomized by Justiniana Prima in its original, sixth-century context, remained vital in the seventh and eighth centuries. Agnellus' vision of Ravenna in the ninth century, which would have been immediately comprehensible to anyone living there in the fifth or sixth, was not so much an antiquarian reverie aimed at resuscitating an urban ideology and reality that had been irretrievably lost in the interim as it was the product of an unbroken tradition. The ideological resonances and the practical functions of late antique monumental topography never entirely disappeared, even in a period as exceptionally tumultuous as the seventh and eighth centuries were, when the social, economic and political institutions of the late empire changed – not only in extreme cases such as Britain and the Balkans – into something distinctly different and 'early medieval.' The really striking thing, I think, is that in the regions discussed later in this chapter, from Spain to Byzantium, a certain topographical and conceptual essence of the late antique city lived on, in a period when cities throughout the former Roman empire might have become as peripheral to the ordering of society as they did in Britain and the Balkans, as indeed it has been suggested in one way or another that they did in a number of important recent studies.

For Liebeschuetz, it is primarily the decline of traditional civic institutions, particularly the *curiae* and the competitive politics of euergetism that led *curiales* in the early and high empire to take the leading role in civic government, including the maintenance and embellishment of urban topography, which resulted in the inexorable 'decline and fall of the Roman city,' in both East and West, between the fourth century and the seventh.[9] And certainly it is quite

[8] Cf. Hendy 1985, 76–85.
[9] Liebeschuetz 2001a.

clear that municipal councils had ceased to exist in their high imperial form almost everywhere by the seventh century, as Liebeschuetz shows, in large part as a result of the fiscal and administrative reordering of the empire undertaken beginning in the third and fourth centuries, which increased the financial burdens even as it reduced the prestige and political influence associated with curial service, as we have seen.[10] Thus, if by 'decline and fall of the Roman city' we intend simply the end of cities as places governed and adorned by *curiales/bouleutai*, then indeed they had 'fallen' – Rome included – by the seventh century.[11] In that case, however, we would beg completely the question of why so many 'Roman' cities remained as populous as they did through the seventh and eighth centuries, and why the leading members of society – who seem remarkably often to be the direct descendants of the local aristocrats who comprised the *curiae*, who had simply become bishops or government officials when such titles became more prestigious and influential than curial service[12] – still gravitated to them as widely and consistently as they did.

With regard to the cities of the eastern Mediterranean in particular, Byzantinists such as Wolfgang Brandes and John Haldon have stressed administrative factors to likewise argue for a profound hiatus in patterns of urban living and urban continuity in the seventh and eighth centuries, when, they suggest, Constantinople became the sole urban center of any real importance in the Byzantine empire. Their primary motive for proposing an almost total rupture between early and middle-Byzantine urbanism is succinctly stated in a coauthored chapter:

> Perhaps the single most important development should be seen in the State's transfer of attention from towns to rural settlements as key elements in its fiscal administration; it also made possible the evolution of a very different type of non-State-oriented urban centre from the ninth century and beyond, a type which evolved organically, with no State role at all (except as defensive or administrative centres, but not as necessary elements of a set of fiscal administrative structures upon which the State depended for the extraction of resources), in the context of the needs of their hinterlands for centres of exchange.[13]

Thus, for Brandes and Haldon, the 'Roman' city was, *primarily and fundamentally*, a place where taxes from the rural hinterland were collected and processed *on behalf of the state*.[14] With the radical reorganization of the Byzantine fiscal system and the introduction of the themes (essentially militarized administrative districts under the command of a 'general' or *strategos*) following the

[10] See Chapter 2.
[11] On the disappearance of the Roman senate in the early seventh century, Chastagnol 1996.
[12] Durliat 1990, 55–57; Laniado 2002; Rapp 2005, 172–207; Wickham 2005, 153–258.
[13] Brandes and Haldon 2000, 171.
[14] See also Brandes 1989, 1999; Haldon 1997, 92–124; 1999.

Persian and Arab invasions in the first half of the seventh century, urban centers no longer fulfilled this role because taxes were levied by theme rather than by individual city, and cities consequently dropped off the map.

Yet to my mind, the implication that 'defensive or administrative' considerations not strictly connected with 'a set of fiscal administrative structures upon which the State depended for the extraction of resources' are basically nugatory is already disconcerting. Even on a purely economic level, moreover, this approach would seem to suggest that while in the Roman period, cities served as clearinghouses for the productive surplus of their surrounding regions, this function was so narrowly connected to the financial demands of the state that cities lost their primary reason for being when themes supplanted *poleis* as the primary fiscal units in what remained of the empire; towns and cities thus disappeared for a couple of centuries, only to reappear 'organically' in the ninth when they again served the 'needs of their hinterlands for centres of exchange.' I cannot imagine why rural populations during the seventh and eighth centuries – and only during this period – had no such need for centers of exchange (or, for that matter, how 'hinterlands' might exist prior to and independently of their center).

In any case, while Brandes and Haldon are technically right that individual cities in the seventh and eighth centuries were less central – at least in theory – to the marshalling of essential resources on behalf of the Byzantine state than they had been before,[15] the observation hardly suffices to explain – or, perhaps better, to predict a priori[16] – the disappearance of cities, unless we really wish to think that cities had no other compelling reason for being. The same can be said for the views first expressed thirty years ago by Richard Hodges, according to whom the breakdown of the late Roman mechanisms of taxation in the successor kingdoms of the West resulted in the disappearance of anything that might reasonably be called a state, which requires a 'monopoly of force' to exist, whence 'The reinforcement of power by this monopoly of force necessarily entails taxation in order to maintain the force. This, of course, has a string of systemic consequences,' chief among them, for our purposes, the disintegration of the classical city along with the state and its replacement, after a predominantly rural seventh century, by the rise of new mercantile towns beginning in the eighth.[17]

[15] I say 'technically right' because although it is true that the *polis* was no longer the principal unit by which taxes were assessed and collected, the administrative and financial apparatus of the themes themselves remained heavily city based (see later in this chapter).

[16] Cf. Haldon 1997, 94.

[17] Hodges 1982, 186 and passim; cf. also Hodges and Whitehouse 1983. For a sensible critique of Hodges in relation to the – manifestly urbanized – Lombard kingdom, see Harrison 1993, 24 and passim, with the section on Lombard Italy later in this chapter. For a more general and extremely effective deconstruction, see Samson 1994, whose criticisms are not substantively rebutted in Hodges' later reiteration of his original theses (Hodges 2000); Verhulst likewise

In response, we might note that according to this perspective, neither the *poleis* of classical Greece, which certainly did not owe their existence primarily to the financial needs of an overarching imperial bureaucracy or 'state,' nor the *civitates* of peninsular Italy during the early empire, exempt as they were from the taxes levied on provincial cities, have much right to have existed, or at any rate to be called 'cities.' Further, from Byzantium to Visigothic Spain, Merovingian Gaul and Lombard Italy, cities manifestly did continue to serve as clearinghouses for the collection and redistribution of the products of their surrounding countryside. Across much of the West, the vast landed patrimonies controlled by urban-based bishops such as Bertram at Le Mans and Didier at Cahors in the seventh century would alone have sufficed to ensure cities' continuing importance as central nodes for the economic exploitation of their rural hinterlands.[18] But more: Durliat's meticulous – albeit controversial – marshalling of the written sources clearly does suffice to show that bishops across Iberia, Gaul and Italy consistently took in hand that most crucial task of late Roman *curiales*, the collection and redistribution of tax revenues on behalf of the 'state'; and they did so, moreover, from their seats in cities, which remained the primary fiscal units of the Visigothic, Lombard and Frankish kingdoms.[19] In Byzantium, meanwhile, from Anatolia to Sicily, while tax revenues were calculated by theme rather than by city from the seventh century, it is quite clear that the officials (*kommerkiarioi*) responsible for finances and the collection of taxes, and the warehouses where goods and products destined for servants of the state were collected and stored (the *apotheke*, in both a singular and collective sense), not to mention the commanders of the themes themselves (the *strategoi*), all tended to be based in cities whenever possible.[20] Nor were only thematic capitals bustling focal points for craft production and commercial markets, as the case of Naples shows so well.[21] It is worth recalling that Michael Hendy, whose work on the Byzantine economy remains fundamental, himself

[] stresses that where Roman cities survived in northwest Europe in the fifth–eighth centuries, the stable presence of civic and religious authorities was a more important factor than commercial activity (or the absence thereof) (1999, 3–46); cf. also Carver 1993, 16–17.

[18] On Bertram, Didier and Merovingian Gaul in general, see Durliat 1979; Weidemann 1986; Samson 1994.

[19] Durliat 1990, esp. 159–75.

[20] See esp. Hendy 1985, 626–52; also Brandes 1989, 160–74; Prigent 2010, 159–66. For the debate over the origins and responsibilities of the *kommerkiarioi*, see Brandes 2002, 239–47. On the crucial role of thematic capitals as political, administrative and economic centers – and consequently also as flourishing centers of population and monumental architecture – in the seventh to ninth centuries, see also Ivison 2000; 2007.

[21] See esp. Arthur 2002, 118–43 on the extensive archaeological evidence for manufacturing, markets and long-distance commercial links in the seventh–ninth centuries. For another case of a nonthematic capital with suggestive signs of continued economic vitality in the same period, there is Amastris on the Black Sea coast, to which Zavagno has recently called attention (2009, 129–51, esp. 146–49).

thought that the urban network as constituted in ca. 450 remained substantially intact in ca. 900, for all that the fiscal structures of the state had changed beyond recognition in the interim.[22] Even on its own merits, then, the case for proposing that cities should be expected to have largely disappeared because the Byzantine empire and the Western successor kingdoms tended to rely less on individual cities as the basic building blocks of a ramified fiscal system is seriously flawed; and of course cities need not exist entirely, or even primarily, for economic reasons, as we shall see.

A more complex and nuanced perspective on the factors responsible for a marked decline in standards of urban living, culminating in the seventh century, results from the conjuncture of recent works by Michael McCormick, Chris Wickham and Bryan Ward-Perkins, all of whom, albeit in different ways and with different emphases, adduce the end of the integrated economy of the Roman Mediterranean as a defining feature of the period.[23] While political fragmentation in the fifth-century West had already forced cities (and kingdoms) to rely increasingly on local resources, with a commensurate decline in economies of scale, specialized production, productive surpluses and thus also a degradation of the physical fabric of urban communities, the archaeological evidence points to the seventh century – in the wake of the Persian and Arab conquests, whence we come almost full circle back to Pirenne – as the period when cities, in both East and West, were forced to rely to an unprecedented extent on the resources of their immediate hinterlands.[24] One result was that the leaders of church and state on the one hand, and local populations on the other, had fewer resources than ever before to invest in both monumental infrastructure and residential architecture.

Nor would I argue with any of this picture in its broad outlines. Cities quite clearly tended to be poorer and more isolated in the seventh century: the quality and quantity of manufactured goods is generally low relative even to the fifth and sixth centuries, as are the technical standards of what little was built in the period, both indications of a decline in specialized skills and a general penury of resources. The effects of recurring episodes of plague across the Mediterranean from the 540s on, coupled with endemic warfare in both East and West, very probably provoked a general demographic decline in both urban and rural areas, as well as exercising a destabilizing effect on both urban markets and the productivity of the countryside.[25] Further, while there is evidence for the continuing collection of taxes both in cash and in kind across the Western

[22] Ibid., 69–138, esp. 99–100.
[23] McCormick 2001; Ward-Perkins 2005; Wickham 2005.
[24] In addition to the works cited in the preceding note, see the exceptionally useful overview of Delogu 2010b, 39–92; on the fifth century, see also Delogu and Gasparri (eds.) 2010, esp. Delogu 2010a and Cosentino 2010.
[25] Little (ed.) 2006.

successor kingdoms in Italy, France and especially Visigothic Spain, both the rate of taxation and the efficiency of collection may often have been substantially lower by the seventh century than they had been during the late empire, thus leaving the authorities with fewer resources to invest in urban upkeep.[26] The evaporation of somewhere between half and three-quarters of the tax base of the Byzantine state following the loss of its most productive provinces in the seventh century left the administration in Constantinople, along with its provincial representatives, similarly strapped for disposable income.[27]

The effects of these processes on the material contours of urban society are now far better understood, thanks to several decades' worth of increasingly rigorous scientific archaeology devoted to late antiquity and the early Middle Ages. With the (partial) exception of churches and palaces of bishops and secular rulers, very few substantial *ex novo* architectural commissions were undertaken in cities anywhere in the former Roman empire in the seventh century. What projects can be documented were largely confined to the upkeep of selected elements of the monumental patrimony inherited from the past, notably city walls, while much of the rest was left to fall into ruin or dismantled. Domestic architecture was often subdivided into smaller, humbler units, in the case of existing structures, or built in more ephemeral materials such as wood and clay, leaving city dwellers substantially colder, damper and more cramped than their predecessors; and large areas inside the city walls were given over to gardens or abandoned, often resulting in considerably sparser patterns of settlement (a 'leopard-skin' configuration, as it has come to be called in Italy).[28]

Hence also the famous 'dark earth' found in early medieval levels at so many sites, from England and Scandinavia to Italy and Spain, which undoubtedly reflects substantial changes in the built environment and in patterns of human activity, though there continues to be no consensus on what, exactly, the stuff represents. However, dark earth can at least be said with some assurance to consist of decayed organic materials that did not transport themselves to so many old Roman towns across the western empire, whence it should be an index of a continuing human presence of some sort. If the more optimistic interpreters are correct to see in it the decomposed remnants of structures in wood and thatch, it might even betoken rather dense settlement, albeit of a

[26] Durliat, on the other hand, has argued that tax rates across the Western successor kingdoms remained at late Roman levels (1990, esp. 97–110). One need not accept Durliat's 'extreme continuitist' position that late Roman fiscal structures remained substantially intact through the Carolingian period to be nonetheless impressed by the volume of evidence he assembles for the continued collection of taxes in Iberia, Italy and Gaul from the fifth century through the ninth. More detailed discussion of the Western kingdoms follows later in this chapter.

[27] The very plausible estimate of Hendy (1985, esp. 620).

[28] On all these points, see the more detailed regional discussions later in this chapter, along with the sources cited at nn. 23–24. On domestic architecture, see also Galetti 2009.

distinctly non-monumental character reflected also in the relative poverty of the material culture often recovered in connection with these dark strata.[29]

In any case, it is reasonable to assume that urban populations did tend to decline almost everywhere, though this phenomenon would only point to a systemic ruralization of society were it possible to demonstrate a relative resiliency of population figures for the countryside. In fact, there is no way at present to reliably gauge rural demographic trends in the East or the West, yet what evidence there is hardly suggests that the countryside was booming from the seventh century on, or that, in other words, the decline of the cities was accompanied by a surge in the population and prosperity of rural settlement.[30] At present, then, the best assumption is probably that populations more often than not declined somewhat in both city and country, in which case the resilience of cities, as continuing foci of *relative* concentrations of population, appears the more significant.[31]

For in my view, the really surprising reality that remains to be fully explained is the tenacity with which the imperial, provincial and episcopal capitals of the late Roman period, and many other urban centers besides, clung to life across so much of the former Roman empire, not merely as centers of population, but in fact also as places in which something of both the monumental form and the functional, or at least ideological, *raison d'être* of the late Roman city was consciously maintained. In seeking to explain why the leaders of church and 'state' in Visigothic Spain, Frankish Gaul and Lombard Italy, in those parts of the Mediterranean that remained in Byzantine control following the Arab conquests of the seventh century, and even in the Levantine heartland of the Umayyad caliphate and in Umayyad Spain as well, continued to reside and perform their official functions in cities as consistently as they did, we should get some way toward understanding why so many of these places survived the tumultuous transitional period between late antiquity and the early Middle Ages.

The defensive fortifications summarily dismissed as lasting incitements to urban living by Brandes and Haldon, for one, surely often constituted a powerful inducement to continued settlement within their confines, particularly in a period marked by almost constant warfare (nor will it be coincidence that contemporary sources overwhelmingly stress sieges of cities, as opposed to pitched battles, as the dominant dynamic of military campaigns).[32]

[29] For the 'optimistic' viewpoint, see Dark 2002, 50–53 (on Britain); Galetti 2009, 730; Pani Ermini 2009, 670 (Italy); for a critique, Halsall 2007, 358–59. See also Verslype and Brulet (eds.) 2004.

[30] For an overview, see Wickham 2005, 442–518.

[31] Cf. Ward-Perkins 2009, esp. 103–05 (on Lombard Italy).

[32] On the predominance of siege warfare, in addition to the literary sources cited later, see Bradbury 1992, 1–19; Bachrach 2001, 98 and passim on the West; for the East, the thriving Byzantine literary genre of siege warfare manuals (*poliorketika*) speaks volumes; for an

A continuing economic role, even in the absence of state intervention, likewise seems a priori likely: unless we wish to imagine that all agricultural production occurred on a household, subsistence level, and that each household moreover produced all of the storage containers, plates, tools, furnishings and so on that it required, urban markets will have had their continuing attractions, albeit on a much-reduced scale, as centers for the collection and exchange of essential goods and commodities.[33] Further, it is beyond doubt that the landed resources controlled by the church in all the regions under consideration were massive, and that these lands were controlled from, and their productive surpluses accumulated in, the cities where bishops and their administrative apparatus continued to be based. The bishops alone, in other words, will have sufficed to maintain something of the 'consumer city' model inherited from antiquity, spending revenues derived from their rural estates not only on a dizzying profusion of urban churches, monasteries and episcopal complexes, but also, often, on essential infrastructure such as walls.[34]

In what follows, however, I will contend that the most underappreciated, and perhaps the single most significant, factor behind the survival of so many Roman cities in the seventh and eighth centuries was the – remarkably simple – reality that many of the most prominent holders of high office, civic and ecclesiastical, continued to be unable to imagine executing their public mandates and displaying their authority and that of the institutions they represented without the surviving backdrop of the late Roman city and, still more simply and fundamentally, a crowd of spectators. Lest the idea be dismissed immediately as an anachronistic projection of modern preoccupations onto ancient realities, we might cite the letter written ca. 527 by Cassiodorus in the name of King Athalaric to Severus, the governor (*corrector*) of Lucania and Bruttium:

> As we know that you, laudably following the counsels of the prefects, have learned all of those things which pertain to putting in order the affairs of the *res publica*, and above all that you recognize, learned in literature as you are, that the appearance of those cities is beautiful, which are known to have crowded concourse (*conventum*) of peoples. For thus indeed in those places the ornament of liberty shines forth and the impetus (*effectus*) necessary [to effect] our commands is preserved. It is given to wild beasts to seek the fields and woods, but to men to cherish their paternal

overview, see McGeer 1995; see also Kirilov 2007 on the relationship between walled circuits and settlement, and Ivison 2000 for the strategic importance of walled cities for the defense of the Byzantine interior and Constantinople.

[33] Cf. Ward-Perkins at n. 31. On the chronic underestimation of the signs of continued economic and commercial activities in Byzantine southern Italy by proponents of 'Dark Age' economic (and urban) collapse – with another refreshingly sensible critique of Hodges et al. (see n. 17) – see Ditchfield 2007, 558–64.

[34] Cf. Samson 1994, esp. 116ff.

hearths above all [There follows a long excursus on how peaceful birds congregate in flocks, while the rapacious hawks and eagles act alone] ... Thus is the desire of mortals especially detestable, who are known to flee the sight of men, nor can anything good be believed of one, to whose life no witness can be found.[35]

Cassiodorus' letter might well be described as a 'nostalgic elegy for the classical city' written at a time when urban realities were changing rapidly;[36] and indeed the purpose of the missive was to recall some *curiales* and *possessores* of Bruttium to their cities, some – but evidently not all – of which were suffering a flight of urban notables presumably seeking in part to escape their administrative obligations.[37] Yet the underlying sentiment transcends the particulars of the historical moment that prompted its expression: How can anyone of accomplishments, rank and prestige be seen to be so in the absence of onlookers? And, we might add, if the investiture of a king or bishop, for example, like the proverbial tree, 'falls' in a forest with nobody to 'hear' it, does it really happen?

As we shall see, the public presentation of power and authority, its actuation by means of ritual and ceremony enacted on an urban stage before crowds of onlookers, remained a consistent feature of life in the seventh and eighth centuries and beyond. It was, moreover, a very particular vision of the 'urban stage,' descended directly from the monumental armature of the late antique city in the form it took from the later third century on, discussed in the preceding chapters: city walls and particularly gates, opening onto a relatively wide and well-maintained street or connected series of streets, perhaps still flanked by colonnades or porticoes, and leading more often than not to the intramural cathedrals and palaces where prominent governmental and ecclesiastical representatives continued to be based.

I will suggest, in other words, that the visual and symbolic proclamation of authority remained fundamentally linked to the practical exercise thereof

[35] *Var.* 3.31.1–3: *Cum te praefectorum consiliis laudabiliter inhaerentem omnia didicisse credamus, quae ad rei publicae statum pertinent componendum, maxime cognivisti litteris eruditus pulchram esse faciem civitatum, quae populorum probantur habere conventum. Sic enim et in illis splendet libertatis ornatus et nostris ordinationibus necessarius servit effectus. Feris datum est agros silvasque quaerere, hominibus autem focos patrios supra cuncta diligere ... Sic mortalium voluntas plerumque detestabilis est, quae conspectum hominum probatur effugere, nec potest de illo aliquid boni veraciter credi, cuius vitae testis non potest inveniri.* The passage, the remainder of which expounds on the ideas expressed in the opening lines cited here, is the subject of Lepelley 1990; see also Fauvinet-Ranson 2006, 30–33. On Severus, *PLRE* II, *s.v.* Severus 16.

[36] The title of Lepelley's article cited in the preceding note.

[37] The passage continues thus (*Var.* 3.31.4): *Redeant possessores et curiales Bruttii in civitatibus suis: coloni sunt, qui agros iugiter colunt.* Yet even in Bruttium, as Fauvinet-Ranson has remarked, the flight of *curiales* was hardly universal; another letter of Cassiodorus reveals an unnamed city in Bruttium with a municipal senate so flourishing that some *curiales* could be summarily removed from the municipal *album* (*Var.* 9.1.4; Fauvinet-Ranson 2006, 32).

in the seventh century and beyond, and that the semiotics of power contin-
ued to be encoded in the contours of urban architecture, above all in the
processional routes that framed and enabled the public appearances of the most
exalted urban inhabitants. In so doing, I will consciously avoid recourse to
the likes of Weber and Foucault and their followers. Were the introduction of
contextually extraneous sociological or anthropological grand theorizing nec-
essary, I would rather cite Clifford Geertz, whose comments on the 'theater-
state' in nineteenth-century Bali seem to me to apply almost verbatim to the
Mediterranean world of late antiquity and the early Middle Ages.

In Bali, minutely choreographed rituals set before the architectural 'stage' of
the royal palace, in front of the eyes of the assembled masses, were the glue that
made the social collective, with a divine king figure at its apex, cohere: 'The
state ceremonials of classical Bali were metaphysical theatre: theatre designed to
express a view of the ultimate nature of reality and, at the same time, to shape
the existing conditions of life to be consonant with that reality; that is, the-
atre to present an ontology and, by presenting it, to make it happen – make it
actual.'[38] And further: 'The idiom of rank not only formed the context within
which the practical relationships of the major sorts of political actors ... took
their shape and had their meaning; it permeated as well the dramas they jointly
mounted, the *décor théâtral* amid which they mounted them, and the larger
purposes they mounted them for. The state drew its force, which was real
enough, from its imaginative energies, its semiotic capacity to make inequality
enchant.'[39] I would replace only 'the state ceremonials of classical Bali' with
'church and court ceremonial of the early medieval West and Byzantium,' and
allow the rest to stand for my thoughts exactly, without for a minute claim-
ing that the early medieval Mediterranean and nineteenth-century Bali (or
anywhere else) can or should be assimilated into a generically applicable the-
oretical framework. Rather, I will focus on instances of the interpenetration
of urban architecture and ceremony that, I think, demonstrate that a critical
mass of powerful social actors would have found playing their appointed roles
almost inconceivable without both the monumental and the human contours
of an urban environment in recognizably late Roman form, beginning with
Visigothic Spain and moving east.

I would preface the following survey with two final points, which apply
more or less equally to both western Europe and Byzantium. The first is that
the trend toward the concentration of resources and disposable wealth in the
hands of a tiny cadre of functionaries directly associated with the ruling estab-
lishment, a process that had gathered steam at least since the time of Diocletian,
became still more pronounced in both the Byzantine empire and the kingdoms

[38] Geertz 1980, 104.
[39] Ibid., 123.

of the West in the seventh and eighth centuries.[40] Thus, as in the preceding
period but if anything to a still greater extent, the rulers of cities and the hold-
ers of episcopal sees – and thus by definition the protagonists in urban-based
ceremonies – were the only ones with the resources to intervene meaningfully
in urban topography, which they naturally tailored or maintained as best they
could to meet their perceived needs.[41]

Second, if there is a single cultural institution that can be said to have been
most assiduously preserved and transmitted almost unchanged in its essentials
between the fourth century and the ninth, it is surely the ceremonial apparatus
invoked by bishops and secular rulers alike. *Adventus*, investitures and liturgical
processions in the early Middle Ages almost invariably appear to have been
modeled on late antique precedents, or at any rate on what those late antique
precedents were perceived to have been in later centuries, as we shall see. But
we should perhaps expect as much a priori, as an inherent characteristic of cer-
emonial is its capacity to be endlessly reproduced, recreated or even reinvented
ex nihilo: as long as models for such ceremonial could be observed some-
where (as they always could at Constantinople and Rome, for example, where
the full gamut of the late antique ceremonial repertoire flourished through-
out the period in question, as did the unsurpassed legacy of both places as
embodiments of solemn grandeur and fountainheads of earthly power),[42] such
examples were available to inspire anyone with the institutional clout and the
will to draw on them. So too, for that matter, were the memories of ceremo-
nies past preserved in the literary record. The economic and demographic
and political structures that underpinned the late Roman empire could hardly
have been reconstituted at the drop of a hat in any given place and time, yet
ceremonial could: it was, in a sense, the simplest, most economical and most
ostentatious means available to heirs of the Roman cultural heritage seeking
to capitalize on the legacy of their storied past.

4.2 THE VISIGOTHIC KINGDOM

On September 1, 672, the Visigothic king Reccesuinth died in the little villa
(*villula*) of *Gerticos*, located in the central Iberian countryside 120 miles distant

[40] This point is central to the formulations of Haldon, Hendy and Wickham alike cited earlier;
cf. also Cosentino 2010; also Banaji 2007, 57–65, 83–84, who stresses the continuing mon-
etization of the Mediterranean economy during the seventh century and beyond, though
the gold was concentrated in the hands of an ever-more circumscribed group of super-rich
individuals.

[41] Cf. Ivison 2000; 2007 on Byzantium; Durliat 1979; Samson 1994 on Merovingian Francia; on
Western bishops as builders and 'managers,' see now also P. Brown 2012, 496–502.

[42] On early medieval ceremonial at Rome and Constantinople, see McCormick 1986; Baldovin
1987; Dufraigne 1994.

from the capital, Toledo.[43] On the same day, the members of his following, in
the midst of their mourning, threw themselves at the feet of the *princeps* Wamba
and 'not only with a single mind but a single voice' begged him to become
their next king.[44] Wamba naturally declared himself unwilling and unable to
undertake the enormous burden of the office, whereupon one of the *duces* pre-
sent stepped forward and threatened, on behalf of all, to run him through with
his sword unless he accepted.[45] 'Overcome not so much by their entreaties as
by their threats,' according to bishop Julian of Toledo, the author of the minor
historical masterpiece whence this account derives, Wamba accepted the king-
ship, though only on one, very particular, condition. Although he had already
been proclaimed king by God and people alike,

> he would not allow himself to be anointed by the hands of the priest
> until he entered the seat of the regal city and arrived at the throne of
> his paternal antiquity, in which it was necessary for him both to take up
> the standards of holy unction and to patiently receive the consent for his
> pre-election of those from far-off places, in order, that is, that he not be
> thought, inspired by rabid ambition to reign, rather to have usurped or
> stolen than received from God the right to such glory. Thus putting off
> the matter with prudent gravity, on the nineteenth day after taking up the
> kingship he entered the city of Toledo.[46]

Only then, nineteen days after his proclamation at *Gerticos*, did Wamba suf-
fer himself to be anointed 'in the palace church (*in praetoriensi ecclesia*), that
is of Saints Peter and Paul, conspicuous in his kingly regalia, standing before
the divine altar,' where he 'gave his pledge to the people in the customary
manner.'[47]

I cannot imagine more explicit testimony to the continuing symbolic and
representational relevance, and the absolute ideological centrality, of the city
in early medieval Spain. Had Wamba not been *seen* to have been anointed
in the customary manner, in full royal regalia, in the customary location – a

[43] Julian of Toledo, *Historia Wambae Regis*, 2–3.

[44] Ibid., 3: *subito una omnes in concordiam versi, uno quodammodo non tam animo quam oris affectu
pariter provocati, illum se delectanter habere principem clamant.*

[45] Ibid.

[46] Ibid.: *Nam eundem virum quamquam divinitus abinceps et per hanelantia plevium vota et per eorum
obsequentia regali cultu iam circumdederant magna officia, ungi se tamen per sacerdotis manus ante
non passus est, quam sedem adiret regiae urbis atque solium peteret paternae antiquitatis, in qua sibi
oportunum esset et sacrae unctionis vexilla suscipere et longe positorum consensus ab praeelectionem sui
patientissime sustinere, scilicet ne, citata regni ambitione permotus, usurpasse potius vel furasse quam
percepisse a Domino dignum tantae gloriae putaretur. Quod tamen prudenti differens gravitate, nono
decimo postquam regnum susceperat die Toletanam urbem ingreditur.* The best introduction to the
Historia Wambae Regis is Martínez Pizarro (2005), with English translation at pp. 175–239.

[47] *Historia Wambae Regis* 4: *At ubi ventum est, quo sanctae unctionis vexillam susciperet, in praetoriensi
ecclesia, sanctorum scilicet Petri et Pauli, regio iam cultu conspicuus ante altare consistens, ex more fidem
populis reddidit.*

palace-church in the capital city – in front of as many witnesses as possible ('the people' included), how could he possibly have convinced his subjects, and potential rivals, that he had received the popular consensus, the divine sanction, and – ultimately – the unction 'at the hands of the holy metropolitan bishop (*pontifex*) Quiricus'?[48] More than simply providing the essential background for the ceremony of investiture, the capital city of the realm also furnished the indispensable crowd of onlookers, which both enriched the ceremony and ensured that the solemn and binding imprint of the coronation ritual was irrevocably stamped on the consciousness of as many witnesses as possible. Otherwise, malicious detractors might have said anything they wished....

The remainder of Bishop Julian's history, which was written within a few years of the events it recounts, goes on to relate the story of Wamba's campaign to suppress a rebellion that began in the year following his coronation (673) in the area of southern Gaul (*Gallia Narbonensis*) still under Visigothic control, centered on the city of Nîmes, and then spread to Catalonia (the *provincia Tarraconensis*). It depicts in no uncertain terms a world in which cities were as central as ever to the designs of the nobility and the clergy, in both strategic and symbolic terms.

The rebellion began at Nîmes at the instigation of the *comes* Hilderic and his associates; the bishop of the city, Aregius, who attempted to oppose them, was summarily exiled, and Hilderic's friend, the abbot Ranimir, subsequently installed as bishop, allegedly without, as Julian pointedly notes, either the consent of the king or the metropolitan bishop, or the appropriate ceremony of investiture.[49] Wamba first dispatched the *dux* Paul to put down the rebellion, only to have him join the conspirators, who proclaimed him king.[50] The important city of Narbonne likewise soon fell to the conspirators, despite the efforts of its loyal bishop, Argebad, to close the gates against them.[51] Thereafter, while Paul and his associates based themselves at Nîmes and rallied support from neighboring Frankish and Aquitainian contingents, awaiting the right moment to invade Spain and conquer the entirety of the kingdom, Wamba set out with an army for southern France in the summer of 673.[52]

The campaign is described exclusively in terms of engagements and sieges centered on fortified cities and *castra*: not once do the opposing sides meet in open-field battle. On his march toward the Pyrenees, Wamba first took

[48] Ibid.: *oleum benedictionis per sacri Quirici pontificis manus vertici eius refunditur.* On the unction of kings – apparently a Visigothic innovation in post-Roman Europe – see Barbero 1970 and esp. Dartmann 2012.

[49] Ibid., 6: *In cuius praeelectione nullus ordo adtenditur, nulla principis vel metropolitani definitio praestolatur; sed erecto quodam mentis superbae fastigio, contra interdicta maiorum ab externae gentis duobus tantum episcopis ordinatur.*

[50] Ibid., 7.

[51] Ibid.

[52] Ibid., 8.

the walled *civitates* of Barcelona and Gerona.[53] The crossing of the Pyrenees, effected by separate detachments of the army, was achieved upon taking four *castra*, whereupon the contingents reunited and continued their march into Gaul, bound first for Narbonne.[54] The city, under the command of Paul's *dux* Wittimir, refused to surrender to Wamba and closed its gates, while Wittimir ascended to the wall top to hurl insults at the king; after a bloody siege lasting eight days, Wamba's troops finally took it.[55] They then set out for Nîmes, the source of the rebellion and Paul's base of operations, pausing along the way to subdue the *civitates* of Béziers, Agde and Maguelone.[56] When advance elements of Wamba's army arrived at Nîmes, Paul and his allies 'chose to give battle inside the city from the walls, rather than risk the uncertain chances of looming danger outside the city.'[57] Again after days of bloody combat, the city was taken, and its remaining defenders hunted down in the amphitheater, where they had barricaded themselves when Wamba's troops succeeded in entering the city after burning the gates and undermining the walls.[58]

Wamba's subsequent arrival before the city with the remainder of his army is described in terms worthy of any late antique *adventus*:

> Hurrying on his way, the *princeps* came to the city with the admirable spectacle of his army and an awesome parade. The terrifying standards of war were there. When the sun shone on the shields, the earth itself coruscated with a double light; the radiant arms themselves magnified the blaze of the sun beyond its usual measure.... Who could explain what a parade there was of the army, what glory of arms, what beauty of youth, what consensus of spirits?[59]

The unfortunate Paul, who had thrown off his regal vestments (*regalia indumentia*) in desperation, was dragged out of the substructures of the amphitheater with his remaining faithful, and conducted outside the city, where Wamba had disposed all of his forces in full battle array a stade distant from the walls. All were thus treated to the spectacle of Paul tied with arms splayed between two mounted *duces*, who dragged him by the hair before the king.[60] Paul's

[53] Ibid., 11.

[54] Ibid. The *castra* are named as *Libiae*; *Caucoliberi*; *Vulturaria*; and *Clausuras*.

[55] Ibid., 12.

[56] Ibid., 13.

[57] Ibid.: *eligunt potius intra urbem suis de muris bellum conficere quam extra urbem improvisos casus patentis periculi sustinere.*

[58] Ibid., 13–19.

[59] Ibid., 23: *Festinato tandem profectionis itinere, pervenit princeps ad urbem cum terribilis pompae et exercituum admiratione. Erant enim ibi bellorum signa terrentia. Cumque sol refulsisset in clipeis, gemino terra ipsa lumine coruscabat; ipsa quoque radiantia arma fulgorem solis solito plus augebant. Sed quid dicam? Quae ibi fuerit exercituum pompa, quis decor armorum, quae species iuvenum, quae consensio animorum, explicare quis poterit?*

[60] Ibid., 24.

humiliation was thus as patently, publicly, and hence indisputably proclaimed as Wamba's coronation had been, an antithesis that Julian stressed by noting that Paul's defeat occurred on the first anniversary of Wamba's coronation.[61]

Three days later, Paul's public humiliation continued with the ancient ceremony of the *calcatio collis*, the ritual abasement of a defeated usurper to which the emperors of late antiquity had so often treated the people of Rome, Constantinople, Ravenna... 'Paul himself, freighted with irons along with the others, was exhibited to the *princeps* seated on his throne. Then, according to the custom of the ancients, prone on the ground ('with the spine of his back bent') he submitted his neck to the royal footprints, and was then judged with the rest before the whole army.'[62] Though all thought him worthy of death,[63] the pious king spared his life, perhaps because the spectacle of his ignominy was not yet complete, as many more crowds were destined to behold the proclamation of his defeat and Wamba's triumph.

On his leisurely return to Spain, Wamba first took the time to make a triumphal *adventus* into the second city of the rebellion, Narbonne; surely Paul's ritual humiliation was repeated there, for the benefit of all who had once hailed him as king.[64] But the definitive proclamation of Wamba's victory and Paul's abject submission was — as Wamba's coronation had been — deferred until their arrival at the *sedes regia*, Toledo. Julian explicitly states his reasons for describing the event in detail, in terms that I would not hesitate to use for the motives that led Wamba to stage the spectacle itself: 'And nevertheless, it is necessary to explain the glorious triumph with which he entered the regal city, exulting over his enemies, so that, as succeeding centuries will hail the sign of his glory, so the ignominy of the seditious will not pass from the memory of those to come.'[65]

There follows a detailed description of the triumph, presented as the culmination of Julian's narrative. At the fourth mile from the city, Paul and his companions, heads and beards shaved, feet bare and wearing squalid clothing, were loaded onto carts drawn by camels. 'The king of perdition himself' went first, wearing a 'laurel' crown made from blackened skins, followed by the rest, as they made their way 'into the city, with the people standing on both sides.'[66]

[61] Ibid., 20.

[62] Ibid., 27: *Tertia iam post victoriam victoribus advenerat dies, et Paulus ipse onustus ferro cum ceteris consedenti in throno principi exhibetur. Tunc antiquorum more curba spina dorsi vestigiis regalibus sua colla submittit, deinde coram exercitibus cunctis adiudicatur cum ceteris.*

[63] Ibid.: *quum universorum iudicio et mortem exciperent, qui mortem principi praeparassent.*

[64] Ibid., 28: *placida progressione Narbonam contendens, urbem victor ingreditur.*

[65] Ibid., 29: *Et tamen, sub quo celebri triumpho regiam urbem intraverit, de inimicis exultans, explicare necesse est, ut, sicut ingentis eius gloriae signum saecula sequutura clamabunt, ita seditiosorum ignominia non excidat a memoria futurorum.*

[66] Ibid., 30: *Etenim quarto fere ab urbe regia miliario Paulus princeps tyrannidis vel ceteri incentores seditionum eius, decalvatis capitibus, abrasis barbis pedibusque nudatis, subsqualentibus veste vel habitu induti, camelorum vehiculis imponuntur. Rex ipse perditionis praeibat in capite, omni confusionis*

It was a spectacle whose principal reason for being was manifestly the lasting impression it was meant to make on the largest possible number of witnesses: 'nor should this be thought to have occurred without the dispensation of the just judgment of God; that their placement on carts before the eyes of all, that is, should demonstrate the lofty and sublime heights of their disgrace, and that those who beyond human custom seek elevation by craftiness of mind will stand out all the more when they pay the price for their undertaking. Therefore let these matters be placed on record for the centuries to come.'[67] Julian, in other words, is attempting to do for posterity by describing these ceremonies what Wamba meant to do for those living in his own time by staging them.

In its ensemble, the *Historia Wambae regis* is an unparalleled portrait of the 'thought-world' of seventh-century Visigothia, whence the length at which it has been treated here. Even if we wished – surely unwisely – to think it all pure invention, the fact would remain that Julian was capable of thinking the way he did, and judged it expedient to do so in his 'official' account of his hero Wamba's exploits. I strongly doubt that such considerations were totally alien to the calculations of the king himself, or that his manifest predilection for public ceremonies staged in cities was inspired by unrelated concerns.[68] It might further be noted that in the hands of an absolute monarch and his servants, urban topography can become as much a programmatic statement of ideology and intent as a panegyric; both, again to quote Geertz, can equally be 'designed to express a view of the ultimate nature of reality and, at the same time, to shape the existing conditions of life to be consonant with that reality.'[69]

It was, I repeat, a 'reality' in which cities and ceremony, and the intimate symbiosis between the two, were as fundamental as ever to the ordering of society as envisioned by its leading members. Every one of Wamba's triumphal processions (not to mention his coronation), which invariably occurred at cities, and *a fortiori* the spectacle at Toledo, the 'regal city,' were more awe-inspiring for the urban backdrop in front of which they occurred. That backdrop, ultimately, is also what gave these entries their sense and purpose: had there not been crowds to witness the processions and absorb the message of the king's unimpeachable authority encoded therein, the processions would never have happened. Julian's account suggests further reasons for the continuing centrality

ignominia dignus et picea ex coreis laurea coronatus. Sequebatur deinde hunc regem suum longa deductione ordo suorum dispositus ministrorum, eisdem omnes adstantibus populis, urbem intrantes.

[67] Ibid.: *Nec enim ista sine dispensatione iusti iudicii Dei eisdem accessisse credendum est, scilicet ut alta ac sublimia confusionis eorum fastigia vehiculorum edoceret sessio prae omnibus subiecta, et qui ultra humanum morem astu mentis excelsa petierant, excelsiores luerent conscensionis suae iniuriam. Sint ergo haec insequuturis reposita saeculis.*

[68] For additional takes on the exceptional importance of ceremony, and public humiliation in particular, in the *Historia Wambae*, see McCormick 1986, 307–23; De Jong 1999.

[69] See earlier in this chapter, n. 38.

of cities, to be sure, among them their enormous strategic importance: control over territory, such as that usurped by Paul and his allies, continued to depend on control of cities, as the chosen objectives of Wamba's military campaign (and every other military campaign described in Visigothic sources, for that matter) indicate.[70] But control over cities, in turn, was ensured by the ability to exercise effective authority and to marshal consensus based on the support of the nobility, the church, the army and urban populations,[71] which brings us back full circle to the urban ceremonial repertoire invoked by Wamba, and by Visigothic kings – and bishops, as Julian's text also suggests[72] – in general.

Julian's Wamba, in fact, is anything but an isolated example in the context of Visigothic Spain, whose rulers consistently displayed an attachment to cities as political and administrative centers in the late antique and Byzantine mold, beginning especially with the reign of Leovigild (569–86), the king whose victories over the Sueves in the north, the Byzantines in the south, and numerous essentially autonomous *civitates* elsewhere in the Iberian Peninsula laid the groundwork for the development of a centralized Visigothic state with its capital at Toledo.[73] Urban centers manifestly constituted the focal points of the political, fiscal and administrative apparatus of the newly consolidated kingdom, beginning with Toledo itself, Leovigild's chosen *sedes regia*, where he established his primary residence and palatine bureaucracy.[74] Control over the remainder of the peninsula, much of it newly subject to Toledo, was ensured by *comites* and *duces* stationed in its other leading cities, beginning with the capitals of the Diocletianic provinces: Braga, Mérida, Córdoba, and Tarragona,[75] and extending to other still-populous *civitates* such as Zaragoza, Ampurias, Seville, Valencia and Barcelona.[76] These cities were also the fiscal motor of the

[70] See, for example, Isidore's *Historia Gothorum* and John of Biclar's *Chronicon*, passim.

[71] Cf. Collins 1983, 108–23; McCormick 1986, 315–23; Díaz 1999, 346–47; Dartmann 2012. Canon 10 of the Eighth Council of Toledo in 653 (Vives 1963, 283) is explicit about the required consensus of the bishops and the 'nobles of the palace' in the election of the new sovereign, which – closely anticipating the circumstances of Wamba's coronation in the *Historia Wambae* – was to occur only in Toledo or the place where the previous sovereign died, 'to avoid conspiracies of the few or the seditious tumult of the rustic plebs': *Abhinc ergo deinceps ita sunt in regni gloriam perficiendi rectores, ut aut in urbe regia aut in loco ubi princeps decesserit cum pontificum maiorumque palatii omnimodo eligantur adsensu, non forinsecus aut conspiratione paucorum aut rusticarum plebium seditioso tumultu.*

[72] See n. 49 for Julian's allusion to the lack of appropriate ceremony and consensus accompanying the – thus by definition illegitimate – investiture of Paul's ally, Ranimir as Bishop of Nîmes.

[73] Collins 1983, 41–58; Martin 2003, esp. 141ff.

[74] Collins 1983, 71ff.; Díaz 1999, 335ff.; Martin 2003, passim; Kulikowski 2004, 287–309; Carrobles Santos et al. 2007, 97–161. Specifically on the palatine administration at Toledo, the *officium palatinum*, see also Isla Frey 2002.

[75] The fifth, Carthago Nova/Cartagena, remained in Byzantine hands until it was captured and sacked during the reign of King Sisebut (612–21).

[76] See n. 74.

Visigothic state, the centers where royal tax collectors (*numerarii*) in the employ of the *comes patrimonii* at Toledo and local bishops collaborated in ensuring that the products of the surrounding countryside destined for the fisc were collected and also, at least in theory, still commuted into gold coin (*adaeratio*). This process is glimpsed with tantalizing vagueness in the *De fisco Barcinonensi*, a letter addressed to the *numerarii* by four bishops in ca. 592, regarding the conversion rate of barley into coin in the *civitas* of Barcelona.[77]

But cities were also the symbolic pillars of the Visigothic kingdom taking shape under Leovigild and his son Reccared (586–601), the places that located the realm firmly in the urban tradition of the late Roman state, its sovereigns in the shoes of late Roman emperors. Immediately following his victorious campaigns in ca. 578, according to John of Biclar's nearly contemporary *Chronicle*, the best surviving source for the period, Leovigild undertook the foundation of a new city, named *Recopolis* – again in the best late antique tradition – after his son and heir Reccared.[78] It was, in essence, a dramatic urban gesture, a showpiece city designed to exalt the king as a city founder in the mold of his most illustrious Roman predecessors (Diocletianopolis, Constantinopolis, Marcianopolis, Justiniana Prima), and to harness the architectural and ceremonial essence of the late antique capital to proclaim the ascendancy of the new ruling dynasty, via topographical idioms derived from those favored by the late Roman and Byzantine state.[79]

Recopolis features an upper, walled citadel comprising a basilica and an associated palace complex evidently designed to house both civic and ecclesiastical officials. The one gate to the citadel was accessed via a wide street, lined by shops, itself the final tract of the principal thoroughfare of the walled lower city, which in turn led directly to the one known gate in the lower circuit-wall (Figure 4.2).[80] The 'official' buildings on the acropolis are thus, literally, the culmination of a single, main street that linked them with the residential quarters below and, via the one gate in the lower circuit, the world beyond. Recopolis gravitated, in other words, around a single monumental armature that strongly

[77] Nearly every aspect of this document, and thus its consequences for our understanding of the fiscal structures of the Visigothic kingdom, is the subject of debate. For one recent perspective, with an overview of the main points of contention, see Fernández 2006 (also for the original text, with English translation). What it clearly does show, in any case, is the operation of a relatively articulated apparatus for the collection of taxes, based on individual *civitates*; a perusal of the *Leges Visigothorum* of the later sixth and seventh centuries tends to confirm the impression (e.g., *LV* 12.1.2; 5.4.19); cf. also Isidore, *Historia Gothorum*, 55. See generally Martin 2003, passim.

[78] *Chron.* 50: *Leovegildus rex, extinctis undique tyrannis et pervasoribus Ispaniae superatis, sortitus requiem propriam cum plebe resedit et civitatem in Celtiberia ex nomine filii condidit, que Recopolim nuncupatur, quam miro opere in menibus et suburbanis adornans, privilegia populo nove urbis instituit.*

[79] Arce 2000; 2001, esp. 89–91; Velázquez and Ripoll 2012, 147–53.

[80] For recent topographical overviews of the city, in light of recent excavations and with ample additional bibliography, see Olmo Enciso 2007; 2008.

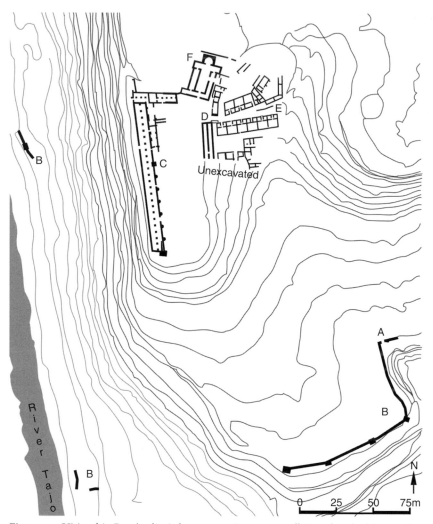

Figure 4.2 Visigothic Recópolis. A: lower gate; B: circuit-wall; C: palace building with turreted façade; D: upper gate; E: street; F: basilica. (Author.)

recalls Justiniana Prima in terms both of form and – I presume – function. There is no other route the occupants of the upper citadel could have used to enter and exit their palatial compound, process through the city and appear in majesty to the population that inhabited the residential and commercial quarters of the lower city until the Arab conquest (and even after).[81]

Recopolis, in short, was simultaneously the product of and the ultimate testament to Leovigild's success in establishing himself as the ruler of a state

[81] On continued signs of habitation through the seventh century, when many formerly open, apparently public spaces were given over to commercial and residential uses (perhaps suggesting even an increase in population, albeit in connection with a decline in the pristine monumentality of the urban layout?), see Olmo Enciso 2000, 390–92; 2007, 192–93; on the Islamic phases, *id*. 2000, 393–97; Velázquez and Ripoll 2012, 168–71.

sufficiently centralized to provide him with the unparalleled fiscal resources necessary to undertake a project on such a scale, and his concomitant desire to display himself and the enhanced prestige of his office with the inevitable trappings of late antique imperial pomp and splendor. So things seemed a half century later to the hostile Isidore, for whom Recopolis was intimately connected to Leovigild's public persona: 'He (Leovigild) first enriched the fisc and first swelled the treasury with the plunder of the citizens and the spoils of war. He also founded a city in Celtiberia, which he called Recopolis from the name of his son. And he was the first to sit on a throne covered in royal vestment among his people, while before him dress and deportment was shared by the people and kings.'[82] Military and political ascendancy, followed by a city, followed by ceremony; all of them are inextricably interrelated in the mind of Isidore.

Indeed, while Leovigild and his immediate successors had far more resources to devote to urban projects than their predecessors (Leovigild in fact founded another city, *Victoriacum*, while Suintila [621–32] celebrated a victory over the Basques by erecting yet another new city, *Ologicus*, with the forced labor of the conquered),[83] their initiatives represent a difference of degree more than one of kind. If there is a constant in the centuries following the end of effective Roman government in Spain in ca. 460, it is surely the absolute centrality of cities in the designs of both lay and ecclesiastical magnates. In the absence of any effective central authority in the later fifth and early sixth centuries, the political map of the peninsula was often subdivided at the level of individual *civitates*, yet insofar as the evidence allows us to judge, the local authorities overwhelmingly preferred the city to the country, as did the representatives of the church.[84] Cities offered protection; they allowed the stockpiling of agricultural surpluses and taxes, and the possibility of commercial exchanges; but on a still more elemental and ubiquitous level, what they seem to have offered is a critical mass of people: a *populus* whose consent and complicity, real or imagined, coerced or voluntary, in the designs of rulers and bishops is ultimately what allowed rulers and bishops to exist as such and to have designs of any sort in the first place.

As in Julian's history of Wamba, the fundamental importance of urban theater is most consistently expressed in relation to the public humiliation

[82] *Historia Gothorum*, 51: *fiscum quoque primus iste locupletavit primusque aerarium de rapinis civium hostiumque manubiis auxit. condidit etiam civitatem in Celtiberia, quam ex nomine filii sui Recopolim nominavit. primusque inter suos regali veste opertus solio resedit: nam ante eum et habitus et consessus communis ut populo, ita et regibus erat.* Generally on this remarkable passage, cf. Arce 2001.

[83] On Victoriacum, John of Biclar, *Chron.* 60; on Ologicus, Isidore, *Historia Gothorum*, 63: [Vascones] *Ologicus civitatem Gothorum stipendiis suis et laboribus conderent, pollicentes eius regno dicionique parere et quicquid imperaretur efficere.*

[84] On the role of cities during the first century after the end of Roman rule in Iberia, the recent survey of Kulikowski (2004, 197–214; 256–86) is very useful; see also Halsall 2007, 338–46, who likewise stresses the extent to which 'aristocrats continued to see cities as the focus of political activity' (ibid., 340).

of the defeated. So in the 490s, the Visigothic capital at Toulouse was where a certain Burdunelus, who had opposed Euric's forces in Spain, was dragged off to be roasted alive inside a bronze bull, in what must have been a designedly unforgettable spectacle.[85] A decade later, when the unfortunate 'tyrant' of Dertosa, Petrus, was defeated by the Visigoths, his head was carried off for display in the nearest regional center, Zaragoza.[86] Whatever Petrus had been, or claimed to have been, before his defeat, the public spectacle of his head at Zaragoza ensured the king's enemy a lasting legacy as a (humiliated) tyrant and usurper. But by the end of the sixth century, Toledo had become the location of choice for such displays, as it remained in Wamba's day; like the *Historia Wambae*, John of Biclar's *Chronicle* concludes with an especially explicit description of the fate that awaited an attempted usurper, the *dux provinciae* Argimundus, who led a palace intrigue against Reccared in 589. Following the execution of his coconspirators, 'Argimundus himself, who had desired to take up rule, first interrogated with the whip, then disgracefully shaven, and then with his right hand amputated, gave an example to all in the city of Toledo by parading through (*pompizando*) seated on an ass, and taught that servants should not be arrogant to their lords.'[87] The public nature of the example made of Argimundus, of course, is the point of the episode, presumably in reality and certainly in its literary incarnation: without 'all in the city of Toledo,' the spectacle of Reccared's triumph and the fate that awaited those who dared oppose him would have remained, for all practical intents and purposes, invisible, and thus unable to bolster his meticulously contrived aura of invincibility.

Cities, in short, remained the premier venue in which the presence of authority could be displayed to those over whom it was claimed, by those claiming to exercise it. In the century before the accession of Leovigild and Reccared, that authority seems to have been most consistently and effectively exercised by bishops of individual cities, upon whom increasing responsibility for local affairs often devolved in the absence of effective central government.[88] There are hints to this effect in the literary sources, and particularly in the archaeological record, which is now beginning to take shape thanks to several decades' worth of increasing attention devoted to the post-Roman period. We thus turn to the topography of Spanish cities in the sixth and seventh centuries, in order to address the all-important question of the extent to which their

[85] This according to the so-called *Consularia Caesaraugustana* (75a), a fragmentary and often garbled account of mid-sixth-century date.

[86] Ibid., 87a.

[87] *Chron.* 93: *Ipse autem Archemundus, qui regnum assumere cupiebat, primum verberibus interrogatus, deinde turpiter decalvatus, post hec dextra amputata, exemplum omnibus in Toletana urbe asino sedens pompizando dedit et docuit famulos dominis non esse superbos.* (Explicit.)

[88] See Kulikowski 2004, esp. 215–45, whose account underlies much of what follows.

enduring institutional and ceremonial functions translated into the formal, and functional, realm of constructed space.

We begin with Mérida, the capital of the late Roman diocese of Spain, which is relatively well served by literary, epigraphic and archaeological evidence. An inscription of 483 informs us of the repair of the city wall and the principal bridge across the Guadiana, undertaken by the Gothic noble Salla and the bishop Zeno, an initiative apparently confirmed by evidence of extensive repairs to the old, Augustan circuit.[89] What archaeological evidence there is for the intramural area relates chiefly to domestic structures uncovered across six roman *insulae* in the Morería neighborhood. While there are signs of destruction and partial abandonment in the later fifth century, the area was again thriving in the sixth, when older *domus* were preserved, along with the street network, but subdivided to house multiple families; if anything, then, this neighborhood became more populous in the sixth century than ever before, and remained so into the Islamic period.[90] This urban populace appears constantly in the *Vitas Patrum Emeritensium* (hereafter *VPE*), a mid-seventh-century compilation on the lives of Mérida's illustrious bishops, which is also the principal source for new monumental architecture in the city center, none of which has yet been identified archaeologically.[91]

The bishop of the city resided in an intramural palace, and presided in what is always called an *atrium*, where he received visitors and conducted official business, and where all those in need, 'both citizens of the city and *rustici* from rural areas,' might come for handouts of wine, honey and oil.[92] The adjacent cathedral of St. Mary formed part of a larger complex, which included also a smaller church (*basilicola*) dedicated to St. John with an adjoining baptistery, all 'covered with a single roof.'[93] Of particular note is the location of the residence of the *dux* of the city in the immediate vicinity of the episcopal complex: by the later sixth century, evidently, the leading representatives of both

[89] *ICERV*, 363.

[90] Mateos Cruz and Alba Calzado 2000, 149–50; Kulikowski 2004, 212–13. Generally on the topography of the city from the fourth century through the ninth, with an emphasis on substantial continuity in essential infrastructure, see Mateos Cruz and Alba Calzado (2000); also Mateos Cruz 2000, Collins 1983, 88–105.

[91] The text was likely written in the 630s, and later reworked and corrected in the 670s: see Maya Sanchez, *CCSL* 116, lv–lvii. Substantial remains of monumental Visigothic-era structures have been found in the vicinity of the forum and elsewhere, but what exactly these structures were is as yet unknown: see, e.g., Mateos Cruz and Alba Calzado 2000, 147–48.

[92] *VPE* 5.3: *si quis vero de civibus urbis aut rusticis de ruralibus ad atrium ob necessitate accessisset, licorem vini, olei vel mellis a dispensantibus poposcisset…* On the bishop's Sunday audiences in the atrium, 4.6: *Quodam igitur dominico die, dum in atrium com multis filiis eclesie resideret* [the bishop Paulus], *ut mos est, arcidiaconus cum omni clero in albis ab ecclesia venientes coram eo adstiterunt.*

[93] Ibid., 4.9: *pervenerunt ad eclesiam sancte Marie ad baselicolam sancti Iohannis, in qua babtisterium est; que nimium contiqua antefate baselice, pariete tantum interposito, utreque unius tecti tegmine conteguntur.*

civic and ecclesiastical authority resided in close proximity, in an arrangement suggestively similar to that already observed at Recopolis.[94]

Outside the walls, the focal point of cult and building activity was the complex that arose around the shrine of Saint Eulalia in the east of the city, where the fourth- and fifth-century mausolea surrounding the grave of the saint were replaced, ca. 500, with an imposing basilica; high-status burials continued in the area, and a large *xenodochium* for the care of the poor, the sick and pilgrims, the remains of which have been plausibly identified in the vicinity of the basilica, was erected in the later sixth century by Bishop Masona.[95] In the *VPE*, the two poles of episcopal activity in the city are invariably the episcopal complex inside the walls and the shrine of Eulalia outside. When Bishop Paul abdicated in favor of his nephew Fidelis, he 'left the atrium and all the privileges of his office and took himself off to a most vile cell at the basilica of Saint Eulalia';[96] and all of Mérida's other bishops followed his example in death by receiving burial at the shrine.[97] The contest between Masona and the Arian bishop Sunna, sent to the city by Leovigild, came to a head in a learned disputation between the two bishops for control of the basilica of Eulalia; prior to his victorious performance, Masona left his residence to spend three days in prayer at the basilica, before returning directly to the atrium, where he proceeded to humiliate Sunna in a public debate.[98] But the centrality of the route between the *episcopium* and the shrine of Eulalia is most apparent in descriptions of ceremonial processions. When a disgraced conspirator was pardoned by Masona, he was required to process directly from the church of Eulalia to the episcopal palace, walking before the horse of a mounted deacon.[99] On Easter, following mass in the cathedral of Mary, the bishop led all the people, singing and chanting psalms, through the east gate of the city and on to the church of Eulalia, which lay immediately beyond it.[100]

The main processional route in the city, in sum, was clearly the axis between the palace, or better, the palaces of both bishop and *dux*, and the extramural complex of Eulalia. Topographically speaking, it seems very likely that this route comprised a single street, leading directly from the palaces to the east

[94] Ibid., 5.10: the residence of the *dux Emeritensis civitatis* in the time of Reccared, Paulus, is said to be *valde contiguo atrio*, whence he was able to come immediately to the aid of Bishop Masona when the latter's enemies conspired against him.

[95] *VPE* 5.3; on the archaeological remains, Mateos Cruz 2000, 508–11; Mateos Cruz and Alba Calzado 2000, 152; Kulikowski 2004, 235–39; 291–93.

[96] *VPE* 4.4: *Ipse vero sanctissimus senex mox derelinquens atrium et omnia privilegia honoris sui sese ad basilicam sancte Eulalie in cellulam vilissimam contulit.*

[97] Ibid., 5.15.

[98] *VPE* 5.5: *Tertio demum die ad atrium, quod est fundatum intra meniis ipsius urbis, repedavit.*

[99] *VPE* 5.11: *de ecclesia sancte Eolalie usque ad atrium, quod est fundatum intra muros civitatis, ante caballum Redempti diaconi pergeret ordinavit.*

[100] *VPE* 5.11; 5.12.

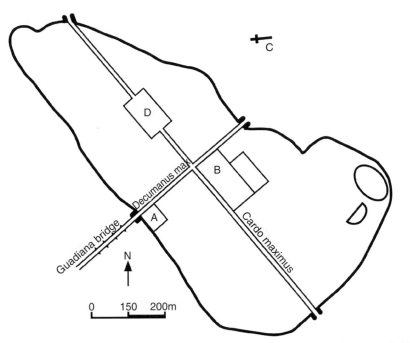

Figure 4.3 Visigothic/early Islamic Mérida. A: Alcazaba; B: municipal forum (probable location of episcopal complex and palace of *dux*); C: Santa Eulalia; D: provincial forum. (Author.)

gate of the city and the shrine of the martyr beyond; the *VPE* at least implies as much, as does a glance at the map of the city (Figure 4.3). The bridge across the Guadiana repaired in 483 led directly to the west gate, which in turn faced the east gate beyond which lay the shrine of Eulalia; the Roman forum lay along this route, where the residences of bishop and *dux*, along with the cathedral and baptistery, are all best located by the sixth century.[101] Thus, while the architectonic characteristics of the processional route remain to be determined, we can at least imagine with some assurance that Mérida in the sixth and seventh centuries gravitated around a single, monumental corridor comprising the bridge, the west gate, the intramural episcopal complex and ducal residence near the forum, the east gate and the shrine of Eulalia. The same might indeed be said for the eighth and ninth centuries, when the city's new Islamic rulers constructed their citadel, the Alcazaba, just inside the west gate, flanking what evidently remained its most frequented axis of movement.[102]

The general outlines of the situation proposed for Mérida can be more confidently documented in a number of the other leading urban centers of

[101] On the placement and evolution of the forum, Ayerbe Vélez, Barrientos Vera and Palma García 2009. On the location of the episcopal complex and the residence of the *dux*, which have yet to be archaeologically identified, cf. Mateos Cruz and Alba Calzado 2000, 150–51; Kulikowski 2004, 292; Wickham 2005, 661.

[102] Mateos Cruz and Alba Calzado 2000, 156 and ff.

Visigothic Spain, both with regard to the continuing presence of relatively dense intramural residential quarters, and above all with regard to the placement of cathedrals and episcopal residences, which often came to occupy forums beginning in the later fifth century, when these spaces seem no longer to have maintained their original civic functions.[103] At Tarragona, the monumental heart of the city as it had existed since the Flavian period was only altered beginning ca. 500, when two large buildings, probably a cathedral and an episcopal palace, rose on the site of the Flavian forum at the highest point in the city.[104] At Zaragoza, the Tiberian forum was similarly transformed, perhaps in the first half of the sixth century: the *curia* was refashioned into a church, while much of the remaining space of the forum, its monumental pavers removed, was occupied by grain silos and *spolia*-built domestic structures.[105] So too at Valencia, an episcopal complex flanked by multiple churches came to occupy the forum in the course of the sixth century.[106]

While the great public buildings of the Byzantine, Visigothic and Umayyad periods at Córdoba arose in a previously peripheral area in the south of the city near the banks of the Guadalquivir, they too were disposed along a single, monumental corridor flanking both sides of the principal *cardo* of the city, itself likely the urban tract of the Via Augustea, which crossed the Guadalquivir on a massive bridge just south of the south gate of the city, called during the Islamic period the Bab al-Sura, the gate of the statue, presumably for its surviving – and evidently striking – sculptural decoration.[107] Inside the gate, to the east of the street, the cathedral of St. Vincent was built in the mid-sixth century, perhaps on the site of an earlier martyrium dedicated to that most famous of the city's martyrs, which might in turn suggest that the original Augustan circuit was extended to encompass a previously extramural cemetery, perhaps in the mid-sixth century, when the city passed back and forth between Byzantine and Visigothic control.[108] The palace of the governors of the city, built either by the Byzantines or the Visigoths, lay across the street from the cathedral and its adjacent episcopal residence; this imposing topographical conjunction of civic and ecclesiastical authority was preserved intact when Córdoba became the capital of the Islamic emirate of al-Andalus in 716, at which point the governor's residence was transformed into the palace of the emirs, the Alcazar, while the cathedral of Vincent was razed to make way for the Great Mosque.[109] The

[103] As Kulikowski has convincingly argued in his survey of Spanish cities in late antiquity (Kulikowski 2004, 216 and passim); see also Wickham 2005, 656–65, and the various contributions in Gurt and Ribera (eds.) 2005, e.g., Mateos Cruz 2005.

[104] Kulikowski 2004, 222–24.

[105] Ibid., 227–28.

[106] Ramallo Asensio 2000, 373; Kulikowski 2004, 230–32.

[107] Marfil Ruiz 2000, 119.

[108] Ibid., 123–30.

[109] Ibid., 135–40.

street in between was carefully maintained to its original width, with no sign of encroachment from the monumental complexes on both sides, whence it continued to define the sequential experience of the urban façade in the form it took by the later sixth century: the bridge over the Guadalquivir, a (new?) gate, ostentatiously adorned with sculpture, and the principal intramural foci of civic and religious life situated just beyond.[110]

This brings us, finally, to Toledo, and the palace-church dedicated to Peter and Paul, the *ecclesia praetoriensis*, where Wamba was anointed before the assembled populace. While the exiguous literary, epigraphic and archaeological data available permit only a speculative reconstruction of the city's monumental topography in the Visigothic period, they hint at a configuration with marked similarities to both Mérida and Córdoba, focused along the urban tract of the highway that entered the city from the east via the great Roman bridge – the Alcantara – over the river Tagus/Tajo and on through the Alcantara gate.[111] The strategically vital area in the vicinity of the Alcantara bridgehead is the probable location of the principal palatine residence in Wamba's day, including the church of Peter and Paul, first attested in the acts of the Eighth Council of Toledo in 653 and thereafter described as *in suburbio Toletano (vel sim.)*.[112] The continued development of this area in the later seventh century is suggested by the so-called Mozarabic Chronicle of 754, which interestingly enough devotes the most explicit notice of a major campaign of urban renewal found in any surviving text to Wamba himself, and includes transcripts of the inscription placed above several unspecified gates, strongly implying that Wamba devoted much of his attention to work on walls and gates.[113] It is tempting to imagine, as others have, that this initiative included a separate fortification for the palace-quarter, particularly as we know that the Alcazar, the compound occupied

[110] Ibid., 129–30.

[111] Though the attested remains of the gate date to the Middle Ages, the original entry was very probably also axially aligned with the bridge, perhaps on the line of the later walls. Not far to the west, parts of the Roman curtain wall and a tower have been excavated beneath the current Puerta del Sol; the projecting, semicircular contours of the tower and the construction of its foundations in large blocks of reused stone point to a date in the Tetrarchic period: see Carrobles Santos 2004, 9–14; Carrobles Santos et al. 2007, 57–59.

[112] See esp. Carrobles Santos et al. 2007, 108–13; cf. Velázquez and Ripoll 2000, 558–60. The church is said to be *in suburbio Toletano* at, e.g., Toledo XII.4 (*a.* 681).

[113] *Continuatio Isidoriana Hispana* (López Perreira 1980, 52–55): *Huius temporibus in era DCCXII [anno 674] Uuamba Gothis prefectus regnat annis VIII. Qui iam in supra fatam eram anni tertii sceptra regia meditans civitatem Toleti mire et eleganti labore renobat, quam et opere sculptorio versivicando pertitulans hoc in portarum epigrammata stilo ferreo in nitida lucidaque marmora patrat: Erexit fautore Deo rex inclitus urbem Uuamba sue celebrem protendens gentis honorem. In memorii quoque martirum, quas super easdem portarum turriculas titulavit, hec similiter exaravit: Vos, sancti domini, quorum hic praesentia fulget, Hanc urbem et plebem solito salvate fabore.* The text of the inscriptions is independently confirmed by *ICERV* 361. Cf. McCormick 1986, 306: 'The fact that Wamba's building activities in the capital included the adornment of one or more gates with sculpture and commemorative inscriptions indicates a lasting concern with the architectural backdrop of such ceremonies [sc. *adventus*].'

by the city's Islamic governor and garrison that later rose on this site, was surrounded by the ninth century by its own circuit-wall, which made it effectively independent of the city and essential for the control of its approaches, and would explain well the 'suburban' designation of the palace and church in the earlier sources.[114]

Further support for locating the Visigothic palatial quarter in the environs of the Alcantara Bridge and the Alcazar comes from the large quantity of extremely high-quality fragments of Visigothic-period architectural sculpture found in the area, much of it featuring motifs such as shells and lunettes, which have parallels in contemporary Byzantine architectural sculpture and point to a secular identity for the source building(s), in marked contrast to the sculpture found in the area of the cathedral, for example, with its more explicitly Christianizing imagery.[115]

There is, finally, the remarkable illustration on fol. 142r of the *Codex Vigilanus*, a Mozarabic manuscript dated to 974–76 and thought to reproduce a seventh-century Visigothic original, which presents an exquisitely schematized rendering of the city of Toledo (Plate VII).[116] The upper portion of the image shows the city itself, labeled *regia sedes Toletana*, in the guise of an elaborately patterned wall surmounted by four towers and pierced by two gates, the one on the left marked *ianua urbis*, and that on the right *ianua muri*. Beneath the gate on the left appears the cathedral of the city with its dedication to the Virgin, while the palatine church of Peter and Paul appears beneath the gate to the right. As others have noted, the apparent distinction between the gate of the city properly speaking and the gate of 'the wall' accords well with the dual circuits attested in the Islamic period; each church, according to this scheme, was thus juxtaposed with the gate by which it was accessed: the city gate for the cathedral, and the gate in the adjacent circuit – presumably the one by the bridge – for the palatine church of the Apostles.[117] In any case, this illustration represents yet another striking visualization of the essence of the capital city inherited from the late Roman world: a monumental armature characterized by a looming wall pierced by a gate leading to the (palace) church, followed by another gate leading to the cathedral.

And in fact, the road leading from the bridge, after traversing the Alcantara Gate, pointed straight for the site of the cathedral and presumable episcopal complex, which all are agreed stood beneath the current, thirteenth-century cathedral, the site of an unusual concentration of Visigothic sculptural fragments,

[114] Velázquez and Ripoll 2000, 558–60; Carrobles Santos et al. 2007, 108–13. While remains of this circuit have yet to be identified, ninth- and tenth-century descriptions clearly indicate its presence: Carrobles Santos et al. 2007, 187.

[115] Barroso Cabrera and Morín de Pablos (2007), 761–70.

[116] Velázquez and Ripoll 2000, 560ff.; Carrobles Santos et al. 2007, 103ff.; a nearly identical image appears in a second manuscript dated to 992 (ibid.).

[117] Carrobles Santos et al. 2007, 108–11.

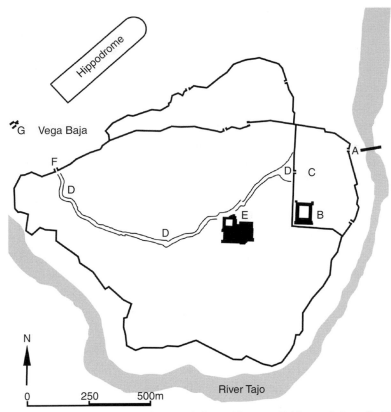

Figure 4.4 Visigothic/early Islamic Toledo. A: Alcantara Bridge and Gate; B: Alcazar; C: later Visigothic palatial quarter and church of Peter and Paul (?); the fortified citadel dates at least as early as the ninth century, and perhaps to the Visigothic period; D: main processional avenue (following the outline of the modern streets); E: cathedral and episcopal complex; F: Puerta del Cambrón; G: Santa Leocadia (earlier Visigothic palatial quarter?). (Author.)

some clearly belonging to a church.[118] Following the preserved course of the street between the gate and the cathedral farther to the west, one arrives at the western gate in the circuit, today's Puerta del Cambrón, which in turn leads to the site of the third of the Visigothic capital's three great churches, the martyrial basilica of Santa Leocadia (Figure 4.4). Dedicated in 618 by King Sisebut and subsequently the site of several church councils, the church, which has yet to be definitively identified, was clearly located in the vicinity of an early Christian cemetery situated near the remains of the Roman circus, an area densely occupied during the Visigothic period, judging by the quantities of ceramics and sculptural fragments found there.[119] One of the more striking finds to emerge in recent years is the traces of a massive building annexed to the circus in the late Roman period, with well-built stone walls two meters thick, which may

[118] Barroso Cabrera and Morín de Pablos 2007, 771–73; Carrobles Santos et al. 2007, 104–08.
[119] Velázquez and Ripoll 2000, 550–60; Barroso Cabrera and Morín de Pablos 2007, 773–76.

thus represent yet another late antique palace-circus complex.[120] Perhaps the kings occupied this area until the mid-seventh century, when the more strategically situated, defensible and central area by the bridge was developed; this might explain why from 653 on, the church of Peter and Paul was preferred, along with the cathedral, as the site of church councils, while Santa Leocadia had been favored in the decades after 618.[121]

Although many of the details of this topographical overview remain debatable, the essential fact remains that all of the attested foci of monumental architecture in Visigothic Toledo — and for that matter in its Islamic successor — lay along a single axis, comprising the Alcantara bridge and gate, the Alcazar, the Cathedral, the Puerta del Cambrón and the Vega Baja (the area of the circus and its environs, including the basilica of Santa Leocadia). The known or hypothetical locations for all three of the city's great churches, as well as its palace-quarters, lie along this route, as does an impressive percentage of all the Visigothic-era architectural sculpture yet discovered. Toledo too, in short, gravitated around a single monumental itinerary that linked palaces, churches, city walls and gates into a continuous, integrated sequence, the essential background for the public humiliations and triumphs, the military and ecclesiastical processions that defined the public display of authority in the Visigothic capital.

We might finally note that the legacy of Toledo's architecture and pageantry was powerful enough that a century after its fall to Spain's Muslim conquerors, it provided the template for the new capital of the resurgent Christian kingdom of the Asturias at Oviedo. According to the late ninth-century Asturian chronicles, when Alfonso II (791–842) sought to make of Oviedo a fitting capital for his expanding realm, he strove to resuscitate both the architectural forms and the institutional and representative functions of the erstwhile Visigothic capital: 'He established the whole (ceremonial) order of the Goths (*ordo Gothorum*) as it had been at Toledo, in both Church and Palace.'[122] The extant churches, with their finely dressed masonry and stone vaulting, speak to the persistence of the finest technical traditions of Toledo, while the mention of Alfonso's triumphal entry into the city following a victorious campaign in Gallaecia suggests a similar persistence (or resurgence) of ceremonial traditions.[123] The topography of

[120] Carrobles Santos et al. 2007, 59–64.

[121] Cf. Velázquez and Ripoll 2000, 560; Carrobles Santos et al. 2007, 112–16. Three councils were held at Santa Leocadia in the 630s (Toledo 4 [633], 5 [636] and 6 [638]), after which there is notice of only one more, Toledo 17 (694). Ewig long ago proposed that this was the principal palatial quarter in the city, based largely on the presence of the circus and the church of Santa Leocadia, whence he assumed – improbably, in my view – that the later *ecclesia praetoriensis* of Peter and Paul was located in the same area (1963, 31–36).

[122] *Albelda Chronicle*, 44.1 (Bonnaz [ed.] 1987, 24): *Omnemque Gothorum ordinem sicuti Toleto fuerat tam in Ecclesia quam in Palatio in Oveto cuncta statuit*; see also the *Chronicle of Alfonso III*, 14.1 (ibid., 50–51).

[123] *Chronicle of Alfonso III*, 14.2 (Bonnaz [ed.] 1987, 52); Oviedo is called the *sedes regia* in the *Albelda Chronicle*, 47.6 (Bonnaz [ed.] 1987, 27).

the new *sedes regia* was again the stage upon which the sovereign proclaimed his right, sanctioned by God, embodied in the royal palace and its three surrounding churches, and manifest in his victories, to rule.[124]

In sum, while architectural typologies of both public and residential buildings changed substantially between the fifth century and the seventh, the essential connective and ceremonial armature of the late antique city (gate-street-intramural loci of power) was often maintained or indeed fashioned *ex novo*, ready to serve the needs of kings and bishops who remained as attached as ever to public performances (of charity, of penitence, of devotion, of triumph and humiliation) staged for the benefit, and with the essential participation, of the urban populations whose gardens, workshops and dwellings transformed the stately, single-family *domus* of the late empire, and often even the theaters, amphitheaters, circuses and forums of the high empire, into pullulating popular quarters.[125] As Isidore knew, a city might be constituted by its walls and buildings, but a *civitas* could only be defined as the product of the citizens who inhabited it.[126]

None of this is to say that urban landscapes in the Iberian Peninsula were not radically changed by the seventh century, nor that many – most, even – of the cities in existence in the imperial period had not disappeared: of the several hundred *civitates* known for the imperial period, approximately eighty are attested in the seventh century.[127] There was also pronounced regional variation. In the former Byzantine enclave in the southeast following its conquest in the early seventh century, and the erstwhile Suevic kingdom in the northwest, where Braga alone shows substantial signs of continuity, subjection to Visigothic dominion seems to have signaled – perhaps not coincidentally – a relative decline in the fortunes of cities in what seem to have remained impoverished and peripheral areas of the Visigothic polity.[128] But for all that the administrative geography of the peninsula was considerably rarified and regionalized, enough *civitates* remained to ensure that leading functionaries of the church and the Visigothic administration had an available urban milieu in which to base themselves. These cities were overwhelmingly the seats of surviving episcopal sees – the figure eighty largely derives from the subscriptions of church councils[129] – many of which of course also played host to Visigothic comital governors.

[124] Much the best description of the palace and the three nearby churches, dedicated to the Savior, St. Mary and St. Tyrsus, appears in the *Chronicle of Alfonso III*, 14.1 (Bonnaz [ed.] 1987, 50–51). For a succinct description of the surviving structures, see Carrobles Santos et al. 2007, 136–40.

[125] For numerous examples of all such residential arrangements, see the overview of Ramallo Asensio 2000.

[126] *Etym.* 15.2.1: *Civitas est hominum multitudo societatis vinculo adunata, dicta a civibus, id est ab ipsis incolis urbis. Nam urbs ipsa moenia sunt, civitas autem non saxa, sed habitatores vocantur.*

[127] Kulikowski 2004, 287.

[128] On the relative lack of signs of urban continuity in the southeast and northwest, Wickham 2005, 659–63.

[129] Kulikowski 2004, 287.

And if the later seventh century appears to be a period of decentralization, when rurally based nobles asserted themselves at the expense of the kings in Toledo and their representatives in provincial capitals, with a consequent decline in urban building projects and the maintenance of essential infrastructure, the trend was quickly arrested during the first century following the Umayyad conquest, when the fiscal and political machinery of the emirate of al-Andalus was firmly ensconced in surviving cities, Córdoba, of course, but also Seville, Mérida, Toledo, Zaragoza.[130] Further, even in the later seventh century, kings such as Wamba and the bishops who anointed them and chronicled their deeds still looked to cities as the source and the guarantor of worldly authority. The later seventh century may have been characterized by the rise of 'proto-feudal' rural nobles, but where are their names? The protagonists in all the surviving literary sources cited earlier, charismatic hermits and monks aside, operated in primarily urban milieux, where they could be seen to be protagonists, and remembered as such. Much the same can be said for the Frankish kingdom, though it is often characterized as less urban centered, by the seventh century, than both Spain and Italy.

4.3 MEROVINGIAN GAUL

Though Merovingian rulers never established a single, predominant *sedes regia* comparable to Visigothic Toledo, Lombard Pavia and Byzantine Constantinople, and though they clearly did develop a secondary network of suburban and rural palaces and *villae* where they spent much of their time, the political, ecclesiastical and fiscal structures of the Frankish realm remained firmly rooted in the old Roman *civitates*.[131] The kings of the four *Teilreiche* established upon the death of Clovis in 511 always claimed one or more cities, complete with palaces, as their capitals and seats of power – their *sedes* or *cathedrae regni*, as Gregory of Tours called them[132] – as did their successors for the next two centuries, and the Carolingians after them. Every city had its count responsible, in the name of the king, for local administration; every city had its bishop and episcopal complex, the administrative and fiscal center of each diocese, where the proceeds from the church's immense landed patrimonies were stored and

[130] Moreno 2009; cf. Olmo Enciso 2000, 390–92.

[131] Vercauteren 1959; Ewig 1963, esp. 47–53; Brühl 1968, 9–24; 1975; 1990; Loseby 1997; Dierkens and Perrin 2000; McKitterick 2008, 171–78.

[132] See, e.g., Greg. Tur. *HF* 2.38 (Clovis establishes his *cathedra regni* at Paris); *HF* 4.22 (the division of the kingdom among the four sons of Clovis' last surviving son Chlothar, upon the latter's death in 561): *Deditque sors Charibertho regnum Childeberthi sedemque habere Parisius, Gunthramno vero regnum Chlodomeris ac tenere sedem Aurilianensem, Chilperico vero regnum Chlothari, patris eius, cathedramque Sessionas habere, Sygibertho quoque regnum Theuderic sedemque habere Remensim*; also Fredegar, *Chron.* 3.29; on the division of 511 among Clovis' four sons, who likewise took Reims, Paris, Soissons and Orleans as their capitals, Greg. Tur. *HF* 3.1.

processed.[133] By the seventh century, these invariably urban-based bishops also increasingly assumed the burdens of secular administration outside of the principal capitals, including the collection of taxes owed to the royal fisc, from which public revenues they could in turn provide for the maintenance of urban infrastructure, as bishop Desiderius (or Didier, ca. 630–50) famously did in restoring the walls of Cahors and constructing a new aqueduct.[134]

Without rehashing the endless bibliography and ongoing discussions about the condition of Gallic cities between the sixth and eighth centuries, we might better turn to the – admittedly fragmentary – evidence for the continuing relationship between topography and ceremony in a number of leading cities in the Frankish kingdoms. Taken together, the indicators are sufficient, I think, to suggest the following essential points. The first is that cities remained the venue of choice for the most ostentatious and symbolically significant manifestations of public ceremony: coronations, baptisms, religious celebrations and triumphal *adventus*. In short, when Merovingian sovereigns most needed to assert their legitimacy, marshal the consent of their subjects and trump the claims of their opponents, they staged the display of their regal dignity in cities. Such displays were all the more essential given the turbulent and fragmented nature of Merovingian politics, when strife and often open warfare between the kings of the various subkingdoms was endemic, and further exacerbated by an unending succession of local rebellions and attempted usurpations:[135] in a very late Roman way, the never-ending struggle for legitimacy had to be acted out in front of an urban backdrop, before the eyes of the greatest possible number of onlookers. Second, again – not coincidentally – in a manner reminiscent of late Roman sovereigns and their provincial representatives, Merovingian rulers often traveled widely throughout their domains, the better to assert their royal prerogatives, suppress disturbances, compel compliance and bring their awe-inspiring spectacle before as many of their subjects as possible. The mobility of the sovereigns, and the simultaneous presence of as many as four royal courts

[133] See n. 131.

[134] *Vita Desiderii*, c. 16–17, with Durliat 1979. Even if Durliat's very plausible suggestion that the funds for these projects came from the taxes owed to the royal fisc and collected by the bishop be off the mark, the fact remains that Desiderius commanded massive resources, which sufficed also for a plethora of monumental religious edifices erected in and around Cahors (*Vita Desiderii, loc. cit.* and passim). In the second half of the seventh century, Bishop Leodegar of Autun likewise took charge of repairing the walls of his city, and of many other civil and ecclesiastical building projects: see *Passiones Leudegarii* I, c. 2, p. 285: *Praeterea innuunt eius industriam ecclesiae pavimenta velaque aurea et atrii constructio nova, murorum urbis restauratio, domorum reparatio, et quae erant nimia vetustate consumpta per se reddentecrata, visa videntibus testimonia.* Generally on the growing role of bishops in secular governance (including public works) in Merovingian Gaul, see now also Kreiner 2011. For another example of a seventh-century bishop using rents from public lands for building projects at Rouen, *Vita Ansberti*, c. 17: *Census etiam, qui de vicis publicis canonico ordine ad partem pontificis persolvi consueverant, gratuita benignitate in restaurationibus ecclesiarum … indulsit.*

[135] For an overview, see Wood 1994.

in the Merovingian sphere, indeed gave scope for many more royal epipha-
nies, in many more places, than occurred in any of the other Western succes-
sor kingdoms or Byzantium.[136] But (third), like in Visigothic Spain, Lombard
Italy and Byzantium, the protocols of urban ceremonial in Merovingian Gaul
descended in a direct and unbroken continuum from the later Roman empire,
notably including *adventus* and other processions along a main street, 'crowned'
for the occasion with garlands, textiles and the like in the manner of the late
Roman *coronatio urbis*.[137] As we shall see, Gregory of Tours, our best source for
such rituals, was keenly aware of their potential (or better, their necessity) as a
means of establishing legitimacy and proclaiming sovereignty.

These observations lead, finally, to the crux of the matter: in many leading
cities of Merovingian Gaul, there are suggestive hints of ongoing efforts made
to preserve and often embellish the principal urban thoroughfare that remained
the preferred venue for processional ceremonial. The intramural tract of this axis
often passed in the immediate vicinity of the cathedral and *episcopium*, and often
the civil palace as well, while the extramural continuation of the same street led
with striking regularity to the site of the preeminent extramural shrine, com-
plete with monastery and – later – royal residence that grew up outside so many
important Merovingian, and later Carolingian, cities, as Brühl in particular has
shown.[138] Thus, the twin intra- and extramural poles of cities such as Tours, Paris
and Reims bracketed the ends of a processional way, a linear urban core that
could still define the perceptual and functional experience of the Merovingian
city, never more so than on those occasions when the mighty sought publicly
to exalt themselves in the style of their Roman predecessors.

We begin with Tours, site of Clovis' imperial coronation in 507, followed
by the four principal royal capitals of the sixth century, the cities allotted to
Clovis' four sons upon his death and the division of the realm in 511, and
again to the four sons of Clothar in 561: Paris, Orléans, Soissons and Metz.
Immediately following his victory over the Visigoths in 507 at Vouillé, accord-
ing to Gregory of Tours, Clovis received codicils of office from the Byzantine
emperor Anastasius, and had himself proclaimed *consul* and *augustus* at Tours, via
a ceremony patently inspired by both the ritual protocols and the topography
of Constantinople.[139] The parade began in the extramural shrine of St. Martin,

[136] Cf. McCormick 1986, 328–78, esp. 330–32 on the ubiquity of *adventus* under both the
Merovingians and the Carolingians.

[137] A particularly striking example of a *coronatio urbis* is Gregory of Tours' description of Clovis'
baptism in Reims in 496, when the streets of the city were allegedly bedecked in figured
textiles (*HF* 2.31); see n. 167; see also *Passiones Leudegarii* I, c. 17, p. 299, for a late seventh-
century *coronatio urbis* in connection with the *adventus* of Ebroin and Leudegar at Autun.
Generally on *adventus* in the Latin West in the early Middle Ages, Dufraigne 1994, 329–455
is fundamental.

[138] Brühl 1975 and 1990; see later in this chapter for individual cases.

[139] Cf. McCormick 1989.

where Clovis assumed a white tunic, chlamys and diadem, and 'mounting his horse, with the most benevolent goodwill distributed gold and silver, *strewing it from his own hand to those present along that route, which runs between the gate of the atrium* [of St. Martin] *and the cathedral of the city*, and from that day was hailed as consul and augustus.'[140] The church of St. Martin thus stood in for that of St. John at the Hebdomon at Constantinople, whence the newly crowned emperor proceeded east into the city and along the Mese to Hagia Sophia: at Tours, Clovis likewise went east along the extramural prolongation of the main *decumanus* of the city, which bisected the small, late Roman enceinte and led, just past the west gate in the wall, directly past the cathedral. Beyond the cathedral, perhaps just inside the eastern gate of the city and certainly in close proximity to the road, lay the royal palace established, in all probability, on the site of the late Roman *praetorium* (Figure 4.5a).[141]

Thus, the three preeminent loci of spiritual and temporal prestige in Tours, the places where distinguished residents and visitors alike would congregate from the sixth century through the Carolingian period, were all arrayed along the stretch of road that began with St. Martin and led, via the city gate, to the cathedral/*episcopium* and royal palace. This was the route Clovis followed when he needed the background of a city and the cheering crowds lining his itinerary to complete the spectacle of his coronation and ensure its enduring fame; it remained the favored location for processional ceremonies in the time of Gregory of Tours,[142] and in the seventh century,[143] and presumably in the Carolingian period too, when a royal residence was added to the shrine of Martin to house kings during their regular visits to the sanctuary, thus making of Tours a classic example of the 'bipolar' Frankish city, comprising the walled city center and a preeminent extramural sanctuary, linked by a single main

[140] Greg. Tur. *HF* 2.38: *Igitur ab Anastasio imperatore codecillos de consolato accepit, et in basilica beati Martini tunica blattea indutus et clamide, inponens vertice diademam. Tunc ascenso equite, aurum argentum in itinere illo, quod inter portam atrii et eclesiam civitatis est, praesentibus populis manu propria spargens, voluntate benignissima erogavit, et ab ea die tamquam consul aut augustus est vocatatus.* On the architecture and chronology of the shrine of St. Martin and its surrounding edifices, see TCCG Vol. 5, 32–35.

[141] For the location of the cathedral (quite certain) and the palace (conjectural but certainly near the main *decumanus*), see Brühl 1975, esp. 107–09; on the episcopal complex, see also TCCG Vol. 5, 28–31.

[142] Whenever Gregory refers to processions held on important church feasts, for example, they seem – not surprisingly – to have traversed the road between the cathedral and St. Martin: see, e.g., *HF* 5.4 (an Epiphany procession featuring a cross and *signa* that went from the cathedral to St. Martin); 5.11 (an Ascension procession again from the cathedral to St. Martin); also the stational catalogue at 10.31, where these two churches predominate over all the rest.

[143] When the remains of Bishop Leodegar of Autun arrived at Tours on their way to Poitiers in the 680s, they were received with a triumphal *occursus* of the people and clergy, and conducted 'through the middle of the city,' surely again along the main *decumanus*: *Passiones Leudegarii* II, c. 27, p. 350: *Hoc audiens huius civitatis pontifex, qui tunc aderat, vir Dei Chrodbertus, processit obviam cum choris psallentium, cum lampadibus vel omni honore habeto. Et acceptum cum suis feretrum, per medium transiret civitatis.*

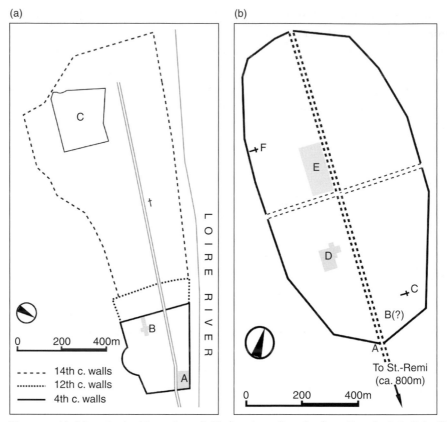

Figure 4.5(a) Merovingian Tours. A: probable location of royal palace; B: cathedral; C: basilica and monastery of St. Martin. (Redrawn after Brühl 1975, modified.); (b) Merovingian Reims. A: Porte Bazée; B: palace?; C: St. Pierre-les-Dames; D: cathedral and *episcopium*; E: forum; F: St. Pierre-le-Vieil. (Redrawn after Brühl 1975, modified.)

thoroughfare.[144] As for the populace that witnessed these spectacles, methodologically rigorous excavations conduced since the 1960s have revealed consistent traces of dense residential occupation both inside the walled circuit and beyond, the latter concentrated especially along the axis connecting the city center with the shrine of Martin, throughout the Merovingian period and beyond: early medieval Tours, in short, was a bustling place.[145]

On a rather grander scale, a similar 'bipolar' configuration evolved at Paris, whose transformation into the most prestigious city in the Frankish domains began when Clovis established it as the 'seat of the realm' following his

[144] On the construction of the royal residence (perhaps under Charlemagne) and the fortification wall built around the shrine (by the early tenth century at the latest), see Brühl 1975, 109–10 and 105, respectively; also Chevalier 1972.

[145] See the remarkable diachronic overview of ancient and medieval Tours, based on the results of the past forty years' worth of excavations, presented in Galinié (ed.) 2007, passim.

coronation in Tours.[146] Thereafter, the city evidently grew larger and more prosperous than ever before, while its symbolic significance became such by the later sixth century that it was – in theory – forbidden to any reigning monarch to enter it without the consent of his fellow sovereigns.[147] Merovingian Paris too manifestly gravitated around a single main street, usually referred to simply as the *platea* by contemporaries, which bisected the fortified city center on the Île de la Cité, bracketed by gates in the late Roman wall opening onto bridges over the Seine on the north and south flanks of the island. This *platea*, which corresponds with today's rue de la Cité, was lined with shops along much or all of its length, packed so closely that a fire that started by the south gate in 585 was pictured to have passed from one shop to the next, all the way to the north gate on the other side of the island.[148]

The cathedral and episcopal complex, located beneath the current cathedral of Notre Dame, and the royal palace, situated in all probability across the *platea* on the site of the *praetorium* occupied by the *caesar* Julian during his residence in Paris in the late 350s, were both accessed via this main *platea* and its bridges over the Seine.[149] Further, the shrine of St. Denis, founded by Queen Geneviève at the end of the fifth century, lay nine kilometers north of the city along the same road. Dagobert I (r. 623–39) transformed the existing *martyrium* of Dionysius, Rusticus and Eleutherius into a grandiose architectural showpiece, complete with a richly appointed (and richly endowed) new basilica, monastery and charitable foundations,[150] where he and his successors were subsequently buried.[151] As if to reify further the connection between the walled city center and the suburban shrine, Dagobert endowed the latter with properties conspicuously located along the connecting street, 'inside and outside the city of Paris and the gate of the city, which sits by the prison of Glaucinus.'[152] St. Denis thus embarked on the trajectory that saw it develop

[146] The *cathedra regni*: Greg. Tur. *HF* 2.38; Fredegar, *Chron.* 3.24. See generally Dierkens and Perrin 2000, 270–77.

[147] A prohibition routinely broken whenever political expediency dictated: see Greg. Tur. *HF* 6.27; 7.7.

[148] Greg. Tur. *HF* 8.33: A woman first dreamt of seeing a man 'burning the houses of the merchants one by one' (*domus neguciantum ex ordine succedentem*), beginning in the south; the fire itself then began in the first building by the south gate, and spread across the island all the way to the north gate. This is the same *platea* through which the Count Leudast wandered in 583, admiring the rich array of spices, silver and other luxury goods for sale in the flanking shops (ibid., 6.32). For archaeologically documented traces of houses located just west of the *platea*, on the rue de Lutèce, which remained inhabited into the eighth century, see Busson 1986.

[149] Brühl 1975, 14–27; Dierkens and Perrin 2000, 286–87.

[150] *Gesta Dagoberti I*, c. 17–20, 29, 33, 35, 37, 40, 51.

[151] Fredegar, *Chron.* 4.79; *Liber historiae Francorum*, c. 43; *Gesta Dagoberti I*, c. 42–43.

[152] *Gesta Dagoberti I*, c. 33: *Dagobertus rex Parisius rediens atque in amore saepe dictorum martyrum Dyonisii ac sociorum eius … areas quasdam infra extraque civitatem Parisii et portam ipsius civitatis, quae posita est iuxta carcerem Glaucini, quam negociator suus Salomon eo tempore praevidebat, cum omnibus teloneis, quemadmodum ad suam cameram deserviri videbatur, ad eorum basilicam tradidit.*

into the leading shrine of the realm by the mid-eighth century, the burial place of monarchs, site of Pippin's coronation by Pope Stephen II in 754, the new church inaugurated by Pippin in the same year, and later of a royal palace built, perhaps, by Charlemagne.[153] Thus, just as at Tours, the principal extramural focus of cult activity and royal patronage lay on-axis with the central *platea*, the intramural trunk of which framed the approaches to the cathedral, *episcopium* and royal residence.

The most vivid picture of the royal *adventus* and liturgical processions adumbrated in the literary record that traversed this axis,[154] the spinal column of Merovingian Paris, comes not from Paris but rather from Orléans, where King Guntram made his triumphal entrance in 585 after defeating the usurper Gundobald. As is so often the case in the Merovingian sources, Guntram reserved his most elaborately contrived urban spectacles for moments of crisis, when the need to proclaim his legitimacy and demonstrate his sovereign dignity was the most pressing. (Or, if we prefer, Gregory of Tours reserved his most detailed account of urban ceremonial for that part of his narrative in which he was most concerned with glorifying his hero Guntram and demonstrating his triumphant vindication of his right to rule, in the wake of a serious challenge to his authority.) Immediately following his victory, Guntram went first to Paris, where he stood in as godfather at the baptism of Chilperic's son Clothar, the latest heir to the Merovingian line, thus proclaiming the succession of Clovis' line in the most visible fashion imaginable, before the populace of the grandest capital of the realm.[155] He then returned to his own domains in Burgundy and went first to the traditional capital of the region, Orléans, which he had neglected in favor of Tours:

> And when he came to the city of Orléans, it was the day of the Feast of St. Martin, that is July 4. An immense crowd of the people came to meet him with standards and banners, singing his praises. And here the language of the Syrians [Greek], there of the Latins, there even of the Jews rang out with all manner of praises, crying out: 'long live the king, may his reign over his peoples last countless years!' And even the Jews, who were seen to participate in these praises, cried out: 'may all peoples adore you and may they bend their knee to you and be your subjects!'[156]

On the location of the *carcer Glaucini* near the north gate on the Île de la Cité, *MGH SS* 2, 413, n. 1.

[153] Brühl 1975, 27–33; Heitz 1980, 22ff.; Hen 2007, 111–16.

[154] E.g., Greg. Tur. *HF* 6.27 (Chilperic enters the city for Easter in 583, baptizes his son amidst great festivities); Fredegar, *Chron.* 4.26 (victorious *adventus* of Theoderic following his defeat of Clothar in 603/04).

[155] Greg. Tur. *HF* 8.1.

[156] Ibid.: *Sed cum ad urbem Aurilianensem venisset, erat ea die solemnitas beati Martini, id est quarto Nonas mensis quinti. Processitque in obviam eius inmensa populi turba cum signis adque vixillis, canentes laudes. Et hinc lingua Syrorum, hinc Latinorum, hinc etiam ipsorum Iudaeorum in diversis laudibus*

It was, in other words, a triumphal *adventus* in the best late Roman and Byzantine tradition, complete with the *occursus* of the people outside the gate to line the route of the arriving sovereign, the banners and standards, the chanted acclamations voiced by a large and diverse populace that was at once the protagonist and the audience, the recipient, of the spectacle. Without the festive, adoring crowd, there was no ostentatious manifestation of sovereign dignity; without the ostentatious manifestation of sovereign dignity, the importance of Guntram's victory and the vindication of his right to rule could not have been proclaimed, both to the residents of the capital who witnessed it, and to the readers of Gregory's history. Only thus could Guntram, as Gregory put it, 'make himself great in the eyes of his people.'[157]

Unfortunately, the topography of Merovingian Orléans remains so poorly known that any attempt to situate Guntram's *adventus* in its architectural context would be pure guesswork.[158] Soissons likewise remains largely an archaeological terra incognita, though a passing reference of Gregory's suggests that Soissons too was perceived to gravitate around a single principal avenue known simply as 'the' *platea*.[159] What is clear in both cases is that the surviving late Roman walls continued to house the cathedral, *episcopium* and royal palace,[160] and that both cities continued to serve as the stages for the ceremonies that Merovingian monarchs most wanted to be seen and remembered. Soissons, along with Paris, hosted one of the two circuses that Chilperic famously built (restored?) in 577, on the eve of a civil war against his fellow kings Guntram and Childebert, evidently to bolster his own prestige and consolidate his hold on power just when it seemed most threatened: 'spurning their embassy, he commanded circuses to be built at Soissons and Paris, and in them gave a spectacle for the people.'[161] When Chilperic's two young sons later died, he had one buried at Paris and one at Soissons, the better again to cultivate his connection with the inhabitants of the two leadings cities of his kingdom.[162] Another telling episode occurred in 589, when the people of Soissons, evidently accustomed to the presence of a resident sovereign and vexed that King

variae concrepebat, dicens: 'Vivat rex, regnumque eius in populis annis innumeris dilatetur.' Iudaei vero, qui in his laudibus videbantur esse participes, dicebant: 'Omnes gentes te adorent tibique genu flectant adque tibi sint subditi '

[157] Ibid.: *ad Aurelianensem urbem venit, magnum se tunc civibus suis praebens.*

[158] Cf. Dierkens and Perrin 2000, 288–89; for an overview of what is known, TCCG Vol. 8, 86–88.

[159] Greg. Tur. *HF* 9.9: *Haec vero per plateam Sessionicae civitatis … ferebatur*; on the (lack of) archaeology, cf. TCCG Vol. 14, 54.

[160] Orléans: Brühl 1975, 46–52; TCCG Vol. 8, 88–91; Soissons: Brühl 1975, 37–40; Dierkens and Perrin 2000, 282–84.

[161] *HF* 5.17: *Quod ille* [Chilpericus] *despiciens, apud Sessionas atque Parisius circus aedificare praecipit, eosque populis spectaculum praebens.* Orléans, meanwhile, was chosen for the baptism of Dagobert I's long-awaited heir, Sigebert, in ca. 631 (*Gesta Dagoberti I*, c. 24).

[162] *HF* 5.34.

Childebert preferred to dwell elsewhere, sent an embassy to him in Strasbourg requesting that he send one of his sons to preside at Soissons. When Childebert complied by dispatching his eldest son, Theodebert, along with a full palatine corps of retainers, Theodebert was received with the trappings of a full-fledged *adventus*.[163] Urban ceremonial remained, as always, a two-way street: the city was ennobled by the presence of a resident sovereign, as was the sovereign by the spectacle of his acclaiming subjects in their urban setting. In the mid-eighth century, Soissons again served as the stage upon which the most epochal events of the age played out: the Carolingian royal dynasty was born there with Pippin's coronation in 751, followed by his son Carloman's coronation in 768 (Charlemagne's simultaneous coronation likewise occurred before an urban backdrop, at Noyon).[164]

With regard to the fourth of the original Merovingian *sedes regiae*, Reims, it is possible to say a bit more on the basis of textual sources, though the archaeological data remain very thin. The city's main *cardo*, which bisected lengthwise the relatively large oval of the late Roman enceinte,[165] quite clearly remained the urban spine of the Merovingian – and Carolingian – city. The cathedral church of St. Mary and the *episcopium*, located on the site of today's cathedral of Notre Dame, opened directly onto this street, approximately 300 meters north of the city's south gate, the Porte Bazée. While the location of the royal palace established on the site of the former Roman provincial governor's palace remains more conjectural, the most plausible suggestion permitted by the documents places it on the far side of the same *cardo*, just inside the south gate.[166] The intervening stretch of the *cardo*, then, would be the *platea* Clovis followed in 496 when he left the palace on his way to be baptized like a 'second Constantine' by Bishop Remigius, festooned for the occasion with figured tapestries – a classic *coronatio urbis* in the late Roman mold.[167] We might imagine the 3,000 soldiers allegedly baptized on the occasion processing along

[163] Ibid., 9.36: *Suscepitque eum populus gaudens ac depraecans, ut vitam eius partisque sui aevo prolixiore pietas divina concederet* (a clear echo of the acclamations voiced during Guntram's *adventus* at Tours in 585: see earlier in this chapter at n. 156).

[164] *Annales Regni Francorum, anno* 750 [751]; *anno* 768.

[165] The fourth-century circuit was 2,950m long and enclosed ca. 60.5ha; it was restored in the early ninth century under Bishop Ebo (ca. 816–35; see Flodoard, *Historia Remensis Ecclesiae* 2.19, p. 179–80); on the walls, see Neiss 1984, 176–77.

[166] Brühl 1975, 64–67. The adjacent church of St. Pierre-les-Dames would thus be the descendent of the palace-chapel of St. Peter *ad cortem* or *ad palatium* attested in Carolingian-era sources; see, e.g., Hincmar (*Vita Remigii*, c. 14, p. 295), on the *oratorio sancti Petri iuxta domum regiam*, where Clovis' queen, Hrothild, held her vigil on the night before Clovis' baptism. On the location and remains of the cathedral, see TCCG Vol. 14, 34–36.

[167] Greg. Tur. *HF* 2.31: *Velis depictis adumbrantur plateae, ecclesiae curtinis albentibus adurnantur, baptistirium conponitur, balsama difunduntur, micant flagrantes odorem cerei.* Ibid. for Clovis as a 'New Constantine.' Cf. Hincmar, *Vita Remigii*, c. 14, pp. 295–97, esp. 296: *Interea eundi via ad baptisterium a domo regia preparatur, velisque ac cortinis depictis ex utraque parte protenditur et desuper adumbratur.* For the main *platea* (in the singular), see also Greg. Tur. *HF* 3.15.

with their sovereign, thus imbuing the spectacle with still more of the aura of the late Roman triumphal ceremonial that it manifestly recalled (and that had presumably indeed followed the same street, the likely venue for the *adventus* of arriving provincial governors bound for the *praetorium*).[168]

Following the foundation of the basilica and monastery of St. Remi in the mid-sixth century, which grew into one of the premier royal monasteries of the Carolingian kingdom by the time of Charlemagne, seat of a royal palace by the mid-ninth century at the latest, the preeminence of the same intramural tract of the *cardo* between the cathedral and the south gate will have grown still more pronounced, for the area of the monastery was accessed from the city center via the same south gate (tellingly called the *Porta Basilicaris*), following the extramural extension of the *cardo* some 900 meters farther to the south.[169] The cathedral, meanwhile, continued to host moments of high ceremonial drama: Pope Stephen II and the newly crowned Peppin appeared there in 754, as did Charlemagne and Pope Leo III in 799;[170] in 816, it was the site of Louis the Pius' coronation by Pope Stephen IV,[171] becoming thereafter the place of coronation for French monarchs throughout the Middle Ages. Thus, Reims developed the same bipolar topography already observed at Tours and Paris, with the heart of the intramural city center once again connected with the primary site of extramural cult, and royal patronage, via the continuation of the principal intramural thoroughfare (Figure 4.5b).

Called by Flodoard the 'Imperial Way' (! – *via Cesarea*), this route linking the cathedral and *episcopium*, probably the royal palace, and the extramural complex of St. Remi together in an axial sequence was thus by definition the space where the powerful most frequently appeared in public, and also the primary backdrop for processional ceremonies.[172] Its absolute prominence in the topographical horizons of the city and the conceptual geographies of its inhabitants comes through best in relation to the episcopate of Bishop Rigobert (ca. 693–744), who 'is said to have been accustomed to stand above this gate, which is called the Basilicaris (either because it so abounds in the basilicas placed around it, or because it stands on the route of those going to

[168] On the 3,000 soldiers allegedly baptized along with Clovis, Greg. Tur. *HF* 2. 31

[169] Brühl 1975, 70–72; generally on the architectural elaboration of the complex and the rapidly growing cult of Remigius from the sixth century to the ninth, see also Isaïa 2010, 197ff.

[170] On both events, Flodoard, *Historia Ecclesiae Remensis* 2.19, p. 179; earlier, at the end of the seventh century, it was the site of Charles Martel's baptism (*Vita Rigoberti*, c. 8).

[171] Flodoard, *Historia Ecclesiae Remensis* 2.19, p. 178.

[172] Flodoard, *Historia Ecclesiae Remensis* 1.4, p. 69. For continued indications of processions between the cathedral and St. Remi in the eleventh century, see Brühl 1975, 70. Already in the seventh century, the basilica of St. Remi was the preferred burial site for the bishops of Reims (Flodoard, *Historia Remensis Ecclesiae* 2.6; 2.7); and in 771, it received its first royal burial with the deposition of Carloman (Isaïa 2010, 398–400). It is noteworthy that known early medieval burials mainly cluster in close proximity to the road: see TCCG Vol. 14, 32.

the intramural and extramural foci of both civic and ecclesiastical administra-
tion would be known, simply, as the 'royal way' (*via regia*).[184]

A similar combination of existing, continuously occupied Roman structures
integrated with new, usually religious edifices can be postulated for Trier and
Cologne. At Trier, the best evidence is the remarkable preservation of the prin-
cipal components of the city's fourth-century armature of power arrayed to
the east of the main *cardo*, beginning with the Porta Nigra itself in the north,
followed by the cathedral and episcopal complex, the Constantinian audience
hall, which came to comprise part of the archbishops' residence by the tenth
century, and finally the *Kaiserthermen* at the intersection of the main *decumanus*
from the bridge over the Moselle (Figure 2.6).[185] It is surely significant that so
many of the principal components of the episcopal and palatial quarter of the
city discussed in Chapter 2, sequentially disposed along the axis of the main
cardo, survived not only the 'Dark Ages,' but indeed all subsequent ages up to the
present. While the colonnades along the *cardo* may well have vanished between
the Germanic invasion of 406/07 and the Hunnic sack of 451, and the city as
a whole reached a low ebb in the fifth century, the fact that Trier never lost
its monumental nucleus indicates both that consistent, long-term efforts were
made to preserve it, and that the most important actors in the Merovingian
city, such as the immensely prestigious and influential Bishop Nicetius in the
mid-sixth century, continued to occupy and animate these spaces.[186]

The subject of occupation requires a clarification that cannot be too often
reiterated: as also at Metz and at Cologne, where we now turn, the relative lack
of intermediate strata – including dark earth – between the late Roman and
Carolingian levels in the heart of Trier indicates not that the city was abandoned
during this period (as the abundant sixth- and seventh-century burials from
its extramural cemeteries amply demonstrate), but rather that the Merovingian
city was characterized by the tenacious maintenance and continued occupa-
tion of surviving Roman buildings, as opposed to significant new construc-
tion, apart from the occasional church.[187] As Samson has so lucidly observed,

[184] Brühl 1990, 61. Though this 'royal' road surely featured prominently as the stage for stational
and liturgical processions long before the tenth century; for examples of such processions
already in the seventh century, see *Vita Sancti Arnulfi*, c. 10; 26 (*MGH SRM* 2, 426–46);
by Chrodegang's time in the mid-eighth century, the annual stational cycle had reached a
remarkable degree of complexity (see Chapter 5).

[185] Cf. Brühl 1990, 83.

[186] While bishop of Trier between ca. 550 and 568, Nicetius corresponded directly with Justinian
and Lombard queens (*Epistulae Austrasiacae* 7 and 8, respectively), sought skilled builders from
Bishop Rufus of Turin for his construction projects at Trier (ibid., 21), as well as receiving
petitions, salutations and commendations from a host of others (ibid., 5–6; 24; for further
hints of Nicetius' remarkable prestige, also *Epp.* 14 and 22).

[187] On Metz, where dark earth is far more prevalent (and thick) on the periphery than in the
city center, see Halsall 1996, 245 (though the lack of such layers should not indicate abandon-
ment, as Halsall wishes, but rather the opposite); on the apparent persistence of Roman-

it is precisely the continued occupation of older buildings that is hardest to document archaeologically: when floors are kept clean, and the existing fabric of the building little altered and subjected to only the most necessary repairs, the occupational history of a site becomes almost impossible to document archaeologically.[188] It is only in the Carolingian period and later, when a spate of new construction led to the reconstruction or obliteration of older Roman structures, that abundant archaeological traces of activity return, leaving the impression of a hiatus between the Roman and Carolingian levels.

A case in point is the *praetorium* in Cologne, situated – in yet another suggestive hint of functional continuity – under the medieval Rathaus and carefully excavated and studied during the 1950s. As its excavators noted, it is the very lack of evidence of material datable between the Roman and Carolingian periods that indicates its continued use in Merovingian times.[189] What archaeology documents well is traces of destruction, collapse and rubble, whence the total absence of any such deposits in the *praetorium* is best interpreted as good evidence of its continuing use in the intermediate period, as – *pace* Steuer – is the fact that only one Merovingian coin was found on its flooring: had someone not been sweeping the floors, we should expect far more coins and datable small finds.[190]

But perhaps intramural Cologne was devoid of permanent residents, as Steuer wished, and its profusion of extramural churches and cemeteries indicative only of a rural population gravitating around the empty intramural shell (as Halsall has also suggested for Metz in the fifth and early sixth centuries),[191] in which case the lack of coins and other materials in the *praetorium* might be interpreted as evidence of abandonment *tout court*. Hardly: as the extensive excavations conducted around the cathedral and Haymarket in the 1990s so vividly show, the monumental corridor straddling the *cardo maximus* from the cathedral in the north to the *praetorium* and forum to the south was bustling during the early Middle Ages (Figure 4.6). The area around the forum was continuously occupied, and the Roman-era structures around the periphery of the open

period public and residential structures through the early Middle Ages and beyond, see also Wagner 1987. On Cologne, where again there is a conspicuous lack of dark earth in the central nucleus around the *praetorium* and cathedral, see Schütte 1995, with the discussion later in this chapter.

[188] Samson 1994, esp. 97–103.

[189] Doppelfeld 1956; 1975.

[190] Cf. Samson 1994, 100–03; Schütte 1995, 164; *contra* Steuer 1980.

[191] Halsall 1995, 228–30; but recent excavations at Metz too are turning up more signs of living, working residents, among them the occupants of the glass and ceramics workshops that clustered around the extramural amphitheater throughout the fifth century (Bet et al. 2011). For the location of the extramural churches and cemeteries at Cologne, several of which feature numerous Merovingian-period burials (notably St. Severinus, suggestively located south of the city along the line of the main *cardo*), see the plan at TCCG Vol. 12, 42–43, with discussion at 52–66.

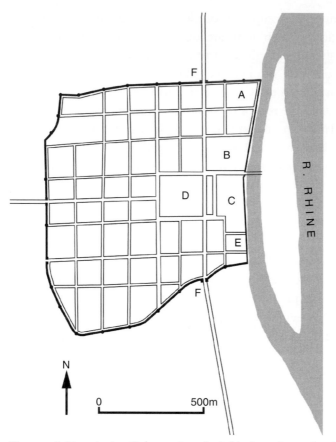

Figure 4.6 Merovingian Cologne. A: cathedral/episcopal complex; B: *praetorium*; C: cult area; D: Roman forum; E: Capitol; F: *cardo maximus*. (Author.)

space maintained until being razed and replaced with timber buildings after the Viking raids of the 880s.[192] (Indeed, as Schütte has stressed, the evidence for late ninth-century destruction levels is plentiful across the city, while there is nothing comparable for the preceding centuries, when such deposits of rubble and detritus were evidently not allowed to form.[193]) The basalt pavers of the Roman streets, meanwhile, were kept clear into the high Middle Ages.[194] But perhaps the most striking and unexpected results of the excavations in the area of the Haymarket/forum were the rich sequences of glass, ceramics, coins and luxury goods stretching in an unbroken continuum from the late Roman to the Carolingian periods. According to the excavator, by the eighth century, the richness and the typologies of the finds are comparable to the assemblages from the greatest of the North Sea emporia, such as Ribe.[195]

[192] Schütte 1995, 164.
[193] Ibid., 168.
[194] Ibid., 175.
[195] Ibid., 165–67; 170.

It can take but a single dig to dismantle generations' worth of self-perpetuating shibboleths about the collapse of urban economies in the Dark Ages, as the Crypta Balbi excavations of the 1980s did for Rome,[196] and the Haymarket excavations of the 1990s did for Cologne. And unless we wish – implausibly and surely prematurely – to assume that Cologne is an anomaly, it will become harder to maintain, with Hodges, that the emporia of the North Sea and Channel coasts (Dorestad, Ribe, Haithabu, Quentovic, Hamwic, etc.) usurped the economic functions of older Roman cities, and indeed replaced them as northern Europe's only urban sites worthy of the name by the eighth century.[197] That the emporia have looked so uniquely, anomalously dynamic to some modern archaeologists' eyes owes a great deal to their precipitous decline after a couple of centuries or less of existence, leaving their rich sequences undisturbed until the arrival of the modern archaeologists; similar traces in Roman-era *civitates* are harder to come by precisely because of their history of continuous occupation.[198]

In short: even in economic and commercial terms – to say nothing of institutional continuity, symbolic prestige and ceremony – old Roman *civitates* could remain vital in the 'Dark Ages,' whence (again) the relative sparseness of Merovingian levels in places such as Cologne and Trier should be interpreted not in terms of desertion, but rather as selective maintenance, in an undeniably difficult period when relatively few ambitious building projects occurred, of the most significant monuments inherited from the Roman past. The prolific signs of commerce and craft production at Cologne are also, of course, signs of population, the discovery of which should help to replace the hordes of Merovingian dead buried around cities such as Metz, Trier and Cologne back into the world of the living.[199] Merovingians were not merely buried in cities: they lived there too, and were present to witness those most dramatic moments of political theater that continued to be staged in old *civitates*, and not – ever – in the mushrooming emporia of the North Sea and Channel coasts.

Indeed, it is precisely such signs that Merovingian Cologne was hardly a ghost town, filled with nothing other than crumbling ruins interspersed with a few churches, that allow us to make sense of events like those of the year 717, when Charles Martel, having defeated Chilperic III and his rival

[196] Manacorda 1990; Arena et al. (eds.) 2001.

[197] E.g., Hodges 2000, 35–67 (collapse of older cities); 76ff. (rise of the emporia).

[198] Cf. Samson 1994, esp. 111–12. On emporia as basically epiphenomenal 'mushroom cities,' whose rapid ascent and equally rapid decline – in contrast to the surviving Roman *civitates*, whose roots went much deeper, and depended far less on commerce for their survival – is closely linked to the waxing and subsequent waning of royal authority over their peripheral locations, see Verhulst 1999, esp. 44–47; generally on the rise and fall of the emporia, see also Henning 2007.

[199] Samson 1994, 97–100.

majordomo Ragamfred, immediately headed straight for Cologne. Upon his arrival, he took the city, captured his hostile stepmother, Plectrude, along with his father, Pippin's, treasury, which Plectrude had – naturally – installed in the relative safety of the city, and then proceeded to coronate his own rival king, Chlothar.[200] When Charles chose the stage for the coronation ceremony that crowned the year's victories in the field and laid the foundation for his political future, in other words, he picked the city of Cologne, and probably more specifically the monumental corridor between the *praetorium* in the south and the cathedral not far to the north, along the axis of the main *cardo* just to the west, the very part of the city where residential occupation remained densest in the eighth century.[201] Only thus could the bishop and people of the city so recently in the service of Charles' enemies become both witnesses to, and participants in, the event designed to mark the definitive ascent of Charles and his party to the summit of power, and to echo throughout the Frankish realm. Had the city been depopulated and ruinous, Charles' choice of venue would be rather harder to explain.

To sum up: the preceding collection of brief topographical sketches of Merovingian cities should, at least provisionally, indicate that careful stewarding and selective enrichment of the topographical framework inherited from the late Roman period led more often than not to the further privileging of that axial sequence of key monuments so characteristic of the late antique city. As for the architectural décor of the connecting streets themselves, we may, unfortunately, never know very much. There is simply no way to determine when, for example, the columns lining the *cardo* at Trier were carted off as *spolia* (as all late Roman street colonnades eventually were, whether as the result of destruction or later medieval urban restructuring);[202] or those of the grand, two-story porticoes recently identified along the main *decumanus* at Reims;[203] or to know what the shops lining the *platea* spanning the Île de la Cité at Paris looked like, and whether they maintained any pretentions to architectural grandeur, continuous porticoes included.

Yet there are a few suggestive signs. The colonnaded *cardo* at the heart of late Roman Autun seems to have preserved its late Roman paving intact and

[200] *Liber Historiae Francorum*, c. 53 (written a scant decade after the events in question): *item* [Carolus] *cum multa preda in Auster reversus, Colonia civitate veniens, ibique seditione intulit. Cum Plectrude matrona disceptavit et thesaurus patris sui sagaciter recepit regemque sibi statuit Chlotharium nomine.*

[201] For a topographical overview, see Brühl 1990, esp. 14–27; on the concentration of population in the eastern part of the city near the river, along the axis of the *cardo*, see also TCCG Vol. 12, 47.

[202] Though in the case of Trier, as noted earlier, they are perhaps unlikely to have survived the combination of the Germanic invasion of 406/07 and the Hunnic sack of 451.

[203] Several main streets at Reims received such porticoes, in what appears to have been a coordinated, citywide intervention undertaken at some point during the second century AD: Byhet 2007, 433.

unobstructed across its full width through the end of the first millennium and beyond;[204] perhaps the continuous porticoes that gave the late Roman avenue its definitive architectural stamp were equally conscientiously maintained. An eye-opening passage from the late seventh-century *passio* of Bishop Leudegar at any rate evokes what may be this very street, once again, a full 350 years after it was first 'crowned' for the *adventus* of Constantine in 311, bedecked with garlands and surrounded by adoring throngs for the *adventus* of the exiled Leudegar and the majordomo Ebroin.[205] Those standing along the garlanded street, with their candles and their antiphonal chants, intent on the spectacle unfolding along the *platea* and oblivious to the ravages inflicted by the intervening centuries on the surrounding neighborhoods might, for a moment, have imagined that little had changed.

In some cases, porticoes may even have been installed for the first time along urban arteries of growing importance. One tantalizing hint in this regard comes in relation to the extensive urban construction campaigns undertaken by Bishop Desiderius (Didier) of Cahors in the second quarter of the seventh century. In addition to rebuilding the walls of the city, installing a new aqueduct, and constructing a new episcopal complex, Desiderius also erected a new basilica (in Roman-style *opus quadratum*, no less[206]) and monastery 750 paces from the cathedral and *episcopium*, apparently on-axis with the latter and connected to it via a main street.[207] Might the street leading to the basilica, then, be the location of the 'double porticoes he adjoined to [the basilica] with consummate craftsmanship,' according to his later biographer?[208] Might Desiderius, in other words, have adopted not only a long-unused Roman construction technique for his new basilica, but also resuscitated the use of twin

[204] Rebourg 1998, 178–79.
[205] *Passiones Leudegarii*, c. 17, p. 299: *Laetatur ecclesia de pastoris praesentia rediviva, plateiae ornantur virentiis, aptant diaconi caereis, clerici tripudeant cum antephonis, gaudet civitas tota de adventu sui pontificis post persequutionis procella.* The only other plausible site of the *adventus* is the westernmost *cardo* of the city, which led to what was probably the original gate in the reduced enceinte surrounding the cathedral and episcopium in the southwest corner of the Roman circuit, which may date as early as the later fourth or fifth century, or as late as the eighth or ninth: see Balcon-Berry 2011, esp. 36–37 (who favors the earlier date for the reduced circuit, but cf. Labaune 2011, 42–47, at p. 47).
[206] See n. 208.
[207] This seems to me the most likely interpretation of the *Vita Desiderii*, c. 20, which appears to place the new episcopal complex on the one hand, and the monastery and basilica on the other, as linked poles along a route 750 paces long: *Desiderius itaque praeter alia magnifica opera edificavit monasterium sub ipso Cadurcae municipio, in cunctis aeditibus eximium, septingentos circiter et quinquaginta passus a praecipua pontificum sede distante, quem summo studio, miro ac singulari opere in domorum vel ecclesiarum extructione patratum.* On all of Desiderius' building projects, see Rey 1963.
[208] *Vita Desiderii*, c. 31: *Denique primam inibi basilicam more antiquorum praeripiens quadris ac dedolatis lapidibus aedificavit, non quidem nostro Gallicoque more, sed sicut antiquorum murorum ambitus magnis quadris extrui solet, ita a fundamentis ad summa usque fastigia quadris lapidibus opus explevit, cui geminos summo porticus adiciens opere adsimilavit.*

flanking porticoes, the better to make his new foundation the culmination of an urban itinerary singled out by its architectural décor, in late antique style, as the centerpiece of Desiderius' reconstructed city? The 'double portico,' at any rate, seems more likely to have been a framing device for the route leading the basilica than a more traditional atrium or narthex, neither of which would fit well with the biographer's description.

In any case, with the expansion of the *episcopium* and the foundation of the grand new monastery and basilica 750 paces away, seventh-century Cahors joined the ranks of the 'bipolar' cities. More than ever in Merovingian Francia, if an urban façade worthy of the name was to be maintained with the (relatively) limited resources available to kings and bishops of the age, it was best concentrated in the environs of a principal intramural street, connecting with a main gate in the city wall and, often, a preeminent site of extramural cult and royal or episcopal patronage beyond. If traces of monumental porticoes surviving into, or built new during, the seventh and eighth centuries are to be found, it will surely be along these central urban arteries.

4.4 LOMBARD ITALY

There is little dispute that Italy remained the most urbanized region of Western Europe, albeit with pronounced regional variations, and that even the previously rural-dwelling Lombards who occupied the majority of the peninsula beginning in 568 based their administrative and political apparatus in cities from the beginning.[209] The Lombard kings variously preferred Verona, Pavia and Milan during the first half century after their arrival, before settling themselves permanently in Pavia, while dukes governed from palaces in dozens of other cities, from Brescia, Bergamo and Cividale in the north, via Spoleto and Rieti, to Benevento in the south. As urban continuity is not seriously in question, we might proceed directly to the topography of the principal Lombard capitals, the urban showpieces that underpinned the exercise of sovereign authority and served as models for the dukes in their own capitals, and ask to what extent the rulers who inhabited them, relative newcomers to the urban traditions of the erstwhile Roman empire in 568, imbibed and exploited the architectural vernacular of power inherited from the late empire.

[209] Useful overviews of Lombard urbanism include Gasparri 1990, 277–92; Harrison 1993; C. La Rocca 2003; cf. also Wickham 2005, 644–56; Ward-Perkins 2009. On cities still under Byzantine control, Zanini 1998, 182–90; Arthur 2006; see also Christie 2006, 183–280 for all of Italy. The part of the peninsula that seems to have experienced the most profound de-urbanization is much of the southern interior (Puglia, Basilicata and Calabria) away from the Tyrrhenian coast (Martin 2009); the ports of the Adriatic coast were bustling too, however, and there is demonstrable urban survival at some inland sites as well: see Raimondo 2006 for Reggio Calabria, Crotone, Vibo Valentia and Cosenza; Volpe 2006, 573ff. for Canosa; Ditchfield 2007, 558–64, esp. 561 for the port cities of Taranto, Bari, Brindisi and Otranto.

We begin with Pavia, which by the second quarter of the seventh century had definitively supplanted Milan and Verona as the principal – indeed the only – seat of the Lombard kings.[210] Thereafter, the city grew larger than ever previously under Roman and Gothic rule, and sprouted a bevy of new constructions to match its status as the urban figurehead of the kingdom.[211] Once again, the rulers themselves were the primary sponsors of this building boom, the main protagonists with resources and the authority to intervene meaningfully on the urban fabric of the city as a whole and refashion it into the image of a capital city worthy of their regal pretensions.[212] The center of it all, around which the affairs of the city and kingdom as a whole gravitated, was the royal palace, originally built or rebuilt by Theoderic at the beginning of the sixth century, perhaps on the site of an existing *praetorium*.[213] This *sacrum palatium* is the place from which the large majority of extant royal diplomas and charters issued from 626 until the fall of the kingdom in 774 emanated,[214] where the law codes beginning with the Edict of Rothari in 643 were formulated and promulgated,[215] judicial hearings conducted, fines and taxes collected and stored, and Lombard and foreign dignitaries alike received by the king, who presided over an ever-more ramified and structured palatine bureaucracy whose administrative and ceremonial protocols increasingly drew their inspiration from Constantinople.[216]

While physical remains of the palace have yet to be conclusively identified, and some uncertainly remains even as to its location, the balance of the evidence clearly points to a spot in the eastern part of the walled enclosure. Property documents of the tenth century and later indicate that the palace gardens (*viridarium*) extended south of the main *decumanus* inside the eastern flank of the city wall, while the heart of the palace lay just to the north on the far side of the street.[217] This location, straddling the *decumanus* just inside the eastern gate of the circuit, fits particularly well with the one intervention on the profane topography of the palace and its surroundings by a Lombard king mentioned in

[210] From the accession of Arioald in 626 on, all the evidence suggests that Pavia was the only *sedes regia* of the kingdom: Brühl 1968, 370–75; 1969, 191–92; Mor 1969; Gasparri 1987, 41–44.

[211] Hudson 1987, 245–60; Brogiolo 2000, 144–50; cf. Majocchi 2008, 27–37.

[212] The most telling metric available is church foundations. For thirteen of the twenty-one churches and monasteries known to have been built between 569 and 774 for which a patron can be identified, one was founded by a bishop, four by members of the nobility, and fully eight by the royal family; see Majocchi 2008, 29–30.

[213] *Anon. Val.*, c. 71: *item* [Theodericus] *Ticino palatium thermas amphitheatrum et alios muros civitatis fecit*; Fredegar, *Chron.* 2.57; Paul the Deacon, *HL* 2.27; cf. Bullough 1966, 92; Brühl 1969, 190; Hudson 1987, 241–45.

[214] Brühl 1968, 351–55; 1969, 191; Harrison 1993, 101; cf. Majocchi 2008, 25.

[215] *Edictus Rothari*, Prol.: *Dato Ticino in palatio*. The best overview of Rothari's edict remains Delogu 1980, 62–82.

[216] On all the preceding points, see Gasparri 1990, esp. 254–68; on the palatine bureaucracy, also Brühl 1968, 377–80; Harrison 1993, 99ff.

[217] Hudson 1987, 241–45.

the literary record. This is Paul the Deacon's much-cited comment that 'King Perctarit [r. 672–88] built with magnificent workmanship a gate in the city of Pavia, contiguous with the palace, called the Palatine Gate (*porta Palatiensis*).'[218]

Leaving aside for a moment the question of where exactly this gate was, the project manifestly aimed at adorning the approaches to the palace with an ostentatious entranceway with clear ceremonial pretentions that cannot have failed to recall the nearby Chalchi gate fronting the Ravennate palace, and of course its archetype at Constantinople, as has been often noted.[219] Likewise well rehearsed is the significance of this project in its late seventh-century context, when relations between the Lombard court and both Rome and Constantinople dramatically improved. Significant steps in this process include the accession of the Catholic King Aripert (r. 653–61), son of Theodelinda; the official conversion of the Lombard people from Arianism to Catholicism under his son Perctarit at the Synod of Milan in 680, followed immediately by Constantinople's formal recognition of the Lombard state and renunciation of its territorial claims in northern Italy;[220] and thereafter the ecumenical council (itself clearly in emulation of the Constantinopolitan synods) convened at Pavia under Perctarit's son Cunicpert in 698, which finally ended the Three Chapters Schism and returned the northern Italian dioceses to full communion with Rome.[221] From 680 on, delegations from Pavia regularly frequented the courts at Rome and Constantinople;[222] Cunicpert began to mint gold coins modeled on Byzantine prototypes,[223] a slew of Catholic churches and monasteries rose under royal patronage,[224] and in the midst of it all – it is often assumed in direct connection with the events of 680 – the approaches to the palace were aggrandized.[225] Precisely when the Lombard kings, in other words, were normalizing relations with the Byzantine emperor in Constantinople, the exarch in Ravenna and the pope in Rome, Perctarit took a step aimed at fully integrating his temporal seat into the architectural *koine* of contemporary centers of power: by embellishing the entrance to the main route leading to

[218] *HL* 5.36: *His diebus rex Perctarit in civitate Ticinensi portam contiguam palatio, quae et Palatiensis dicitur, opere magnifico construxit.*

[219] Cf. Ewig 1963, 37; Bullough 1966, 89–90; Ward-Perkins 1984, 168–69; Hudson 1987, 256; Brogiolo and Gelichi 1998, 68.

[220] Delogu 1980, 96–101; Gasparri 1987, 44–47

[221] See esp. Delogu 1980, 101–07, with the *Carmen de Synodo Ticinensi*, an encomium for Cunicpert produced in the wake of the synod, which celebrated the king in the grand tradition of late antique sovereigns and Byzantine emperors who presided over ecumenical councils, persecuted heretics, founded cities, etc. Cf. also Gasparri 1987, 46–47; Majocchi 2008, 34; Delogu 2009, 262–66.

[222] E.g., *Carmen de Synodo Ticinensi*, p. 190, l. 26ff.; cf. Delogu 1980, 99–100.

[223] Delogu 1980, 106–09; Arslan 1986.

[224] Paul the Deacon, *HL* 4.47, 4.48, 5.33, 5.34, etc.; cf. Hudson 1987, 248; Brogiolo and Gelichi 1998, 138–39.

[225] On the connection with the Porta Palatiensis, see esp. Delogu 1980, 105.

the palace, Perctarit ensured that the display of his regal dignity was preceded by a suitably monumental passageway, the significance of which would hardly have been lost on the envoys of the other Catholic potentates of his age.

Given the probable location of the palace immediately inside the east gate of the city, to the north of the *decumanus*, most have assumed that the Porta Palatiensis was a remodeled version of the existing eastern gate in the city wall (perhaps a triumphal arch incorporated into the late Roman circuit), and this is almost certainly right.[226] To begin with, there is the obvious point that such an ostentatious monument is likely to have been placed to be experienced by the largest possible number of people, and thus on much the most frequented road in the city, where indeed it would have been impossible to avoid. More importantly, however, there are – in my view – telling indications that beginning in the middle of the seventh century, when Pavia had become the unrivalled *sedes regia* of the Lombard kingdom, a conscious effort was made to create a privileged monumental axis along the *decumanus* that had always been the city's principal thoroughfare, already tellingly described by Jonas of Bobbio in the 620s as, simply, the 'city-center street' (*via mediae civitatis*), where an unfortunate cleric on his way through the city was accosted by a Lombard nobleman.[227]

The first notable intervention was the foundation by Aripert, shortly after his accession in 653, of a new church dedicated to the Savior just outside the western gate, the Porta Marenca, which for the next half century became a sort of dynastic mausoleum for the kings of his line, the 'Bavarian' dynasty descended from Theodelinda.[228] Next, at an unknown moment, but very probably during the episcopate of Damian (ca. 680–710), in connection with the official embrace of Roman orthodoxy, the cathedral was transferred from the extramural SS Gervasius and Protasius to the intramural church of St. Stephen.[229] The new cathedral, along with an episcopal complex featuring baths and a baptistery, was located in the middle of the city probably just south of the *decumanus*; a second church dedicated to Mary (Sta. Maria del Popolo) was later built adjacent to it under Liutprand (712–41), thus forming a typical northern Italian double-cathedral complex comprising the 'summer cathedral' of Stephen and the 'winter cathedral' of Mary.[230] Hence, by the beginning of

[226] See n. 219.

[227] *Vita Columbani* 2.24: [The cleric Bledulf] *a beato Atala ad Ticinum directus fuisset ibique pervenis-set, viaque mediae civitatis ambulans, obvium habuit Ariowaldum ducem Langobardorum.*

[228] Paul the Deacon, *HL* 4.48. Perctarit (d. 688); Cunicpert (d. 700) and Aripert II (d. 712) were all buried there: ibid., 5.37, 6.17, 6.35, respectively.

[229] Bullough 1966, 100–01; Delogu 1980, 107–08; Hudson 1987, 247 all favor the episcopate of Damian for the move, which likely accompanied Pavia's subtraction from the archbishop of Milan and direct subordination to the pope in Rome in ca. 700, perhaps by way of reward for the favorable outcome of the synod of 698–99 (cf. Hoff 1943, 56–72; Majocchi 2008, 34–35).

[230] On all these structures, see Bullough 1966, 100–02; Hudson 1987, 252–53; Majocchi 2008, 35–36.

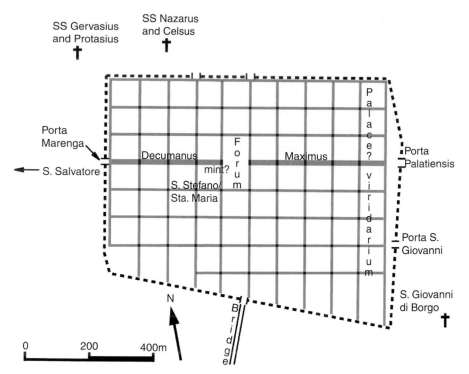

Figure 4.7 Lombard Pavia, schematic plan. (Author.)

the eighth century, the intramural tract of the *decumanus* was bracketed by the 'dynastic' church of S. Salvatore in the west and the palace in the east, with the cathedral, baptistery and episcopal palace roughly midway in between. Surely Perctarit's Porta Palatiensis is best imagined along this route, as the architectural exclamation point on the palatine end of a linear armature of conspicuous and symbolically pregnant edifices, developed by the kings and – secondarily – bishops of the city over the half century when Pavia came into its own as a capital, and when its rulers increasingly based their public deportment on the example of Constantinopolitan court ceremonial, with all its processional ritual and dramatic exploitation of liminal space (Figure 4.7).[231]

Even after Charlemagne's armies occupied Desiderius' kingdom and took Pavia in 774, the momentum of its urban growth continued unabated in the ninth and tenth centuries, when the city again served as the capital of the *Regnum Italiae*, furnishing as it had under Lombard rule an urban ideal to

[231] We might see more than coincidence in the unusual emphasis Paul the Deacon gave to the ceremonial welcome Perctarit received upon his return to Italy in 672, evidently an *adventus* in the best late antique tradition (*HL* 5.33): *Exinde ad patriam tendens, cum ad claustra Italiae venisset, iam ibi omnia obsequia palatina omnemque regiam dignitatem cum magna Langobardorum multitudine praeparatam, se repperit expectari*; on Perctarit's emulation of Byzantine ceremonial protocols, see also Delogu 2009, 266.

be emulated and aspired to by the bishops and dukes of other urban centers in its orbit, among them Milan, Brescia, Bergamo, Verona, Cividale....[232] For a better sense of the extent to which the essence of the late antique capital as a monumental itinerary configured to frame the display of sovereign authority remained a living reality for the Lombards, however, the archaeological and textual evidence from the southern Lombard duchy of Benevento is particularly precious.

Thus we turn to Benevento, where Desiderius installed his son-in-law Arechis as duke in 758,[233] and where the latter, perhaps in part inspired by his long sojourn at Desiderius' court in Pavia, immediately set about enhancing the architectural patrimony of his own capital.[234] The first and, judging by the response of later chroniclers, most noteworthy project was the construction of the church of Hagia Sophia, begun almost immediately upon Arechis' arrival, if not before under his predecessor Gisulf II (742–51),[235] and apparently completed by 768, when it was dedicated with the translation of numerous relics from southern Italy and beyond.[236] Its central plan and its dedication – 'in Greek letters' – patently identified the new structure with its Constantinopolitan archetype, as ninth-century chroniclers themselves observed.[237] The topographical emulation of Constantinople grew more pronounced following the fall of Pavia and the northern Lombard kingdom in 774, when Arechis, having assumed the royal diadem and title of *princeps* of the Lombards, either reconstructed an existing palace or built one from scratch in the immediate vicinity of Hagia Sophia, allowing him to shuttle back and forth, like a Byzantine emperor in miniature, from his temporal seat to the nearby church.[238] The final touches to the monumental facelift given to Benevento upon its promotion from ducal to royal seat came with the renovation of the city walls and their extension to the west, creating a 'new city' (*civitas nova*) south of the principal

[232] Cf. Ewig 1963, 42–43. On Pavia in the ninth and tenth centuries, Bullough 1966, 97–116; Brühl 1969; Hudson 1987, 260–90; Majocchi 2008, 39–67.

[233] Paul the Deacon, *HL* 6.56–58.

[234] In addition to the texts cited in the following notes, see the excellent overview in Delogu 1977, esp. 13–27; on Hagia Sophia, also Carella 2011, 35–55.

[235] So claims the *Chronica monasterii Casinensis*, 1.6; Carella 2011, 35–36 is inclined to agree.

[236] *Translatio duodecim martyrum* (MGH SRL, 574–76); *Translatio Sancti Mercurii*; Erchempert, *Historia Langobardorum Beneventanorum*, c. 3; *Chronica monasterii Casinensis*, c. 9.

[237] *Translatio Sancti Mercurii*, c. 1: *Arechis igitur princeps illustris, perfecta iam sancte Sophie basilica, quam ad exemplar illius condidit Iustiniane*; Erchempert, *Historia Langobardorum Beneventanorum*, c. 3: *Infra Beneventi autem moeniam templum Domino opulentissimum ac decentissimum condidit, quod Greco vocabulo Agian Sophian, id est sanctam sapientiam, nominavit*; cf. *Chronica monasterii Casinensis* 1.9.

[238] *Chronica monasterii Casinensis*, 1.9: *ubi dum maxima devotione quoniam vicinum loco illi palatium erat frequentem consuetudinem in oratione pernoctandi haberet* [Arechis]. On Arechis' palace, most likely an expansion or reconstruction of the existing ducal residence, but yet to be identified archaeologically, see Rotili 1986, 107–09; ibid. for the numerous documentary sources that locate the palace in the vicinity of Hagia Sophia.

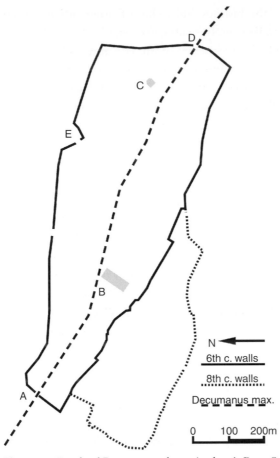

Figure 4.8 Lombard Benevento, schematic plan. A. Porta S.
Lorenzo; B: cathedral complex; C: Hagia Sophia (royal pal-
ace nearby); D: Porta Somma; E: Porta Aurea. (Author.)

existing *decumanus* – the intramural tract of the Via Appia – leading to Hagia
Sophia and the palace (Figure 4.8).[239]

Thus, by the end of Arechis' long reign in 787, the expanded city of
Benevento took the form of an elongated rectangle running roughly east
to west, bisected by a single principal *decumanus* leading directly from the
Porta S. Lorenzo in the west to the Porta Somma in the east, the *platea pub-
lica maior* and *platea publica recta* of later documents.[240] A visitor approaching

[239] *Chronica monasterii Casinensis*, 1.9: *Hinc Arichis Francorum metu perterritus civitatem novam
Benevento addidit.* On the existing wall and the expanded circuit of Arechis, see Rotili 1986,
86–106; 143–55; also Finella 2003, 35–41. On the *decumanus* as the urban tract of the Via Appia,
see Rotili 1986, 16–19.

[240] On this street, identified by a number of tenth- and eleventh-century acts and charters as
passing in the immediate vicinity of both the cathedral and Hagia Sophia, see Rotili 1986,
135–40; Finella 2003, 18–20 (both, however, are strangely unaware that *platea* unambiguously
means 'street' and not 'piazza,' as even the texts they cite so clearly show – the *platea publica
maior qua itur ad portam Summam*, for example, is beyond doubt the main *decumanus* [Finella
2003, n. 15 on p. 24]; *platea* likewise unequivocally meant 'street' at Salerno (Delogu 1977, 121),

along this street from the west would have encountered first the cathedral and episcopal complex at approximately the midway point of the street,[241] followed, near its eastern extremity, by the new church of Hagia Sophia and, somewhere nearby, Arechis' lavishly appointed royal palace. While the parallels with Constantinople in particular, where the palace and Hagia Sophia likewise lay at the eastern extremity of the city's principal thoroughfare, are clear enough, the total disappearance of the palatine complex in Benevento, with the exception of Hagia Sophia, makes it impossible to elucidate the full extent of the topographical parallels between the Byzantine and southern Lombard capitals.

For a better sense of what the new palace may have been like, we must look to Salerno, where Arechis transformed the largely derelict remains of a once prosperous Roman town into the second city of the newly minted principality of Benevento, endowing it with new walls, streets and churches, in addition to a sumptuously appointed royal residence.[242] Recent interventions on the site of the palace have uncovered substantially more of the original fabric of the structures built under Arechis, beginning in or just after 774, than were previously known to exist. The palatine complex rose two stories high, with the principal reception rooms and the palatine church on the upper level, above the remains of a Roman bath building incorporated into the ground-floor substructures of the new palace.[243] The main entrance faced south toward the sea, and gave onto a grand staircase linking the façade of the palace with a sort of wide, fortified esplanade running parallel to the seashore, enclosed between the principal wall of the city to the north and a lower, secondary fortification – rather like the *proteichos* at Constantinople – nearer the shoreline

and for that matter everywhere West and East alike in the early Middle Ages (see Chapter 4.3 for *plateae* at Merovingian Paris and Soissons, and Carolingian Reims; Chapter 3.7 for the *platea maior* at Ravenna; also Spanu 2002 on the East).

[241] On the cathedral, perhaps on this site from the later fourth century but whose earliest extant remains date ca. 600, see Carella 2011, 22–34; cf. Rotili 1986, 169–81; the façade faced directly onto the *decumanus maximus*.

[242] Erchempert, *Historia Langobardorum Beneventanorum*, c. 3: *Nanctus itaque hanc occasionem, et ut ita dicam Francorum territus metu, inter Lucaniam et Nuceriam urbem munitissimam ac precelsam in modum tutissimi castri idem Arechis opere mirifico exstruxit, quod propter mare conticuum, quod salum appellatur ... Salernum appellebatur;* cf. *Chronicon Salernitanum,* c. 10; *Chronica monasterii Casinensis*, c. 12, with Delogu 1977, 36ff.; Amarotta 2004, esp. 21ff.; Di Muro 2008, 105–17. Salerno was a prosperous town during the fourth century that decayed dramatically in the fifth; following the Byzantine reconquest of southern Italy in the mid-sixth century, it was the site of a modest fortified castrum that subsequently passed under the control of the dukes of Benevento by ca. 650. On the archaeological record for the period preceding its transformation under Arechis, see Di Muro 2008, 101–05.

[243] Delogu 1977, esp. 42–61 is still very valuable, though the excavations and architectural analysis conducted since have substantially enhanced our understanding of the palace: see, e.g., Amarotta 2004, 291–300 (also 11–35 for his earlier overview of 1979); Di Muro 2008, 105–10; Peduto 2011, 258–65.

to the south.[244] The palatine church of Peter and Paul lay along the northern façade of the palace, adjacent to a second principal *decumanus*, installed by Arechis' urban planners and paved with basalt, which connected the area of the palace with the site where the cathedral subsequently rose not far to the east, and the eastern gate in the city wall beyond.[245]

Thanks to the recent campaigns of restoration and study of the extant remains, it is now clear that the other three sides of the palace were faced on their upper floor with continuous, arcaded loggias.[246] The principal, southern façade of the palace, with its colonnaded gallery overlooking the water, thus manifestly belongs in the late antique tradition of Antioch, Split and probably Constantinople and Thessaloniki too, propagated via further intermediate exemplars such as Theoderic's palace in Ravenna. Surviving fragments of the *opus sectile* wall and floor revetment are likewise, as Peduto has recently stressed, in the best late antique tradition, and indeed reprise geometrical motifs and color combinations characteristic of palatial architecture and reception spaces from the fifth-century *domus pinciana* at Rome to Paulinus' nearby episcopal complex at Nola.[247] From its solid, mortared masonry to its colonnaded loggias to its interior furnishings, Arechis' palace embodied an architectonic semantics of power that stretched back in an unbroken line to the later Roman empire, a formal and symbolic continuum further reified by the classicizing marble inscriptions installed in the palace, bearing Paul the Deacon's encomiastic verses likening Arechis' new city to the greatest imperial capital of all, Rome: 'emulous of Romulean temples, these edifices arise.'[248]

Apart from its connection to two of the principal through-streets of the city in its post-774 incarnation, the ceremonial potential of Arechis' palatine complex is best captured by the anonymous author of the late tenth-century *Chronicon Salernitanum*, which includes a fascinating account of the reception allegedly prepared for the envoys sent by Charlemagne to the court at Salerno in 786 during the course of the difficult negotiations by which Arechis secured the continuing independence of the southern Lombard kingdom. The minutely orchestrated spectacle began long before the envoys entered the city, when

[244] The *Chronicon Salernitanum* (c. 29) attributes the construction of this second, lower wall, described as an *antemurale*, to Arechis' son Grimoald. On the street – later called the *via carraria* – running through the enclosed corridor between the walls, see Delogu 1977, 43 and n. 118, 147–49; Amarotta 2004, 127. Generally on the topography of the area, see Amarotta 2004, 12–20, 99–121. On the grand stairway in front of the palace, see *Chronicon Salernitanum*, c. 12.

[245] Probably the thoroughfare known in later documents as the *Platea Domnica*: Di Muro 2008, 108; cf. Delogu 1977, 122.

[246] Peduto 2011, 258–60.

[247] Ibid., 261–65.

[248] *aemula Romuleis consurgunt moenia templis*; cf. Delogu 1977, 54–55; Peduto 2011, 261; for the full text of the *carmen* composed by Paul the Deacon in praise of Salerno, see Neff (ed.) 1908, 14–18.

Arechis gathered the full panoply of his army, armed and attired in diverse and dazzling fashion, and sent a delegation to meet Charlemagne's *missus* and his suite on the road.[249] Conducted to the grand staircase of the palace, the arriving party encountered ranks of the kingdom's most comely youths arrayed to left and right, holding falcons and other birds of prey; a flourish of trumpets rang out and the envoys, expecting to find the *princeps* Arechis himself in the midst of the festive ensemble, were surprised to see no sign of him. Peremptorily invited to 'go on ahead!,' they passed through the portal into a chamber where their path was again flanked by yet more young men, in different attire, playing instruments. Again failing to find Arechis, and once again exhorted to proceed forward, the envoy came into yet another room, where the same scenario played out again, before finally arriving in the *aula* where Arechis sat on a golden throne, surrounded by elderly dignitaries.[250] 'And beholding the great wisdom of Arechis, and the palace which he had built, and the food of his table, and the dwellings of his servants and the ranks of his ministers, their clothing and their attendants, [the envoy] was greatly amazed.'[251]

One might well question the veracity of the episode, recounted by an anonymous monk some two centuries after it allegedly happened; and it is certain that the palace had been substantially rebuilt by his day, though it probably maintained the basic contours of its original configuration.[252] Yet there is much of value here all the same. There is the insight, first and foremost, that Arechis' self-proclamation as *princeps Longobardorum*, autonomous ruler of the only surviving Lombard polity, depended largely on his ability to present himself plausibly as such by means of architecture and ceremony. As has often been noted, there is a clear causal relationship between Charlemagne's overthrow of the northern Lombard kingdom in 774 and Arechis' immediate assumption of princely titles and regalia, followed by the refortification and remodeling of both Benevento and Salerno, including of course the installation of sumptuous new palatial quarters, complete with churches, in both places.[253] It is hard to avoid the impression that the creation of arresting urban itineraries culminating in palaces was the *sine qua non* of Arechis' attempt to style himself sovereign ruler of Italy's last independent Lombard realm.

And indeed, what the story of Charlemagne's envoy does show quite clearly is a prevailing vision of Salerno as an armature of power in the late antique mold – a sequential itinerary comprising its walls and gates, the approaches to the palace, the monumental stairway to the main entrance and the sequence

[249] *Chronicon Salernitanum*, c. 12.
[250] Ibid.
[251] Ibid. c. 13: *Et videns autem omnem sapienciam Arichis, et palacium quod hedificaverat, et cibus mense eius, et habitacula servorum, et ordines ministrancium, vestesque eorum et pincernas, miratus est valde.*
[252] Cf. Amarotta 2004, 293.
[253] E.g., Delogu 1977, 13–16; Amarotta 2004, 21; Carella 2011, 223–25.

of rooms beyond culminating in the royal aula – the experience of which could be structured, animated and guided toward its crowning moment (the epiphany of the ruler) by the servants and retainers of the king in all their ceremonial panoply. Nor is there any reason to doubt that the chronicler's vision of the city as a vehicle for the ceremonial exaltation of the ruler substantially corresponds with the intentions of Arechis himself, unless we wish to think his monumental refashioning of Benevento and Salerno in the immediate aftermath of his assumption of princely rank the product of pure coincidence. I suspect, in fact, that the chronicler's story is rooted in reality. If ever Arechis deployed the ceremonial armature he had labored to create at Salerno to its full potential, it must have been in 786, with Charlemagne menacingly perched at Naples at the head of an army, when Arechis needed more than ever to play the role of a sovereign ruler worthy of Charlemagne's respect.

If nothing else, this brief survey of three Lombard capitals should, I hope, suffice to suggest that the late antique progression toward the condensation of monumental topography in urban power centers continued unabated into the seventh and eighth centuries. Lombard rulers in Pavia, Benevento and Salerno continued to privilege a principal thoroughfare, capable at once of masking signs of urban decay and 'ruralization' elsewhere, and providing a fitting backdrop for processional ceremonies and court ritual in the late antique mold, which unfolded among the most grandiose and symbolically pregnant edifices of the age (royal and ducal palaces, cathedrals and episcopal complexes, the Porta Palatiensis at Pavia, Hagia Sophia at Benevento).

The condition of the streets linking these axially disposed architectural centerpieces remains very much an open question, and the archaeological evidence at present hardly suffices to indicate how wide and straight they remained, much less whether they still featured the continuous flanking porticoes of their late antique predecessors. Yet what evidence there is (nearly all of it documentary) for a narrowing and de-monumentalization of principal thoroughfares as a result of encroachment by flanking structures points to the tenth century and later for Pavia, Benevento and Salerno, and indeed for leading Byzantine centers such as Naples and Ravenna as well. Only then, it seems, did demographic and commercial growth prompt more intensive development and occupation of spaces fronting onto main streets, such that concessions were increasingly granted allowing the construction of arcaded loggias (!) along the street front of existing buildings, the pillars of which were allowed to rest on the roadbed, as long as they permitted an unimpeded flow of traffic along the street.[254] At present, the most plausible scenario for the darkest of

[254] Pavia: Bullough 1966, 108–09; Benevento: Rotili 1986, 135–40; Salerno: Delogu 1977, 126–27; Naples: Arthur 2002, 38–40; at Ravenna, the late antique porticoes lining the street between the episcopium and the palace may have survived still longer; see Chapter 3, n. 199. Lehmann-Hartleben (1929, 2109–10) long ago wondered whether the covered arcades so characteristic

the 'Dark Ages' in the seventh and eighth centuries in these cities, all of which indeed preserve much of their Roman or Lombard-era street plans up to the present, involves the substantial preservation and maintenance of processional arteries in something approaching their late Roman form, or at least their full width. The same is true for Byzantium, to which we now turn, where in a few suggestive instances the archaeological record is rich enough to demonstrate that the monumental décor of late antique processional ways was in fact tenaciously maintained through the seventh and eighth centuries.

4.5 BYZANTIUM

We begin with Sicily, which alone suffices to give the lie to any contention that all of what remained of the Byzantine empire during and after the upheavals of the seventh century ceased to gravitate around surviving Roman cities. Sites such as Messina, Catania, Agrigento, Lilibeo, Taormina, Lipari, Palermo and Syracuse never lost their urban character over the long and relatively peaceful centuries between Belisarius' reconquest of the island for Constantinople in 535 and the Arab occupation over the course of the ninth century (ca. 827 to ca. 902). The administrative structures of church and government were indelibly rooted in these urban centers, all of which also preserve traces of considerable, albeit reduced, populations, as well as signs of significant economic activity linked to the collection and redistribution of the produce of their surrounding territories, much of which went either north to Rome or – increasingly – east to Constantinople and the armies on the eastern frontiers.[255] In political and administrative terms, the old provincial capital of Syracuse retained its primacy under Byzantine rule, first as capital of the reconstituted province under Justinian and then, from the 690s, of the newly instituted theme of Sicily.[256] With the Byzantine reconquest of 535, Palermo rose to a position of importance second only to Syracuse, becoming the primary center of government and administration in the west of the island, a sort of pendant to Syracuse in the east.[257] Given that the ceremonial repertoire

of cities in (for example) northern Italy from the later Middle Ages until the present might not descend directly from their late Roman forebears. Still today, the archaeological data do not permit an adequate response to this suggestive – marvelous – idea, though the subject would surely benefit from the dedicated study it richly deserves.

[255] All points stressed in the recent overview of Maurici 2010; see also, e.g., Cracco Ruggini 1980, 26–32; on the continuing administrative importance of cities in Byzantine Sicily, see further Kislinger 2010; cf. also Arthur 2006; on (chronically underestimated) signs of 'Dark Age' economic and commercial activities in the cities of Byzantine southern Italy, see Ditchfield 2007, 558–64.

[256] Cracco Ruggini 1980, 38–43.

[257] Signs of Palermo's definitive affirmation as the leading center of Byzantine administration in western Sicily are already apparent in 536, when, according to Procopius, Belisarius left garrisons only in Syracuse in the east and Palermo in the west upon his departure for the Italian

in leading Byzantine administrative centers likewise continued uninterrupted and unabated in the seventh and eighth centuries, as we have seen, one might see more than coincidence in the fact that these two cities preserve the most compelling signs of continued maintenance and, at Syracuse, reconstruction of a principal urban thoroughfare.

In the case of the originally Punic city of Palermo, the urban fabric had gravitated since its establishment in the Archaic Period around a single main street, flanked by side streets half as wide at regular intervals, bisecting the elongated profile traced by the Carthaginian circuit of walls, which continued to define the fortified periphery of the site at least as late as the tenth century.[258] That the line of the road corresponds precisely with the route of the Corso Vittorio Emanuele II, the main artery of the modern city, over the entirety of its length strongly suggests that under both Byzantine and Arab (and Norman, and Aragonese) dominion, this road was maintained and kept largely unobstructed, though there is no archaeological evidence for the architectonic elaboration of its immediate surroundings in the Roman or Byzantine periods, much less for the presence or continued preservation of flanking porticoes or colonnades.[259] The implantation of the cathedral, dedicated in 603, immediately adjacent to the street at any rate indicates that it will have remained the venue of choice for processional and liturgical ceremonies throughout the Byzantine period, and then again under Norman rule.[260]

With regard to Syracuse, there is good archaeological evidence to indicate that a principal street connecting Akradina and Neapolis, the two most monumental quarters of the Greek and Roman city, was handsomely repaved and widened in the third quarter of the seventh century, and thus very probably in connection with the presence of Constans II in the city from 663 until his assassination in 668.[261] Given that Constans evidently intended to make the capital of the still flourishing province of Sicily his principal residence, and arrived with sufficient palatine officials and select troops from the Anatolian field army (the *Opsikion*) to present a truly imperial spectacle in his new

mainland (*BG* 1.8, with Giardina 1987, 244–46); in the time of Pope Gregory I (590–604), stewardship of the church of Rome's extensive patrimonies in Sicily was likewise divided into eastern and western spheres, supervised by *rectores* resident in Syracuse and Palermo (ibid., 246–49).

[258] On the walls, Belvedere 1987, 290–93; on the street network, ibid., 293–301.

[259] Unfortunately, the road was cleared and very possibly expanded to twice its ancient width in 1564, when any remaining traces of late antique colonnades will likely have vanished (Belvedere 1987, 294).

[260] On the foundation of the cathedral, Maurici 2010, 135. Upon the Arab conquest of the city in 831, the structure was transformed into a mosque (ibid.), thus providing yet another example of functional and structural continuity of the monumental armature of Romano-Byzantine cities under Muslim rule to set alongside those in Spain (see earlier in this chapter) and the Levant (see later in this chapter).

[261] Agnello 2001, 35–36; cf. Maurici 2010, 122–23.

western seat,[262] it is tempting to imagine that the desire to stage processional spectacles on the Constantinopolitan model was at least one of the factors behind the monumentalization of a principal urban thoroughfare. Whether the similarities between Constans' 'New Constantinople' (as it were)[263] at Syracuse and the Mese of its archetype on the Bosporus extended to the provision of flanking colonnades remains, on the present state of the evidence, impossible to determine.

Nonetheless, the likelihood of their presence at Syracuse increases with a glance just southward across the Mediterranean to Carthage, reconquered by Belisarius from the Vandals just two years before Syracuse, in 533. Upon the reestablishment of Byzantine provincial administration in the ancient provincial capital of Africa, an extensive campaign of urban restoration aimed especially at the re-pristination of churches and public spaces was undertaken, which featured the installation of new porticoes along a number of city streets, many of which were also repaved and furnished with new sewers.[264] These porticoes, evidently thought desirable enough to be built even at the cost of encroaching on and thus narrowing the roadbed of existing thoroughfares,[265] further testify to the extent to which the porticated street continued to define the topographical horizons of leading Byzantine administrative centers, not only in the eastern Mediterranean but also in those parts of the West controlled from Constantinople. Hence, one might suspect *a fortiori* that porticoes once graced the flanks of the prominent urban artery at Syracuse that was monumentally re-edified a century later, almost certainly at the moment when the city rose from provincial to imperial capital upon the arrival of a resident emperor and his retinue.

Proceeding roughly from west to east, we come next to Greece, beginning with Corinth. Following the administrative restructuring under Diocletian and Constantine, Corinth remained the capital of the province of Achaea, whence it also became the seat of a metropolitan bishop in the fourth century, as it remained until the Ottoman conquest; with the creation of the theme of Hellas at the end of the seventh century, Corinth maintained its status as the chief military and administrative center in southern Greece.[266] Thanks to the sparseness of modern occupation of the site, and a century's worth of

[262] On the sigillographic evidence for the stable presence of units of the Opsikion during Constans' residence in Syracuse, see Prigent 2010, 166–75; generally on Constans' sojourn in Syracuse, see also, e.g., Cracco Ruggini 1980, 32–37.

[263] Generally on the continuing tendency of Byzantine seats of government in Italy to model themselves on Constantinople in both topographical and ceremonial terms, see von Falkenhausen 1989, 432–37; 464; also see Zanini 2003, 196–97.

[264] Hurst 1993, 333; cf. Humphrey 1980, 114–17; Leone 2007, 172.

[265] Ibid.

[266] Zavagno 2009, 41ff.

careful excavations, we have an unusually complete and continuous picture
of Corinth's urban fabric in comparison to other leading Greek cities such as
Athens and Thessaloniki. It is particularly fortunate that its twentieth-century
excavators were often relatively conscientious in recording the Byzantine
phases of the site, leaving us unusually well informed about the topographical
evolution of the city's urban core over the centuries.

From the time of Corinth's refounding as a Roman colony in 44 BC, this
urban core centered on the Lechaion Road, the wide, straight avenue leading
south from the port of Lechaion directly to the lower Agora, the center of
civic life, which it entered via a wide, marble stairway surmounted by a grand
gateway (*propylaia*) topped by twin quadrigas of Helios and Phaeton.[267] The
road itself was more than 8m wide, and paved with slabs of hard limestone
over the entirety of its 1.5km length between Lechaion and the Agora.[268] By
the end of the first century AD, the excavated section closest to the Agora was
lined on both sides with shops fronted by continuous, marble colonnades that
terminated at the façade of the marble-revetted *propylaia*, beyond which stood
the agora with its panoply of temples, basilica and *curia*.[269] It was, in short,
a classic example of MacDonald's high imperial urban armature: a principal
thoroughfare, lined with continuous colonnades and punctuated at key transi-
tional points by arches and gateways, that directed the flow of traffic through
the city center and shaped the experience of the city's monumental topogra-
phy (Figures 4.9 and 4.10).

Like so many eastern Mediterranean cities, Corinth flourished during the
fifth and sixth centuries,[270] and as at the places discussed in the preceding
chapter, the central colonnaded armature of the Lechaion Road appears only
to have increased in prominence in late antiquity. Large-scale building proj-
ects increasingly clustered in the environs of the road, among them extensive
restorations of the 'Great Baths,' which opened directly off the eastern col-
onnade shortly before it terminated at the propylaia.[271] Across the street from
the baths, a section of the row of shops behind the west colonnade – but not
the colonnade itself – was removed shortly after 400 to make way for a mon-
umental hemicycle, the single most ostentatious civic monument erected in
the late antique city.[272] The colonnades and covered sidewalks along the street
were scrupulously maintained, and the *propylaia* too was refurbished on one

[267] Pausanias, 2.3.2. On the redevelopment of the city after 44 BC, see Romano 2003, 285ff.

[268] Fowler and Stillwell 1932, 135–41.

[269] Ibid., 148–92; Edwards 1994, esp. 263–76.

[270] The best overview is (the unfortunately unpublished) A. Brown 2008; see also Rothaus 2000,
8–31; Hattersley-Smith 1996, 212–33.

[271] Two restoration campaigns are archaeologically attested, the first ca. 400, the second in the
early sixth century: see Biers 1985, 61–62 and passim; cf. Hattersley-Smith 1996, 217–18,
232–33.

[272] Fowler and Stillwell 1932, 145–57; Scranton 1957, 14–15.

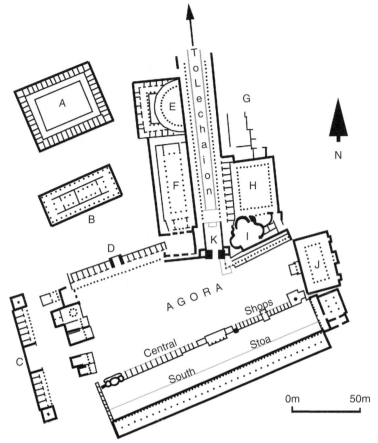

Figure 4.9 Byzantine Corinth. A: North Market; B: Temple of Apollo; C: West Shops; D: North-West Shops; E: hemicycle; F: Lechaion Road basilica; G: Great Baths; H: Peribolos of Apollo; I: Peirene Fountain; J: Julian Basilica; K: Propylaia. (Author.)

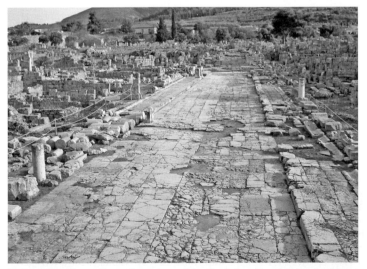

Figure 4.10 The excavated portion of the Lechaion Road today, looking toward the Propylaia. (Author.)

or more occasions, perhaps as late as the sixth century, judging by the style of the architectural fragments found nearby.[273] The agora just beyond seems by the fifth century to have hosted the cathedral and residence of the metropolitan bishop, who joined the representatives of the provincial administration already installed in the area.[274] Shortly thereafter, around the middle of the fifth century, the northern terminus of the road at Lechaion was also dramatically embellished with the addition of a sprawling basilica, more than 80m long.[275] Like at Constantinople, the city's grandest and most-frequented avenue was thus bracketed, from its extramural beginnings to its intramural terminus, by preeminent sites of Christian cult.

But what Corinth allows us to see better than any of the sites hitherto examined is the fate of its central colonnaded armature after the sixth century, during and after the 'darkest' of the seventh and eighth centuries, when the city undoubtedly reached its lowest ebb. Though it is clear that Corinth survived the first Slavic incursions in the 580s, and seems never to have been without a resident population and a metropolitan bishop for any extended period during the unsettled two centuries that followed prior to the reestablishment of firm Byzantine control over southern Greece at the beginning of the ninth century, the city undoubtedly stagnated. Little of note was built in the seventh century, and still less in the eighth; coin finds dwindle to almost nothing; and cemeteries began to invade the periphery of the lower agora and some of its surrounding structures.[276] With the reprisal of Byzantine control over all of the Peloponnese at the beginning of the ninth century, the territory subject to the thematic administration in Corinth grew dramatically, and the city subsequently grew increasingly wealthy, populous and densely built, reaching a peak of prosperity and population density in the twelfth century.[277]

It is only in light of the signs of depopulation and creeping decay detected across much of the city center during the seventh and eighth centuries that the preservation of the Lechaion Road assumes its full significance: the remarkable fact is that the roadbed and sidewalks remained uncovered and unobstructed, while the colonnades and the shops behind retained much or all of their pristine architectural grandeur. So much is clear from a number of archaeological indicators. Finds of ninth- and tenth-century coins on the roadbed itself demonstrate that the Roman surface and the sidewalks both remained uncovered and unobstructed.[278] While countless modifications were made to the flanking shops, they retained their original floor plan into the

[273] Scranton 1957, 14 and passim.
[274] Scranton 1957, 9–12; cf. Rothaus 2000, 23–25.
[275] Hattersley-Smith 1996, 224–25, with prior bibliography.
[276] Scranton 1957, 27–33; Williams 2003, 395–96.
[277] See esp. Scranton 1957, 34–83; cf. Hattersley-Smith 1996, 227–33; Saunders 2003, 396–97.
[278] Scranton 1957, 37–38; Hattersley-Smith 1996, 231.

twelfth century and beyond; in the ninth century, many of the shops received a new front wall, installed just behind the line of the original one.[279] In the mid-tenth century, and only then, the Roman stairway leading up to the *propylaia*, preserved until then to its full width, was covered by a much more gradually sloping ramp, more suitable for horses, which itself rested directly on the (still intact) pavers of the roadway beneath. The number of architectural fragments of the *propylaia* itself included in the fill for the ramp may even indicate that the gateway had remained substantially intact until the construction of the new terminus of the road.[280] All indications are thus that the entirety of the monumental ensemble of the Lechaion Road contained within the reduced circuit of the late antique walls,[281] including its sidewalks, shops and even its colonnades never fell into serious disrepair in the seventh and eighth centuries, when so much of the remaining intramural area clearly did. It was never built over, never abandoned and never despoiled.[282]

Indeed, it was only in the twelfth century that the Lechaion colonnades transformed into something more closely resembling the contemporary Islamic *suq*, as the flanking shops were finally allowed to encroach on the sidewalks and roadbed, leaving only a narrow path in between, though many of the columns remained near the spot where they ultimately fell.[283] Until that time, Corinth continued to vaunt its monumental colonnaded street, and thus to have one area in which its metropolitans, *strategoi*, and all those arriving from the Lechaion harbor might still experience – and be experienced in – the urban environment most representative of the late antique capital.

In light of the thesis proposed in this book and in this chapter, I am (unsurprisingly) inclined to see more than coincidence behind the fact that one of the late antique and Byzantine provincial and metropolitan capitals most susceptible to detailed archaeological investigation has preserved unusually clear signs of precisely the sort of monumental architectural triage that I propose characterized the approach of urban authorities across much of both the Latin West and the Byzantine East in the seventh–ninth centuries. Until the high Middle Ages, when economic and demographic expansion prompted the wholesale redrawing of urban topography and the creation of new connective armatures and architectural focal points, the best solution often remained the preservation of a privileged monumental corridor inherited from late antiquity. If more late antique capitals had not been continuously

[279] Fowler and Stillwell 1932, 150–51, 157; Scranton 1957, 77–78.

[280] Fowler and Stillwell 1932, 191–92; Scranton 1957, 38. The *terminus post* for the construction of the ramp is given by tenth-century coins found on the roadbed beneath.

[281] On the late antique (probably early fifth century) wall-circuit, the course of which is still imperfectly understood, see Gregory 1979.

[282] Scranton 1957, 37–38; and esp. 77: 'It is, then, probable that in the earlier phases, even into the tenth century, many if not all of the columns of the colonnades still stood.'

[283] Ibid., 77–78; Fowler and Stillwell 1932, 150–51, 157.

inhabited up to the present, and had past generations of archaeologists been as attentive to postclassical phases as were those working at Corinth in the early and middle years of the twentieth century, many more 'Lechaion Road scenarios' might now be known. Many more perhaps remain to be identified; already, there are signs that Corinth is not an isolated phenomenon.

Elsewhere in Greece, mention has already been made of Thessaloniki, where the 'Mese' remained the principal artery of the city throughout the Middle Ages.[284] Unsurprisingly, especially at a site as continuously and densely occupied as Thessaloniki, archaeology has as yet been unable to clarify when the columns of its flanking Tetrarchic-era porticoes were carried off as *spolia*, though a date later than the eighth century seems plausible, if only for the resilience of the colonnades at Corinth, its neighboring thematic and metropolitan capital, and of course those of the Mese at Constantinople, to whose continued existence and visual *éclat* the authorities in a regional capital of Thessaloniki's ongoing importance and particularly close links with Constantinople can hardly have been insensible.[285]

Another useful parallel to the situation at Corinth is Athens, where the urban tract of the ancient Panathenaic Way was adorned with flanking colonnades from the Dipylon Gate, to the Classical Agora, and on to the Roman Agora around AD 100.[286] While the section between the Dipylon Gate and the Classical Agora, left outside the reduced late antique circuit of walls, was largely ruinous by ca. 400, the colonnades along the road linking the two agorai were rebuilt to a height of two stories at the beginning of the fifth century, when this road served as a principal entry to the heart of the reduced city center circumscribed by the third-century walls (its western terminus was in fact a primary gate in the defensive circuit, located at the eastern edge of the Classical Agora, which itself remained outside the walls).[287] Midway along this imposing new colonnaded avenue rose a sumptuously appointed complex centered on an apsidal hall, accessed directly from the closely contemporary colonnades along the street and tentatively interpreted by the excavators as an official residence 'well suited to public audiences and official ceremonial.'[288] This building remained in use for centuries, and was extensively restored shortly after a numismatic *terminus post* of 658, thus very possibly in connection with the visit of Constans II during his journey west to Sicily in the winter of 662/63; the colonnades, meanwhile, stood to their full two-story height until the late seventh century, when the upper story at least collapsed.[289]

[284] See Chapter 2.3.
[285] On the continuing presence of porticoes along the Mese and other streets at Constantinople through the Middle Byzantine period, see Mundell Mango 2001, 47–50, with Chapter 3.
[286] Shear 1973, 370–77, 385–90.
[287] Ibid., 390–95.
[288] Ibid., 394.
[289] Ibid., 397–98.

Thus at Athens, too, the colonnaded processional way inherited from late antiquity endured largely intact until (what might once have seemed) a surprisingly late date, in the second half of the seventh century, when it perhaps served one last time to provide the fairest face the town had left to offer for the benefit of an arriving emperor and his suite. Thereafter, however, the Athenian colonnades were allowed to crumble, while the colonnades along the central artery of the nearby provincial and metropolitan capital, Corinth, stood for several centuries longer. We might again see more than chance behind the comparatively lengthy survival – unlikely to have occurred without dedicated maintenance efforts – of the most characteristic element of the late antique urban armature of power, the colonnaded processional way, precisely in the urban center occupied by the leading regional representatives of both church and state.[290]

Proceeding, finally, to Anatolia, the heartland of what remained of the Byzantine empire following the loss of Egypt and the Levant in the 630s and 640s, and the epicenter of modern scholarly debate over the fate of cities and urban living during the Byzantine 'Dark Ages' (seventh–ninth centuries), we begin with Amorium, located on the Anatolian plateau 100 miles southwest of Ankara. Excavations in progress since 1987 have begun to reveal Amorium as a place with wide-ranging, indeed potentially revolutionary implications for the study of seventh–ninth-century urbanism.[291] The site's exceptional importance stems from several factors, both historical and archaeological, beginning with its accessibility to large-scale excavation: as one of the prime instances of a leading early and middle Byzantine site in Anatolia whose remains are not hidden beneath modern development, its topography and occupational history can be reconstructed in relatively detailed and holistic fashion, as in the case of Corinth. While much more remains to be uncovered and studied, enough of the city has already been excavated to offer a valuable cautionary tale to those still inclined, with serious archaeological study of early medieval urbanism in Anatolia still in its infancy,[292] to insist on the almost complete disappearance of urban life and monumental topography across the region.

Like so many other cities in western Asia Minor, Amorium flourished during late antiquity, and indeed expanded dramatically from the end of the fifth century, when the old city center at the foot of the acropolis was greatly extended with the addition of a new, very solidly built circuit of walls that enclosed fully 75ha. Of the three large churches so far identified in the lower

[290] Though Athens too may have remained considerably more populous and vital – albeit demonumentalized – than once assumed: for signs of continuing life from the seventh century on, see Zavagno 2009, 33–60.

[291] For recent syntheses, with further bibliographical references, see Ivison 2007; 2012; Lightfoot 2010.

[292] Cf. Wickham 2005, 626ff.; Zavagno 2009, 26–29.

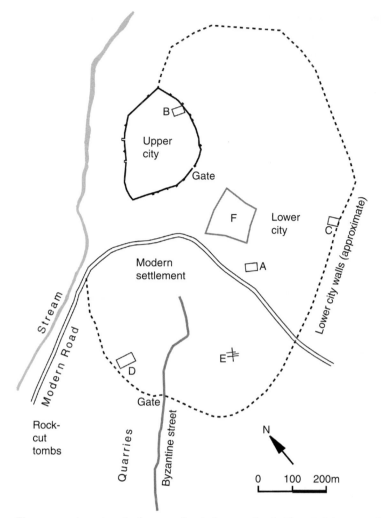

Figure 4.11 Amorium in the seventh–ninth centuries. A: Church A (excavated); B: Church B; C: Church C; D: Church D; E: 'Large Building'; F: enclosure. (Author.)

city, the one excavated to date (Church A) was built at approximately the same time, along with its adjoining baptistery and additional residential or service buildings; a luxuriously appointed bath building revetted with marble imported from Greece followed shortly thereafter in the sixth century, along with another monumental structure (the 'Large Building') tentatively identified as an official residence or administrative complex (Figure 4.11).[293]

Perhaps in part for its robust infrastructure and facilities, and surely also for its location at a strategic junction of roads, athwart one of the two principal routes leading east from Constantinople through Anatolia to the Levant,

[293] On all of these structures, see Ivison 2007, 35–39; Lightfoot 2010; on the church, also see Ivison 2010, 312–18.

Amorium was made the capital of the newly established Anatolikon theme in the mid-seventh century, when the remnants of the retreating Eastern armies were settled in Anatolia and preparations undertaken to defend what remained of the empire against the Arabs.[294] As thematic capital and strongpoint on the road between the new frontier in eastern Anatolia and the capital, the place was crucial to the defense of the interior provinces and the capital, and consequently the target of regular attacks by Muslim armies for nearly two centuries leading up to its capture and destruction at the hands of the Caliph al-Mu'tasim in 838, whereupon it lay in ruins for at least a generation before an imperial intervention brought it slowly back to life, albeit in a reduced form centered on the massively refortified acropolis overlooking the lower city.[295]

The single most remarkable result of the current excavations is the discovery that the grand structures that had shaped the topographical horizons of the late antique city in its sixth-century heyday (the new wall, the bath complex, the 'Large Building' and Church A) were assiduously maintained throughout the centuries leading up to 838.[296] Apart from the acropolis, the fortifications of which perhaps correspond with the establishment of thematic government in the mid-seventh century, the administrators of the early medieval city apparently undertook few new projects of note, choosing instead to preserve the existing architectural patrimony, carefully patching and buttressing where necessary.[297] Further, the lower city clearly remained home to a large and indeed growing civilian population, judging by the dense residential quarter excavated around the bath building, which seems to have become more crowded during the eighth and early ninth centuries.[298] Dense sequences of coins datable throughout the seventh, eighth and early ninth centuries testify to a flourishing local economy (no doubt stimulated in part by the salaried officials and élite soldiers stationed in the thematic capital),[299] as does extensive evidence of craft production (glass, metalwork) and commercial activity.[300] It is remarkable, in sum, what a couple of decades' worth of serious archaeological work can do to put a 'Dark Age' city back on the map in all its sweeping (75ha) extent and surviving architectural grandeur, particularly when it is recalled that as recently as 1999, Brandes could still characterize Dark Age Amorium

[294] Brandes 1989, 133–35; Ivison 2007, 28–29.
[295] For the chronology and effects of the Arab incursions into Asia Minor in the seventh and eighth centuries, many of which reached Amorium, see Brandes 1989, 44–80; on the abundant archaeological evidence for violent destruction associated with the siege and capture of the city in 838, see most recently Ivison 2012.
[296] Ivison 2007, 40–48.
[297] Cf. Ivison 2007, 40; on the date of the upper citadel, ibid., 41–43.
[298] Ibid., 46–48; 55.
[299] On the coins, see now esp. Katsari, Lightfoot and Özme 2012; also inter alia Lightfoot 2009.
[300] Lightfoot 2007; 2012.

as a hilltop fortress, a small military *kastron* overlooking the desolate ruins of a once-flourishing late antique city, with no reasonable claim to urban status in demographic, economic or topographical terms.[301]

But in addition to demonstrating the perils of pronouncements of urban demise made in the absence of sufficient archaeological data, Amorium provides a starting point for rethinking other interpretive paradigms applied in the past to postclassical urbanism in Asia Minor. To begin with, it is nowhere near the sea, proximity to which Brandes thought essential for the survival of the handful of places he acknowledged to have remained relatively urban in the seventh–ninth centuries (Thessaloniki, Nicaea, Ephesus, Smyrna, Trebzond).[302] Thus, as continued urban prosperity clearly was possible without the benefit of a direct sea route to Constantinople, any inland site with good road connections and the continued support of the central administration might – in theory – have fared as well as Amorium. Second, its location directly in the path of invading Muslim forces, and the regular sieges and even occasional sackings it endured in the seventh and eighth centuries, evidently did little to reduce the vitality of the city, nor did they leave any visible signs of destruction in the city center.[303] Hence, while endemic warfare can hardly have been propitious for the cities of Anatolia, the lugubrious succession of battles and invasions that unfolded there from the seventh century on can no longer be assumed a priori to have posed a fatal obstacle to urban survival, even in the regions most regularly involved. Further, Amorium provides a timely reminder that the presence of a fortified citadel of the type commonly built in the seventh or eighth century (at Aphrodisias, Sardis, Ephesus, Pergamon, Ankara, to name but a few)[304] need by no means indicate that occupation was limited to these citadels, or predominantly military in nature.[305]

In this regard, one thinks immediately of nearby Ankara, also a thematic capital, equally strategically located on the second of the main highways leading to the eastern frontiers of the empire, and provided with a walled citadel overlooking the city likely datable to the same period (the mid-seventh century) as the one at Amorium.[306] Lead seals testify to the presence of *kommerkiarioi* and an *apotheke* at Ankara by the mid-seventh century,[307] indicating that

[301] Brandes 1999, 38–40.

[302] Brandes 1999, 25; more detailed discussion of these cities with 'relative continuity' of occupation appears in Brandes 1989, 124–31. Cf. the rejoinder in Lightfoot 2007, 270–71.

[303] See n. 296.

[304] For these and additional examples of citadels likely or certainly datable to the seventh or eighth centuries, see Foss and Winfield 1986; Niewöhner 2007, 128–34.

[305] Cf. Kirilov 2007, 11–15; Niewöhner 2007, esp. 133–35.

[306] Little of archaeological note has occurred in the intervening decades to render Foss' 1977 survey of late antique and early medieval Ankara out of date (Foss 1977b, esp. 72–86); on the date of the citadel, ibid., 74.

[307] Ibid., 75–76.

the city functioned precisely as a thematic capital should be imagined to have done: as the seat of financial administration for its surrounding territory, and the point at which the productive surplus of that territory was gathered, processed and redistributed, particularly to support the troops and other agents of the state occupied in the administration and defense of the region.[308] The problem at Ankara is that the ancient city lies squarely beneath the remains of the modern one, leaving only the citadel relatively visible and accessible to investigation, whence Ankara has been cited alongside Amorium as a canonical example of a great late antique city reduced to a small, fortified refuge in the Dark Ages.[309] Yet surely, all the risks of generalizing on the basis of a single site notwithstanding, the burden of proof should henceforth rest with those who would continue to maintain that early medieval Ankara resembled a minor upland military outpost more than its neighboring – and to all appearances closely comparable – thematic capital to the south, in terms of population, of economic, commercial and administrative activity, and of surviving monumental topography. The same might be suggested for a number of other sites, such as Euchaita in north-central Anatolia, long ago identified by Trombley as still populous and architecturally monumental in the later seventh century, on the basis of the detailed topographical references included in an early medieval *vita* of its local saint Theodore Teron; the results of a recently launched interdisciplinary research project on the site are thus to be eagerly anticipated.[310]

What is lacking, for the present, at all of these sites is hard physical evidence for the persistence of monumental armatures centered on main streets, though at Amorium, the archaeological data currently available already suggest that the network of streets in the lower city as it existed in the sixth century remained substantially intact at the time of its fall in 838.[311] It might also be noted that following its promotion to thematic capital, Amorium was elevated from suffragan bishopric of the metropolis of Pessinus to autocephalous metropolitan see,[312] in keeping with the ongoing tendency for the administrative circumscriptions of the church to mirror closely those of the civil administration. The presence of both the resident *strategos* of the

[308] See Section 4.1.

[309] Brandes 1999, 138–40.

[310] Trombley 1985; for the text, Delehaye 1909, 183–201. Brandes, in keeping with his insistence on urban collapse – above all for inland sites such as Euchaita – promptly dismissed the text as undated and problematic, and Euchaita as nonurban in the Dark Ages (Brandes 1999, 47–49); a definitive resolution must await the results of the ongoing project (for preliminary reports, see www.princeton.edu/avkat).

[311] Ivison 2007, 38–39.

[312] The earliest attestation of the city's new autocephalous status comes from a seal of the early eighth century (Ivison 2010, 325), though the promotion likely came earlier, in connection with Amorium's elevation to thematic capital.

Anatolikon theme and the archbishop, along with their respective servants and retainers, will hence have guaranteed the continuance of a robust ensemble of public, processional ceremonies, including full-fledged *adventus* staged along the route between a city gate and the cathedral, as occurred upon the arrival of St. Theodore of Sikyon at the city around the year 600.[313] But while we might therefore strongly suspect the continued maintenance of a principal processional way at Amorium, particularly given the care taken to preserve other key monuments inherited from late antiquity, its identification awaits the results of the continuing excavations. Several other Anatolian cities, however, already reveal more about the postclassical fate of their ceremonial armatures, some of which were in fact partially or wholly ruinous by the seventh century, while others give tantalizing signs of continued preservation and use.

At Ephesus, to turn to the later history of a site already discussed in detail, there seems to be a bit of both abandonment and preservation in the period following the Persian occupation of western Asia Minor in 616, an event that does – as Foss long ago postulated – seem to have marked a moment of profound change in the city's urban trajectory.[314] Recent excavations along the Embolos have confirmed continued occupation of the shops and colonnades along the street until the early seventh century,[315] while the precipitous decline in coins datable after 616 suggests – precisely – this date as the moment when the street ceased to function as the commercial heart of the city.[316] Thereafter, the structures surrounding the street were leveled and filled with rubble, upon which rose a scattering of small, flimsily built houses during the later seventh and eighth centuries, in what had become a peripheral, extramural suburb, still however traversed by the street itself, the roadbed of which was kept clean and unobstructed until the tenth or eleventh century.[317]

Nonetheless, there is no doubt that Ephesus always remained a sizeable and populous settlement, which even relatively pessimistic commentators have included among the Anatolian sites that fared best in the seventh–ninth centuries.[318] Somewhat less than half the area of the late antique city was

[313] Ivison 2010, 321 on the *adventus* of Theodore; also 325 on the likely persistence of similar ceremonies in the succeeding centuries. As the cathedral itself has yet to be securely identified, it remains impossible at present to identify, or even to speculate regarding the course of, the processional route.

[314] See Foss 1979, 103–05; Schindel 2009, 213 and passim; the earthquake once proposed as the principal cause of the damage and urban transformation evident in the second decade of the seventh century (e.g., Brandes 1989, 83) is better viewed as a secondary factor at best.

[315] Iro, Schwaiger and Waldner 2009.

[316] Schindel 2009, esp. 196–213.

[317] Iro, Schwaiger and Waldner 2009, 66; cf. Foss 1979, 113.

[318] Foss 1979, esp. 103–15; Brandes 1999, 25–26.

enclosed within a new circuit of walls stretching from the port and the theater in the south, via the Cathedral of Mary (rebuilt on a smaller but still considerable scale in the early eighth century), to the circus in the north, while a smaller circuit encircled the basilica of St. John a kilometer away on the hill of Ayasuluk.[319] With regard to the city's ceremonial topography, the point of note concerns the course taken by the new walls in relation to the Arkadiane. As Foss noted, the walls cannot be thought to predate the seventh century, unless we wish to imagine that the circuit excluded the upper embolos in a period when this portion of the street still defined the heart of the urban collective; the circuit thus fits much better after ca. 616, following the radical transformation and 'suburbanization' of the upper Embolos.[320] It is all the more remarkable, then, to observe that the new circuit extended just far enough south to respect the course of the Arkadiane along its entire 600m length. That one section of the wall near the theater ran close enough to the street to incorporate the shops along its south side, while leaving the roadbed and the area occupied by its flanking colonnade clear, is a precious hint that the authorities resident in the city, its metropolitan bishops and the resident *strategoi* of the Thrakesion theme, viewed the city's single most imposing tract of colonnaded street as an urban feature worth maintaining (Figure 4.12).[321] Certainly it appears that at the moment the wall was built, likely between the mid-seventh century and the eighth, the Arkadiane itself determined the southern extension of the new circuit, given that all the other monumental remains attested in the area lie to the north of the street.

As usual, the principal difficulty lies in determining the chronology of the eventual ruin of the Arkadiane, the moment at which its flanking colonnades ceased to be maintained and its roadbed encroached on by the miserable huts cobbled together out of fragmentary rubble noted and summarily removed by the early twentieth-century excavators.[322] Given that the paving of the extra-mural continuation of the street along the upper Embolos was kept clear until the tenth/eleventh century, it seems best to imagine that the principal axis of movement in the intramural area was maintained at least as long, and that the houses that eventually occupied the roadbed date to a later period. At present, the available archaeological indicators are simply insufficient to date the end

[319] Ibid. See also the contributions of Ladstätter, Külzer and Pülz in in Daim and Drauschke (eds.), vol. 2.2. On the rebuilding of the cathedral following its destruction by fire, see Foss 1979, 112; Brandes 1989, 84.

[320] Foss 1979, 106–07, with nn. 314–15 on the transformation of the upper Embolos.

[321] On the relationship of the wall to the shops along the Arkadiane, Foss 1979, 111; ibid., 107–08 on Ephesus becoming the capital of the Thrakesion theme, which Foss imagines to have occurred under Leo III in the early eighth century; Brandes 1989, 84, is more cautious, given the lack of documentary evidence, but concurs that Ephesus likely was the thematic capital.

[322] Kiel 1964, 83: '[T]raurige Zeugen aus der letzten Epoche der lysimachischen Stadt, da auch die Säulenhallen der Arkadiusstraße in Trümmer gesunken waren und arme Leute auf der noch nicht mehr benötigten breiten Fahrbahn ihre dürftigen Hütten bauten.'

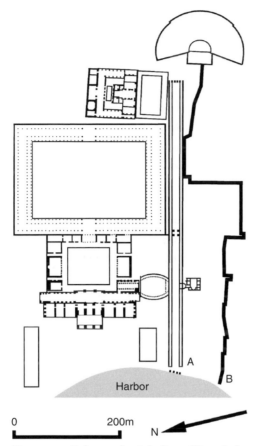

Figure 4.12 Ephesus: the Arkadiane (A) and the seventh/eighth-century circuit-wall (B). (Author.)

of the Arkadiane with greater precision; more work in this relatively poorly understood part of the site is much to be desired.

Another hint of continued striving after the monumental décor of principal axes of movement comes from nearby Miletus, where a reduced circuit of walls enclosing the most monumental neighborhoods of the imperial-era city center was built in – probably – the seventh or eighth century (Figure 4.13).[323] The Market Gate, the ornate, multistory entranceway to the south agora erected in the second century, now reconstructed in Berlin, became a principal city gate in the new fortifications. A new tower flanked the entrance on its exterior, while the inward-facing columnar façade was preserved intact until an earthquake provoked its collapse in the twelfth or thirteenth century.[324] When we recall that much the largest intramural church attested in the

[323] For the dating, I follow Niewöhner 2011, who makes a persuasive case against the Justinianic date often assigned to the wall on the basis of an inscription of 538, which is probably unrelated.

[324] On the final collapse of the monument, Maischberger 2009, 118.

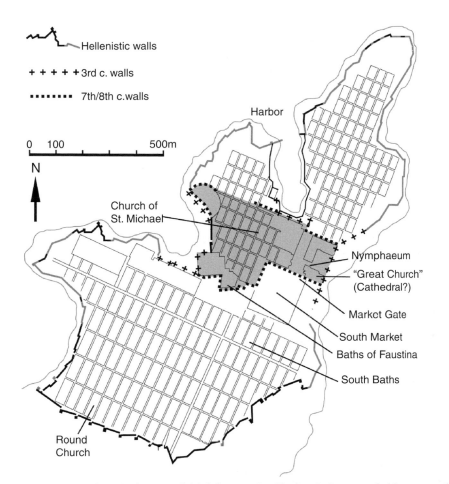

Hellenistic walls

+ + + + + 3rd c. walls

▪▪▪▪▪▪▪ 7th/8th c.walls

Harbor

0 100 500m

N

Church of
St. Michael

Nymphaeum

"Great Church"
(Cathedral?)

Market Gate

South Market

Baths of Faustina

South Baths

Round
Church

Figure 4.13 Miletus in the seventh/eighth centuries. Shading indicates probable extent of area enclosed within the reduced Byzantine circuit. (Redrawn after Niewöhner 2011.)

city, presumably the cathedral known to have been restored and augmented around the year 600,[325] lay just inside this gate, the case grows for viewing the Market Gate and the road that ran through it as the most frequented and most ceremonially prominent axis in the postclassical city, which may explain the extraordinary care apparently taken to maintain the delicate columnar façade of the gate for another half millennium after its insertion into the defensive circuit.

Even at Sardis, often cited as a canonical example of seventh-century urban collapse,[326] the picture may be less bleak than once thought. Certainly, the magnificent colonnaded street running through the center of the city built ca. 400, along with its flanking shops, seems like the Embolos at Ephesus to have suffered in a moment suggestively close to the Persian occupation in 616,

[325] Dally et al. 2011, 84.
[326] Foss 1976, esp. 54ff.; Brandes 1989, 86–88.

when many of the shops and workshops lining the street were abandoned.[327] Nonetheless, the street itself was repaved later in the century, whereafter its environs remained the most intensively occupied area of the lower city for centuries, judging by the distribution of finds recovered to date.[328] This suggests both that at Sardis, too, habitation may not have contracted to the fortified citadel, and that what had been the grandest colonnaded street of the late antique city remained a pole of attraction well into the middle Byzantine period, when the city still served as the metropolis of the ecclesiastical province of Lydia, as it had since the fourth century.[329]

We close at the opposite end of Anatolia, with Anazarbos in Cilicia, home to one of the most impressive and until very recently most underappreciated colonnaded armatures anywhere in the empire.[330] From the Severan period on, when the street was built, Anazarbos gained in prominence for its location along the main highway through Anatolia to the eastern frontier, becoming a prime staging point for subsequent campaigns against the resurgent Sassanian empire. The street itself was the urban tract of the highway, running north-south through the center of the city for distance of 1,750m, where it attained a width of fully 34m in its northern half, and 28m in the south.[331] It was flanked on both sides by open sidewalks, behind which lay a second walkway covered by continuous porticoes, supported by approximately 1,000 monolithic columns along the full length of the street.[332] There is not a city in the empire whose topographical profile was more dramatically dominated by a central colonnaded thoroughfare, which in this case must be imagined as the backdrop for vast military formations on parade or on their way to the east.

Anazarbos manifestly continued to gravitate around this gigantic – even 'megalomaniacal'[333] – parade route for centuries, long after its urban area was circumscribed first by an extensive circuit of walls, perhaps around 400, and a second, much shorter circuit that cannot predate Justinian, and may well date later still in the seventh century.[334] In both cases, however, the walls respected the street and its architectural décor as much as possible: the south gate in

[327] Harris 2004; see also the sources cited in the following note.

[328] Foss 1976, 57; Yegül 1986, 17–19; Niewöhner 2007, 129, Rautman 2011, 24. The mid-seventh century repaving covered both the original roadbed and the porticoes (whose fragmentary columns appear in the fill), but respected the façades of the shops, some of which preserve traces of continuing occupation. Of course, the fact that this street was the intramural continuation of the main highway from the Aegean coast probably does much to explain its restoration and the continued signs of activity nearby from the mid-seventh century on.

[329] On Sardis as metropolitan seat until the Turkish conquest, Foss 1976, 4.

[330] Posamentir 2008; 2011.

[331] Posamentir 2008, 1021.

[332] Ibid.

[333] Ibid., 1023.

[334] Posamentir 2011, 208–09.

both circuits was formed by a late second-century triumphal arch spanning the road, which in the case of the later circuit required the wall to make an awkward dogleg south to include the final stretch of colonnaded street, the course of which it scrupulously respected as far as the arch. The exterior façade of the gate itself was carefully maintained even after the erection of the later circuit, while the sculptural decoration of its interior facing was removed, indicating a clear ongoing concern with preserving the monumental 'face' the city presented to those arriving via its principal thoroughfare.[335] Inside the circuit, meanwhile, the principal monuments of late antiquity were designed either to embellish the street itself or to cluster in its vicinity. Not far inside the south gate, a massive new arch was built across the street in about 500, with a central bay over the roadway and two smaller lateral archways on each side, corresponding with the open and the colonnaded walkways, both evidently still preserved and functioning at this point.[336] Also ca. 500, the largest and grandest church in the city, dedicated to the Apostles, was built midway along the street, just where another arch marked, or rather concealed, a slight bend in the road, which thenceforth served as a sort of monumental entranceway to the church itself (Figure 4.14). The ceremonial (as well as visual and symbolic) potential of attaching the new center of intramural cult to the city's colonnaded processional artery cannot have been lost on the archbishops and governors then resident in the city, following its promotion to provincial capital and metropolitan see of Cilicia Secunda under Theodosius I.[337]

As is so often the case, the crucial issue of the grand avenue's subsequent fate cannot be definitively addressed on the current state of the evidence, but an argument can in fact be made that it maintained much of its monumental profile into the seventh century, and perhaps well beyond. Much hinges on the chronology of the second, reduced circuit of walls, which as noted earlier quite clearly dates to a period when the street remained the city's architectural centerpiece. As of now, all that is certain is a *terminus post* in the sixth century, based on the latest *spolia* incorporated into the wall.[338] Thus, it should not be earlier than Justinian, yet the technique of the wall, its thickness and lack of architectural ornamentation points to a date in the seventh century, given the similarity of walls such as those at Miletus and Side;[339] that Procopius says nothing about Anazarbos in the *de Aedificiis* might also favor the later dating. Even if the circuit does date to the sixth century, however, there is the further, rather remarkable fact that fully ninety of the

[335] Ibid., 209.
[336] Ibid., 214–15.
[337] For the church, Posamentir 2011, 210–14; the city's promotion to capital of Cilicia Secunda occurred under Theodosius I (ibid., 212).
[338] Posamentir 2011, 216ff.
[339] On these circuits, see Niewöhner 2011, esp. 121–22.

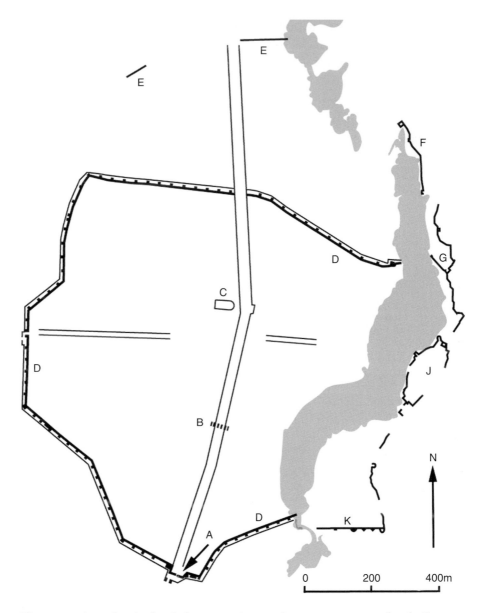

Figure 4.14 Anazarbos in the sixth century. A: second-century monumental arch; B: monumental arch (ca. 500 AD); C: Church of the Apostles; D: second circuit-wall (sixth–seventh century); E: first circuit-wall (ca. 400?); F: sections of first circuit-wall on cliff; G: sections of second circuit-wall on cliff; J: later, Armenian fortifications; K: Byzantine gate (sixth–seventh century phase?) (Author.)

columns flanking the street have survived in situ,[340] suggesting that the road suffered neither violent destruction, nor spoliation, and thus perhaps that the Byzantine authorities devoted themselves to the preservation of this greatest of all colonnaded parade routes for some time after the mid-seventh century,

[340] Posamentir 2008, 121–22; a larger number of column bases were likewise found in place.

when Anazarbos was more than ever a staging point and strategic forward bastion near a threatened frontier.

While more case studies might be introduced regarding the *Nachleben* of Anatolian cities and ceremonial armatures, it is perhaps best to acknowledge that they would be hypothetical and premature in a region where the task of early medieval archaeology is just beginning, and where indeed so little is known of the broader picture that a single new excavation (Amorium) can prompt a substantial revision of long-cherished commonplaces. At present, it is perhaps best to say simply that Brandes' handful of 'cities with relative continuity' in the seventh to ninth centuries is likely much too short,[341] and that there are suggestive signs of a continuing symbiosis between monumental processional armatures and prominent representatives of church and government, for whom the urban backdrop evidently remained, if not indispensable, at least highly desirable for the execution of their mandates. This is particularly true for thematic and metropolitan capitals, still the administrative and symbolic cornerstones of the empire, which continued to attract funds and architectural patronage from the court in Constantinople.[342]

Future work may even vindicate Niewöhner's (at present provocative) hypothesis that the arrival of the Turks in the Anatolian heartland from the late eleventh century marks a greater caesura in patterns of urban life in the region than the preceding 'Dark Ages,' and that only during this later period did many previously robust urban centers truly shrink to precarious fortified refuges, when they did not disappear entirely.[343] Certainly Amorium, which seems only to have retreated within the narrow confines of its hilltop citadel in the face of the Turkish menace, and dwindled to insignificance thereafter, appears to fit this new paradigm rather well.[344] Anatolia would then constitute another, much later example of urban breakdown on the pattern discussed at the beginning of this chapter for Britain and the Balkans, where cities really disintegrated only upon falling under the control of peoples (initially) foreign to the urban traditions of the Classical Mediterranean, including of course the symbolic, representational and ceremonial roles still reserved for cities in most Roman successor states.[345]

[341] See n. 302. This is not to deny for a minute that many urban centers did decay or disappear totally, as Foss, Brandes and others have said.

[342] Cf. Ivison 2000, esp. 18–25.

[343] Niewöhner 2007, 135–38 and passim; the observation that many more urban churches seem to have been built across Anatolia in the 'Dark Ages' of the seventh–ninth centuries than in the following centuries leading up to the Turkish conquest already provides valuable food for thought (ibid.). P. Thonemann's remarkable new 'historical geography' of the Maeander valley from antiquity to the end of the Byzantine period also makes the Turkish conquest in the thirteenth century – with which he ends his history – a pivotal caesura in the urban trajectory of the region (2011, 1–4 and passim).

[344] On Amorium during and after the Turkish conquest, see Lightfoot 2000. Recent fieldwork at Phrygian Hierapolis indicates a similar trajectory of abandonment: see Arthur 2012, 285–98.

[345] See Section 4.1.

Partly as a reminder of what perished with the Turkish conquest, in terms of institutional and ceremonial continuity, we close with a series of vignettes from the island of Lesbos in the ninth century, contained in a late ninth-century account of the lives and deeds of three local saints, David, Symeon and George.[346] The text powerfully recalls what is too easily forgotten. For all that the Byzantium of the ninth and tenth centuries was a different world from the eastern Roman empire of the fourth, in one profound sense, little had changed: the provincial representatives of civic and ecclesiastical administration, and the Constantinopolitan institutions they embodied, only effectively existed insofar as they maintained the capacity to impress themselves on the consciousness, the daily reality, of a critical mass of people; to make those subject to their jurisdiction, again in the words of Geertz, participants in 'theatre designed to express a view of the ultimate nature of reality and, at the same time, to shape the existing conditions of life to be consonant with that reality.'[347] This meant, whenever possible, an urban stage. In the case of Lesbos, the stage was Mytilene, the leading actors the *strategos* and metropolitan bishop of the Cyclades, the supporting cast and audience alike the population of the island.

For the iconophile author of the text, the definitive repudiation of iconoclasm in 842 was a particularly epochal moment, marked at Lesbos by the return from Constantinople of its native son George, an octogenarian who had campaigned tirelessly against iconoclasm, for his consecration as archbishop. He was received at the port with a proper *adventus,* hailed by cheering multitudes and then escorted back to the city by a procession of clerics and islanders come from all over for the occasion, carrying torches and crosses and singing psalms, and conducted to the church of Mary *Theotokos.*[348] Six days later, when enough time had elapsed to allow all comers to assemble in the capital, the *strategos* of the island sent out heralds to summon all to the church of the Theotokos; from there, accompanied by all of his officials and all the people, carrying torches and singing hymns – 'as is fitting' – he led a dawn procession to the shrine of the martyr Theodora, where George was enthroned.[349]

[346] *Acta graeca ss. Davidis, Symeonis et Georgii Mitylenae in insula Lesbo*; on the date of composition, p. 210.

[347] See n. 38.

[348] *Acta graeca ss. Davidis, Symeonis et Georgii Mitylenae in insula Lesbo* 253, lines 10–21: Ταύτῃ δ᾿ἐπιδημήσαντες ὡς τοῦ δρόμωνος τῷ λιμένι κατάραντος τὴν τῶν θεοφόρων ἀνδρῶν ἐπιδημίαν ὁ πλῆθος ἀνέμαθον, ποταμοὺς ἦν ἰδεῖν ἀνθρώπων ἀπὸ τῆς πόλεως ἐν τοῖς λιμέσι συρρέοντας, πάσης ἡλικίας, πάσης ἰδέας ἀνδρῶν, γυναικῶν, παίδων, τῶν ἐν τέλει τῶν ἀπὸ τοῦ κλήρου πάντων λαμπροφορούντων καὶ βαΐα ταῖς χερσὶ βασταζόντων, ἁγίων τε καὶ τοῦ κυριακοῦ σταυροῦ εἰκόνας ἐπιφερόντων, λαμπάσι τε καὶ μύροις τὸν ἀέρα καταθολούντων, ὕμνοις τε τοὺς ἁγίους καὶ ᾠδαῖς ὑποδεχομένων καὶ προπεμπόντων, καὶ πάντων τῆς γλυκείας ἐκείνης ἐπαπολαῦσαι ποθούντων θέας τῶν ἁγίων καὶ πανεγύρεως. Οὕτω τοίνυν τῆς προπομπῆς ὑπὸ τῆς πόλεως τοῖς ἁγίοις γεγενημένης, τῷ τέως ἐν τῷ τῆς πανάγνου καὶ θεομήτορος ναῷ κατηντήκεισαν.

[349] Ibid., 253.28ff., esp. lines 3–7: Ἅμα δ᾿ ἡμέρᾳ μετὰ λαμπάδων, ὡς εἰκός, καὶ ὕμνων ἐπὶ τὸν τῆς μάρτυρος Θεοδώρας σηκὸν λαμπροφοροῦντες ὅ τε στρατηγὸς καὶ ἡ τάξις σὺν τῷ πλήθει

In the following year, 'the people of the island' again congregated in Mytilene for the funeral of the saintly ex-stylite Simeon, another tireless opponent of iconoclasm, whom the iconoclast Bishop Leo had attempted to remove from his column at Mytilene by building a bonfire around the base of it.[350] Whereas the erstwhile bishop had been unsuccessful in his attempts to assemble the islanders to witness Simeon's travails (even those who brought the wood for the fire repented of it),[351] they now flocked to Simeon's bier, circulating around it singing dirges and psalms before finally escorting it to its burial place in the church of the Theotokos.[352] For the author of the *vita*, popular participation in the pageants staged at Mytilene is the ultimate token of legitimacy: when a heretical bishop persecutes a saintly defender of orthodoxy, the illegitimacy of the spectacle is driven home by the unwillingness of the faithful to attend; the saint's legacy is assured, and his sanctity proclaimed, when the people of the island voluntarily flock to the capital to participate in his exequies.

In the following year, 844, the death of Archbishop George himself during Holy Week gave occasion for the most sumptuous spectacle of all. On the day of the funeral, 'all, both of the city and of the island,'[353] assembled in Mytilene. They witnessed there a procession led by the clergy 'both from the city and from far off,' joined by the *strategos* himself at the head of his troops, all disposed according to rank and station; the priests took up the body and the procession headed off to the burial site at the church of the Theotokos, bearing lamps and singing songs.[354]

That this text is the tendentious production of a local author naturally anxious to emphasize the importance and popularity of local saints, and burnish the prestige of the church of Mytilene, there can be no doubt. None the less noteworthy is its effortless fluency in the idioms of late antique public ceremonial, *adventus* and processional spectacles in particular, which obviously remained a living reality in ninth-century Lesbos. (Whatever distortions of reality it proposes, the features of the ceremonies described had at least to be plausible and immediately recognizable to a contemporary audience.) The lamps and torches,

τὸν ἀρχιερέα προπέμψαντες ἐπὶ τὸν ἀρχιερατικὸν κανονικῶς τὸν τοῦ Θεοῦ ἄνθρωπον ἀναβιβάσαντες ἐγκαθίδρησαν.

[350] Ibid., 227–29.

[351] Ibid., 227, line 25ff.

[352] Ibid., 255, lines 26–31: Τῆς δ' ἐκδημίας αὐτοῦ πανταχοῦ διαφημισθείσης, οἱ τῆς νήσου συναθροισθέντες καὶ πικρῶς τὴν αὐτοῦ στέρησιν δακρύοντες καὶ ὀλοφυρόμενοι, τό τε τίμιον αὐτοῦ καὶ πολύαθλον σῶμα περικυκλοῦντες στεναγμοῖς τε καὶ ᾠδαις καὶ ᾄσμασι ἐπικηδείοις προπέμψαντες ἐπὶ τὴν τῆς Θεοτόκου μονὴν ὁσίως καὶ μεγαλοπρεπῶς τοῦτο κατέθεντο.

[353] Ibid., 258, line 31: οἱ τῆς τε πολιτείας καὶ τῆς νήσου πάντες.

[354] Ibid., 258, line 36–259, line 5: Ἔνθεντοι καὶ οἱ τοῦ κλήρου οἵ τε τῶν ἐν τέλει καὶ τῆς πολιτείας, ὅ τε στρατός, οὐδὲ ὁ στρατηγὸς τούτων ἀπολειπόμενος, κατὰ τάξεις διαιρεθέντες χερσὶ πρεσβυτέρων τὸ ἱερὸν ἐκεῖνο καὶ θαμμάσιον σῶμα μετακομίσαντες, λαμπάσι τε καὶ ψαλμοῖς καὶ μύροις μεγαλοπρεπῶς αὐτὸ προπεμψάμενοι ἐπὶ τῷ σεβασμίῳ ναῷ τῆς θεομήτορος, ἔνθα καὶ τὰς ἀσκητικὰς ἐκείνας ὁ θαμμαστὸς παλαίστρας διήνυσε, κηδεύσαντες ἐντίμως κατέθεντο.

the standards and banners, the ritual chanting and acclamations, the grouping of participants according to rank and station: all of it is the direct descendant of the ceremonies adumbrated in the imperial panegyrics of the third and fourth centuries. And just as it had been in the third and fourth centuries, the city was still a half millennium later the indispensable venue for public ceremony, the obvious place to communicate and connect with the largest possible audience, whence the constant stress on the convergence of the population of the island as a whole upon Mytilene. For all that the author doubtless exaggerated the concourse of rural dwellers from across the island come to honor his heroes, the picture of the city as the center, the natural destination for all islanders on those occasions when leaders were proclaimed, tested or buried, can hardly be a complete fiction. Another Constantinople in miniature, Mytilene was where the church, the government and the army still, as always, joined together to parade in front of the assembled multitudes, not merely to proclaim, but to constitute, to effect, the mystical unity of the Byzantine body politic.

It is these links with Constantinople, with orthodox Christianity, with the political and cultural and ritual legacy of the Roman empire, all imbricated in the physical fabric and the living present of surviving ancient cities, that ended in Anatolia with the arrival of the Seljuk Turks, who built and inhabited towns to be sure, but towns that embodied discrete and very different cultural traditions; towns that were new stages (to push our dramatic metaphor still further) for a wholly new kind of sociopolitical theater.[355]

As for the physical fabric of early medieval Mytilene, unsurprisingly, far too little is known to attempt a detailed reconstruction. Indeed, if we are to say anything further about the topographical ideal and reality of the eastern Mediterranean city from the seventh century on, it is best to leave both Anatolia and the Aegean and move farther east. Ironically enough, the single best region of the eastern Mediterranean in which to explore post-Roman townscapes is that part that passed soonest out of Byzantine control, the Levant, conquered by the Arabs in the 630s and 640s. The region boasts an unusual concentration of well-preserved urban sites, many of them largely or entirely free of modern occupation. Thanks to the efforts of a new generation of archaeologists and historians, the urban trajectory of the Levant in the early Islamic period now looks less bleak – and certainly less chaotic with regard to the treatment of monumental public buildings and spaces – than it did even thirty years ago, when Kennedy wrote his famous article on colonnaded streets.[356] The Umayyad authorities turn out often to have been attentive stewards of existing urban topographies, and occasional founders of new urban nuclei in which they clearly strove to reproduce what were perceived to be the most characteristic aspects of the Romano-Byzantine cityscape. When the new Muslim rulers of the Levant sought to

[355] See, e.g., Wolper 2003.
[356] Kennedy 1985. See now Avni 2011b and Walmsley 2012; also Walmsley 2007, esp. 34–45.

appropriate the essence of the Romano-Byzantine city, in other words, they seized on a particular set of architectural features, beginning with colonnaded thoroughfares and their monumental architectural appendages.

4.6 THE UMAYYAD LEVANT

The single most striking embodiment of this urban ideal is the miniature city of Anjar in Lebanon, built under the auspices of the Umayyad ruling dynasty along the main road linking the capital at Damascus with the Mediterranean coast at the beginning of the eighth century. For reasons that remain speculative, construction ceased around 715, even before the project had reached completion, whereafter its imposing remains lay mostly undisturbed until the arrival of modern excavators. Its rectangular enceinte measures 310m by 370m, and bristles with fully forty towers. Gates in each side of the wall, oriented to the four points of the compass, give onto the main *cardo* and *decumanus*, both of them wide, – 20m wide! – straight avenues lined along their full length with continuous, arcaded colonnades, with contiguous files of rectangular shops opening onto the covered sidewalks behind.[357] The two streets converged on 'a purely classical tetrapylon'[358] at the center of the city. The two most prominent intramural edifices were located in close proximity to the street crossing, along the *cardo* in the southeast quadrant of the city. Anjar's principal (only?) mosque rose adjacent to the tetrapylon, its main entrance opening directly onto the *cardo*. Just south of the mosque, also facing onto the *cardo*, stood the 'Great Palace,' an imposing, rectangular complex centered on an open courtyard flanked by two apsidal halls (Figures 4.15 and 4.16).

Were it not for the material record, the inscriptions and the notices in both Byzantine and Arab chronicles, all of which make Anjar unquestionably an Umayyad foundation of the early eighth century, it would appear, at least at first glance, the most canonical of late Roman urban foundations, the latest in an unbroken urban continuum stretching back to that first Syrian 'new city' founded 500 years earlier, Philippopolis.[359] We may never know precisely why Anjar was built, nor why it was abandoned: no matter.[360] Whatever the reasons for its creation, Anjar's size, its residential quarters and its commercial facilities clearly differentiate it from roughly contemporary rural palaces such as M'shatta, and proclaim its urbanizing pretensions.[361] What is clear is that the

[357] Hillenbrand 1999.
[358] Ibid., 62.
[359] Though of course it does have distinctively Islamic features, notably the mosque and the design of the houses; the monumental armature, however, is effectively that of the late antique capital.
[360] For a range of possible interpretations of the motives for Anjar's foundation, see Hillenbrand 1999, 66–77, 86–93. The death of al-Walid I, the apparent mastermind behind Anjar, in 715 is perhaps the single most likely factor (ibid., 91).
[361] Here, I am fully in agreement with Hillenbrand 1999, 71ff.; see also Whitcomb 2006, 72–73.

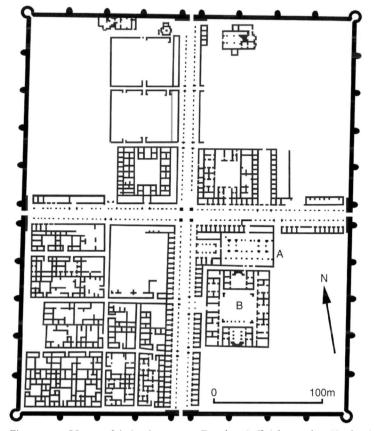

Figure 4.15 Umayyad Anjar. A: mosque; B: palace/official complex. (Author.)

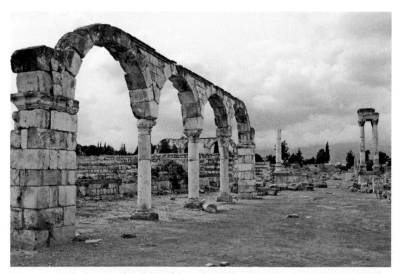

Figure 4.16 Anjar, arcades along the *cardo*, with tetrapylon in background. (Photo: Wikimedia Commons/Arian Zwegers.)

Umayyad patrons – probably the caliph al-Walid I in the first place – of this new urban showpiece knew exactly what constituted the essence of the late antique centers of power they so avidly sought to reproduce: a circuit-wall thick with largely ornamental towers, complete with imposing gates opening onto the principal, colonnaded avenues that led directly to the intramural foci of governmental and spiritual authority.[362] Further, as Hillenbrand has noted, Anjar is a powerful indication that the Umayyads were hardly averse to monumental public spaces and streets, a further nail in the coffin of the notion that existing colonnaded streets in the early Islamic Levant inevitably metamorphosed into narrow, pullulating pathways.[363]

And while Anjar at present seems to have been the largest and most architecturally ambitious of the early Islamic urbanizing foundations, it is hardly unique in formal terms, which is to say in the contours of its monumental armature. Recent investigations at the Red Sea port of Aila (Aqaba, Jordan), to take but one suggestive example, have shown that the central walled enclosure, once thought to be a Tetrarchic-period legionary camp, is in fact a mid-seventh-century Islamic foundation, a 'miniature city' around which the settlement grew during the following centuries.[364] Tiny as it is (167m x 134m), it nonetheless has the closely spaced projecting towers, the four gates opening onto the intersecting *cardo* and *decumanus* (as it were), as well as a 'tetrapylon' at the crossing of the streets, 'actually a domed building with four arched openings, not unlike a *chahar-taq* of Sassanian and later Islamic tradition';[365] this last feature, along with the walls, seems a clear sign that the builders of Aila were striving to echo the most ostentations and representative features of the late antique urban armature. For all that the original plan of the site changed almost beyond recognition over the following centuries, the extent to which the late antique tradition remained a living reality in the early Islamic period is none the less striking.

Nor was this obvious respect for late antique urban forms limited to *ex novo* projects. As recent scholarship is increasingly inclined to acknowledge, the imprint left on the cities of the Near East by their new Muslim overlords during the Umayyad period seems more often than not to have been quite limited: monumental topography remained largely unaltered, and the relatively few important new constructions undertaken – principally mosques – were

[362] Cf. Bejor 1999, 109–10.

[363] Hillenbrand 1999, 84–86: 'It is a specific corrective to the somewhat simplistic model which presents the Arab population as hostile to concepts of urban order.' Excavations undertaken since 1990 are beginning to reveal Ramla, founded in 715–17 by Abd al-Malik and destined to become the capital of the province of Filastin, to be another salient example of an Umayyad urban foundation planned according to the most 'classical' principles of orthogonality, featuring spacious streets arranged in a grid pattern: see Avni 2011a, 123–33.

[364] Whitcomb 2006, 71–73 and n. 28; on the evidence for the date, ibid., 65–66.

[365] Ibid., 68.

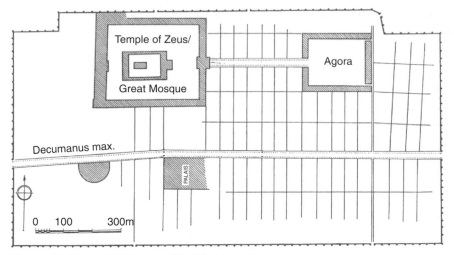

Figure 4.17 Umayyad Damascus. (Modified from Bauer 1996.)

integrated more or less seamlessly into existing urban networks.[366] We might go a step further to say that when the Umayyads began to build imposing new mosques in cities across the Levant, particularly from the reign of 'Abd al-Malik (685–705),[367] a clearly conscious effort was often made to place them in proximity to principal colonnaded thoroughfares. In the process, the Muslim authorities only further enhanced the topographical prominence of these privileged axes, thus continuing the plurisecular progression toward the privileging of such primary armatures relative to the urban fabric as a whole.

An obvious example is Damascus, capital of the Umayyad caliphate, where al-Walid I's Great Mosque was installed at the beginning of the eighth century amidst the partially dismantled shell of the vast temple of Jupiter, which had itself been designed as the culmination of a sequential, linear urban itinerary centered on the broad, colonnaded *decumanus* that linked the agora in the east of the city with the monumental propylaia of the temple-temenos to the west (Figure 4.17).[368] In this case, however, it is rather a topographical distinction without a difference, as the preeminent site of intramural cult simply transformed from a pagan temple into a mosque, leaving the connective armature by which the area was accessed, including the colonnaded avenue between the agora and the grand entrance to the precinct of the mosque, substantially unchanged.[369]

A more revealing case study is Gerasa/Jerash in Jordan, a 'second-tier' but nonetheless populous city in both the Byzantine and early Islamic periods,

[366] Magness 2003; Walmsley 2007, 2011a, 2011b; Avni 2011a, 2011b.

[367] Walmsley and Damgaard 2005, 362–63, 372–73.

[368] On the temple and its approaches in the Roman period, see Sauvaget 1949, esp. 315–25, 345–49; on the mosque, see Flood 2000.

[369] Indeed, both of the city's principal colonnaded streets, the *decumanus* leading to the temple precinct and the main *decumanus* to the south, evidently continued to function for some time,

where the city's first purpose-built congregational mosque has recently been uncovered in the most privileged of all locations, at the crossing of the city's principal *cardo* and the south *decumanus*.[370] These two streets, both flanked by continuous colonnades, intersected at a circular plaza, crowned in the center with a massive tetrapylon (Figure 4.18; cf. Figure 1.1). When the new mosque was erected ca. 730–40, a concerted effort was made to situate it immediately adjacent to the (preserved) oval plaza and the tetrapylon, in the southwest angle formed by the converging streets. The mosque rose directly over the carefully and laboriously leveled remains of a late Roman bath, which continued to function until the moment of its destruction to make way for the mosque,[371] a suggestive testament to the priority given to placing this new sacred pole in the most prominent and most frequented of all the city's public spaces. Further, the razing of the baths aside, the project's masterminds otherwise sought to incorporate the new structure as seamlessly as possible into the existing armature: while its axis diverged somewhat from the older orthogonal schema to accommodate its qibla-orientation,[372] its perimeter walls scrupulously respected the full width of both *cardo* and *decumanus*. At its southeast corner, where the perimeter wall angled out toward the *cardo*, a new row of shops was subsequently installed on-axis with the western colonnade of the street, thus disguising the divergent geometry of the mosque and integrating it still more closely with the road itself.[373]

While additional examples of Umayyad complicity, as it were, in existing late antique urban armatures might be adduced, among them the wide, usually colonnaded streets lined with shops built during the early Islamic period at Palmyra, Rusafa, Pella, Bet Shean/Skythopolis and Arsuf/Apollonia,[374] we need not belabor the point further for present purposes. And for that matter, for every startling case such as Jerash that emerges to complement the central argument of this book, counter-examples of unmitigated decay and careless disregard for the aesthetic and functional qualities of processional spaces might

as scattered finds of surviving architectural remains and their lasting imprint on the modern topography of the city suggests (on both streets, see Sauvaget 1949, 236–30, 345–59). Bejor imagines that the colonnades of the street linking the agora and the mosque were indeed maintained during the Umayyad period (1999, 50–51). The earthquake of 749 and the violent end of the Umayyad caliphate with the sack of Damascus in 750 likely provoked serious damage unlikely to have been repaired subsequently.

[370] See Walmsley and Damgaard 2005; Walmsley 2011a, 272–76; 2011b, 141–46, in addition to the preliminary online reports at: http://miri.ku.dk/projekts/djijp/. In the Umayyad period, Jerash was the capital of one of the administrative districts of the Jund al-Urdun.

[371] Walmsley and Damgaard 2005, 371; Walmsley 2011a, 280.

[372] Walmsley and Damgaard 2005, 366–67.

[373] Walmsley 2011a, 276 and figure 7.

[374] On all of these new street projects, see now Walmsley 2012, 321–29. Amman/Philadelphia (Walmsley 2011b, 147–48) and Tiberias (Walmsley 2007, 88–89) also saw notable enhancements made to their existing armatures during the Umayyad period.

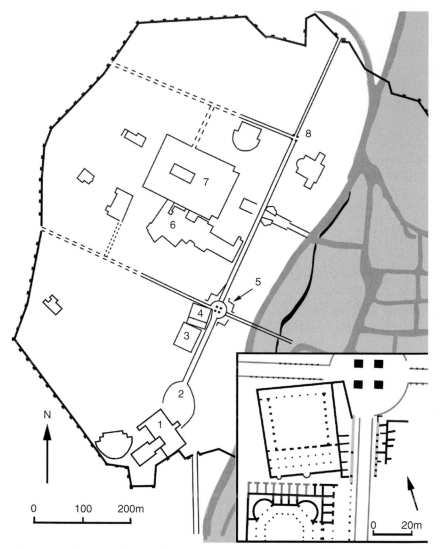

Figure 4.18 Jerash in the eighth century. 1: Artemis temple and forecourt; 2: oval plaza and colonnaded cardo; 3: macellum; 4: congregational mosque; 5: circular plaza and southern tetrapylon; 6: episcopal complex(?) – two churches and residential structures); 7: Zeus temple and forecourt; 8: northern tetrapylon. Inset: detail of mosque and new shops installed adjacent to southern tetrapylon. (Author.)

undoubtedly be adduced. Further, I have passed over the fundamental question of ceremonial continuity, the extent, that is, to which the grand avenues preserved under Umayyad rule continued to serve as the stage for the public appearances of caliphs or provincial and regional governors, a topic that cries out for detailed study.[375] A provisional response might be that while the

[375] The single most important treatment of ceremonial in the Umayyad world remains O. Grabar's unpublished PhD dissertation, *Ceremonial and Art at the Umayyad Court* (Princeton, 1955; see esp. 18ff.); see also Sauvaget 1947, 122–57.

Umayyad caliphs eschewed much of the absolutist pomp and magnificence of both their Byzantine and Sassanian predecessors and their Abbasid successors, they were by no means innocent of the symbolic potential of monumental architecture, particularly sequential spatial itineraries punctuated by gateways and their approaches.[376]

The essential point for our purposes, which the examples of Anjar, Aila, Damascus and Jerash amply demonstrate, is that the Muslim authorities in the erstwhile eastern provinces of the Byzantine empire were entirely conversant with – indeed fluent in – the architectural vernacular of power inherited from the East Roman/Byzantine world. The more scholars begin to approach the story of early Islamic urbanism as something other than a disheveled, anarchic postscript to that of antiquity, the more apparent it becomes that central monumental armatures were frequently substantially preserved (or further embellished, or even, in cases such as Anjar, built new), and that the most notable architectural interventions, mosques and palaces/official residences above all, tended to be established in close proximity to main colonnaded thoroughfares. In the Umayyad Levant too, the essence of the late antique capital lived on.

If there is a moment of relatively profound change, even rupture, in urban landscapes across much of the Levant, it is the mid-eighth century. The first blow was the powerful earthquake of 749, which leveled buildings, famously including street colonnades, across much of modern Israel, Lebanon and western Syria and Jordan.[377] This natural disaster was followed by an equally momentous political cataclysm in 750, when the Abbasids overthrew the Umayyad caliphate, sacked Damascus and subsequently transferred their capital to the newly built city of Baghdad, founded far to the east by al-Mansur in 762.[378] The grand monuments and avenues of cities across the region, Caesarea Maritima, Skythopolis/Bet Shean, Pella, Gerasa/Jerash, Philadelphia/Amman, Bostra and Damascus, to name just a few,[379] never regained their former grandeur after the earthquake, surely to some extent – I would say a great extent – because they had been politically (and ceremonially?) marginalized by the transfer of the center of power to Baghdad.[380] The round city of Baghdad, in turn, became the new urban showpiece of the Islamic world, in its initial form a place of rigid geometrical symmetry, wide streets and open plazas whose rulers unquestionably did avail themselves of elaborate public ritual rooted in Sassanian and

[376] See esp. Flood 2000, 180–83; cf. Grabar 1987, 148–49.

[377] On the date of the quake, see esp. Foerster and Tsafrir 1992; on its magnitude and epicenter along the Dead Sea fault, see Marco et al. 2003.

[378] For the historical and political context, see Kennedy 1981.

[379] Earthquake damage at Caesarea: Dey, Goodman-Tchernov and Sharvit, forthcoming in *JRA* 27 (2014); Skythopolis/Bet Shean: Tsafrir and Foerster 1997; Pella and Jerash: Walmsley 2011a, esp. 282–84; 2011b, 137–41; Amman: Harding 1951; Bostra: Foss 1997, 237–45; many more instances of damage are summarized in Marco et al. 2003, 667.

[380] Cf. (with varying degrees of emphasis) Foss 1997; Wickham 2005, 625; Walmsley 2007, 151.

Byzantine precedent, notably including processional ceremonies focused on gateways and liminal spaces.[381] Denuded of much of their symbolic, ceremonial and administrative functions, the towns of the Levant remained as residential and commercial centers,[382] architecturally unpretentious communities whose formerly grandiose streets perhaps then, gradually and organically, at last transformed into the *suqs* that Sauvaget, Kennedy and others imagined them to have become centuries sooner.

At the time when the Umayyads were looking to distill the essence of late Roman cities into the spirit of their own maturing urban habit, however, the grand colonnaded street lived on at the center of the urban collective. At the opposite end of the former Roman empire, another group of attentive, exquisitely self-conscious observers of Roman urban traditions arrived at an uncannily similar set of architectonic solutions at the end of the eighth century, when they too turned their hands to evoking the most famous capitals of the Mediterranean world, past and present. They were the founders of what can only be described as 'monastic cities' in the Carolingian empire, royal monasteries established, in the best late antique tradition of urban or 'urbanizing' showpieces, under the direct patronage and protection of the sovereign himself, beginning with Charlemagne. This curious intersection between Umayyad Syria and Carolingian Francia is not, I think, coincidental. It is not the result of independent 'revivals,' two separate attempts in two different places to resuscitate previously lost urban traditions, by chance arriving at similar results at similar times. Frankish monks and Umayyad princes fixated on porticated processional armatures because they remained a living reality, the features that defined both the image from afar and the daily experience of those cities, Rome, Constantinople and Jerusalem above all, that continued to inspire wonder and emulation throughout the lands occupied by Rome's cultural offspring. We thus turn back to the West one last time, to give Carolingian monastics the final word in a book about late antique and early medieval urbanism; that it makes perfect sense to do so is, in a way, the essence of what I hope to have shown throughout this study.

[381] Le Strange 1900, esp. 15–29; Lassner 1970; Grabar 1987, 64–68; Micheau 2008. By the ninth century, the city gravitated around a 'Grand Avenue' where public processions, ceremonial entrances and the like were staged (Micheau 2008, 228).

[382] On the considerable economic prosperity and demographic vitality of Levantine cities even after the mid-eighth century, which was badly underestimated in the past, see Walmsley 2007, 53–55; 71–90; Avni 2011b.

CHAPTER FIVE

POSTSCRIPT: ARCHITECTURE, CEREMONY AND MONASTIC CITIES IN CAROLINGIAN FRANCIA

Perhaps the single most potent illustration of the enduring power and pervasiveness of the distinctive amalgam of monumental architecture and ceremony that so profoundly conditioned the idea and the reality of the late Roman cityscape comes not from a surviving Roman city, but rather from a monastery in the northwest corner of Carolingian Francia. This is the site of Centula/St. Riquier in Picardy, founded in the middle of the seventh century, apparently following the death of the local hermit Richarius in ca. 645, whose remains were translated to the site and placed in the small church erected there.[1] Around 790, Charlemagne installed his friend and confidante Angilbert as lay abbot. Over the next decade, Angilbert leveled the humble existing structures and set about creating a grandiose architectural ensemble *ex novo*, funded by Charlemagne and destined to become one of the leading royal abbeys of the realm.[2] Construction seems to have been well under way by 799, when the imposing new abbey church was dedicated; in the following year, Charlemagne celebrated Easter at Angilbert's sprawling new foundation.[3]

We are fortunate to possess two lengthy excerpts devoted to the configuration and adornment of the monastery and the liturgical regimen in force

[1] Magnien (ed.) 2009, 17–20.
[2] On Charlemagne's patronage, see *Chronicon Centulense* 2.7, 2.8, 2.9; Lot (ed.) 1894, 54, 57, 61.
[3] On all of the preceding points, see generally Hubert 1957; Heitz 1974; 1980, 51–62; McClendon 2005, 153ff.; Magnien (ed.) 2009, 20–24. For Charlemagne's Easter visit, *ARF a.* 800, p. 111.

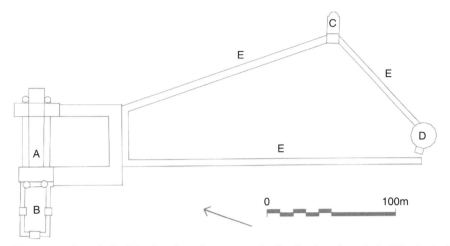

Figure 5.1 Centula/St. Riquier, plan of monastery in Carolingian phase. A: St. Riquier/*ecclesia maior*; B: *paradisus*; C: St. Benedict; D: St. Mary; E: *longaniae*. (McClendon 2005, fig. 160.)

there from the pen of Angilbert himself, respectively the so-called *De perfectione et dedicatione Centulensis ecclesiae libellus* and the *Institutio Angilberti Centulensis*, both preserved in the *Chronicon Centulense*, a history of Centula written by the monk Hariulph at the end of the eleventh century.[4] A longer version of the *Institutio* is also extant in a twelfth-century manuscript in the Vatican Library.[5] Coupled with the results of the archaeological campaigns undertaken at the site over the past century, most recently under the direction of H. Bernard,[6] these accounts provide a uniquely detailed picture of one of the most monumental, architecturally ambitious monastic projects undertaken in the Carolingian world, a place inspired and configured down to its most minute details by the meticulously studied interplay between architectural form and liturgical function (Figure 5.1).[7]

The abbey church was an imposing edifice, some eighty meters long, with a transept and massive crossing tower at both the east end, dedicated to St. Richarius, and the west, dedicated to the Savior, linked by a short nave. The east end terminated in an apse, the west in an arcaded façade fronted by an atrium (*paradisus*) with entrances on the north, south and west sides.[8] Far to the south rose the centrally planned church of St. Mary and the Apostles, with a twelve-sided exterior wall surrounding an internal hexagon, topped by a lofty

4 Lot (ed.) 1894. On the date and composition of the *Chronicon Centulense*, see esp. xvi ff. The *De perfectione* is at *Chron.* 2.8–10 (pp. 57–70); the *De institutione* at 2.11 (pp. 70–76).
5 BAV, Collection of Queen Christina 235, fols. 77v–82r; Lot (ed.) 1894, 296–306.
6 See inter alia Bernard 1978, 1982, 2002, 2009.
7 Cf. Heitz 1974, 31: 'Ce qui frappe en premier lieu c'est que l'implantation du monastère fut elle-même conditionnée par un dessein liturgique grandiose.'
8 See esp. Bernard 2002, 91ff.

spire that joined the two of the abbey church to evoke the Trinity;[9] to the northeast, along the banks of the river Scardon, stood the smallest of the monastery's three churches, dedicated to St. Benedict and reserved for the exclusive use of the monks. But the most remarkable feature of this topographical ensemble was the covered colonnades, called *longaniae* by Angilbert,[10] which connected these churches together and delimited the periphery of a massive, irregularly shaped enclosure:

> If one observes the configuration of the place, the *ecclesia maior*, which is of S. Richarius, appears at the north; the second, smaller one in honor of our lady S. Mary located on the near bank of the river Scardon is to the south; and the third, which is the smallest, is on the east. Thus the cloister [*claustrum*] of the monks is a triangle: that is, from S. Richarius to S. Mary, there is one roof; from S. Mary to S. Benedict, one roof; and likewise from S. Benedict to S. Richarius, one roof. Thus it is that, with the walls running together from this side and that, the open space in the middle is a triangle.[11]

Hariulph's description, which was written when the monastery looked substantially as it had in Angilbert's time and corresponds closely with the topographical indications given in the *De perfectione* and *De institutione*, is supplemented by two seventeenth-century engravings independently copied from a miniature in the now-lost autograph of the *Chronicon Centulense*, both of which show the *longaniae* as continuous, arcaded porticoes connecting the three churches (Figure 5.2).[12] With the distance between the abbey church in the north and St. Mary to the south established by excavation at ca. 300m, it is clear that the full length of the circuit approached 700m.[13] Further, if Angilbert's reference to the ground level of the *longania* between St. Mary and the abbey church, and a stairway leading to the upper level of the same *longania* is to be taken at face value, some or all of these porticoes may initially have been two stories high(!).[14]

[9] Bernard 2002, 88–91; 2009, 57–60.

[10] Lot (ed.) 1894, 297, 305–06.

[11] *Chronicon Centulense* 2.7, Lot (ed.) p. 56: *Si igitur situs loci discernatur, animadvertur major ecclesia, quae sancti Richarii est, aquilonem tenere, secunda, inferior, quae in honore nostrae dominae sanctae Mariae citra fluvium Scarduonem sita est, austrum; tertia, quae minima est, orientem. Claustrum vero monachorum triangulum factum est, videlicet a sancto Richario usque ad sanctam Mariam, tectus unus; a sancta maria usque ad sanctum Benedictum, tectus unus; itemque a sancto Benedicto usque ad sanctum Richarium, tectus unus. Sicque fit ut, dum hinc inde parietes sibi invicem concurrunt, medium spatium sub divo triangulum habeatur.*

[12] On these engravings, see Lot (ed.) 1894, lxiii–lxiv; Parsons 1973, 23; Bernard 2009, 55–57. The autograph of Hariulph perished in 1719, when the abbey was devastated by fire.

[13] Bernard 1982, 522–23; generally also *id.* 2009, 77–82.

[14] Lot (ed.) 1894, 297, quoted at n. 16, with Bernard 1982, 522. Another possibility is that the (single-story) *longania* ascended the upward slope toward the abbey church by the stairs mentioned, continuing at a higher level via the west wing of the square cloister attached to the south side of the church: see Bernard 2009, 78.

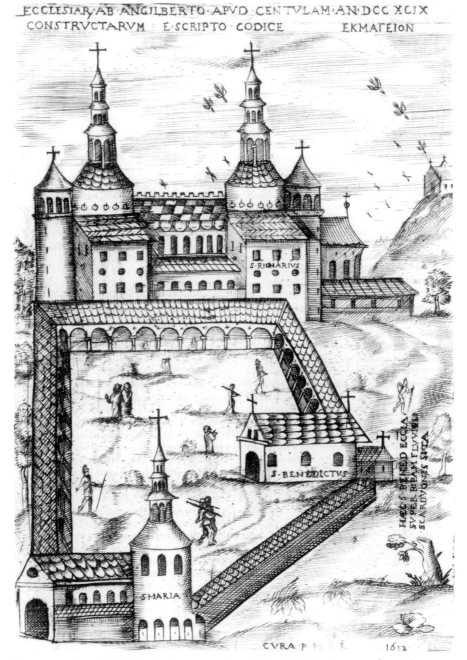

Figure 5.2 Centula/St. Riquier in an engraving of 1612. (McClendon 2005, fig. 158.)

The *De institutione* again and again shows how integral to the liturgical program of the monastery these porticoes were. They were activated on a daily basis by the long files of chanting monks who processed along them from the abbey church to the two lesser ones and back again, under cover in bad weather and in front of the arcades in fair, in the process transforming the

700m periphery of the cloister into a grand processional route whose arcaded backdrop would have been immediately recognizable, in form and function alike, to any resident of a late antique capital:

> Upon the completion of matins and vespers, all the choruses[15] straight-away gather themselves in orderly fashion in front of [the image of] the holy passion, and with only ten psalmists from each chorus remaining behind, proceeding through the *porta sancti Gabrielis*, and through the chamber of the lord abbot and on through the western part of the cloister they come singing to [the church of] S. Mary, where having performed the oration according to the requirement of the time, they turn back and come to [the church of] S. Benedict located in the eastern part of the cloister; thence through the stairway of the arches they enter [the chapel of] S. Maurice and thus, entering the basilica of S. Richarius, they are returned to their choruses.[16]

Neither the space nor the solemn processions, however, were conceived for the benefit of the monks alone. The cloister was merely the monumental heart of a far more extensive monastic city, inhabited by several thousands of farmers and craftsmen occupying the surrounding lands owned by the monastery,[17] whose presence at the monastery was frequently expected, not only when rents and services were due, but above all for the liturgical ceremonies marking the greatest Feast Days. The prescriptions contained in the longer version of the *De institutione* preserved in the Vatican Library show with particular clarity the extent to which the ensemble of monastic build-ings was conceived, above all, as the center of a grand processional armature that extended even beyond the monastery proper to encompass seven neigh-boring villages.

[15] The 300 monks of Centula were divided into a trinity of three choirs comprising 100 monks each, stationed in different parts of the abbey church; each choir was joined by a group of *pueri* drawn from the 100 novice singers in the monastery, who were divided into three groups of 33, 33 and 34: *Chronicon Centulense* 2.11, Lot (ed.) 70–71.

[16] Ibid., 71: *Matutinali etenim seu vespertinali officio consummato, mox omnes chori ordinabiliter se ante sanctam passionem congregent, decem tantum psalmistis uniquique choro remanentibus, et sic per portam sancti Gabrielis, ac per salam domni abbatis ambulando per occidentalem claustri regionem cantando veniant ad sanctam Mariam, ubi oratione pro temporis ratione deposita, remeando veniant ad sanctum Benedictum in orientali parte claustri situm; inde per gradu arcuum intrent ad sanctum Mauricium, sicque, intrantes sancti Richarii basilicam, restituantur suis choris.*

[17] A ninth-century list of the abbey's possessions that follows the *De institutione* in the Vatican manuscript puts the lay population at 2,500 households: see Lot (ed.) 1894, 306–07: *In ipsa Centula habentur mansiones hominum saecularium MMD.* Following its account of the rents owed in cash and in kind by every household, this remarkable document proceeds to enu-merate the various tenants who owed their services to the monastery, all organized in *vici* according to their profession: builders; tailors; saddle makers; bakers; cobblers; carders and fullers; leatherworkers; vintners; tavern keepers; and a garrison of 110 soldiers (Lot [ed.] 1894, 307–08). See also the inventory of the monastery's possessions compiled in 831 on the orders of Louis the Pius (*Chronicon Centulense* III.3, Lot [ed.], 86–97, at p. 94).

On Palm Sunday, for example, following services in the abbey church, 'the monks should come to St. Mary where, after singing Terce and taking up branches and palm-fronds, proceeding together with the people (*populus*) along the street of the monastery, they enter the atrium (*paradisus*) by the gate of the Holy Archangel Michael,' before going on to the western part of the church dedicated to the Savior, where mass was celebrated. In foul weather, however, the procession followed the *longania* itself: 'But if the weather does not permit this, let them come from St. Mary through the *longania* at ground level and thence to the stairway of the same *longania* by which one ascends. Upon ascending, and continuing through that same *longania*, let them enter through the doorway of Saint Maurice and thus let them come through the middle of the church to [the shrine of] the Holy Savior to perform mass.'[18]

The role of the inhabitants of the surrounding communities is more explicitly outlined in Angilbert's description of the 'solemn litanies' performed on major festivals. On such occasions, 'the crosses and processions of the neighboring communities should proceed to [the church of] S. Richarius; from Durcaptum I [cross]; from Drusciacum I, from Bersacca I, from Villaris I, from Mons Angelorum I, from Mons Martyrum I, from Angilbertvilla I.'[19] The crosses were placed in the *paradisus* fronting the west façade of the church; the *populus* then waited outside the western entrance of the atrium, the men to the north and the women to the south, while the 300 monks and the 100 children of the *schola* filed out of the church and through the atrium. Monks carrying holy water and censors appeared first, followed by seven devotional crosses and seven reliquaries. Thereafter came seven deacons, seven sub-deacons, seven acolytes, seven exorcists, seven lectors and seven host bearers, and then the rest of the monks, all walking in files of seven, 'that in our work we may demonstrate the septiform grace of the holy spirit, and' – rather more prosaically – 'because if such a multitude of brothers were to proceed by twos or threes, a mile would hardly contain them.'[20] The function of the diffuse configuration of the three churches and the 700m of *longaniae* connecting

[18] Lot (ed.) 1894, 296–97: *Post capitulum vero procedentes, veniant ad sanctam Mariam ubi, tertia cantata et ramis ac palmis acceptis, per viam monasterii una cum populo accedentes, ad portam beati Archangeli Michaelis paradisum ingrediantur … Quod si ratio aeris hoc non permiserit, de Sancta Maria per longaniam terra tenus usque ad Ascensorium ipsius longaniae quo sursum ascenditur veniant. Quibus ibidem sursum ascendentibus per ipsam longaniam pergentes, ingrediantur per ostium Sancti Mauricii atque sic per medium ecclesiae accedant ad Sanctum Salvatorem missam ad perficiendam.* Cf. Heitz 1963, 77–82.

[19] Ibid., 299: *Ad sollemnes letanias faciendas convenient cruces et processiones vicinarum ecclesiarum ad Sanctum Richarium, de Durcapto I, de Drusciaco I, de Bersaccas I, de Villaris I, de Monte Angelorum I, de Monte Martyrum I, de Angilbertvilla I.*

[20] Ibid., 300: *Et ideo eos septenos ambulare decernimus ut in nostro opere gratiam septiformem Sancti Spiritus demonstreremus, et quia tantam fratrum multitudinem si bini vel terni incederint, unum vix miliarium caperet.*

them thus, incidentally, becomes clear: the cloister itself was expressly designed to permit hundreds of monks to file around its confines in the course of their daily rounds.[21]

The route followed by the major processions involving the monks and the whole *populus*, however, ranged far more widely still. Once all the monks had gone through the *paradisus* and passed through the files of the laity, segregated by sex, awaiting outside, they were followed by the *schola* of the lay children, and then by the laity themselves with their seven village crosses, again in ranks of seven, grouped according to sex, rank and station, even down to the 'masses (*populus mixtus*) of the infirm and the old.'[22] The extant portion of the *De institutione* preserved in the Vatican manuscript proceeds to outline the route followed by this cavalcade of monks and laity on three successive days, beginning on Easter Sunday. On the first day, 'they should go through the middle of the monastery on the public road and through the southern gate, and circling along the wall, they should return through the northern gate'; all the while, the monks sang antiphonal chants, then psalms, and then the Gallican, Italic (Ambrosian) and – 'most recently' (*novissime*) – Roman liturgies, while the *pueri* and 'all others who can' chanted first the Apostolic Creed, then the Constantinopolitan and Athanasian Creeds, and finally – 'most recently' – the Lord's Prayer, until the whole procession had returned to the abbey church.[23] Following mass, the people all returned to their villages, leaving the crosses in the *paradisus*. On the second day, with everyone in their places as on the preceding day, the procession wended its way still farther afield to incorporate stations in the village churches of Villaris and Mons Angelorum.[24] On the third day, the procession headed for the village churches in Mons Martyrum and Angilbertvilla, returning thence 'along the public road, and then in front of the houses of the builders and others up to the gate joined to their houses, and from there ... to [the church of] St. Mary to celebrate mass.'[25] The village crosses accompanied the parade on each day and were returned to the atrium of the abbey church at night, where they evidently remained until the vigil of the Assumption, when the 'people from outside (*forinsecus populus*),

[21] Cf. Heitz 1974, 37.

[22] Lot (ed.) 1894, 300.

[23] Ibid., 300: *His ita constitutis, eodem primo die vadant per medium monasterii per publicam viam et per portam meridianam murum girando, revertantur per portam septentrionalem.*

[24] Ibid., 301–02: *Secundo etenim die eundum ordinem quo supra, et viam usque ad jamdictam portam observantes pergant recto itinere per ecclesiam Sancti Martini in Villaris, et inde juxta eandem villam, ad sinistram tamen partem eam dimittentes, perveniant ad illam ecclesiam in Monte Angelorum.*

[25] Ibid., 302: *Tertio autem die, de sepedicta ecclesia promoventes per prefatam portam egrediantur, inde recto itinere perveniant ad illam ecclesiam in Monte Martyrum; ubi, finita oratione, revertantur per Angilberti Villam, et inde juxta murum per portam meridianam et per viam publicam, et sic coram mansionibus fabrorum vel ceteris usque ad portam quae ipsis mansionibus conjungitur, inde perveniant ad Sanctam Mariam missam ad celebrandam.*

with their crosses ... praising god and blessing the Lord, should return to their churches to hear mass.'[26]

These lengthy prescriptions for liturgical observances at Centula, all the more valuable as they come from the pen of the person responsible for the design of the new monastery, vividly capture the extent to which the complex as a whole was designed as a grand ceremonial space, a monumental architectural backdrop for the processions that animated its various component parts and bound the monastic center and its surrounding communities into an indissoluble topographical and spiritual ensemble, a monastic city of God. The parallels with Rome, with its seven ecclesiastical regions, each with its own deacon and regional cross, and its calendar of popular liturgical processions (*collectae*) presided over by the popes themselves, are unmistakable.[27] When we recall that the three extramural basilicas in Rome most frequently visited in the course of both stational processions and *collectae*, St. Peter, St. Paul and St. Lawrence, were themselves reached by lengthy, covered colonnades, at least one of which had been refurbished scant years earlier by Pope Hadrian I, the parallel with Centula's three churches and *longaniae* becomes still more striking.[28]

For the half century preceding Centula's reconstruction, relations between the Frankish and Roman churches had of course grown increasingly intimate; and already by the 760s, the Frankish envoy to the papal court, Chrodegang, presided over an elaborate stational liturgy at his archiepiscopal see in Metz, centered on an episcopal complex that perhaps featured precisely seven churches by Chrodegang's time, which was manifestly modeled on that of Rome.[29] A complete stational list for the period between the beginning of

[26] Ibid., 302: *Forinsecus autem populus cum crucibus suis propter vigiliam Ascensionis Domini, laudantes Deum et benedicentes Dominum, redeant ad ecclesias suas ad audiendam missam.*

[27] For the Roman *collectae*, see *Ordines Romani* XX–XXII (Andrieu 1931–61, vol. 3, 231–62); on the distinction between *collectae*, 'popular liturgical processions of a penitential nature,' and stational liturgy, in the sense of papal processions to the site of masses scheduled on fixed days in the church calendar, see Baldovin 1987, 153–66 and 234–38; also Häussling 1973, 186–98. The processions at Centula involving the neighboring people are equivalent to the *collectae* at Rome, on which they are clearly based, as Baldovin notes (1987, 162); cf. Häussling 1973, 55. See also Heitz 1963, 126–27 on the significance of the number seven, which evoked both Roman and apocalyptic traditions.

[28] For the growing prominence of the churches of St. Peter, St. Paul and St. Lawrence in the liturgical cycle by the sixth century, see Baldovin 1987, 154–55. See also Chavasse 1993, 57–59; and *id*. 231–46 for the role these three shrines played during Lent, the most liturgically intensive period of the Roman calendar, when they were the only extramural stations visited by the pope. On Pope Hadrian I's restoration of the colonnade from Castel Sant'Angelo to St. Peter's, see Chapter 2.1.

[29] See generally Häussling 1973, 80–98, 174–81, 198–210. On the episcopal complex at Metz and its (probable) seven shrines, see Heitz 1967; 1974, 34–35; 1980, 13–20; TCCG Vol. 1, 43–46. On the extent of Chrodegang's efforts to transform Metz into a kind of Frankish avatar of papal Rome in both topographical and liturgical terms, see Semmler 1973b, 232–36, and esp. Claussen 2004, 157–65 and 276–89, with Paul the Deacon, *Liber de episcopis Mettensibus* (*MGH*

Lent and the Saturday after Easter, likely compiled by Chrodegang himself, reveals stations at a remarkable thirty-six churches in and around the city, with the three principal shrines attached to the *episcopium* (the cathedral of St. Stephen and the churches of St. Mary and most of all St. Peter) the preferred stations on Sundays and during Easter week.[30] Further, as Carol Heitz has shown, the correspondence between the stations of the Paschal period at Metz and Centula is remarkably close, enough so to suggest 'a strictly determined order … in use across all the territory of the Frankish kingdom,' based chiefly on Roman observance.[31]

While the number of churches in the monastery proper at Centula was reduced to three, the resemblance to Rome was in some ways even more pronounced, given the importance attributed to the seven surrounding villages (the inclusion of 'Angilbertvilla' among them perhaps suggests that Angilbert had a hand in achieving the requisite number), with their parish churches, local clergy and processional crosses. The monastic churches at Centula thus stood in for the leading devotional basilicas of Rome – among them the three great extramural shrines with their adjoining '*longaniae*' – whither the clergy and the people of the seven regions, grouped according to their rank and station,[32] would process with the pope on important dates in the church calendar, while the village churches stood in for the Roman *tituli* scattered throughout the city's seven ecclesiastical regions.[33] Hence, when Charlemagne spent Easter of 800 at the new abbey, he will have been treated to an evocation of the topographical and liturgical splendor of the papal capital, where he was to be crowned emperor the following Christmas, in the heart of his own realm. It was a splendor equally well known to Angilbert, who had traveled to Rome on Charlemagne's behalf several times in the 790s.[34]

But Rome was not the only venerable Christian metropolis to inform the architectural and liturgical dispositions of Angilbert's new monastery. As Heitz

SS 2, 268): *Ipsumque clerum abundanter lege divina Romanaque imbutum cantilena, morem atque ordinem Romanae ecclesiae servare praecepit* [Chrod.]*, quod usque ad id tempus in Mettensi ecclesia factum minime fuit.*

[30] For this remarkable document, discovered in 1927 by T. Klauser in Paris (BN ms. 268), see Klauser 1930; on the dating and probable attribution to Chrodegang, which has never been seriously challenged, see esp. 184ff. On the first day of Lent and Palm Sunday, the document calls for full-blown *collectae* on the Roman model, with the people of the city processing with their bishop and clergy from a collect church to a stational mass held in the *Episcopium* (ibid., 166, 181). The Roman focus of the Easter liturgy at Metz is further evident in the stational predominance of the church of St. Peter.

[31] See Heitz 1963, 82–91, at 87.

[32] *Ordo Romanus* XXI, Andrieu 1931–61, vol. 3, 248.

[33] For the Lenten stations in Rome, see Chavasse 1993, 231–46.

[34] Certainly in 792 and 796 (*ARF a.* 792 and *a.* 796, pp. 90, 99); and possibly in 794 (Bullough 1991, 158–59, n. 162). On the 'Franco-Roman' *laudes* performed for the Carolingian ruler on major feasts, notably Easter, see Kantorowicz 1946, 85ff.

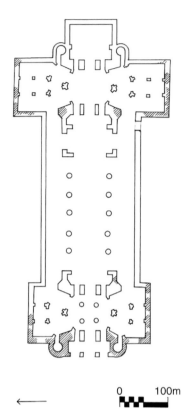

Figure 5.3 The abbey church at Centula/St. Riquier in its first phase. (McClendon 2005, fig. 161.)

in particular has demonstrated, Jerusalem provided a second template that was assiduously evoked at Centula, above all in the abbey church, whose configuration was manifestly inspired by the Holy Sepulcher complex, where the Anastasis rotunda on the site of Christ's tomb in the west faced the basilical-plan martyrium of the Holy Apostles to the east. So too at Centula, the western part of the church, with its massive, centrally planned crossing tower and its grand reliquary in the crypt beneath containing twenty-five relics of Christ, was dedicated to Christ the Savior, while the nearly identical eastern end, dedicated to Richarius and the Apostles, housed relics of the apostles in the apse, as did the martyrium in Jerusalem (Figure 5.3).[35] If the tantalizing archaeological evidence adduced by Bernard in favor of his reconstruction of the crossing towers as (essentially round), sixteen-sided polygons can be trusted, the echoes of the Anastasis Rotunda will have been still more pronounced.[36] Certainly the Anastasis Rotunda was further evoked in the *paradisus* fronting the church of the Savior at Centula, the three gates of which on the north, west and south sides were surmounted by chapels dedicated to the Archangels Raphael, Michael and Gabriel respectively, as were the three small apses projecting off the ambulatory of the rotunda in Jerusalem.[37] When we recall further that the Easter ceremony in Jerusalem

[35] See *Chronicon Centulense* 2.9–10, Lot (ed.) 1894, 61–69, with Heitz 1963, 102–13.

[36] For Effman (1912) and Heitz (e.g., 1974, 31), for example, these towers were round, as they are shown in the seventeenth-century engravings; Jansen (1982) and McClendon (2005, 157) are inclined to prefer square towers, given the rarity of circular crossing towers at the time and the difficulties of mating circular structures with quadrangular foundations, though as they acknowledge, it remains possible that round or polygonal upper stories were added in wood. I see no good reason to doubt the basic verisimilitude of the engravings and the miniature on which they are based (cf. Bernard 2009, 55–56 and passim, *contra* Jansen 1982), which clearly shows essentially circular towers, and find Bernard's latest reconstruction of the towers as internal octagons surrounded by external, sixteen-sided polygons, based on excavated traces of the pillars at the crossing of the west transept, quite convincing (Bernard 2002, 91ff.; 2009, 61–65).

[37] *Chronicon Centulense* 2.8, Lot (ed.) 1894, 60; Heitz 1963, esp. 113–18; 1974, 33 on Arculf's plan – widely diffused in Carolingian Francia – of the Anastasis Rotunda. For the Anastasis complex, see also, e.g., Baldovin 1987, 46–49.

found the people gathered with the clergy at the Anastasis Rotunda, prior to setting out on a stational procession, the parallel with the Easter procession at Centula that began at the monastery's own 'Anastasis' is unmistakable, as is the extent to which Centula was conceived as a microcosm of the Holy City *par excellence*, where the Easter Week liturgy continued to unfold and to be seen by Western pilgrims in the eighth century, long after it had come under Muslim control.[38]

One additional parallel might be adduced regarding the topographical correlation between the monastery as a whole and the city of Jerusalem: as noted earlier, Justinian's grand Church of Mary, the Nea Ecclesia, was linked upon its completion in the 540s to the Holy Sepulcher complex in the north by the continuous, newly built colonnades lining the southern section of the *cardo maximus*, which subsequently framed the processions linking these two principal foci of Jerusalem's stational liturgy, and featured so prominently in the depiction of Jerusalem in the Madaba Map mosaic.[39] We should therefore probably see more than coincidence behind both the positioning and the dedication of Centula's own church of Mary, which likewise rose directly to the south of the monastery's 'Anastasis,' the western end of the abbey church dedicated to the Savior, to which it was connected by the straight, colonnaded *longania* spanning the 300m interval between them (Figure 5.1). It would seem that Angilbert's scheme again, as with the example of Rome, went beyond isolated architectural and topographical 'references' to Christian capitals to reproduce extended ceremonial armatures. As at Jerusalem, so too at Centula, one processed from the cathedral/abbey church dedicated to Christ in the north, to the second most prestigious church, dedicated to Mary, in the south, via a single, principal axis of movement embellished with continuous colonnades.

Hence, it should come as no surprise to find echoes at Centula of the other leading Christian capital of Angilbert's day, Constantinople, the city which, along with Rome and Jerusalem, maintained the most elaborate and lasting cycle of stational observances in all of Christendom. And as we have seen, the liturgy at Constantinople developed in particularly close connection with the topography of the city from the time of Constantine on: the colonnaded armature of the Mese and its associated forums, imperial monuments and churches arose in conjunction with the processional ceremonies favored by the resident imperial court and the patriarchal administration alike. Nowhere, indeed, were

[38] On Frankish pilgrims in the Holy Land, and Charlemagne's concern for their well-being, see Hen 2007, 172–76. For the Easter gathering at the Anastasis, Baldovin 1987, 61–63, 78; cf. also Heitz 1963, 100. On the continuation of the Easter Week processions after the Arab conquest, see Baldovin 1987, 100–02 (the tenth-century *Typikon* of the Anastasis provides especially precious testimony in this regard). Generally on the influence of Jerusalem – second only to Rome – on the form of the stational liturgy celebrated at Centula, see Heitz 1963, 91–102.

[39] See Chapter 3. For stations at the Nea, see Baldovin 1987, 98.

urban topography and liturgical observance more integrally connected;[40] and the stational liturgy at Constantinople was characterized, more than at Rome and Jerusalem, by the frequency of the popular liturgical processions of supplication (rogations) that brought the clergy and people together to traverse the colonnaded streets on their way to stational masses held inter alia on the anniversaries of defining events in the city's past, such as the earthquake of 447 and the Avar and Persian siege of 626.[41] The Easter processions at Centula had precisely the same popular and supplicatory character, a correspondence that appears the more calculated in light of Angilbert's description of the relics he obtained for his new monastery, in which relics from Constantinople take pride of place alongside others from Rome and Jerusalem:

> When indeed we saw that the abovementioned churches in honor of our lord Jesus Christ, and his glorious mother, and of all his saints had been founded with prudent counsel, as described above, we burned with great desire and much ardor of love ... that we should deserve to obtain a portion of the relics of those saints to adorn those same holy churches of God ... that is in the first place [relics] from the holy Roman church, given by the highest *pontifex* Hadrian of blessed memory, and after him the venerable Roman pope Leo; from Constantinople and Jerusalem, by means of legates sent there by my lord [Charlemagne], and then from Italy, Germany, Aquitaine, Burgundy and Gaul.[42]

Charlemagne's emissaries to the East thus ensured that at Centula, a potent physical and spiritual connection mediated by relics was established not only with Rome, but also − and before anywhere else − with Constantinople and Jerusalem, the very three places that most directly inspired both the liturgical program and the material contours of the monastery and its surroundings.

Centula, in short, was designed from its inception under Angilbert as a distillation of the topographical, architectural and ceremonial essence of the three most venerable Christian cities of the eighth-century Mediterranean world, a monastic city complete with a numerous lay population to provide goods and services for its 'ruling' monks,[43] and to look on and often

[40] Cf. Baldovin 1987, 204: 'Constantinople more than any other city experienced a conjunction of urban milieu and Christian worship.'

[41] Ibid., esp. 211ff.; cf. Heitz 1974, 34 with n. 27; Kantorowicz 1946, 36–38.

[42] *Chronicon Centulense* 2.9, Lot (ed.) 1894, 61–62: *Dum enim praescriptas aecclesias prudenti consilio in honore Domini nostri Ihesu Christi, suaeque gloriosae genitricis, et omnium sanctorum ejus, sicut supra scriptum est, fundatas perspiceremus, magno desiderio nimioque amoris ardore sumus accensi, ut, secundum possiblitatem nostram, eodem Domino miserante, partem reliquiarum illorum sanctorum ad ornandas easdem sanctas Dei aecclesias adipisci mereremur ... id est inprimis [reliquias] de sancta Romana aecclesia, largiente bonae memoriae Adriano, summo pontifice, et post eum venerabili Leone, papa Romano; de Constantinopoli vel Hierosolimis, per legatos illuc a Domino meo directos, ad nos usque delatas; deinde de Italia, Germania, Aquitania, Burgundia, atque Gallia.*

[43] See n. 17.

participate when those monks acted as civic and ecclesiastical dignitaries in those and countless other cities did when they made their most ostentatious public appearances, processing through and around a monumental urban core composed of grand edifices (primarily churches and palaces) and the colonnaded streets that linked them. The remarkable *longaniae* at Centula must represent a conscious evocation of the colonnades that remained an integral component of the 'urban' experience, from Angilbert's rural corner of Francia to the ongoing, living reality of Rome, Jerusalem and Constantinople. Nor was Centula an aberration: as we shall see, the 'Carolingian Renaissance' witnessed a rather wider resurgence of colonnaded, urbanizing ceremonial armatures in the Carolingian heartland.

We begin with the great royal monastery of Lorsch, the site of one of the most remarkable and most discussed architectural jewels of the Carolingian realm, the so-called *Torhalle*, or gatehouse. A modest structure measuring only 9.76m by 6.09m, excluding its two projecting stair towers, the Torhalle is outstanding for its classicizing forms and the adornment of its exterior, the two long sides of which are faced in polychrome stonework set in geometric patterns, interspersed with engaged Corinthian half-columns on the ground floor and ionic pilasters in the attic (Plate VIII).[44] The three, equally sized arched gateways of the ground floor are surmounted by a rectangular chamber occupying the entirety of the upper story, accessible via the two spiral staircases in the flanking towers. While the function of this unique edifice remains the subject of lively debate, particularly regarding the original purpose of the upper chamber (its identification as a reception room or audience hall for visiting royalty – a *Königshalle* – is preferable to the older view that made it a chapel),[45] it is in essence a simulacrum of a three-bayed Roman triumphal arch, as Krautheimer long ago recognized. Its three apertures with their intermediate half-columns immediately recall the arches of Septimius Severus and – above all – Constantine in Rome, both of which remained standing over the final stretch of the old Triumphal Way/Sacra Via on its way into and through the Roman Forum.[46] The stonework of the façades, meanwhile, is most closely paralleled in the polychrome facings of a number of city walls and gates built in northwest Europe in the late third century, the best extant examples of which are the circuit at Le Mans and the *Römerturm* at Cologne, themselves imperially sponsored urban monuments *par excellence*, as I have suggested elsewhere.[47]

[44] The *Torhalle* bobs precariously in a vast ocean of scholarly ink: useful overviews include Behn 1934, 70–90; Meyer-Barkhausen and Walbe 1953; Binding 1977; Jacobsen 1985, 9–16; McClendon 2005, 91–104; for the debate over its dating, see n. 56.

[45] See, e.g., Gerke 1949; D'Onofrio 1976; Behn 1977, 262; Binding 1977, 281–84.

[46] Krautheimer 1942, 32–34.

[47] Dey 2010; cf. Binding 1977, 274.

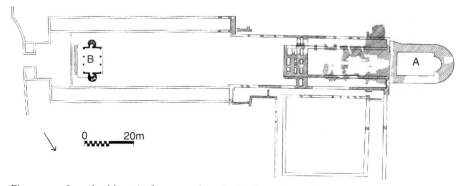

Figure 5.4 Lorsch abbey. A: funerary chapel added 876; B: *Torhalle*. (After McClendon 2005 fig. 96.)

But the best testimony to the *Torhalle*'s basic function as a material evocation of triumphal arches in Rome is its place within the topographical scheme of the monastery as a whole, which was manifestly conceived as a sort of miniature embodiment of a (Christian) Roman city (Figure 5.4). The *Torhalle* is located on-axis with, and not far inside, the main, west gate in the monastery's enclosure wall, which in turn opened onto a long, colonnaded forecourt leading all the way to the grand entranceway – a freestanding westwork with two flanking towers – of the atrium/*paradisus* fronting the façade of the abbey church.[48] The principal 'street' of the abbey thus consisted of an axial armature comprising, from west to east, the gate in the enclosure wall; the colonnaded forecourt with the *Torhalle* in its western third; the *paradisus* with its monumental entranceway; and the façade of the church itself. Further, this primary axis of vision, movement and ceremony was intersected at right angles by what was apparently another street running between the north and south gates in the monastery's enclosure wall, the *cardo maximus*, as it were;[49] the axes of the two streets crossed in the *paradisus*, which we might thus imagine as the '*umbilicus*' of the site as a whole, a sort of stand-in for the tetrapyla at the crossing of the colonnaded streets at Thessaloniki, Antioch, Split and so many other late Roman cities. When we recall that the *paradisus* at Centula was the starting point for the grandest processional ceremonies in the annual liturgical calendar, the placement of its equivalent at Lorsch at the intersection of the monastery's two principal thoroughfares appears all the more significant. Whatever else it was, then, and however else

[48] For a topographical overview, Behn 1977, 262ff.; on the westwork, *id.* 1934, 32–40. The turreted façade opening onto the atrium appears to correspond with the *castellum* mentioned in the description of the fire that destroyed the monastery in 1090: *Codex Laureshamensis* 134, Glöckner (ed.) vol. 1, 404.

[49] Behn 1934, 94–102, with plan 29; Heitz 1980, 43. The enclosure wall is said to have been constructed under Richbod, shortly after he became abbot in 784: *Codex Laureshamensis* 12, Glöckner (ed.) vol. 1, 288–89.

it functioned, the *Torhalle* was above all a kind of architectural exclamation point, an unusual, brilliantly adorned freestanding gateway that definitively marked the route between the gate of the monastery and the church as a Triumphal Way (or Sacra Via) on the Roman model, lined with colonnades and punctuated by the closest approximation of the Arch of Constantine built anywhere in Charlemagne's dominions.[50]

The circumstances of Lorsch's foundation and early development only strengthen the impression of its privileged and very carefully conceived relationship with the city of Rome. The site originally centered on a church dedicated to St. Peter, located about 500m away from the later monastery, founded by a *comes* Cancor and his widowed mother, Willeswind, in or just before 764.[51] Almost immediately, Cancor and Willeswind placed the new foundation under the authority of Chrodegang, who soon thereafter installed his brother Gundeland as abbot, sending him to Lorsch along with a group of monks from the monastery of Gorze.[52] In 765, Chrodegang also dispatched the remains of Nazarius, one of three Roman martyrs whose corporeal relics he had triumphantly brought back from Rome in the preceding year as a gift from Pope Paul I.[53] As a result of the popularity of Nazarius' remains, as well as the limitations of the original site, the monastery was rebuilt on its present location beginning in 767. In 772, Gundeland gave the monastery to Charlemagne, who granted it charters of immunity, and whose patronage soon placed Lorsch among the leading royal monasteries of his realm.[54] The new church was completed in 774, and the relics of Nazarius transferred there, in a dedication ceremony presided over by Lullus of Mainz and attended by Charlemagne himself, his family and his court.[55]

From its inception under the (arch-Romanizer) Chrodegang, then, and its reception of some of the very first corporeal relics ever sent to Francia (or anywhere) by a Roman pope, Lorsch enjoyed a particularly close connection with the city of Constantine and the popes, a connection that can only have been strengthened by Charlemagne himself, whose visit in 774 indeed followed immediately upon his triumphant return from Italy following the

[50] Cf. Selzer 1955, 29–37; Binding 1977, 283–84; 289–90. That said, the *Torhalle* is hardly an exact copy: among other discrepancies, it lacks the larger central passageway of the Arch of Constantine, whence an intermediary influence has been proposed in the form of the triple-arched gateway fronting the atrium of St. Peter's in Rome: see McClendon 2005, 97–100, with prior bibliography.

[51] Modern scholarly reconstructions of Lorsch's first decades rest primarily on the testimony of the *Codex Laureshamensis*; on all the following points, see the overview of Semmler 1973a, 75–85; cf. also Innes 1998, esp. 303–11.

[52] *Codex Laureshamensis* 3, Glöckner (ed.) vol. 1, 270–72; cf. *Annales Laureshamensis*, Pertz (ed.), 28–30.

[53] Ibid., with Claussen 2004, 258–61; cf. *Vita Chrodegangi*, c. 28–31.

[54] *Codex Laureshamensis* 3–5, Glöckner (ed.) vol. 1, 272–76.

[55] *Codex Laureshamensis* 7, Glöckner (ed.) vol. 1, 282–83.

conquest of the Lombards. It is to the years or decades immediately follow-
ing Charlemagne's subjugation of the Lombards and his assumption of the
title *patricius Romanorum* that the construction of the *Torhalle* almost certainly
belongs, as most scholars – *pace* Jacobsen – continue to believe.[56] While it is
tempting to imagine that this manifestly 'Romanizing' monument, with its
clear triumphal overtones, was erected to commemorate the Lombard con-
quest and Charlemagne's subsequent visit to Lorsch on September 1, 774, it
seems unlikely to have been completed in the scant months separating the fall
of Pavia from Charlemagne's arrival at the monastery. Perhaps it rose imme-
diately thereafter, or perhaps it was the work of Richbod, the most prolific
builder among Gundeland's successors, who replaced the old wooden cloister
on the south side of the abbey church with a square, stone cloister and embel-
lished the church itself, presumably in the years between becoming abbot in
784 and 791, when he was made archbishop of Trier.[57] In any case, it seems
quite clear that the *Torhalle* was an integral component of an ambitious archi-
tectural showpiece designed, in part, to recall the urban processional routes of
the great Christian capitals of late antiquity, and of Rome in particular.

Much the same can be said for the grandest and most symbolically charged
building project of Charlemagne's reign, his palace-city at Aachen. Planned
and largely completed during the later 780s and 790s, at exactly the time when
the new monastery at Centula was taking shape, Aachen was patently intended
to be Charlemagne's answer to the greatest capitals of Christian antiquity,
Rome, Constantinople and Ravenna above all, though with shades of other
places as well, notably Constantine's first capital in nearby Trier. In creating
a new urban showpiece – explicitly called a 'New Rome'[58] – at the center
of his realm, Charlemagne – himself the *novus Constantinus* – placed himself

[56] Jacobsen (1985, 17ff.) has re-proposed a date in the last quarter of the ninth century, when
the new crypt-church added to the east end of the abbey church became a sort of royal
mausoleum for the eastern Carolingians; cf. also Innes 1998, 318–20. Jacobsen's dating, based
primarily on the style of the column capitals and other decorative carvings, has been con-
vincingly rebutted by R. Meyer, the author of the *magnum opus* on early medieval capitals
in Germany, who argues in favor of the traditional dating to the last quarter of the eighth
century: see Meyer 1997, 214–55, 530–34, 573–76. In any case, the political and ideological
circumstances of Charlemagne's reign provide at least as convincing a context for the erec-
tion of the *Torhalle*, though its construction and the triumphal, urbanizing pretentions it
belies would be no less remarkable in the later period. For additional supporters of the late
eighth-century dating, see the following note.

[57] On Richbod's building activities, see *Codex Laureshamensis* 12, Glöckner (ed.) vol. 1, 288–90.
He remained abbot of Lorsch until his death in 804. Proponents of a date in the early years
of Richbod's abbacy include Heitz (1980, 46) and McClendon (2005, 102). Binding (1977,
esp. 288–90) prefers 774, in connection with Charlemagne's visit to the abbey; see also 273–80
for a résumé of the various dating hypotheses proposed in the past.

[58] In an anonymous poem of praise (the so-called *Karlsepos*) addressed to Charlemagne shortly
after his imperial coronation in 800 (*MGH Poetae Latini Aevi Carolini* I, 368): *sed et urbe potens,
ubi Roma secunda Flore novo, ingenti, magna consurgit ad alta Mole, tholis muro praecelsis sidera tangens.*

squarely in the tradition of the city founders of antiquity, from Alexander the Great and Justinian to, of course, Constantine himself, the founder of the first 'New Rome' and the paradigm of the Christian emperor that Charlemagne most assiduously cultivated.[59] Columns and marbles were laboriously transported from Rome and Ravenna, that Aachen might literally embody the most glorious capitals of the Christian West; Charlemagne called one of the two basilical halls opening off of the palatine chapel, likely the place where synods were held, 'the Lateran';[60] the atrium fronting the chapel featured a fountain in the form of a pinecone, in emulation of the *pigna* fountain at St. Peter's; a Gallo-Roman statue of a bear, still preserved at Aachen, almost certainly stood in for the *lupa* at the Lateran; the equestrian statue of Theoderic that graced the entrance of the palace in Ravenna, transported to Aachen in 801, presumably fulfilled a similar function in its new home.[61] And so on: the parallels between Aachen and all the cities mentioned earlier, and more besides, are almost endless, as is the ever-growing bibliographical corpus on the subject; for present purposes, it will suffice to note that the two architectural and functional centerpieces of the whole complex, the palatine chapel and the imperial audience hall, were reached by porticoes and an arcaded atrium patently inspired by the ceremonial armatures of the same late antique capitals. Indeed, these two buildings and the axes of movement and ceremony that shaped their approaches and connected them were literally at the center of the new 'city,' the poles around which everything else gravitated (Figure 5.5). The relative prestige of this monumental core was further accentuated by its stone construction, which has left it alone accessible to archaeological investigation, whereas the constellation of living and working spaces that once surrounded it, built in perishable materials, has vanished with hardly a trace.[62]

Stat pius arce procul Karolus loca singula signans, Altaque disponens venturae moenia Romae... On the date and composition of this remarkable document, see Schaller 1976; Godman, Jarnut and Johanek (eds.) 2002. On the possibility that the site described is Paderborn as opposed to Aachen, McKitterick 2008, 140–41 (in my view, Aachen remains preferable).

[59] Cf. Krautheimer 1942, 35–36; Heitz 1963, 150–52; Kreusch 1965, 532–33; Untermann 1999, 162–63. The remarkable frescoes in the audience hall of the palace at Ingelheim, which juxtaposed Charlemagne with the legendary city builders Alexander the Great, Romulus and Remus, and Constantine are particularly eloquent testimony to the urbanizing pretentions of Charlemagne's palace foundations, as are the repeated references to the palace complex at Paderborn as the *urbs Karoli*, which indeed became the nucleus of the town that rose around it over the course of the ninth and tenth centuries. On Ingelheim, see Grewe 1999; on Paderborn, Gai 1999; cf. also McKitterick 2008, 167–68.

[60] For the identification of the 'Lateran' at Aachen, see esp. Falkenstein 1966; cf. id. 1991, 250–51.

[61] On all of the preceding points, see the overviews of Hugot 1965; Kreusch 1965; Falkenstein 1991; Binding 1996, 72–98; Untermann 1999; McClendon 2005, 108–23.

[62] Cf. Untermann 1999, 152, 161–62. For what little can be said of the residential and commercial facilities, based on the (vague) literary sources, see Hugot 1965, 544–46; Falkenstein 1991, 269–73; McKitterick 2008, 167–68.

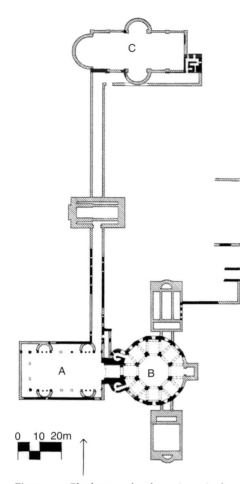

Figure 5.5 Charlemagne's palace-city at Aachen. A: forecourt; B: Palatine Chapel; C: audience-hall. (After McClendon 2005, fig. 114.)

In the south stood the Palatine Chapel, an internal octagon surrounded by a sixteen-sided polygon – just like the crossing towers at Centula – clearly inspired in part by San Vitale in Ravenna, and perhaps the Anastasis Rotunda in Jerusalem as well; work seems to have been largely complete by 798, if not earlier.[63] The main entrance, on the west, opened onto a paved courtyard measuring 36m by 17m, flanked on both long sides by arcades springing from an alternating sequence of columns and pillars, resting on a stepped platform raised ca. 50cm above the level of the courtyard (Figure 5.6).[64] While the space, with its pinecone fountain in the center, evidently hearkened back to the atrium of St. Peter's in Rome, and perhaps the imperial forums too, given the presence of two flanking *exedrae* behind the arcades on each side, it bears a closer formal and apparently functional relationship to the arcaded, sunken 'courtyard' – really the final stretch of the colonnaded street – leading to the façade of Diocletian's palace at Split. And as at Split, there seems to have been no continuous passageway behind the arcades;[65] rather, in both cases, the arcades on their raised, stepped platforms appear above all to have served for ranks of spectators in attendance at the processions and other ceremonies that gave these spaces their *raison d'être*. The long, porticated forecourt of the Palatine Chapel is, in short, a street-like feature that cannot be conceived, any more than it can have been designed,

[63] Kreusch 1965, 469–505; Binding 1996, 180–88 and 96–97; Untermann 1999, 152–61. On the architectural precedents, see esp. Bandmann 1965; also McCormick 2011, 184–96 on the links between Aachen and Jerusalem, esp. 191–93 on the Palatine Chapel and the Anastasis Rotunda.

[64] Kreusch 1965, 505–11; Falkenstein 1991, 262–64; Binding 1996, 89; McClendon 2005, 116–20.

[65] The two *exedrae* on each side appear to have prevented continuous movement behind the arcades of the forecourt: see McClendon 2005, 118.

Figure 5.6 The palatine chapel and arcaded entrance-court at Aachen. (McClendon 2005, fig. 124.)

independently of the echo of the *laudes regiae* that rang out when the emperor appeared there.[66]

To the north stood Charlemagne's audience hall, a stone basilica nearly 50m long and more than 20m wide with a single nave and a wide, western apse spanning almost the whole width of the nave in a manner reminiscent of the Constantinian basilica at Trier, which also clearly inspired the blind arcades that punctuated its exterior walls.[67] This audience hall was connected to the porch of the Palatine Chapel via a stone-built, two-storied gallery approximately 120m in length.[68] At the midpoint of this gallery stood an imposing structure, measuring ca. 30m by 15m at its base and standing at least two stories

[66] As Kantorowicz (1946, 45–54 and passim) showed so well, imperial acclamations on the late antique model were incorporated into the Frankish liturgy precisely in the third quarter of the eighth century, following the elevation of the Carolingians to royal status, and exploded in popularity under Charlemagne; on the *laudes* at Aachen and the predominantly regal/ imperial – as opposed to papal – focus of the liturgy performed in the Palatine Chapel, see Kantorowicz 1946, 62–63; Heitz 1963, 154–57; Häussling 1973, 170–73. On the 'stage-like' quality of the atrium and its apparent centrality with regard to the ceremonial repertoire surrounding Charlemagne's public appearances, cf. McClendon 2005, 118.

[67] Hugot 1965, 546–56; Binding 1996, 89–92. The two smaller apses, one on each long side of the structure, give the structure a further resemblance to the *triclinia* gracing late antique palaces, from Ravenna, to Constantinople, to the Lateran Palace in Rome.

[68] Kreusch 1965, 511–29; Binding 1996, 92–93. Extensive tracts of the upper level of the gallery, still preserved in the late nineteenth century, reveal that the western elevation was lit by broad trifora windows spaced at regular intervals; the best plan is that of Kreusch 1965, figure 14. This is presumably the 'portico, which [Charlemagne] had built with laborious massiveness between the church and the audience-hall,' which Alcuin says collapsed in 813 (*Vita Caroli Magni*, 32): *Porticus, quam inter basilicam et regiam operosa mole construxerat, die ascensionis Domini subita ruina usque ad fundamenta conlapsa.*

high, as its thick foundations and flanking staircases leading to the upper level of the porticated walkway indicate, which cannot have failed to recall the contours of a looming gateway. While this robust edifice may well have had additional uses (among other possibilities, the upper story may have functioned as a kind of loggia or *solarium* for the emperor), it is clearly a liminal feature through which traffic between the church and the audience hall passed, an integral and visually striking component of the raised walkway with marked architectonic – and I presume symbolic – similarities to arches and gateways bestriding principal urban arteries.[69]

The entirety of the ensemble of church, two-story walkway, 'gatehouse' and audience hall thus bears a close and almost certainly intentional resemblance to Constantinople, where as we have seen, the imperial palace was connected to Hagia Sophia by a two-storied gallery that passed through the upper level of the Chalke gate, linking the twin foci of temporal and spiritual authority in an indissoluble whole.[70] It is precisely this blending of temporal and spiritual that seems to have underlain the conception of the monumental center of Aachen, where Charlemagne and his retinue, like the emperor in Constantinople (or for that matter Arechis II in Benevento),[71] processed back and forth between the twin poles of the Palatine Chapel and the imperial audience hall, via a long, stately *porticus* complete with a looming gateway.[72] The resemblance to the Chalke in Constantinople, and indeed generally to arches and tetrapyla at the crossing of principal city streets, was all the more pronounced if, as Kreusch and Hugot imagined, the main east-west road in the region was accessed via a street passing through the ground floor of the gatehouse at right angles to the walkway above.[73] The short, west face of the gatehouse would then have served, like the Chalke at the termination of the Mese, as the main entrance

[69] Generally on this structure and the debate over its function, see Falkenstein 1991, 248–49; Binding 1996, 93–96; see also, e.g., Kreusch 1965, 529–32; Hugot 1965, 567–68.

[70] See Chapter 3.3.

[71] See Chapter 4.4.

[72] It is in this context that Charlemagne's presentation of himself as the New Constantine, the figure remembered by many since the time of Eusebius as the epitome of the Christian emperor, assumes its full significance. One wonders whether it is precisely this passageway that was traversed by Louis the Pius and more than twenty members of his retinue upon the conclusion of services in the Palatine Chapel on Holy Thursday of 817, when according to the Frankish Annals, its fragile wooden members gave way and deposited the assembled company on the ground in a heap of ruins: Might this fragile wooden structure have been the result of ad hoc repairs made following the collapse of the stone *porticus* in 813 (see n. 68)? See *ARF a.* 817, p. 146: *Feria quinta, qua cena Domini celebratur, cum imperator ab ecclesia peracto sacro officio remearet, lignea porticus, per quam incedebat, cum et fragili materia esset aedificata et tunc iam marcida et putrefacta, quae contignationem et tabulatum sustinebant, transtra pondus aliquod ferre non possent, incedentem desuper imperatorem subita ruina cum viginti et eo amplius hominibus, qui una ibant, ad terram usque deposuit.*

[73] Kreusch 1965, 529–31; Hugot 1965, 539–40, with figures 1–2. Both note the parallels with the Chalke.

to the inner enclosure of the palace, delimited on its west flank by the line of the gallery. Regardless, the topographical centerpiece of Charlemagne's urban project was a condensed version of the very feature that had made a city worthy of the name since late antiquity, from Rome, to Trier, to Ravenna, to Constantinople and beyond: a monumental processional way connecting the churches and palaces where the mighty still – or again – made manifest their divinely sanctioned right to rule, and to be beheld in so doing.

And as at Aachen, so too at Lorsch and Centula, though in these monastic centers the veneration of the sovereign *in absentia*, while undeniably present, took second place to ceremonies focused on the veneration of God and church.[74] All three places, however, are manifestly grounded in a common architectural vernacular of power rooted in the ceremonial armatures of the late antique city.[75] It should be stressed that none of the three, nor any of the other grand building complexes of the Carolingian era, are 'models' or faithful copies of any particular city or site in its entirety.[76] Returning to the issue of Aachen and its architectural precedents, one might adduce additional parallels ad infinitum with, for example, Trier, where the Constantinian audience hall communicated with the cathedral via the major, colonnaded *cardo* departing from the Porta Nigra, an arrangement that recalls the arrangement of the Palatine Chapel, porticated gallery and audience hall at Aachen. The resemblance may be more than coincidental, or again it may not; that there is no sure way of answering the question is, in a way, the point: Carolingian royal monasteries and palaces simultaneously 'referenced' a panoply of venerable cities in ways both material and symbolic, mixing, matching and superimposing their features to produce original architectural and topographical syntheses. Thus, Aachen was a pastiche of many renowned cities, but on a more fundamental level, it was simply the latest in an unbroken sequence of 'capitals' built in response to a common paradigm characterized by porticated transitional spaces linking temporal and ecclesiastical foci in a continuous progression.

The same is true for Lorsch,[77] and of course for Centula, where the unusually rich textual sources suffice to show that the diffuse cluster of churches with their intervening *longaniae* were not merely 'allusions' to the topographical template developed in late antique capitals, but its living, functional descendants. Like the grand colonnaded avenues of late antiquity, the massive 'cloister' at Centula derived much of its formal inspiration and its ultimate significance

74 Cf. Heitz 1963, 158–61.

75 On the triumphal character of Charlemagne's *adventus* to royal monasteries such as Centula, and the *laudes* chanted on such occasions, see Kantorowicz 1946, 72–73.

76 Cf. Krautheimer 1942, 15; Kreusch 1965, 532–33; Falkenstein 1991, 282–88.

77 On the architectural and functional kinship between the *Torhalle* at Lorsch and the 'gatehouse' in the midst of the elevated gallery at Aachen, see Binding 1977, 282–83.

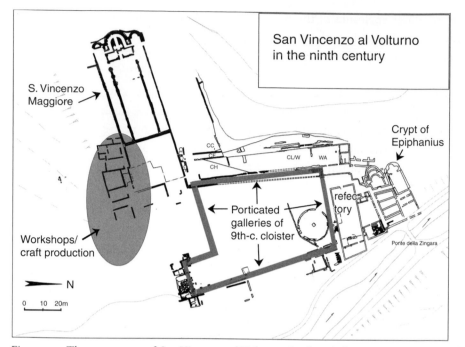

Figure 5.7 The monastery of San Vincenzo al Volturno in the ninth century. (Courtesy of F. Marazzi/scavi archeologici di San Vincenzo al Volturno, modified by author.)

from the processional ceremonies that occurred there, and that, together with their physical setting, proclaimed Centula a 'capital' in its own right, a royal monastery conceived in the image of the place that remained inextricably associated with the display of sovereign authority by king and clergy, the earthly regents of God: the city. It is also undoubtedly true to a greater or lesser degree for a myriad of other sites peopled by actors whose words and gestures have disappeared forever, but whose physical remains survive as mute testament to their vanished ceremonial rounds, such as the southernmost royal monastery in Charlemagne's dominions, San Vincenzo al Volturno in the south-central Apennines, reconstructed beginning under Angilbert's contemporary Joshua (abbot from 792–817) with a vast, irregularly shaped colonnaded cloister that resembles no other monastery as much as Centula (Figure 5.7).[78]

We might close by coming full circle to where we began in the third century, with the imperial ritual *par excellence*, the *adventus*. Whether we wish to define the Carolingian monarchs and their court as itinerant or not, Charlemagne and his successors undoubtedly crisscrossed their dominions – like late Roman emperors and provincial governors before them – with remarkable frequency.[79]

[78] Marazzi et al. 2002, 253–58; Marazzi 2008, 334–37 and esp. 247–48.
[79] For a recent overview of the issue, with convincing arguments that the early Carolingians – and particularly their courts – were less itinerant than usually thought, see McKitterick 2008, 137–213.

Their preferred stopping places were the royal monasteries and palaces, whence there is yet better reason to place royal monasteries such as Lorsch and Centula alongside a royal residence such as Aachen. Poems celebrating the advent of the sovereign are a ubiquitous feature of Carolingian literary culture, nowhere more so than at another royal monastery, St. Gall. As Kantorowicz long ago observed: 'There is reason to believe that the codification of the reception ceremonial first took place in monastic circles, and the great number of poems *In adventu Regis*, which have been handed down from the Abbey of St. Gall, may remind us that no town or city was visited by mediaeval monarchs so frequently as were the favored royal monasteries.'[80] The place where the sovereign lodged became, for that time, the center of the Carolingian world, where he was received with all the ceremony, and all the acclamations, reserved for the arrival of late antique sovereigns at their own capitals.[81] All the more reason, then, for these monasteries and residences to be designed in the image of cities, and to reproduce, albeit in abbreviated form, the ceremonial armatures that so profoundly conditioned the urban experience beginning in the later Roman empire, and ensured that cities remained synonymous with the exercise and display of sovereignty, from the era of Constantine to that of Charlemagne, and ever thereafter.

[80] Kantorowicz 1944, 208.
[81] On the *laudes hymnidicae* voiced for the *adventus* of Carolingian sovereigns, and their unbroken descent from late antique ruler acclamations, see Kantorowicz 1946, 71–76. See also, e.g., Hack 1999 on the reception of Pope Leo III at Paderborn in 799 and *Empfangszeremoniell* under Charlemagne.

CONCLUSIONS

By way of wrapping things up, let us begin by setting out briefly what, in light of the foregoing, we can now claim to know, what we would like to think we know, and what we need to know better.

Chapters 2 and 3 may at least suffice to give a better sense of how the late antique city, under the influence of the central government and its provincial representatives, metamorphosed into a vehicle for the expression of the prerogatives of a (relatively) totalitarian state and universalizing church, and consequently gravitated more and more around the processional avenues where the representatives of these institutions displayed themselves. In topographical terms, the emergence of this new 'political topography' is best seen in the urban and urbanizing sites established from the third century on, such as the Tetrarchic residences and Constantinople, whose designers were free to translate an urban ideal into the realm of built space. But the process is apparent also in existing cities, especially at well-preserved and carefully excavated sites in the eastern Mediterranean such as Ephesus, where the archaeological and epigraphic remains vividly capture the lengthy, gradual process whereby a single, interconnected sequence of streets developed into the focus of architectural patronage and display, of commemoration, of commerce, of leisure and of public ceremonial and communication between rulers and ruled.

In the West, fewer cities featured porticated avenues of comparable size and grandeur, but most of the leading capitals did, an exceptionally important development that has hitherto been chronically underappreciated. The 'imperial'

street porticoes built at Rome and Milan in the fourth century, and almost certainly at Ravenna too in its capital city phase after 402, not to mention the 'regal' portico linking city gate and royal palace at Verona built by Theoderic at the turn of the sixth century, show even better than the more numerous and better-preserved Eastern exemplars just how closely these streets had come to be associated with the ruling establishment; with the exercise of power and the display of sovereign majesty. Where archaeology currently draws a blank, as is so often the case, especially in the West (Rome, Ravenna and Verona included, though emphatically not Milan), the written and pictorial sources nonetheless suggest that the increasing prominence of porticated ceremonial armatures in the late antique city was a widespread phenomenon, especially common in the capitals (already a substantial quorum comprising ca. 100 provincial and metropolitan capitals), but potentially present to varying extents and degrees of magnitude in far more places, notably those many hundreds of urban agglomerations across the empire that rarely, if ever, lacked a resident bishop from late antiquity through the Middle Ages.

The most (literally) graphic demonstration of the ever-increasing prominence of these street itineraries comes in the depictions of cities discussed in Chapter 3, from Rome and Ravenna to Jordan, via the illustrations of the *Notitia Dignitatum*, where a wall, a city gate and a colonnaded street become an iconographic shorthand – almost an ideogram – for the concept of the 'great city.' It should again be stressed how markedly these late antique images differ from their early imperial precedents, such as the towns shown on Trajan's Column, and the city fresco recently found on the Oppian Hill in Rome.[1] The earlier depictions feature a diffuse array of buildings and monuments distributed widely and quite evenly across their intramural confines, much as urban centers actually tended to appear in the early empire, their public buildings sprinkled across the urban fabric according, often, to the whims and the capacities of their individual donors. There is thus reason to suspect that archaeologically well-documented sites such as Corinth, Aphrodisias, Antioch and Jerash are but the tip of a much larger iceberg. Albeit with infinitely varied regional and chronological trajectories, the third century through the sixth was a period when urban authorities tended to put what mattered most along a principal linear itinerary that hosted, among many other activities, their public appearances and the other processional spectacles that loomed so large among the ceremonial protocols of the later Roman empire.

Chapter 4 is a more speculative attempt to explore an intuition, albeit an intuition born of repeated encounters with suggestive hints in its favor, about the unexpected resilience and functional persistence of late antique 'activity

[1] On the fresco from the Oppian Hill, datable to the later first century AD, see La Rocca 2000.

spaces' – porticated armatures – in terms of both space and activities, architecture and spatial praxis.[2] If it has rendered that intuition persuasive, it will have done all that might be hoped, given the present state of knowledge.

What can be easily demonstrated is an unbroken run of both institutional and ceremonial practice across a great deal of the former Roman empire in the early Middle Ages. Cities remained favored residences for civic and ecclesiastical luminaries, from the thematic capitals of Byzantium to the regal and episcopal seats of the West; and these same distinguished representatives of church and 'state' were more than ever, as they had been to a growing extent since the third century, the only actors with the authority and the resources to shape urban topography on a large scale. When leaders from Visigothic Spain to Byzantine Anatolia wanted to make an impression, they more often than not chose to do so in cities, following ritual and ceremonial usages, usually processional in nature, derived directly from the repertoire of the late empire. This is most obviously and famously true at especially prominent places such as Rome, Constantinople and Jerusalem, but it holds far more widely, from Reims in the sixth century, to Toledo in the seventh, to Mytilene in the ninth, to recall a few of the examples discussed earlier.

Though it requires a bit more slogging through much suggestive but unspectacular detail, it can also be shown, I think, that a surprising number of principal thoroughfares inherited from the late Roman period remained poles of attraction for people, patronage and display between the seventh century and the ninth. They continued to be relatively frequented spaces, and to host relative concentrations of monumental architecture, in enough of the widely scattered urban sites presented in Chapter 4 to imply a broader pattern across large swathes of the erstwhile Roman empire, though when speaking of patterns it should never be forgotten that every region and every city, too, has its own peculiar local history. But with regard to the material particulars of these resilient central axes, the maintenance of their monumental décor, their associated gates, buildings and, of course, the porticoes that were their primary signifier in the late empire, we enter fully into the realm of what we need to know better.

That new porticated armatures continued to define the material contours of eighth-century evocations of urban form discussed in Chapter 5, from Anjar to Centula, gives good cause for hope. It should at least strongly caution against assuming an early date for the demonumentalization of existing streets, as should indications of their lengthy persistence in a number of places, be they hints (Ravenna, Corinth) or clear signs (Rome, Constantinople).[3] The scarcity

[2] For the concept of 'activity space,' see Lavan 2003b.

[3] Under the 'hints' category, we might here add one more example in pressing need of further attention, Naples. At present, I can do no better than repeat what Paul Arthur has already said: 'The *media plateia* (Via dei Tribunali) approaching the forum may have been organized

of good evidence is hardly an argument to the contrary, nor need it become so even when far more has been done to seek it out. In the West, the search for street armatures, which almost by definition requires spatially extensive prospection, will be (to say the least) challenging in the midst of teeming modern cities. In the East, where more postclassical sites are available for detailed study, it remains to be seen how consistently archaeology will manage to document and date the blocking, destruction or – more challenging still – spoliation of street colonnades, or the gradual constriction of roadbeds by secondary structures.

In both cases, my contention that early medieval urbanites tended to preserve and at times selectively enhance a connected sequence of roads and monumental architecture inherited from late antiquity will inevitably be difficult, though not always impossible, to verify. The simple fact is that ongoing use and occupation of old buildings tends to be one of the hardest things to document archaeologically because archaeology is generally better at revealing change and destruction than persistence and maintenance. Cologne, for example, furnishes instances both of Roman buildings still standing today, like the fourth-century church of St. Gereon, and others that survived for centuries after the end of the empire only to disappear in the later ninth century or after, among them the *praetorium* and its neighboring structures at the forum. In the former case, how might we tell that St. Gereon was occupied in, say, the twelfth century, or the eighth, were there no documentary evidence to that effect? With regular cleaning of the floors and no distinctive additions made to its fabric, what material traces would testify to an ongoing human presence? In the latter instance, where remains of stone buildings razed and replaced in the later ninth century rest directly on their Roman floors and foundations, with no intervening strata, is this not likelier to indicate regular occupation (and floor sweeping) than desolation and ruin in the intervening centuries, especially given that the area filled up with new structures immediately after the old ones were razed?

And of course, there is the further, crucial issue of the size, density and composition of urban populations in the postclassical period, particularly the nonélites who rarely appear in the sources and presumably lived away from the comparatively monumental armatures frequented by the most influential members of society, but without whom 'public' ceremony would have lost much of its reason for being, not to mention its 'public' character. While

as a processional way, delimited by two arches. An "arcus antiquus qui vocatur cabredatus," demolished in the sixteenth century, seems to have been located at the junction of Via dei Tribunali with Via Atri and Via Nilo, whilst an "arcum roticorum" may have lain at the point where Via dei Tribunali now meets Via Duomo. Perhaps, to the eyes of a Byzantine citizen, the *media plateia* of Naples appeared as an oriental *embolos*, so common in the cities of Asia Minor and the Levant' (2002, 44).

I strongly suspect that these urban 'masses' were more numerous than is often thought at many (most? all?) of the sites discussed earlier, particularly from the sixth century on, archaeologists still lack the interpretive and analytical tools necessary to identify reliably the remains of early medieval housing, from one end of the Mediterranean to the other. We cannot possibly hope to comprehend and document the extent of early medieval settlement in the West, for example, without a better understanding of the taphonomic – and human! – factors that led to the formation of 'dark earth,' to cite but one of the more glaring methodological quandaries that remain to be resolved.[4]

Returning to late and post-Roman ceremonial armatures, if real advances are to be made in our ability to identify them, trace their architectural and occupational history and determine how long they lasted and to what extent they continued to condition the topographical horizons and the daily experience of urban dwellers in the early Middle Ages, more assiduous efforts to seek them out will be necessary. Aside from the obvious point about the need to pay closer attention to the postclassical phases of a site in general, the importance of which is widely acknowledged and increasingly accepted among archaeologists working in the field, and to signs of surviving monumental frameworks centered on main streets connected to city gates in particular, I think there is much hope to be placed in predictive modeling as a way to enhance the efficacy of future investigations. Particularly in urban contexts, where excavation tends to be expensive and limited both in terms of spatial coverage and choice of sites, it will be helpful to have the best possible idea of where to conduct targeted searches for axes of circulation and their associated architectural features.

Hence the potential of 'Space Syntax'-based approaches, essentially the modeling of patterns of movement through space, over time, calculating for an extensive array of contingent variables, natural and anthropogenic.[5] For late and post-Roman cities, historical and topographical factors such as the known locations of walls, gates, churches, palaces and administrative complexes, residential quarters and other poles of attraction (venerable shrines, images, commemorative monuments, foci of popular devotion) can be combined with geophysical variables (type and quality of terrain, contours of physical topography, landmarks and obstacles, water courses, lines of sight) to identify likely channels of circulation through the urban fabric, in places where those channels have vanished. Where they do persist, often uninterruptedly for two millennia, much of course depends on what survived the later medieval and modern eras, and on the extent to which these often still-bustling modern thoroughfares

[4] Cf. Galinié 2010, esp. 344–46 (on Gaul, but with wider relevance).

[5] An approach pioneered with the Space Syntax Project at the London School of Architecture, beginning in the 1970s; its effects are at last beginning to make inroads into the study of the ancient world (e.g., Laurence 2011; Stöger 2011, esp. 41–49).

can be studied archaeologically. As increased attention in recent decades to early medieval remains in general has suffused the 'Dark Ages' with unexpected – though by no means universal – light, we might hope for a similar result with regard to connective armatures in the postclassical city. Ultimately, I hope to have made a sufficiently plausible case for the wide diffusion and tenacious persistence of such armatures in the early Middle Ages, and for the mentalities and historical contingencies that enabled this persistence, to make further inquiry desirable. In the process, we can hope to learn substantially more about the distinctive form of postclassical urbanism, and the motives that caused an ember of the late Roman city to burn until the high Middle Ages, when economic and demographic expansion resuscitated and transformed ancient cityscapes from western Europe, to the Byzantine heartland, to the Islamic world.

Urban survival in the interim owes much to many different influences, which themselves varied greatly from place to place and from time to time. They include military and defensive considerations (the strategic importance of walled cities for the defense in depth of a regional state, and the tactical importance of the walled circuit for individual cities and local populations); administrative and institutional continuity, long known through the written record; and the continuing role of towns and cities as foci of economic and commercial activity, central points for their surrounding territories, which archaeology now begins – but surely only begins – to reveal, from Cologne, to Rome, to Amorium. In both topographical and human terms, however, I think no factor was more ubiquitous and more influential in ensuring the continued preeminence of the urban stage than the urban stage itself. If there is anything people love, rulers and ruled alike, from the ancient and medieval Mediterranean, to precolonial Bali, to twenty-first-century Pyongyang, it is a good parade.

We close by returning full circle to the themes introduced in Chapter 1, with a statement of what the arguments advanced in the foregoing might contribute to the larger, endless debates that swirl on around the end of Roman antiquity and the start of the Middle Ages. In the best of all possible worlds, I would hope to have provided a means of circumventing (once and for all, if possible) the use of 'continuity' and 'catastrophe' as analytical constructs applicable to late antiquity and the early Middle Ages, or at least to have forestalled future attempts to write history within a framework that opposes the two concepts in a dialectical embrace.

Like all cities – and nearly everything else under the Sun – Roman cities began to fall apart from the moment of their creation, even as they simultaneously grew and evolved and flourished. Continuity and catastrophe are inextricably intertwined, for all that the relative prevalence of each in any particular place will fluctuate over time. The result of the unprecedented spate of

construction across Roman-held territory from ca. 100 BC to AD 200 was a pan-Mediterranean constellation of monumental urban agglomerations whose proud remains have become a spurious (or at any rate anomalous) benchmark for gauging transformation and decay in all subsequent epochs, but especially in late antiquity and the early Middle Ages.

If one chooses to look at the, say, 90–95 percent of the intramural urban fabric that lies behind the main processional armatures of the Roman-period cities that remained most populous, topographically robust and politically or administratively central in the early Middle Ages, one will find abundant signs of contraction, dismemberment and/or abandonment that might be characterized as 'catastrophic.' Ruined or razed Roman-period structures; surviving ones shabbily partitioned, modified or replaced with smaller and draftier structures built in perishable materials; accumulations of rubbish and agricultural or organic detritus; the installation of graves, or – potentially but not necessarily even more 'catastrophically' – the absence of all signs of human activity: all proclaim that entropy and decay are universal constants that often outstrip the forces of creation and regeneration. If, however, one focuses on those main processional armatures, and the textually attested individuals who maintained and embellished, inhabited and activated them through public spectacle and ceremony, the impression of an unbroken continuum between the Roman period and the Middle Ages is almost overwhelming, which largely explains why historians have generally invoked catastrophe less than field archaeologists.[6] As archaeology is better at identifying creation and decay than stasis, and well-maintained processional armatures occupied only a small fraction of the intramural area of any given city or town, the majority of the physical evidence recovered from post-Roman cities will show them looking drastically different, usually smaller and poorer, than they had during the Roman-era building boom.

The point is this: the available material and textual indicators of human activity that together *become*, or constitute, the entirety of the historical record for any given place, at any given time, can only be assessed by the historian or archaeologist on their own terms, on a case-by-case, neighborhood-by-neighborhood basis. The introduction of the term 'catastrophe' or its semantic equivalents to the interpretive mix, and likewise 'continuity' when used to mean 'the opposite of catastrophe,' adds precisely nothing of substance to the discussion or the historical record; it merely proclaims the cultural and intellectual leanings of the discussant, and distracts from the more complicated, messy and fascinating situation on the ground. 'Catastrophe,' however, is even more insidious than 'continuity' because it implicitly negates the possibility of life thriving in certain, privileged urban sectors (unlike continuity, catastrophe is, by definition, never partial), and because signs of post-Roman life are more labile

[6] Cf. Ward-Perkins 1997; Galinié 2010.

and easily obscured than signs of death and destruction. Archaeologists, being human beings (really!), will always be inclined to convince themselves that they have found what they are looking for, as post-Roman archaeologists in search of ruin have long all too easily done. (I say 'archaeologists' because unless yet-undiscovered manuscript libraries somehow materialize, potentially paradigm-shifting future discoveries will come primarily from them, whence their role in shaping views of late and post-Roman cityscapes will be crucial.) Catastrophe is a nonstarter, an epistemologically self-fulfilling dead end for future generations of researchers.

Cities, in short, do not exist independently of their inhabitants. They are an artifact and an index of the activities and the volition of those who choose to inhabit them, and who chose to do so without interruption in the post-Roman period – and often until today – in so many of the sites addressed in this book, and in many others besides. If I have succeeded in showing anything, I hope it is that we should all be trying harder to document, and expect a priori to find, signs of thriving monumental corridors in the midst of late and post-Roman cities, where the essence of the urban spectacle in its late Roman form, and the asymmetrical dynamics of power, prestige and patronage implicated therein, played itself out between crowds of beholders and the exalted beheld. This is neither urban continuity nor catastrophe per se, though cities still contained, as always, the seeds of both growth and dissolution. It is, rather, the tenacious perseverance of an 'urban habit' in an unsettled period when there was on the whole less wealth, less skilled labor and fewer willing patrons of urban topography than there had been at the height of the Roman empire. The tenaciousness of that 'urban habit' is all the more remarkable for the radically changed post-Roman world through which it subsisted. It reminds us, one last time, that urban history is human history, which is, in turn, the history of individuals making choices, sometimes against all the odds.

BIBLIOGRAPHY

EDITIONS

Achilles Tatius. J.-P. Garnaud (ed. and trans.), *Achille Tatius d'Alexandrie, Le Roman de Leucippé et Clitophon. Texte établi et traduit*, Paris, 1991.

Acta graeca ss. Davidis, Symeonis et Georgii Mitylenae in insula Lesbo. J. van den Gheyn (ed.), *Analecta Bollandiana* 18 (1899), 209–59.

Acta Sanctorum. Société des Bollandistes, 68 vols., 1643–1940.

Agnellus, Andreas. *Liber Pontificalis*. D. Mauskopf Deliyannis (ed.), *Agnelli Ravennatis Liber pontificalis ecclesiae ravennatis*, CCCM 199, Turnhout, 2006.

Albelda Chronicle. Y. Bonnaz (ed. and trans.), *Chroniques Asturiennes (fin IX^e siècle)* (Paris, 1987), 10–30.

Ambrose. *Epistulae*. O. Faller and M. Zelzer (eds.), *CSEL* 82, 4 vols., Vienna, 1968–96.

Ammianus Marcellinus. W. Seyfarth (ed.), *Ammiani Marcellini rerum gestarum libri qui supersunt*, 2 vols., Leipzig (Teubner), 1978.

Annales Laureshamensis. G.-H. Pertz (ed.), *MGH SS* 1 (Hannover, 1826), 22–39.

Annales regni Francorum inde ab a. 741 usque ad a. 829, qui dicuntur Annales Laurissenses maiores et Einhardi. F. Kurze (ed.), *MGH SRG in usum scholarum* 6, Hannover, 1895.

Anon. *Epitome de Caesaribus*. F. Pichlmayr (ed.), *Sexti aurelii victoris liber de caesaribus*, Berlin (Teubner), 1970.

Anonymous Valesianus. *Anonymi Valesiani pars posterior*. T. Mommsen (ed.), *MGH AA* 9.1, Berlin, 1892, 306–28.

Augustine. *Epistulae*. K. D. Daur (ed.), *CCSL* 31, 3 vols., Turnhout, 2004–09.

Augustine. *Sermones*. F. Dolbeau (ed.), *Vingt-Six Sermons au Peuple d'Afrique*, Paris, 1996.

Aurelius Victor. F. Pichlmayr (ed.), *Sexti Aurelii Victoris liber de caesaribus*, Berlin (Teubner), 1966.

Ausonius. *Opera*. R. P. H. Green (ed.), *The Works of Ausonius*, Oxford, 1991.

Carmen de Synodo Ticinesi. L. Bethmann and G. Waitz (eds.), *MGH SRL*, Hannover, 1878, 189–91.

Cassiodorus. *Magni Aurelii Cassiodori Senatoris opera*. *CCSL* 96–98, Turnholt, 1958–73.

Chronica monasterii Casinensis (Leo of Ostia). W. Wattenbach (ed.), *MGH SS* 7, Hannover, 1846, 574–727.

Chronicle of Alfonso III. Y. Bonnaz (ed. and trans.), *Chroniques Asturiennes (fin IX^e siècle)*, Paris, 1987, 31–59.

Chronicon Paschale. L. Dindorf (ed.), *CSHB* 7–8, Bonn, 1832.

Chronicon Salernitanum. U. Westerbergh (ed.), *Chronicon Salernitanum. A Critical Edition with Studies on Literary and Historical Sources*, Stockholm, 1956.

Chrysostom, John. *Homiliae XXI de statuis*, *PG* 49, cols. 15–222.

Cicero. *Epistulae ad Atticum*. D. R. Shackleton Bailey (ed.), Stuttgart (Teubner), 1987.

Cicero. *De Oratore*. K. W. Piderit (ed.), Leipzig (Teubner), 1859.

Claudian. J. B. Hall (ed.), *Claudii Claudiani Carmina*, Leipzig (Teubner), 1985.

Codex Laureshamensis. K. Glöckner (ed.), 3 vols., Darmstadt, 1929–36.

Codex Theodosianus. T. Mommsen and P. M. Meyer (eds.), *Theodosiani Libri XVI cum Constitutionibus Sirmondianis et Leges Novellae ad Theodosianum Pertinentes*, 2 vols., Berlin, 1905.

Codice topografico della città di Roma. R. Valentini and G. Zucchetti (eds.), 4 vols., Rome, 1940–53.

Collectio Avellana. O. Günther (ed.), *CSEL* 35, Vienna, 1895.

Concilia Visigothorum. See Vives 1963.

Constantine Porphyrogenitus. *De administrando imperio.* G. Moravcsik and R. J. H. Jenkins (ed. and trans.), *CFHB* 1, Washington, DC, 1967.

Constantine Porphyrogenitus. *De caerimoniis aulae byzantinae.* A. Vogt (ed. and trans.), *Le livre des cérémonies*, 4 vols., Paris, 1935–40.

Consularia Caesaraugustana. C. Cardelle de Hartmann (ed.), *CCSL* 173A, Turnhout, 2001.

Continuatio Isidoriana Hispana (Mozarabic Chronicle of 754). J. E. López Perreira (ed. and trans.) *Crónica mozárabe de 754. Edición crítica y traducción*, Zaragoza 1980.

Corpus Inscriptionum Latinarum. Berlin, 1862.

Corpus juris civilis. T. Mommsen et al. (eds.); revised edition ed. W. Kunkel, 3 vols., Heidelberg, 1954.

Die Inschriften von Ephesos. H. Wankel et al. (eds.), 8 vols., *Inschriften griechischer Städte aus Kleinasien*, Bonn, 1979–84.

Dio Cassius. L. Dindorf (ed.), *Historia Romana*, 5 vols., Leipzig (Teubner), 1863–65.

Edictus Rothari. G. H. Pertz (ed.), *MGH Legum* 4, Hannover, 1868, 1–90.

Einhard. *Vita Caroli Magni.* G. Waitz (ed.), *MGH SRG in usum scholarum* 25, Hannover – Leipzig, 1911.

Epistulae Austrasicae. W. Gundlach (ed.), *MGH EP* 3, Berlin, 1892, 110–53.

Erchempert. *Erchemperti Historia Langobardorum Beneventanorum.* G. Waitz (ed.), *MGH SRL*, Hannover, 1878, 231–64.

Eusebius. *De Martyribus Palestinae.* E. Schwartz (ed.), *Über die Märtyrer von Palästina, GCS* 9.2, Leipzig, 1908, 907–50.

Eusebius. *Vita Constantini.* I. Heikel (ed.), *Über das Leben Constantins, GCS* 1, Leipzig, 1902, 1–153.

Eutropius. F. C. Santini (ed.), *Eutropii breviarium ab urbe condita*, Leipzig (Teubner), 1979.

Expositio totius mundi et gentium. J. Rougé (ed. and trans.), *SC* 124 (Série annexe de textes non chrétiens), Paris, 1966.

Evagrius Scholasticus. *Historia Ecclesiastica.* J. Bidez and L. Parmentier (eds.), *The Ecclesiastical History of Evagrius with the Scholia*, Amsterdam, 1964.

Flodoard. *Historia Remensis Ecclesiae.* M. Stratmann (ed.), *MGH SS* 36, Hannover, 1998.

Fontes Iuris Romani Antejustiniani. S. Riccobono et al. (eds.), 3 vols., Florence, 1968.

Fredegar. *Chronica.* B. Krusch (ed.), *Chronicarum quae dicuntur Fredegarii Scholastici libri IV cum continuationibus, MGH SRM* 2, Hannover, 1888, 1–193.

Gesta Dagoberti I. Regis Francorum. B. Krusch (ed.), *MGH SRM* 2, Hannover, 1888, 396–425.

Gregory of Tours. *Historia Francorum.* B. Krusch (ed.), *MGH SRM* 1.1, Hannover, 1884.

Gregory of Tours. *Liber in Gloria martyrum*, B. Krusch (ed.), *MGH SRM* 1.2, rev. ed., Hannover, 1969, 34–111.

Hariulph. *Chronicon Centulense.* F. Lot (ed.), *Hariulph. Chronique de l'abbaye de Saint-Riquier (Vᵉ siècle – 1104)*, Paris, 1894.

Herodian. K. Stavenhagen (ed.), *Ab excessu divi Marci libri octo*, Leipzig (Teubner), 1967.

Hincmar. *Vita Remigii episcopi Remensis.* B. Krusch (ed.), *MGH SRM* 3, Hannover, 1896, 239–341.

Historia Augusta. E. Pohl (ed.), *Scriptores historiae Augustae*, 2 vols., Leipzig (Teubner), 1965.

Isidore of Seville. *Etymologiae.* W. M. Lindsay (ed.), *Isidori episcopi hispalensis etymologiarum sive originum libri XX*, 2 vols., Oxford, 1911.

Isidore of Seville. *Historia Gothorum, Wandalorum Sueborum ad a. DCXXIV.* T. Mommsen (ed.), *MGH AA* 11.2, Berlin, 1894, 241–303.

Jerome. *Chronicon.* J. Fotheringham (ed.), *Eusebii Pamphili chronici canones latine vertit, adauxit, ad sua tempora produxit S. Eusebius Hieronymus*, London, 1923.

John of Biclar. *Chronicon.* C. Cardelle de Hartmann (ed.), *CCSL* 173A, Turnhout, 2001, 59–83.

Jonas of Bobbio. *Vitae Columbani abbatis et discipulorum eius.* B. Krusch (ed.), *MGH SRM* 4, Hannover – Leipzig, 1902, 1–156.

Jordanes. *Getica* and *Romana.* T. Mommsen (ed.), *MGH AA* 5.1, Berlin, 1882.

Julian of Toledo. *Historia Wambae regis.* W. Levison (ed.), *MGH SRM* 5, Hannover, 1910, 486–535.

Lactantius. *De Mortibus Persecutorum*. J. L. Creed (ed. and trans.), Oxford, 1984.

Leges Visigothorum. K. Zeumer (ed.), *MGH LL nat. Germ.* 1, Hannover, 1902.

Libanius. *Libanii opera*. R. Foerster (ed.), 12 vols., Leipzig (Teubner), 1903–27.

Liber Historiae Francorum. B. Krusch (ed.), *MGH SRM* 2, Hannover, 1878, 215–328.

Liber Pontificalis. L. Duchesne (ed.), with additions by C. Vogel, *Le Liber Pontificalis. Texte, introduction et commentaire*, 3 vols., Paris, 1955–57.

Malalas, John. *Chronographia*. J. Thurn (ed.), *CFHB* 35, Berlin – New York, 2000.

Marcellinus Comes. *Chronicon*. T. Mommsen (ed.), *MGH AA* 11.2, Berlin, 1894, 37–108.

Menander Rhetor. D. A. Russell and N. G. Wilson (ed. and trans.), *Menander Rhetor*, Oxford, 1981.

Notitia Dignitatum. C. Neira Faleiro (ed.), *La Notitia Dignitatum. Nueva edición crítica y comentario histórico*, Madrid, 2006.

Notitia Dignitatum. O. Seeck (ed.), Berlin, 1876.

Notitia urbis constantinopolitanae. O. Seeck (ed.), *Notitia Dignitatum*, Berlin, 1876, 227–43.

Panegyrici Latini. C. E. V. Nixon and B. S. Rodgers (ed. and trans.), *In Praise of Later Roman Emperors. The* Panegyrici Latini, Berkeley, 1994.

Parastaseis Syntomai Chronikai. T. Preger (ed.), *Scriptores Originum Constantinopolitarum* 1, Leipzig, 1901, 19–73.

Passiones Leudegarii episcopi et martyris Augustodunensis. B. Krusch (ed.), *MGH SRM* 5, Hannover – Leipzig, 1910, 249–362.

Patria Constantinoupoleos. T. Preger (ed.), *Scriptores Originum Constantinopolitarum* 1, Leipzig, 1901, 1–18.

Paul the Deacon. *Historia Langobardorum*. G. Waitz (ed.), *MGH SRG in usum scholarum* 48, Hannover, 1878.

Paul the Deacon. *Liber de episcopis Mettensibus*. G. Pertz (ed.), *MGH SS* 2, Hannover, 1829, 260–70.

Pausanias. M. H. Rocha-Pereira (ed.), *Pausaniae Graeciae descriptio*, 3 vols., Leipzig (Teubner), 1973–81.

Possidius. *Vita Augustini*. M. Pellegrino (ed. and trans.), *Vita di S. Agostino*, Naples, 1955.

Procopius. *Opera Omnia*. J. Haury (ed.), 4 vols., Leipzig (Teubner), 1962–64.

Prosper of Aquitaine. *Epitoma Chronicon*. T. Mommsen (ed.), *MGH AA* 9.1, Berlin, 1892, 341–499.

Sacrorum Conciliorum nova et amplissima collectio. G. D. Mansi (ed.), 31 vols., Florence–Venice, 1758–98.

Scriptores historiae Augustae. E. Pohl (ed.), 2 vols., Leipzig (Teubner), 1965.

Sidonius Apollinaris. *Opera*. P. Mohr (ed.), *C. Sollius Apollinaris Sidonius*, Leipzig (Teubner), 1895.

Socrates. *Historia Ecclesiastica*. G. C. Hansen (ed.), *Sokrates Kirchengeschichte*, Berlin, 1995.

Sozomen. *Historia Ecclesiae*. J. Bidez (ed.), *Sozomenus Kirchengeschichte*, Berlin, 1960.

Suetonius. *De vita caesarum*. M. Ihm (ed.), Leipzig – Berlin (Teubner), 1923.

Tacitus. *Annales*. C. D. Fisher (ed.), Oxford, 1906.

Tacitus. *Historiae*. C. D. Fisher (ed.), Oxford, 1911.

Theodoret of Cyrrhus. *Epistulae*. Y. Azéma (ed.), *Theoderet de Cyr, Correspondance, SC* 40, 98, 111, 429, Paris, 1955–98.

Theodoret of Cyrrhus. *Historia Ecclesiae*. L. Parmentier (ed.), rev. ed. F. Scheidweiler, *Theodoret Kirchengeschichte*, Berlin, 1954.

Theophanes the Confessor. *Chronicon*. C. de Boor (ed.), *CSHB* 1, 2 vols., Leipzig, 1883–85.

Translatio Sancti Mercurii. MGH SRL, Hannover, 1878, 576–80.

Vegetius. *De re militari*. A. Önnerfors (ed.), Stuttgart (Teubner), 1995.

Victricius of Rouen. *De laude sanctorum*. R. Demeulenaere and I. Mulders (eds.), *CCSL* 64, Turnhout, 1985, 53–93.

Virgil, *Eclogues*. M. Geymonat (ed.), *P. Vergili Maronis Opera*, rev. ed., Rome, 2008, 1–54.

Vita Chrodegangi Episcopi Mettensis. G. Pertz (ed.), *MGH SS* 10, Hannover, 1852, 552–72.

Vita Desiderii Cadurcae urbis episcopi. B. Krusch (ed.), *MGH SRM* 4, Hannover – Leipzig, 1902, 547–602.

Vita Rigoberti episcopi Remensis. W. Levison (ed.), *MGH SRM* 7.1, Hannover – Leipzig, 1919, 54–80.

Zacharias Rhetor. *Historia Ecclesiastica*. K. Ahrens and G. Krüger (eds.), *Die sogenannte Kirchengeschichte des Zacharias Rhetor*, Leipzig (Teubner), 1899.

WORKS CITED

Agady, S., M. Arazi, B. Arubas, S. Hadad, E. Khamis and Y. Tsafrir (2002) 'Byzantine Shops in the Street of the Monuments at Bet Shean (Scythopolis),' in L. V. Rutgers (ed.), *What Athens Has to Do with Jerusalem*, Leuven, 423–506.

Agnello, S. L. (2001) *Una metropoli ed una città siciliane fra Roma e Bisanzio*, Syracuse.

Aldrete, G. (1999) *Gestures and Acclamations in Ancient Rome*, Baltimore.

Alföldi, A. (1970) *Die monarchische Repräsentation im römischen Kaiserreiche*, Darmstadt.

Alföldy, G. (1991) 'Augustus und die Inschriften: Tradition und Innovation. Die Geburt der imperialen Epigraphic,' *Gymnasium* 98, 289–324.

Amarotta, A. R. (2004) *Salerno longobardo. Topografia e strutture del potere*, Salerno.

Amer, G. and M. Gawlikowski, (1985) 'Le sanctuaire impérial de Philippopolis,' *Damaszener Mitteilungen* 2, 1–15.

Ando, C. (2000) *Imperial Ideology and Provincial Loyalty in the Roman Empire*, Berkeley and Los Angeles.

Andrade, N. (2010) 'The Processions of John Chrysostom and the Contested Spaces of Constantinople,' *JECS* 18.2, 261–89.

Andrieu, M. (1931–61) *Les Ordines romani du haut moyen âge*, 5 vols., Louvain.

Arce, J. (2000) 'La fundación de nuevas ciudades en el Imperio romano tardío: de Diocleciano a Justiniano (s. IV–VI),' in Ripoll and Gurt (eds.), 31–62.

Arce, J. (2001) '*Leovigildus rex* y el ceremonial de la corte visigótica,' in Arce and Delogu (eds.), 79–92.

Arce, J. and P. Delogu (eds.) (2001) *Visigoti e Longobardi*, Florence.

Arena, M. S. et al. (eds.) (2001) *Roma dall'antichità al medioevo. Archeologia e storia nel Museo Nazionale Romano Crypta Balbi*, Rome.

Arslan, E. A. (1986) 'Una riforma monetaria di Cuniperto, re dei Longobardi (688–700),' *Quaderni Ticinesi di Numismatica e Antichità Classiche* 15, 249–75.

Arthur, P. (2002) *Naples: From Roman Town to City-State*, Archaeological Monographs of the British School 12, Rome.

Arthur, P. (2006) 'Alcune considerazioni sulla natura delle città bizantine,' in Augenti (ed.), 27–36.

Arthur, P. (2012) 'Hierapolis of Phrygia: The Drawn-Out Demise of an Anatolian City,' in Christie and Augenti (eds.), 275–305.

Asche, U. (1983) *Roms Weltherrschaftsidee und Aussenpolitik in der Spätantike im Spiegel der Panegyrici Latini*, Bonn.

Augenti, A. (2007) 'The Palace of Theoderic at Ravenna: A New Analysis of the Complex,' in L. Lavan, L. Özgenel and A. Sarantis (eds.), *Housing in Late Antiquity*, Leiden – Boston, 425–53.

Augenti, A. (2010) 'Nascita e sviluppo di una capitale: Ravenna del V secolo,' in Delogu and Gasparri (eds.), 344–69.

Augenti, A. (ed.) (2006) *Le città italiane tra la tarda antichità e l'alto medioevo. Atti del convegno (Ravenna, 26–28 febbraio 2004)*, Florence.

Auinger, J. (2009) 'Zum Umgang mit Statuen hoher Würdenträger in spätantiker und nachantiker Zeit entlang der Kuretenstrasse in Ephesos,' in Ladstätter (ed.), 29–52.

Aurenhammer, M. and A. Sokolicek (2011) 'Sculpture and Statue Bases in Late Antique Ephesus: The Evidence of the Upper Agora,' in Dally and Ratté (eds.), 43–66.

Ausenda, G., P. Delogu and C. Wickham (eds.) (2009) *The Langobards before the Frankish Conquest. An Ethnographic Perspective*, Woodbridge – Rochester.

Avigad, N. (1993) 'The Nea: Justinian's Church of St. Mary, Mother of God, Discovered in the Old City of Jerusalem,' in Y. Tsafrir (ed.), *Ancient Churches Revealed*, Jerusalem, 128–35.

Avni, G. (2011a) 'Continuity and Change in the Cities of Palestine during the Early Islamic Period. The Cases of Jerusalem and Ramla,' in Lapin and Holum (eds.), 115–33.

Avni, G. (2011b) '"From Polis to Madina" Revisited – Urban Change in Byzantine and Early Islamic Palestine,' *Journal of the Royal Asiatic Society* 21.3, 301–29.

Avramea, A. (1989) 'Les constructions profanes de l'évêque d'après l'épigraphie et les textes d'Orient,' in N. Duval (ed.), Actes du XIe Congrès international d'archéologie chrétienne, Rome, Vol. 1, 829–35.

Ayerbe Vélez, R., T. Barrientos Vera and F. Palma García (2009) 'Génesis y evolucíon del foro de *Augusta Emerita*,' in *idd.* (eds.), *El foro de Augusta Emerita. Génesis y evolución de sus recintos monumentales, Anejos de AEspA* 53, 807–31.

Bachrach, B. S. *Early Carolingian Warfare: Prelude to Empire*. Philadelphia, 2001.

Bakirtzis, M. (2003) 'The Urban Continuity and Site of Late Byzantine Thessalonike,' *DOP* 57, 35–64.

Bakirtzis, M. (2007) 'Imports, Exports and Autarky in Byzantine Thessalonike from the Seventh to the Tenth Century,' in Henning (ed.), vol. 2, 89–118.

Balcon-Berry, S. (2011) 'L'Enceinte réduite d'Autun (Saône-et-Loire),' in Kasprzyk and Kuhnle (eds.), 19–40.

Baldini Lippolis, I. (1997) 'Articolazione e decorazione del palazzo imperiale di Ravenna,' *CARB* 43, 1–31.

Baldovin, J. F. (1987) *The Urban Character of Christian Worship: The Origins, Development and Meaning of Stational Liturgy*, Rome.

Ballet, P., N. Dieudonné-Glad and C. Saliou (2008) *La rue dans l'antiquité. Définition, aménagement et devenir de l'Orient méditerranean à la Gaule*, Rennes.

Balty, J. (1995) *Mosaïques antiques du Proche-Orient.* Besançon 1995.

Banaji, J. (2007) *Agrarian Change in Late Antiquity: Gold, Labour, and Aristocratic Dominance*, rev. ed., Oxford.

Bandmann, G. (1965) 'Die Vorbilder der Aachener Pfalzkapelle,' in Braunfels and Schnitzler (eds.), 424–62.

Barbero, A. (1970) 'El pensamiento politico visigodo y las primeras unciones regias en la Europa medieval,' *Hispania* 30, 245–326.

Bardill, J. (1999) 'The Golden Gate in Constantinople: A Triumphal Arch of Theodosius I,' *AJA* 103, 671–96.

Bardill, J. (2012) *Constantine, Divine Emperor of the Christian Golden Age*, Cambridge.

Barnes, T. D. (1982) *The New Empire of Diocletian and Constantine*, Cambridge, MA.

Barnes, T. D. (1996) 'Emperors, Panegyrics, Prefects, Provinces and Palaces,' *JRA* 9, 284–317.

Barroso Cabrera, R. and J. Morín de Pablos (2007) *Regia sedes toletana. El Toledo visigodo a través de su escultura monumental*, Toledo.

Bassett, S. (2004) *The Urban Image of Late Antique Constantinople*, Cambridge.

Bauer, F. A. (1996) *Stadt, Platz und Denkmal in der Spätantike*, Mainz.

Bauer, F. A. (2001) 'Urban Space and Ritual: Constantinople in Late Antiquity,' *Acta ad archaeologiam et historiam artium pertinentia* 15, 27–61.

Bauer, F. A. (2008) 'Stadtverkehr in Konstantinopel. Die Zeremonialisierung des Alltags,' in D. Mertens (ed.), *Stadtverkehr in der antiken Welt* (*Palilia* vol. 18), Wiesbaden, 193–211.

Bauer, F. A. (2012) 'Stadt ohne Kaiser. Rom im Zeitalter der Dyarchie und Tetrarchie (285–306 n. Chr.),' in Fuhrer (ed.), 3–85.

Bavant, B. (2007) 'Caričin Grad and the Changes in the Nature of Urbanism in the Central Balkans in the Sixth Century,' in Poulter (ed.), 337–74.

Bavant, B. and V. Ivaniševič (2003) *Iustiniana Prima – Caričin Grad*, Belgrade.

Bavant, B., V. Kondić and J.-M. Speiser (eds.) (1990) *Caričin Grad II. Le quartier sud-ouest de la ville haute*, Belgrade – Rome.

Behn, F. (1934) *Die karolingische Klosterkirche von Lorsch an der Bergstrasse nach den Ausgrabungen von 1927–28 und 1932–33*, 2 vols., Berlin – Leipzig.

Behn, F. (1977) 'Die Ausgrabungen,' in Knöpp (ed.), 259–71.

Bejor, G. (1999) *Vie Colonnate: Paesaggi urbani del mondo antico*, Rome.

Belvedere, O. (1987) 'Appunti sulla topografia antica di Panormo,' *Kokalos* 33, 289–303.

Berger, A. (1997) 'Regionen und Straßen im frühen Konstantinopel,' *Istanbuler Mitteilungen* 47, 349–414.

Berger, A. (2000) 'Streets and Public Space in Constantinople,' *DOP* 54, 161–72.

Bernard, H. (1978) 'Un site prestigieux du monde carolingien: Saint-Riquier. Peut-on connaître la grande basilique d'Anglibert?,' *Cahiers archéologiques de Picardie* 5, 241–54.

Bernard, H. (1982) 'L'abbaye de Saint-Riquier. Évolution des bâtiments monastiques du IXe au XVIIIe siècle,' in *Sous la règle de Saint-Benoît, structures monastiques et sociétés en France du Moyen Age à l'époque moderne*, Paris, 499–526.

Bernard, H. (2002) 'Saint-Riquier. Fouilles et découvertes récents,' in C. Sapin (ed.), *Avant-nefs et espaces d'accueil dans l'église entre le IV^e et le XIIe siècle*, Auxerre, 88–107.

Bernard, H. (2009) 'Saint-Riquier: l'abbaye carolingienne d'Angilbert,' in Magnien (ed.), 55–82.

Bet, P. et al. (2011) 'La céramique domestique et la verrerie de l'antiquité tardive issues de la fouille de la "Zac de l'Amphithéâtre 2006–2008" à Metz: premières observations,' in Kasprzyk and Kuhnle (eds.), 69–81.

Biddle, M. (1976) 'Towns,' in D. M. Wilson (ed.), *The Archaeology of Anglo-Saxon England*, Cambridge, 99–150.

Biers, J. C. (1985) *Corinth XVII: The Great Bath on the Lechaion Road*, Princeton.

Binding, G. (1977) 'Die karolingische Königshalle,' in F. Knöpp (ed.), *Die Reichsabtei Lorsch: Festschrift zum Bedanken an die Stiftung der Reichsabtei Lorsch 764*, vol. 2, Darmstadt, 273–97.

Binding, G. (1996) *Deutsche Königspfalzen: von Karl dem Großen bis Friedrich II. (765–1240)*, Darmstadt.

Bingöl, O. (1998) *Magnesia ad Maeandrum. Menderes Magnesiası*, Ankara.

Birley, A. R. (1988) *Septimius Severus: The African Emperor*, 2nd ed., London.

Blanchet, A. (1907) *Les enceintes Romaines de la Gaule*, Paris.

Bleckmann, B. (2004) 'Bemerkingen zum Scheitern des Mehrherrschaftssystems: Reichsteilung und Territorialansprüche,' in Demandt, Goltz and Schlange-Schöningen (eds.), 74–94.

Blockley, R. C. (1998) 'The Dynasty of Theodosius,' *CAH* 13, 111–37.

Boatwright, M.T. (2000) *Hadrian and the Cities of the Roman Empire*, Princeton.

Borrut, A., M. Debié, A. Papaconstantinou, D. Pieri, and J.-P. Sodini (eds.) (2011) *Le proche-orient de Justinien aux Abbassides. Peuplement et dynamiques spatiales*, Turnhout.

Boschung, D. and W. Eck (eds.) (2006) *Die Tetrarchie. Ein neues Regierungssystem und seine mediale Präsentation*, Wiesbaden.

Bovini, G. (1961) 'La "Basilica Apostolorum" e la "Basilica Martyrum" di Milano,' *CARB* 8, 97–112.

Bovini, G. (1966) 'Antichi rifacimenti nei mosaici di S. Apollinare Nuovo di Ravenna,' *CARB* 13, 51–81.

Bowden, W. (2003) *Epirus Vetus: The Archaeology of a Late Antique Province*, London.

Bowden, W. (2010) 'Early Byzantine Urban Decline in the Southern Balkans,' *Acta Byzantina Fennica* 3, 67–80.

Bowersock, G.W. (1996) 'The Vanishing Paradigm of the Fall of Rome,' *Bulletin of the American Academy of Arts and Sciences* 149, 29–43.

Bowersock, G., P. Brown and O. Grabar (eds.) (1999) *Late Antiquity: A Guide to the Postclassical World*, Cambridge, MA.

Bowes, K. (2008) *Private Worship, Public Values and Religious Change in Late Antiquity*, Cambridge.

Bowes, K. and M. Kulikowski (eds.) (2005) *Hispania in Late Antiquity: Current Perspectives*, Leiden.

Bradbury, J. (1992) *The Medieval Siege*, Woodbridge.

Brandes, W. (1989) *Die Städte kleinasiens im 7. und 8. Jahrhundert*, Berlin.

Brandes, W. (1999) 'Byzantine Cities in the Seventh and Eighth Centuries – Different Sources, Different Histories?,' in Brogiolo and Ward-Perkins (eds.), 25–57.

Brandes, W. (2002) *Finanzverwaltung in Krisenzeite. Untersuchungen zur byzantinischen Administration im 6.-9. Jahrhundert*, Frankfurt-am-Main.

Brandes, W. and J. Haldon (2000) 'Towns, Tax and Transformation: States, Cities and Their Hinterlands in the East Roman World, c. 500–800,' in Brogiolo, Gauthier and Christie (eds.), 141–72.

Bransbourg, G. (2008) 'Fiscalité impériale et finances municipales au IV^e siècle,' *AnTard* 16, 255–96.

Bransbourg, G. (2009) 'Julian, l'*immunitas Christi*, les dieux et les cités,' *AnTard* 17, 151–58.

Braunfels, W. and H. Schnitzler (eds.) (1965) *Karl der Große: Lebenswerk und Nachleben*, vol. 3: *Karolingische Kunst*, Düsseldorf.

Breitner, G. (2011) 'Die Bauornamentik von Felix Romuliana/Gamzigrad und das tetrarchische Bauprogramm,' in Bülow and Zabehlicky (eds.), 143–52.

Brogiolo, G. P. (2000) 'Capitali e residenze regie nell'Italia longobarda,' in Ripoll and Gurt (eds.), 135–62.

Brogiolo, G. P. and P. Delogu (2006) 'La città altomedievale italiana alla luce del convegno di Ravenna,' in Augenti (ed.), 615–28.

Brogiolo, G. P., N. Gauthier and N. Christie (eds.) (2000) *Towns and Their Territories between Late Antiquity and the Early Middle Ages*, Leiden – Boston – Cologne.

Brogolo, G. P. and S. Gelichi (1998) *La città nell'alto medioevo italiano*, Milan.

Brogiolo, G. P. and B. Ward-Perkins (eds.) (1999) *The Idea and Ideal of the Town between Late Antiquity and the Early Middle Ages*, Leiden – Boston – Cologne.

Brown, A. R. (2008) *The City of Corinth and Urbanism in Late Antique Greece*, PhD Diss., University of California, Berkeley.

Brown, P. (1992) *Power and Persuasion in Late Antiquity: Towards a Christian Empire*, Madison, WI.

Brown, P. (2012) *Through the Eye of a Needle: Wealth, the Fall of Rome, and the Making of Christianity in the West, 350–550 AD*, Princeton.

Brown, T. S. (1984) *Gentlemen and Officers: Imperial Administration and Aristocratic Power in Byzantine Italy A.D. 554–800*, Rome.

Brubaker, L. (1999) 'The Chalke Gate, the Construction of the Past, and the Trier Ivory,' *Byzantine and Modern Greek Studies* 23, 258–85.

Brühl, C. (1968) *Fodrum, Gistum, Servitium Regis. Studien zu den wirtschaftlichen Grundlagen des Königtums im Frankenreich und in den fränkischen Nachfolgestaaten Deutschland, Frankreich und Italien vom 6. bis zur Mitte des 14. Jahrhunderts*, 2 vols., Cologne.

Brühl, C. (1969) 'Das "Palatium" von Pavia und die "Honorantiae civitatis Papiae,"' in *Pavia capitale di regno* (Atti del 4° congresso internazionale di studi sull'alto medioevo, Spoleto), 189–220.

Brühl, C. (1975) *Palatium und Civitas. Studien zur Profantopographie spätantiker Civitates vom 3. bis zum 13. Jahrhundert. Band I: Gallien*, Cologne.

Brühl, C. (1990) *Palatium und Civitas. Studien zur Profantopographie spätantiker Civitates vom 3. bis zum 13. Jahrhundert. Band II: Belgica I, beide Germanien und Raetia II*, Cologne–Vienna.

Brunt, P. A. (1990) [1976]: 'The Romanization of the Local Ruling Classes in the Roman Empire,' in Brunt 1990, 267–81.

Bullough, D. A. (1966) 'Urban Change in Early Medieval Italy: The Example of Pavia,' *PBSR* 34, 82–130.

Bullough, D. A. (1991) *Carolingian Renewal: Sources and Heritage*, Manchester – New York.

Bülow, Gerda von (2011) 'Romuliana-Gamzigrad – Ort der Erinnerung oder Herrschaftsort?,' in Bülow and Zabehlicky (eds.), 153–65.

Bülow, Gerda von and H. Zabehlicky (eds.) (2011) *Bruckneudorf und Gamzigrad. Spätantike Paläste und Großvillen im Donau-Balkan-Raum*, Bonn.

Burton, G. P. (1975) 'Proconsuls, Assizes and the Administration of Justice,' *JRS* 65, 92–106.

Busson, D. (1986) 'Découvertes rue de Lutèce,' *Archéologia* 217, 16–21.

Byhet, T. (2001–02) 'Les portiques de rue dans les villes de la Gaule Romaine: un element de *l'amoenitas urbium*?' in R. Bedon (ed.), *Amoenitas urbium. Les agréments de la vie urbaine en Gaule romaine et dans les regions voisines* (*Caesarodunum* 35–36), Limoges, 15–38.

Byhet, T. (2007) 'Contribution à l'étude des portiques de rue dans les villes du Nord de la Gaule,' in R. Hanoune (ed.), *Les ville romaines du nord de la Gaule. Vingt ans de recherches nouvelles*, Lille, 421–46.

Caballero Zoreda, L. and P. Mateos Cruz (eds.), *Visigodos y Omeyas: un debate entre la antigüedad tardía y la alta edad media*, Anejos de *AEspA* 23, Mérida.

Callu, J. P. *La politique monétaire des empereurs romains de 238 à 311*, Paris.

Cameron, Al. (1976) *Circus Factions: Greens and Blues at Rome and Byzantium*, Oxford.

Cameron, Av. (1993) *The Mediterranean World in Late Antiquity, AD 395–600*, London.

Cameron, Av. and J. Herrin (1984) *Constantinople in the Eighth Century: The Parastaseis Syntomai Chronikai*, Leiden.

Canepa, M. P. (2009) *The Two Eyes of the Earth: Art and Ritual of Kingship between Rome and Sasanian Iran*, Berkeley – Los Angeles.

Cantino Wataghin, G. (1992) 'Urbanistica tardoantica e topografia cristiana. Termini di un problema,' in Chiesa and Arslan (eds.), 171–92.

Cantino Wataghin, G., J. M. Gurt Espaguerra and J. M. Guyon (1996) 'Topografia della "civitas

christiana" tra IV e VI sec.,' in G. P. Brogiolo (ed.), *Early Medieval Towns in the Western Mediterranean*, Mantua, 17–43.

Caporusso, D. (1991) 'La zona di corso di Porta Romana in età romana e medioevale,' in *ead.* (ed.), *Scavi MM3: ricerche di archeologia urbana a Milano durante la costruzione della Linea 3 della Metropolitana, 1982–1990*, vol. 1, Milan, 237–61.

Carella, S. (2011) *Architecture religieuse haut-médiévale en Italie méridionale: le diocèse de Bénévent*, Turnhout.

Caroli, C. (1974) 'Note sul Palatium e la Moneta Aurea a Ravenna,' *Felix Ravenna* 107–08, 131–50.

Carrié, J.-M. (1994) 'Dioclétien et la fiscalité,' *AnTard* 2, 33–64.

Carrobles Santos, J. (2004) 'Los muros de Toledo,' in *Las murallas de Toledo*, Madrid, 9–45.

Carrobles Santos, J., R. Barroso Cabrera, J. Morín de Pablos and F. Valdés Fernández (2007) *Regia sedes toletana. La topografía de la ciudad de Toledo en la tardía antigüedad y alta edad media*, Toledo.

Carver, M. (1993) *Arguments in Stone: Archaeological Research and the European Town in the First Millennium*, Oxford.

Cattaneo, E. (1974) 'San Dionigi: Basilica paleocristiana?,' *Archivio Ambrosiano* 27, 68–84.

Chastagnol, A. (1960) *La préfecture urbaine a Rome sous le bas-empire*, Paris.

Chastagnol, A. (1981) 'L'inscription constantinienne d'Orcistus,' *MEFRA* 93, 381–416.

Chastagnol, A. (1986) 'La législation sur les biens des villes au IVe siècle à la lumière d'une inscription d'Éphese,' *Atti dell'Accademia Romanistica Costantiniana* 6, 77–104.

Chastagnol, A. (1994) 'L'évolution politique du règne de Dioclétien (284–305),' *AnTard* 2, 23–31.

Chastagnol, A. (1996) 'La fin du Sénat de Rome,' in Lepelley (ed.), 345–54.

Chavasse, A. (1993) *La liturgie de la ville de Rome du V^e au VIII^e siècle. Une liturgie condi-tionée par l'organisation de la vie in urbe et extra muros*, Rome.

Chevalier, H. (1972) 'La cité de Tours et Chateauneuf du Xe au XIIIe siècle,' *Cahiers d'histoire* 17, 237–47.

Chiesa, G. and E. Arslan (eds.) (1992) *Felix temporis reparatio. Atti del convegno archeologico internazionale Milano capitale dell'Impero Romano, Milano 8–11 Marzo 1990*, Milan.

Christie, N. (1989) 'The City Walls of Ravenna: The Defence of a Capital, A.D. 402–750,' *CARB* 36, 113–38.

Christie, N. (2001) 'War and Order: Urban Remodeling and Defensive Strategy in Late Roman Italy,' in Lavan (ed.), 106–22.

Christie, N. (2006) *From Constantine to Charlemagne: An Archaeology of Italy, AD 300–800*, Aldershot and Burlington, VT.

Christie, N. (2011) *The Fall of the Western Roman Empire: An Archaeological and Historical Perspective*, London – New York.

Christie, N. and A. Augenti (eds.) (2012) *Vrbes extinctae: archaeologies of abandoned classical towns*, Farnham – Burlington, VT.

Christie, N. and S. Gibson (1988) 'The City Walls of Ravenna,' *PBSR* 56, 156–97.

Christie, N. and S. Loseby (eds.) (1996) *Towns in Transition: Urban Evolution in Late Antiquity and the Early Middle Ages*, Aldershot.

Christie, N. and A. Rushworth (1988) 'Urban Fortification and Defensive Strategy in Fifth and Sixth Century Italy: The Case of Terracina,' *JRA* 1, 73–88.

Clark, G. (1999) 'Victricius of Rouen: Praising the Saints,' *JECS* 7.3, 365–99.

Clark, G. (2003) 'Translating Relics: Victricius of Rouen and Fourth-Century Debate,' *EME* 10.2, 161–76.

Claussen, M. A. (2004) *The Reform of the Frankish Church: Chrodegang of Metz and the Regula Canonicorum in the Eighth Century*, Cambridge.

Coarelli, F. (1986) *Il Foro Romano*, vol. 1: *Periodo arcaico*, 2nd ed., Rome.

Coarelli, F. (1988) *Il Foro Boario dalle origini alla fine della repubblica*, Rome.

Collins, R. (1983) *Early Medieval Spain: Unity in Diversity, 400–1000*, New York.

Conant, J. (2012) *Staying Roman: Conquest and Identity in Africa and the Mediterranean, 439–700*, Cambridge.

Congiu, M., S. Modeo and M. Arnone (eds.) (2010) *La Sicilia bizantina: storia, città e territorio*, Caltanissetta.

Corbier, M. (1991) 'Cité, territoire et fiscal-
ité,' in *Epigrafia. Actes du colloque international
d'épigraphie latine en mémoire de Attilio Degrassi
pour le centenaire de sa naissance. Actes de colloque
de Rome (27–28 mai 1988)*, Rome, 629–65.

Corcoran, S. (1996) *The Empire of the Tetrarchs:
Imperial Pronouncements and Government AD
284–324*, Oxford.

Cosentino, S. (2010) 'Fine della fiscalità, fine
dello stato romano?' in Delogu and Gasparri
(eds.), 17–35.

Coupel, P. and E. Frézouls (1956) *Le théâtre de
Philippopolis en Arabie*, Paris.

Cracco Ruggini, L. (1980) 'La Sicilia fra Roma
e Bisanzio,' in R. Romeo (ed.), *Storia della
Sicilia*, vol. 3, Naples, 3–96.

Crawford, J. S. (1990) *The Byzantine Shops at
Sardis*, Cambridge, MA.

Crow, J. (2001) 'Fortifications and Urbanism in
Late Antiquity: Thessaloniki and other Eastern
Cities,' in Lavan (ed.), 89–105.

Crow, J. (2012) 'A Balkan Trilogy,' *JRA* 25,
969–73.

Cubelli, V. (1992) *Aureliano imperatore: la rivolta
dei monetieri e la cosidetta riforma monetaria*,
Florence.

Cuppers, H. (1992) 'Das Spätantike Trier und sein
Umland,' in Chiesa and Arslan (eds.), 227–39.

Ćurčić, S. (1993) 'Late-Antique Palaces: The
Meaning of Urban Context,' *Ars Orientalis* 23,
67–90.

Ćurčić, S. (2000) *Some Observations and Questions
regarding Early Christian Architecture in
Thessaloniki*, Thessaloniki.

Ćurčić, S. (2010a) *Architecture in the Balkans from
Diocletian to Süleyman the Magnificent (ca. 300–
ca. 1550)*, New Haven.

Ćurčić, S. (2010b) 'Christianization of
Thessalonikē: The Making of Christian
"Urban Iconography,"' in Nasrallah, Bakirtzis
and Freisen (eds.), 213–44.

Dagron, G. (1974) *Naissance d'une capitale.
Constantinople et ses institutions de 330 à 451*,
Paris.

Dagron, G. (2002) 'The Urban Economy,
Seventh-Twelfth Centuries,' in Laiou (ed.),
393–461.

Daim, F. and J. Drauschke (eds.) (2010) *Byzanz –
das Römerreich im Mittelalter*, Monographien

des Römisch-Germanischen Zentralmuseums
84, 3 vols., Mainz.

Dally, O., M. Maischberger, P. I. Schneider
and A. Scholl (2011) 'The Town Center of
Miletus from Roman Imperial Times to Late
Antiquity,' in Dally and Ratté (eds.), 81–101.

Dally, O. and C. Ratté (eds.) (2011) *Archaeology
and the Cities of Asia Minor in Late Antiquity*,
Ann Arbor.

Dark, K. (2002) *Britain and the End of the Roman
Empire*, Stroud.

Dark, K. (2004) 'Houses, Streets and Shops in
Byzantine Constantinople from the Fifth
to the Twelfth Centuries,' *Journal of Medieval
History* 30, 83–107.

Dark, K. (ed.) (2004) *Secular Buildings and the
Archaeology of Everyday Life in the Byzantine
Empire*, Oxford.

Darrous, N. and J. Rohmer (2004) 'Chahba-
Philippopolis (Hauran): essai de synthèse
archéologique et historique,' *Syria* 81, 5–41.

Dartmann, C. (2012) 'Die Sakralisierung König
Wambas. Zur debate um frühmittelalterliche
Sakralherrschaft,' *Frühmittelalterliche Studien* 44,
39–58.

De Blois, L. (2006) 'Emperorship in a Period
of Crises: Changes in Emperor Worship,
Imperial Ideology and Perceptions of Imperial
Authority in the Roman Empire in the Third
Century A.D.,' in L. de Blois, P. Funke, and
J. Hahn, eds., *The Impact of Imperial Rome on
Religions, Ritual and Religious Life in the Roman
Empire*, Leiden-Boston, 268–78.

De Francovich, G. (1970) *Il palatium di
Teoderico a Ravenna e la cosidetta 'architettura di
potenza,'* Rome.

Deichmann, F. W. (1969) *Ravenna Hauptstadt des
spätantiken Abenlandes*, vol. I: *Geschichte und
Monumente*, Wiesbaden.

Deichmann, F. W. (1974) Vol. II: *Kommentar*,
1. Teil.

Deichmann, F. W. (1976) Vol. II: *Kommentar*,
Plananhang.

Deichmann, F. W. (1976) Vol. II: *Kommentar*,
2. Teil.

Deichmann, F. W. (1989) Vol. II: *Kommentar*,
3. Teil.

Deichmann, F. W. (1972) 'Das Oktogon von
Antiocheia: Heroon-Martyrion, Palastkirche

oder Katedrale,' *Byzantinische Zeitschrift* 65.1, 40–56.

De Jong, M. (1999) 'Adding Insult to Injury: Julian of Toledo and his *Historia Wambae*,' in Heather (ed.), 373–89.

Delehaye, H. (1909) *Les légendes grecques des saints militaires*, Paris.

Delmaire, R. (1989) *Largesses sacrées et res privata. L'aerarium impérial et son administration du IV*ᵉ *au VI*ᵉ *siècle*, Rome.

Delmaire, R. (1996) 'Cités et fiscalité au bas-empire. À propos du rôle des curiales dans la levée des impôts,' in Lepelley (ed.) 1996, 59–70.

Delogu, P. (1977) *Mito di una città meridionale*, Naples.

Delogu, P. (1980) 'Il regno longobardo,' in G. Galassi (ed.), *Storia d'Italia*, vol. 1: *Longobardi e Bizantini*, Turin, 3–216.

Delogu, P. (1998) 'Reading Pirenne Again,' in R. Hodges and W. Bowden (eds.), *The Sixth Century: Production, Distribution and Demand*, Leiden – Boston, 15–40.

Delogu, P. (2009) 'Kingship and the Shaping of the Lombard Body Politic,' in Ausenda, Delogu and Wickham (eds.), 251–74.

Delogu, P. (2010a) 'Introduzione. Il V secolo come problema della storiografia,' in Delogu and Gasparri (eds.), 7–13.

Delogu, P. (2010b) *Le origini del medioevo*, Rome.

Delogu, P. and S. Gasparri (eds.) (2010) *Le trasformazioni del V secolo. L'Italia, i barbari e l'Occidente romano*, Turnhout.

Demandt, A., A. Golz and H. Schlange-Schöningen (eds.) (2004) *Diokletian und die Tetrarchie*, Berlin – New York.

DeMarrais, E., C. Gosden and C. Renfrew (eds.) (2004) *Rethinking Materiality: The Engagement of Mind with the Material World*, Cambridge.

DeMarrais, E., C. Gosden and C. Renfrew (2004) 'The Materialization of Culture,' in DeMarrais, Gosden and Renfrew (eds.), 11–22.

De Seta, C. (1989) 'Le mura simbolo della città,' in De Seta and Le Goff (eds.), 11–57.

De Seta, C. and J. Le Goff (eds.) (1989) *La città e le mura*, Rome-Bari, 1989.

Dey, H. (2010) 'Art, Ceremony, and City Walls: The Aesthetics of Imperial Resurgence in the Late Roman West,' *JLA* 3.1, 3–37.

Dey, H. (2011) *The Aurelian Wall and the Refashioning of Imperial Rome, AD 271–855*, Cambridge.

Dey, H. (2014) 'Urban Armatures, Urban Vignettes: The Interpermeation of the Reality and the Ideal of the Late Antique Metropolis,' in S. Birk, T. M. Christensen and B. Poulsen (eds.), *Using Images in Late Antiquity*, 190–208.

Dey, H., J. Sharvit and B. Goodman-Tchernov (forthcoming in *JRA* 27) 'Archaeological Evidence for the Tsunami of January 18, 749: A Forgotten Chapter in the History of Early Islamic *Qāysariyah* (Caesarea Maritima, Israel).'

Díaz, P. C. (1999) 'Visigothic Political Institutions,' in Heather (ed.), 321–56.

Díaz, P. C. and L. R. Menéndez-Bueyes (2005) 'The Cantabrian Basin in the Fourth and Fifth Centuries: From Imperial Province to Periphery,' in Bowes and Kulikowski (eds.), 265–97.

Diefenbach, S. (2002) 'Zwischen Liturgie und *civilitas*: Konstantinopel im 5. Jahrhundert und die Etablierung eines städtischen Kaisertums,' in R. Warland (ed.), *Bildlichkeit und Bildort von Liturgie. Schauplätze in Spätantike, Byzanz und Mittelalter*, Wiesbaden, 21–49.

Dierkens, A. and P. Perrin 'Les *sedes regiae* mérovingiennes entre Seine et Rhin,' in Ripoll and Gurt (eds.), 267–304.

Di Muro, A. (2008) *Mezzogiorno longobardo. Insediamenti, economia e istituzioni tra Salerno e il Sele (secc. VII–XI)*, Bari.

Di Segni, L. (1999) 'Epigraphic Evidence for Building in Palaestina and Arabia (4th – 7th c.),' in J. Humphrey (ed.), *The Roman and Byzantine Near East*, vol. 2, Portsmouth, RI, 149–78.

Ditchfield, P. (2007) *La culture matérielle médiévale. L'Italie méridionale byzantine et normande*, Rome.

D'Onofrio, M. (1976) 'La Königshalle di Lorsch presso Worms,' in *Roma e l'età carolingia. Atti delle giornate di studio 3–8 maggio 1976*, Rome, 129–38.

Doppelfeld, O. (1956) 'Römische Großbauten unter dem Kölner Rathaus; Vorbericht über die Rathausgrabung des Jahres 1953,' *Germania* 34, 83–99.

Doppelfeld, O. (1975) 'Köln von der Spätantike bis zur Karolingerzeit,' in H. Jankuhn, W. Schlesinger und H. Steuer (eds.), *Vor- und Früh-formen der europäischen Stadt im Mittelalter*, Göttingen, vol. 1, 110–29.

Downey, G. (1959) 'Libanius' Oration in Praise of Antioch,' *Proceedings of the American Philosophical Society* 103, 652–86.

Downey, G. (1961) *A History of Antioch in Syria*, Princeton.

Dufraigne, P. (1994) Adventus augusti, adventus Christi. *Recherche sur l'exploitation idéologique et littéraire d'un cérémonial dans l'antiquité tardive*, Paris.

Dunbabin, K. M. D. (1999) *Mosaics of the Greek and Roman World*, Cambridge.

Duncan-Jones, R. P. (1982) *The Economy of the Roman Empire: Quantitative Studies*, 2nd ed., Cambridge.

Duncan-Jones, R. P. (1985) 'Who Paid for Public Buildings in Roman Cities?,' in Grew and Hobley (eds.), 28–33.

Durliat, J. (1979) 'Les attributions civiles des évêques mérovingiens: l'example de Didier, évêque de Cahors (630–655),' *Annales du Midi* 91, 237–54.

Durliat, J. (1990) *Les finances publiques de Diocletien aux Carolingiens (284–889)*, Sigmaringen.

Duval, N. (1961–62) 'La place de Split dans l'architecture antique du bas-empire,' *Urbs* 4, 67–95.

Duval, N. (1979) 'Palais et cité de la *Pars Orientalis*,' *CARB* 36, 41–51.

Duval, N. (1984) 'L'architecture religieuse de Tsaritchin Grad dans le cadre de l'Illyricum oriental au VI^e siècle,' in AA.VV., *Villes et peuplement dans l'Illyricum protobyzantin. Actes du Colloque organisé par l'Ecole française de Rome (Rome, 12–14 mai 1982)*, Rome, 399–481.

Duval, N. (1992) 'Le palais de Milan parmi les résidences imperiales du Bas-Empire,' in Chiesa and Arslan (eds.), 137–46.

Duval, N. (1996) 'L'Urbanisme de Caricin Grad. Une ville artificielle et ses bâtiments d'apparat: une spécificité locale ou une étape décisive dans la typologie des *principia* militaires?,' *An Tard* 4, 325–39.

Duval, N. (2003) 'Hommage à Ejnar et Ingrid Dyggve: la théorie du palais du bas-empire et les fouilles de Thessalonique,' *An Tard* 11, 273–300.

Duval, N. and V. Popović (ed.) (2010) *Caričin Grad. 3, L'acropole et ses monuments (cathédrales, baptistère et bâtiments annexes)*, Rome.

Dyggve, E. (1941) *Ravennatum Palatium Sacrum. La basilica ipetrale per cerimonie. Studi sull'architettura dei palazzi della tarda antichità*, Copenhagen.

Eck, W. (2004) *Köln in römischer Zeit. Geschichte einer Stadt im Rahmen des Imperium Romanum*, Cologne.

Edwards, C. M. (1994) 'The Arch over the Lechaion Road at Corinth and Its Sculpture,' *Hesperia* 63.3, 263–308.

Effmann, W. (1912) *Centula: Saint-Riquier. Eine Untersuchung zur Geschichte der kirchlichen Baukunst in der Karolingerzeit*, Münster.

Ensslin, W. (1959) *Theoderich der Grosse*, 2nd ed., Munich.

Esmonde Cleary, S. (1987) *Extra-Mural Areas of Romano-British Towns*, BAR British Series 169, Oxford.

Esmonde Cleary, S. (1989) *The Ending of Roman Britain*, London.

Esmonde Cleary, S. (2013) *The Roman West, AD 200–500. An Archaeological Study*, Cambridge.

Ewig, E. (1963) 'Résidence et capitale pendant le haut Moyen Age,' *Revue Historique* 130, 25–72.

Falkenstein, L. (1966) *Der 'Lateran' der karolingischen Pfalz zu Aachen*, Cologne.

Falkenstein, L. (1991) 'Charlemage et Aix-la-Chapelle,' *Byzantion* 61, 231–89.

Farioli Campanati, R. (1989) 'La topografia imperiale di Ravenna dal V al VI secolo,' *CARB* 36, 139–47.

Farioli Campanati, R. (1992) 'Ravenna, Costantinopoli: Aspetti topografico-monumentali e iconografici,' in Carile (ed.), *Storia di Ravenna* II.2, 127–58.

Farioli Campanati, R. (1999) 'Jerusalem and Bethlehem in the Iconography of Church Sanctuary Mosaics,' in Piccirillo and Alliata (eds.), 173–77.

Faulkner, N. (2000) 'Change and Decline in Late Romano-British towns,' in Slater (ed.), 25–50.

Fauvinet-Ranson, V. (2006) Decor civitatis, decor Italiae. *Monuments, travaux publics et spectacles au VI siècles d'après les variae de Cassiodore*, Bari.

Feissel, D. (1999) 'Épigraphie administrative et topographie urbaine: l'emplacement des actes inscrits dans l'Éphèse protobyzantine (IVᵉ–VIᵉ s.),' in R. Pillinger, O. Kresten, F. Krinzinger and E. Russo (eds.), *Efeso Paleocristiana e Bizantina – Frühchristliches und Byzantinisches Ephesos*, Vienna, 121–32.

Fentress, E. (ed.) (2000) *Romanization and the City: Creation, Transformations, and Failures*, Portsmouth, RI.

Fernández, D. (2006) 'What Is the *De fisco Barcinonensi* About?,' *AnTard* 14, 217–24.

Février, P. A. (1980) 'Vetera et nova: le poids du passé, les germes de l'avenir, IIIᵉ–VIᵉ siècle, in Duby (ed.), *Histoire de la France urbaine*, vol. 1, Paris, 399–493.

Fiema, Z.T. (2008) 'Remarks on the Development and Significance of the Colonnaded Street in Petra, Jordan,' in Ballet, Dieudonné-Glad and Saliou (eds.), 161–68.

Finella, A. (2003) *Benevento medievale. Analisi ed interpretazione dell'impianto urbano*, Rome.

Fiocchi Nicolai, V. (2000) 'Sacra martyrum loca circuire: percorsi di visita dei pellegrini nei santuari martiriali del suburbio romano,' in L. Pani Ermini (ed.), *Christiana loca. Lo spazio cristiano a Roma del primo millennio*, Rome, vol. 1, 221–30.

Fishwick, D. (1987–2005) *The Imperial Cult in the Latin West: Studies in the Ruler Cult of the Western Provinces of the Roman Empire*, 5 vols., Leiden – Boston.

Flood, F. B. (2000) *The Great Mosque of Damascus: Studies on the Makings of an Umayad Visual Culture*, Leiden – Boston – Cologne.

Flusin, B. (2004) 'Les structures de l'Église impérial,' in Morrisson (ed.), 111–41.

Foerster, G. and Y. Tsafrir (1992) 'The Dating of the "Earthquake of the Sabbatical Year" of 749 C. E. in Palestine,' *Bulletin of the School of Oriental and African Studies* 52.2, 231–35.

Foss, C. (1976) *Byzantine and Turkish Sardis*, Cambridge, MA.

Foss, C. (1977a) 'Archaeology and the "Twenty Cities" of Byzantine Asia Minor,' *AJA* 81, 469–86.

Foss, C. (1977b) 'Late Antique and Byzantine Ankara,' *DOP* 31, 29–87.

Foss, C. (1979) *Ephesus after Antiquity: A Late Antique, Byzantine and Turkish City*, Cambridge.

Foss, C. (1997) 'Syria in Transition, A.D. 550–750: An Archaeological Approach,' *DOP* 51, 189–269.

Foss, C. and D. Winfield (1986) *Byzantine Fortifications: An Introduction*, Pretoria.

Fournier, E. (2010) 'The *Adventus* of Julian at Sirmium: The Literary Construction of Historical Reality in Ammianus Marcellinus,' in R. Frakes, E. Digeser and J. Stephens (eds.), *The Rhetoric of Power in Late Antiquity: Religion and Politics in Byzantium, Europe and the Early Islamic World*, London – New York, 13–45.

Fowden, G. (2006) '410 and All That,' *JRA* 19, 706–08.

Fowler, H. N. and R. Stillwell (1932) *Corinth I: Introduction, Topography, Architecture*, Cambridge, MA.

Frakes, J. (2009) *Framing Public Life: The Portico in Roman Gaul*, Vienna.

Fraschetti, A. (1999) '*Veniunt modo reges Romam*,' in Harris (ed.), 235–48.

Fuhrer, T. (ed.) (2012) *Rom und Mailand in der Spätantike. Repräsentationen städtischer Räume in Literatur, Architektur und Kunst*, Berlin – Boston.

Gai, S. (1999) 'Die Pfalz Karls des Großen in Paderborn,' in Stiegemann and Wemhoff (eds.), 183–96.

Galetti, P. (2009) 'Edilizia residenziale privata rurale e urbana: modelli reciproci?,' *Settimane del CISAM* 56, 697–731.

Galinié, H. (ed.) (2007) *Tours antique et medieval. Lieux de vie. Temps de la ville*, Tours.

Galinié, H. (2010) 'La question urbaine entre Antiquité et Moyen Âge: "l'entre-deux des cités" (250–950),' in J. Chapelot (ed.), *Trente ans d'archéologie médiévale en France. Un bilan pour un avenir*, Caen, 337–50.

Gasparri, S. (1987) 'Pavia longobarda,' in *Storia di Pavia*, vol. 2: *l'alto medioevo*, 19–67.

Gasparri, S. (1990) 'Il regno longobardo in Italia,' in S. Gasparri and P. Cammarosano (eds.), *Langobardia*, Udine, 237–305.

Gauthier, N. (1999) 'La topographie chrétienne entre idéologie et pragmatisme,' in Brogiolo and Ward-Perkins (eds.), 195–209.

Geertz, C. (1980) *Negara: The Theater State in Nineteenth-Century Bali*, Princeton.

Gelichi, S. (1991) 'Il paesaggio urbano tra V e X secolo,' in Carile (ed.), *Storia di Ravenna* 2.1, 153–65.

Gerke, F. (1949) 'Die Königshalle in Lorsch und der frühkarolingische Monumentalstil,' in *Kultur und Wirtschaft im rheinischen Raum. Festschrift für Christian Eckert*, Mainz, 131–36.

Ghirardini, G. (1917) 'Gli scavi del Palazzo di Teodorico a Ravenna,' *Monumenti antichi pubblicati per cura della Reale Accademia dei Lincei* 24, cols. 737–838.

Giardina, A. (1987) 'Il quadro storico: Panormo da Augusto a Gregorio Magno,' *Kokalos* 33, 225–49.

Gillett, A. (2001) 'Rome, Ravenna and the Emperors,' *PBSR* 69, 131–67.

Godman, P., J. Jarnut and P. Johanek (eds.) (2002) *Am Vorabend der Kaiserkrönung: das Epos "Karolus Magnus et Leo papa" und der Papstbesuch in Paderborn 799*, Berlin.

Gosden, C. (2004) 'Aesthetics, Intelligence and Emotions: Implications for Archaeology,' in Gosden, Renfrew and DeMarrais (eds.), 33–40.

Gosden, C. (2005) 'What Do Objects Want,' *Journal of Archaeological Method and Theory* 12, 193–211.

Gosden, C. (2006) 'Material Culture and Long-Term Change,' in C. Tilley, W. Keane, S. Küchler, M. Rowlands and P. Speyer (eds.), *Handbook of Material Culture*, London, 425–42.

Grabar, A. (1987) *The Formation of Islamic Art*, rev. ed., New Haven – London.

Graf, A. (1882–83) *Roma nella memoria e nelle immaginazioni del medio evo*, 2 vols., Turin.

Gregory, T. E. (1979) 'The Late Roman Fortification Wall at Corinth,' *Hesperia* 48, 264–80.

Grew, F. and B. Hobley (eds.) (1985) *Roman Urban Topography in Britain and the Western Empire*, London.

Grewe, H. (1999) 'Die Königspfalz zu Ingelheim am Rhein,' in Stiegemann and Wemhoff (eds.), 142–51.

Grierson, P. (1962) 'The Tombs and Obits of the Byzantine Emperors (337–1042),' *DOP* 16, 3–63.

Gros, P. (1998) 'Villes et "non-villes": les ambiguïtés de la hiérarchie juridique et de l'aménagement urbain,' in Gros (ed.), 11–25.

Gros, P. (ed.) (1998) *Villes et Campagnes en Gaule Romaine*, Paris.

Gros, P. (2000) 'L'odéon dans la basilique: mutation des modèles ou désagrégation des programmes,' in Fentress (ed.), 211–20.

Gros, P. and M. Torelli (1988) *Storia dell'urbanistica. Il mondo romano*, Bari.

Guilleux, J. (2000) *L'enceinte romaine du Mans*, Saint-Jean-d'Angély.

Gurt, J. M. and C. Godoy (2000) 'Barcino, de sede imperial a *Urbs regia* en época visigoda,' in Ripoll and Gurt (eds.), 425–66.

Gurt, J. M. and A. Ribera (eds.) (2005) *Les ciutats tardoantigues d'Hispania: cristianització i topografia*, Barcelona.

Guyon, J. (2006) 'La topographie chrétienne des villes de la Gaule,' in Krause and Witschel (eds.), 105–28.

Haas, C. (1997) *Alexandria in Late Antiquity: Topography and Social Conflict*, Baltimore.

Hack, A. T. (1999) 'Das Zeremoniell des Papstempfangs 799 in Paderborn,' in Stiegemann and Wemhoff (eds.), 19–33.

Haldon, J. (1997) *Byzantium in the Seventh Century: The Transformation of a Culture*, rev. ed., Cambridge.

Haldon, J. (1999) 'The Idea of the Town in the Byzantine Empire,' in Brogiolo and Ward-Perkins (eds.), 1–23.

Halsall, G. (1995) *Settlement and Social Organization: The Merovingian Region of Metz*, Cambridge.

Halsall, G. (1996) 'Towns, Societies and Ideas: The Not-so-strange Case of Late Roman and Early Merovingian Metz,' in Christie and Loseby (eds.), 235–61.

Halsall, G. (2007) *Barbarian Migrations and the Roman West 376–568*, Cambridge.

Hannestad, N. (1988) *Roman Art and Imperial Policy*, Aarhus.

Harding, G. L. (1951) 'Excavations on the Citadel, Amman,' *Annual of the Department of Antiquities of Jordan* 1, 7–16.

Harris, A. (2004) 'Shops, Retailing and the Local Economy in the Early Byzantine World: The Example of Sardis,' in Dark (ed.), 82–122.

Harrison, D. (1993) *The Early State and the Towns: Forms of Integration in Lombard Italy AD 568–774*, Lund.

Häussling, A. (1973) *Mönchskonvent und Eucharistiefeier: Eine Studie über die Messe in der abendländischen Klosterliturgie des frühen Mittelalters und zur Geschichte der Meßhäufigkeit*, Münster.

Hattersley-Smith, K. (1996) *Byzantine Public Architecture between the Fourth and Early Eleventh Centuries AD with Special Reference to the Towns of Byzantine Macedonia*, Thessaloniki.

Heather, P. (ed.) (1999) *The Visigoths from the Migration Period to the Seventh Century. An Ethnographic Perspective*, Woodbridge.

Heather, P. (2005) *The Fall of the Roman Empire: A New History*, London.

Hedlund, R. (2008) *"…Achieved Nothing Worthy of Memory." Coinage and Authority in the Roman Empire c. AD 260–295*, Uppsala.

Heinen, H. (1984) 'Vom Ende des Gallischen Sonderreiches bis zur Usurpation des Magnentius (274–350),' in *Trier Kaiserresidenz und Bischofssitz. Die Stadt in spätantiker und frühchristlicher Zeit*, Mainz, 16–31.

Heinen, H. (1985) *Trier und das Treverland in römischer Zeit*, Trier.

Heinrich-Tamáska, O. (ed.) (2011) *Keszthely-Fenékpuszta im Kontext spätantiker Kontinuitätsforschung zwischen Noricum und Moesia*, Rahden.

Heitz, C. (1963) *Recherches sur les rapports entre architecture et liturgie à l'époque carolingienne*, Paris.

Heitz, C. (1967) 'le groupe cathédral de Metz au temps de saint Chrodegang,' in *Saint Chrodegang, communications présentés au Colloque tenu à metz à l'occasion du douzième centenaire de sa mort*, Metz, 123–32.

Heitz, C. (1974) 'Architecture et liturgie processionnelle à l'époque préromaine,' *Revue de l'Art* 24, 30–47.

Heitz, C. (1976) '*More romano*. Problèmes d'architecture et liturgie carolingiennes,' in *Roma e l'età carolingia. Atti delle giornate di studio 3–8 maggio 1976*, Rome, 27–37.

Heitz, C. (1980) *L'architecture religieuse carolingienne. Les formes et leurs fonctions*, Paris.

Heitz, C. (1995) 'Architecture et liturgie en France de l'époque carolingienne à l'an Mil,' *Hortus Artium Medievalium* 1, 57–73.

Hellenkemper, H. (2002) 'Köln 260–355 A. D. Ein unruhiges Jahrhundert Kölner Stadtgeschichte,' in A. Rieche et al. (eds.), *Grabung, Forschung, Präsentation. Festschrift Gundolf Precht*, Mainz, 43–53.

Hen, Y. (2007) *Roman Barbarians: The Royal Court and Culture in the Early Medieval West*, London – New York.

Hendy, M. F. (1985) *Studies in the Byzantine Monetary Economy, ca. 300–1450*, Cambridge.

Henning, J. (ed.) (2007) *Post-Roman Towns, Trade and Settlement in Europe and Byzantium*, 2 vols., Berlin – New York.

Henning, J. (2007) 'Early European Towns: The Development of the Economy in the Frankish Realm between Dynamism and Deceleration AD 500–1100,' in Henning (ed.), vol. 1, 3–40.

Hesberg, H. von (2006) 'Residenzstädte und ihre höfische Infrastruktur – traditionelle und neue Raumkonzepte,' in Boschung and Eck (eds.), 133–67.

Hillenbrand, R. (1999) 'Anjar and Early Islamic Urbanism,' in Brogiolo and Ward-Perkins (eds.), 59–98.

Hodder, I. and S. Hutson (2003) *Reading the Past: Current Approaches to Interpretation in Archaeology*, 3rd ed., Cambridge.

Hodges, R. (1982) *Dark Age Economics: The Origins of Towns and Trade, AD 600–1000*, London.

Hodges, R. (2000) *Towns and Trade in the Age of Charlemagne*, London.

Hodges, R. (2010) *Dark Age Economics: A New Audit*, London.

Hodges, R. and D. Whitehouse (1983) *Mohammed, Charlemagne and the Origins of Europe*, Ithaca, NY.

Hoff, E. (1943) *Pavia und seine Bischöfe im Mittelalter. Beitrage zur geschichte der Bischöfe von Pavia unter besonderer berucksichtigung ihrer politischen stellung*, Pavia.

Hoffmann, A. and U. Wulf (eds.) (2004) *Die Kaiserpaläste auf dem Palatin in Rom. Das Zentrum der römischen Welt und seine Bauten*, Mainz.

Holum, K. and H. Lapin (eds.) (2011) *Shaping the Middle East: Jews, Christians, and Muslims*

in an Age of Transition 400–800 C.E., College Park, MD.

Holum, K. and G.Vikan (1979) 'The Trier Ivory, "Adventus" Ceremonial, and the Relics of St. Stephen,' *DOP* 33, 113–33.

Horden, P. and N. Purcell (2000) *The Corrupting Sea: A Study of Mediterranean History*, Oxford.

Hubert, J. (1957) 'Saint-Riquier et le monachisme bénédictin en Gaule à l'époque carolingienne,' *Settimane del CISAM* 4, 293–309.

Hudson, P. (1987) 'Pavia: l'evoluzione urbanistica di una capitale altomedievale,' in *Storia di Pavia*, vol. 2: *l'alto medievo*, 237–311.

Hugot, L. (1965) 'Die Pfalz Karls des Grossen in Aachen. Ergebnisse einer topographisch-archäologischen Untersuchung des Ortes und der Pfalz,' in Braunfels and Schnitzler (eds.), 534–72.

Humphrey, J. H. (1980) 'Vandal and Byzantine Carthage: Some New Archaeological Evidence,' in J. Pedley (ed.), *New Light on Ancient Carthage*, Ann Arbor, 85–120.

Humphrey, J. H. (1986) *Roman Circuses: Arenas for Chariot Racing*, London.

Humphries, M. (2008) 'From Emperor to Pope? Ceremonial, Space, and Authority at Rome from Constantine to Gregory the Great,' in K. Cooper and J. Hillner (eds.), *Religion, Dynasty and Patronage in Early Christian Rome, 300–900*, Cambridge, 21–58.

Hurst, H. (1993) 'Cartagine, la nuova Alessandria,' in A. Schiavone (ed.) *Storia di Roma* 3.2, Turin, 327–37.

Innes, M. (1998) 'Kings, Monks and Patrons: Political Identities and the Abbey of Lorsch,' in R. Le Jan (ed.), *La Royauté et les élites dans l'Europe carolingienne (début IX^e siècle aux environs de 920)*, Lille, 301–24.

Iogna-Prat, D. (2004) 'Architecture et liturgie,' in A. Wagner (ed.), *Les saints et l'histoire, sources hagiographiques du haut Moyen Âge*,' Paris, 297–308.

Iro, D., H. Schwaiger and A. Waldner (2009) 'Die Grabungen des Jahres 2005 in der Süd- und Nordhalle der Kuretenstrasse,' in Ladstätter (ed.), 53–67.

Isaïa, M.-C. (2010) *Remi de Reims. Mémoire d'un saint. Histoire d'une Église*, Paris.

Isla Frey, A. (2002) 'El "officium palatinum" visigodo. Entorno regio e poder aristocrático,' *Hispania* 62.3, 823–48.

Ivison, E. A. (2000) 'Urban Renewal and Imperial Revival in Byzantium (730–1025),' *Byzantinische Forschungen* 26, 1–46.

Ivison, E. A. (2007) 'Amorium in the Byzantine Dark Ages (Seventh to Ninth Centuries),' in Henning (ed.), vol. 2, 26–60.

Ivison, E. A. (2010) 'Kirche und religiöses Leben im byzantinischen Amorium,' in Daim and Drauschke (eds.), vol. 2.1, 309–43.

Ivison, E. A. (2012) 'Excavations at the Lower City Enclosure, 1996–2006,' in C. S. Lightfoot and E. A. Ivison (eds.), *Amorium Reports 3: Finds Reports and Technical Studies*, Istanbul, 5–151.

Jacobs, I. (2013) *Aesthetic Maintenance of Civic Space: The 'Classical' City from the 4th to the 7th c. AD*, Leuven.

Jacobsen, W. 'Die Lorscher Torhalle. Zum Problem ihrer Datierung und Deutung,' *Jahrbuch des Zentralinstituts für Kunstgeschichte* 1 (1985), 9–75.

Jacques. F. (1983) *Les curateurs des cités dans l'Occident Romain, de Trajan a Gallien*, Paris.

Jacques. F. (1984) *Le privilège de liberté. Politique impériale et autonomie municipale dans les cités de l'occident romain (161–244)*, Rome.

Jansen, V. (1982) 'Round or Square? The Axial Towers of the Abbey Church of Saint-Riquier,' *Gesta* 21.2, 83–90.

Jayyusi, S. K., R. Holod, A. Petruccioli and A. Raymond (eds.) (2008) *The City in the Islamic World*, vol. 1, Leiden – Boston.

Johne, K.-P., T. Gerhardt and U. Hartmann (eds.) (2006) Deleto paene imperio Romano. *Transformationsprozesse des Römischen Reiches im 3. Jahrhundert und ihre Rezeption in der Neuzeit*, Stuttgart.

Johnson, M. J. (1988) 'Toward a History of Theoderic's Building Program,' *DOP* 42, 73–96.

Johnson, S. (1983) *Late Roman Fortifications*, Totowa, NJ.

Jones, A. H. M. (1964) *The Later Roman Empire 284–602: A Social, Economic and Administrative Survey*, 3 vols., Oxford.

Jones, A. H. M. (ed. P. A. Brunt) (1974) *The Roman Economy: Studies in Ancient Economic and Administrative History*, Oxford.

Kantorowicz, E. (1944) 'The "King's Advent": And the Enigmatic Panels in the Doors of Santa Sabina,' *The Art Bulletin* 26, 207–31.

Kantorowicz, E. (1946) Laudes Regiae. *A Study in Liturgical Acclamations and Mediaeval Ruler Worship*, Berkeley – Los Angeles.

Kasprzyk, M. and G. Kuhnle (eds.) (2011) *L'Antiquité tardive dans l'Est de la Gaule. La vallée du Rhin supérieur et les provinces gauloises limitrophes: actualité de la recherche*, Dijon.

Katsari, C., C. S. Lightfoot and A. Özme (2012) *The Amorium Mint and the Coin Finds: Amorium Reports 4*, Berlin.

Kelly, C. (2004) *Ruling the Later Roman Empire*, Cambridge, MA.

Kelly, J. N. D. (1995) *Golden Mouth. The Story of John Chrysostom – Ascetic, Preacher, Bishop*, London.

Kennedy, H. (1981) *The Early Abbasid Caliphate*, London.

Kennedy, H. (1985) 'From Polis to Madina: Urban Change in Late Antique and Early Islamic Syria,' *Past and Present* 106, 3–27.

Kiel, J. (1964) *Ephesos. Ein Führer durch die Ruinenstätte und ihre Geschichte*, Vienna.

Kirilov, C. 'The Reduction of the Fortified City Area in Late Antiquity: Some Reflections on the End of the "Antique City" in the Lands of the Eastern Roman Empire,' in Henning (ed.), vol. 2, 3–24.

Kislinger, E. (2010) 'La città bizantina in Sicilia come centro amministrativo,' in Congiu, Modeo and Arnone (eds.), 147–67.

Klauser, T. (1930) 'Eine Stationsliste der Metzer Kirche aus dem 8. Jahrhundert, warscheinlich ein Werke Chrodegangs,' *Ephemerides Liturgicae* 44 (1930), 162–93.

Klein, H. A. (2006) 'Sacred Relics and Imperial Ceremonies at the Great Palace of Constantinople,' in F. A. Bauer (ed.), *Visualisierungen von Herrschaft. Frümittelalterliche Residenzen Gestalt und Zeremoniell*, Byzas 5, 79–99.

Knöpp, F. (ed.) (1973) *Die Reichsabtei Lorsch: Festschrift zum Bedanken an die Stiftung der Reichsabtei Lorsch 764*, vol. 1, Darmstadt.

Knöpp, F. (1977) *Die Reichsabtei Lorsch: Festschrift zum Bedanken an die Stiftung der Reichsabtei Lorsch 764*, vol. 2, Darmstadt.

Koeppel, G. (1969) 'Profectio und Adventus,' *Bonner Jahrbücher* 169, 130–94.

Kolb, F. (2001) *Herrscherideologie in der Spätantike*, Berlin.

Kolb, F. (2004) '*Praesens Deus*: Kaiser und Gott unter der Tetrarchie,' in Demandt, Goltz and Schlange-Schöningen (eds.), 27–37.

Kondić, V. and V. Popović (1977) *Caričin Grad. Site fortifié dans l'Illyricum byzantin*, Belgrade.

Kostenec, J. (2004) 'The Heart of the Empire: The Great Palace of the Byzantine Emperors,' in Dark (ed.), 4–36.

Kostof, S. (1991) *The City Shaped: Urban Patterns and Meanings through History*, London.

Krause, J.-U. and C. Witschel (eds.) (2006) *Die Stadt in der Spätantike – Niedergang oder Wandel? Akten des internationalen Kolloquiums in München am 30. Und 31. Mai 2003.* Stuttgart.

Krautheimer, R. (1942) 'The Carolingian Revival of Early Christian Architecture,' *The Art Bulletin* 24 (1942), 1–38.

Krautheimer, R. (1983) *Three Christian Capitals: Topography and Politics*, Berkeley.

Kreiner, J. (2011) 'About the Bishop: The Episcopal Entourage and the Economy of Government in Post-Roman Gaul,' *Speculum* 86, 321–60.

Kreusch, F. (1965) 'Kirche, Atrium und Portikus der Aachener Pfalz,' in Braunfels and Schnitzler (eds.), 463–533.

Kuhoff, W. (2001) *Diokletian und die Epoche der Tetrarchie: das römische Reich zwischen Krisenbewältigung und Neuaufbau (284–313 n. Chr.)*, Frankfurt.

Kulikowski, M. (2004) *Late Roman Spain and Its Cities*, Baltimore – London.

Kulikowski, M. (2006) 'The Late Roman City in Spain,' in Krause and Witschel (eds.), 129–49.

Labaune, Y. (2011) 'Quelques observations récentes sur des sites de l'antiquité tardive à Autun (2001–2008),' in Kasprzyk and Kuhnle (eds.), 41–68.

Ladstätter, S. (ed.) (2009) *Neue Forschungen zur Kuretenstraße von Ephesos*, Vienna.

Ladstätter, S. and A. Pülz (2007) 'Ephesus in the Late Roman and Early Byzantine Period:

Changes in Its Urban Character from the Third to the Seventh Century AD,' in Poulter (ed.), 391–433.

Laiou, A. (ed.) (2002) *The Economic History of Byzantium: From the Seventh through the Fifteenth Century*, 3 vols., Washington.

Laniado, A. (2002) *Recherches sur les notables municipaux dans l'Empire protobyzantin*, Paris.

La Rocca, C. (2003) 'Lo spazio urbano tra VI e VIII secolo,' *Settimane del CISAM* 50, 397–436.

La Rocca, E. (1984) *La riva a mezza luna: culti, agoni, monumenti funerari presso il Tevere nel Campo Marzio occidentale*, Rome.

La Rocca, E. (2000) 'L'affresco con veduto di città dal colle Oppio,' in Fentress (ed.), 57–71.

Lauffray, J. (1983–91) *Halabiyya-Zenobia place forte du limes oriental et la Haute-Mésopotamie au VI^e siècle*, 2 vols., Paris.

Lassner, J. (1970) *The Topography of Baghdad in the Early Middle Ages*, Detroit.

Lassus, J. (1934) 'La mosaïque de Yakto,' in G. W. Elderkin (ed.), *Antioch-on-the-Orontes I: The Excavations of 1932*, Princeton, 114–56.

Lassus, J. (1972) *Les Portiques d'Antioche*, Princeton.

Laurence, R. (2011) 'Endpiece: From Movement to Mobility: Future Directions,' in R. Laurence and D. J. Newsome (eds.), *Rome, Ostia, Pompeii. Movement and Space*, Oxford, 386–401.

Laurence, R., S. Esmonde Cleary and G. Sears (2011) *The City in the Roman West c. 250 BC – c. AD 250*, Cambridge.

Lavan, L. (ed.) (2001) *Recent Research in Late-antique Urbanism*, Portsmouth, RI.

Lavan, L. (2003a) 'Late Antique Urban Topography: From Architecture to Human Space,' in Lavan and Bowden (eds.), 171–95.

Lavan, L. (2003b) 'The Political Topography of the Late Antique City: Activity Spaces in Practice,' in Lavan and Bowden (eds.), 314–37.

Lavan, L. (2008) 'The Monumental Streets of Sagalassos in Late Antiquity: An Interpretive Study,' in Ballet, Dieudonné-Glad and Saliou (eds.), 201–14.

Lavan, L. (2009) 'What Killed the Ancient City? Chronology, Causation and Traces of Continuity,' *JRA* 22, 803–12.

Lavan, L. (2012) 'From Polis to Emporion? Retail and Regulation in the Late Antique City,' in Morrison (ed.), 333–77.

Lavan, L. and W. Bowden (eds.) (2003) *Theory and Practice in Late Antique Archaeology*, Leiden – Boston.

Lavan, L., A. Sarantis and E. Zanini (eds.) (2007) *Technology in Transition: A.D. 300–650*, Leiden – Boston – Cologne.

Lehmann-Hartleben, K. (1929) 'Städtbau (in Italien und röm. Reich),' in Pauly-Wissowa, *RE* 3A, 2, cols. 1974–2124.

Leonard, R. D. (2001) 'Evolutionary Archaeology,' in I. Hodder (ed.), *Archaeological Theory Today*, Oxford – Maldon, MA, 65–97.

Leone, A. (2007) *Changing Townscapes in North Africa from Late Antiquity to the Arab Conquest*, Bari.

Lepelley, C. (1979) *Les cités de l'Afrique romaine au Bas-Empire*, vol. 1, Paris.

Lepelley, C. (1990) 'Un éloge nostalgique de la cité classique dans les *Variae* de Cassiodore (VIII, 31),' in M. Sot (ed.), *Haut Moyen Age: culture, éducation et société. Études offertes à P. Riché*, Nanterre, 33–47.

Lepelley, C. (1996) 'Vers la fin du "privilège de liberté": L'amoindrissement de l'autonomie des cités au bas-empire,' in A. Chastagnol, S. Demougin and C. Lepelley (eds.), *Splendidissima civitas. Études d'histoire romaine en hommage à François Jacques*, Paris, 207–20.

Lepelley, C. (1999) 'Témoignages épigraphiques sur le contrôle des finances municipales par les gouverneurs à partir du règne de Dioclétien,' in M. Corbeille (ed.), *Il capitolo delle entrate nelle finanze municipali in occidente ed in oriente*, Rome, 235–49.

Lepelley, C. (2006) 'La cité africaine tardive, de l'apogée du IV^e siècle à l'effondrement du VII^e siècle,' in Krause and Witschel (eds.), 13–31.

Lepelley, C. (ed.) (1996) *La fin de la cité antique et le début de la cité médievale. De la fin du III^e siècle à l'avènement de Charlemagne*, Bari.

Le Strange, G. (1900) *Baghdad during the Abbasid Caliphate*, Oxford.

Lewin, A. (2001) 'Urban Public Building from Constantine to Julian: The Epigraphic Evidence,' in Lavan (ed.), 27–37.

Lewis, S. (1969a) 'The Latin Iconography of the Single-Naved Cruciform Basilica Apostolorum in Milan,' *The Art Bulletin* 51, 205–19.

Lewis, S. (1969b) 'Function and Symbolic Form in the Basilica Apostolorum at Milan,' *JSAH* 28, 83–98.

Liebeschuetz, J. H. W. G. (1972) *Antioch: City and Imperial Administration in the Later Roman Empire*, Oxford.

Liebeschuetz, J. H. W. G. (1992) 'The End of the Ancient City,' in Rich (ed.), 1–49.

Liebeschuetz, J. H. W. G. (2001a) *The Decline and Fall of the Roman City*, Oxford.

Liebeschuetz, J. H. W. G. (2001b) 'The Uses and Abuses of the Concept of Decline in Later Roman History or, Was Gibbon Politically Incorrect?,' in Lavan (ed.) 2001, 233–38.

Liebeschuetz, J. H. W. G. (2006) 'Transformation and Decline: Are the Two Really Incompatible?,' in Krause and Witschel (eds.) 2006, 463–83.

Lightfoot, C. S. (2000) 'Amorium: The History and Archaeology of an Ancient City in the Turkish Period,' in A. Aktaş-Yasa (ed.), *Uluslararası Dördüncü Türk Kültürü Kongresi*, vol. 2, Ankara, 79–89.

Lightfoot, C. S. (2007) 'Trade and Industry in Byzantine Anatolia – The Evidence from Amorium,' *DOP* 61, 269–86.

Lightfoot, C. S. (2009) 'An Important Group of Late 7th-Century Coins from Amorium,' in O. Tekin (ed.), *Ancient History, Numismatics and Epigraphy in the Mediterranean World: Studies in Memory of Clemens E. Bosch and Sabahat Atlan and in Honour of Nezahat Baydur*, Istanbul, 223–26.

Lightfoot, C. S. (2010) 'Die byzantinische Stadt Amorium: Grabungsergebnisse der Jahre 1988 bis 2008,' in Daim and Drauschke (eds.), vol. 2.1, 293–307.

Lightfoot, C. S. (2012) 'Business as Usual? Archaeological Evidence for Byzantine Commercial Enterprise at Amorium in the Seventh to Eleventh Centuries,' in C. Morrisson (ed.), *Trade and Markets in Byzantium*, Washington, DC, 177–91.

Lintott, A. (2003) *Imperium Romanum: Politics and Administration*, London.

Little, L. (ed.) (2006) *Plague and the End of Antiquity: The Pandemic of 541–750*. Cambridge.

Liverani, P. (2007) 'Victors and Pilgrims in Late Antiquity and the Early Middle Ages,' *Fragmenta* 1, 82–102.

L'Orange, H. P. (1965) *Art Forms and Civic Life in the Late Roman Empire*, Princeton.

Loseby, S. T. (1997) 'Gregory's Cities: Urban Functions in Sixth-century Gaul,' in I. Wood (ed.), *Franks and Alamanni in the Merovingian Period*, Woodbridge, 239–70.

Loseby, S. T. (2006) 'Decline and Change in the Cities of Late Antique Gaul,' in Krause and Witschel (eds.), 67–104.

MacCormack, S. (1972) 'Change and Continuity in Late Antiquity: The Ceremony of *Adventus*,' *Historia* 21.4, 721–52.

MacCormack, S. (1976) 'Latin Prose Panegyrics: Tradition and Discontinuity in the Later Roman Empire,' *Revue des Études Augustiniennes* 22, 29–77.

MacCormack, S. (1981) *Art and Ceremony in Late Antiquity*. Berkeley and Los Angeles.

MacDonald, W. L. (1982) *The Architecture of the Roman Empire I: An Introductory Study*, New Haven – London.

MacDonald, W. L. (1986) *The Architecture of the Roman Empire II: An Urban Appraisal*, New Haven – London.

MacMullen, R. (1982) 'The Epigraphic Habit in the Roman Empire,' *AJP* 103, 233–46.

MacMullen, R. (1988) *Corruption and the Decline of Rome*, New Haven.

Magness, J. (2003) *The Archaeology of the Early Islamic Settlement in Palestine*, Winona Lake, IN.

Magnien, A. (ed.) (2009) *Saint-Riquier: Une grande abbaye bénédictine*, Paris.

Maioli, M. G. (1980) 'Classe: campagna di scavo 1978. Relazione preliminare,' *Felix Ravenna* 119–20, 7–23.

Maioli, M. G. (1983) 'Classe, podere Chiavichetta, zona portuale,' in G. B. Montanari (ed.), *Ravenna e il porto di Classe*, Bologna, 65–78.

Maischberger, M. (2009) 'Das Nordtor des Südmarktes, sog. Markttor,' in O. Dally et al. (eds.), *Zeiträume – Milet in Kaiserzeit und Spätantike*, Regensburg, 109–19.

Majocchi, P. (2008) *Pavia città regia. Storia e memoria di una capitale medievale*, Rome.

Mallet, J. and Enguehrd, H. (1964) 'L'Enceinte gallo-romain d'Angers,' *Annales de Bretagne* 24.1, 85–100.

Maloney, J. and B. Hobley (eds.) (1983) *Roman Urban Defences in the West*, London.

Manacorda, D. (1990) *Archeologia urbana a Roma: il progetto della Crypta Balbi*, Florence.

Mango, C. (1980) *The Brazen House. A Study of the Vestibule of the Imperial Palace of Constantinople*, Copenhagen.

Mango, C. (1980) *Byzantium: The Empire of New Rome*, London.

Mango, C. (1985) *Le développement urbain de Constantinople (IVe–VIIe siècles)*, Paris.

Mango, C. (1990) 'Constantine's Mausoleum and the Translation of Relics,' *Byzantinische Zeitschrift* 83, 51–62.

Mango, C. (2000) 'The Triumphal Way of Constantinople and the Golden Gate,' *DOP* 54, 173–88.

Marasović, J. and T. Marasović (1994) 'Le ricerche nel palazzo di Diocleziano a Split negli ultimi 30 anni (1964–1994),' *AnTard* 2, 89–106.

Marazzi, F. (2006) 'Cadavera urbium, nuove capitali e Roma aeterna: l'identità urbana in Italia fra crisi, rinascita e propaganda (secoli III–V),' in Krause and Witschel (eds.), 33–65.

Marazzi, F. (2008) 'San Vincenzo al Volturno. L'impianto architettonico fra VIII e XI secolo, alla luce dei nuovi scavi della *basilica maior*,' in F. Marazzi and F. de Rubeis (eds.), *Monasteri in Europa occidentale (secoli VIII–XI): topografia e strutture*, Rome, 323–90.

Marazzi, F., C. Filippone, P. Petrone, T. Galloway and L. Fattore (2002) 'San Vincenzo al Volturno – Scavi 2000–2002. Rapporto preliminare,' *Archeologia Medievale* 29, 209–74.

Marco, S., M. Hartal, N. Hazam, L. Lev and M. Stein (2003) 'Archaeology, History, Geology of the A.D. 749 Earthquake, Dead Sea Transform,' *Geology* 2003.31, 665–68.

Marcone, A. (2008) 'A Long Late Antiquity? Considerations on a Controversial Periodization,' *JLA* 1, 4–19.

Marfil Ruiz, P. (2000) 'Córdoba de Teodosio a Abd al-Rahmán III,' in Caballero Zoreda and Mateos Cruz (eds.), 117–41.

Martin, C. (2003) *La géographie du pouvoir dans l'Espagne visigothique*, Paris.

Martin, J.-M. (2009) 'L'Italie méridionale,' *Settimane del CISAM* 56, 733–74.

Martínez Pizarro, J. (2005) *The Story of Wamba: Julian of Toledo's Historia Wambae Regis*, Washington, DC.

Mateos Cruz, P. (2000) '*Augusta Emerita*, de capital de la *diocesis Hispaniarum* a sede temporal visigoda,' in Ripoll and Gurt (eds.), 491–520.

Mateos Cruz, P. (2005) 'Los orígines de la cristianización urbana en Hispania,' in Gurt and Ribera (eds.), 49–62.

Mateos Cruz, P. and Alba Calzado, M. (2000) 'De *Emerita Augusta* a Marida,' in Caballero Zoreda and Mateos Cruz (eds.), 143–68.

Matthews, J. F. (1975) *Western Aristocracies and Imperial Court A.D. 364–425*, Oxford.

Matthews, J. F. (1989) *The Roman Empire of Ammianus*, Baltimore.

Maurici, F. (2010) 'Le città della Sicilia bizantina: un problema aperto,' in Congiu, Modeo and Arnone (eds.), 113–46.

Mauskopf Deliyannis, D. (2010) *Ravenna in Late Antiquity*, Cambridge.

Mazzotti, M. (1968–69) 'Una via porticata e due chiese di Ravenna,' *Almanacco Ravennate*, 1968–69, 505–16.

Mazzotti, M. (1971) 'Santa Giustina *in capite porticus* in Ravenna,' *CARB* 18, 369–86.

McClendon, C. (2005) *The Origins of Medieval Architecture: Building in Europe, A.D. 600–900*, New Haven – London.

McCormick, M. (1986) *Eternal Victory. Triumphal Rulership in Late Antiquity, Byzantium and the Early Medieval West*, Cambridge.

McCormick, M. (1989) 'Clovis at Tours, Byzantine Public Ritual and the Origins of Medieval Ruler Symbolism,' in K. Chrysos and A. Schwarcz (eds.), *Das Reich und die Barbaren*, Vienna, 155–80.

McCormick, M. (2001) *Origins of the European Economy: Communications and Commerce A.D. 300–900*, Cambridge.

McCormick, M. (2011) *Charlemagne's Survey of the Holy Land: Wealth, Personnel, and Buildings of a Mediterranean Church between Antiquity and the Middle Ages*, Washington, DC.

McGeer, E. (1995) 'Byzantine Siege Warfare in Theory and Practice,' in I. A. Corfis and M. Wolfe (eds.), *The Medieval City under Siege*, Woodbridge, 123–31.

McKitterick, R. (2008) *Charlemagne: The Formation of a European Identity*, Cambridge.

McLynn, N. B. (1994) *Ambrose of Milan: Church and Court in a Christian Capital*, Berkeley.

McNally, S. (1975) 'Diocletian's Palace: Split in the Middle Ages,' *Archaeology* 28, 248–59.

McNally, S. (1989) 'Introduction: State of Scholarship,' in S. McNally, J. Marasović and T. Marasović (eds.), *Diocletian's Palace: American-Yugoslav Joint Excavations 5*, Minneapolis, 3–43.

McNally, S. (1994) 'Joint American-Croatian Excavations in Split (1965–1974),' *AnTard* 2, 107–21.

McNally, S. (1996) *The Architectural Ornament of Diocletian's Palace at Split*, BAR Int. Series 639, Oxford.

Mentzos, A. (2001–02) 'Reflections on the Interpretation and Dating of the Rotunda of Thessaloniki,' *Egnatia* 6, 61.

Mentzos, A. (2010) 'Reflections on the Architectural History of the Tetrarchic Palace Complex at Thessalonikē,' in Nasrallah, Bakirtzis, and Friesen (eds.), 333–59.

Merlat, P. (1958) 'Rapport sur la portion du mur d'enceinte gallo-romain de Rennes, découverte 18, Quai Duguay-Trouin,' *Annales de Bretagne et des Pays de l'Ouest* 65.1, 97–133.

Meyer, E. (2002) *Rom ist dort, wo der Kaiser ist: Untersuchungen zu den Staatsdenkmälern des dezentralisierten Reiches von Diocletian bis zu Theodosius II*, Mainz.

Meyer, R. (1997) *Frümittelalterliche Kapitelle und Kämpfer in Deutschland. Typus – Technik – Stil*, 2 vols., Berlin.

Meyer-Barkhausen, W. and H. Walbe (1953) *Die Torhalle in Lorsch*, Heppenheim.

Micheau, F. (2008) 'Baghdad in the Abbasid Era: A Cosmopolitan and Multiconfessional Capital,' in Jayyusi et al. (eds.), 221–45.

Millar, F. (1977) *The Emperor in the Roman World (31 BC – AD 337)*, London.

Millar, F. (1983) 'Empire and City, Augustus to Julian: Obligations, Excuses and Status,' *JRS* 73, 76–96.

Millar, F. (1993) *The Roman Near East, 31 B.C. – A.D. 337*, Cambridge, MA.

Millar, F. (2006) *A Greek Roman Empire: Power and Belief under Theodosius II (408–450)*, Berkeley-Los Angeles-London.

Miranda, E. (2002) 'Acclamazioni a Giustiniano I da Hierapolis di Frigia,' in D. De Bernardi Ferrero (ed.), *Hierapolis. Scavi e ricerche, 4. Saggi in onore di Paolo Verzone*, Rome, 109–18.

Mithen, S. (2001) 'Archaeological Theory and Theories of Cognitive Evolution,' in I. Hodder (ed.), *Archaeological Theory Today*, Oxford – Maldon, MA, 98–121.

Mor, G. C. (1969) 'Pavia capitale,' in *Pavia capitale di regno* (Atti del 4° congresso internazionale di studi sull'alto medioevo, Spoleto), 19–31.

Moreno, E. M. (2009) 'De Hispania a al-Andalus: la transformación de los espacios rurales y urbanos,' *Settimane del CISAM* 56, 473–94.

Morrison, C. (ed.) (2004) *Le Monde Byzantin*, Vol. 1. *L'Empire Roman d'Orient, 330–641*, Paris.

Morrison, C. (ed.) (2012) *Trade and Markets in Byzantium*, Washington, DC.

Motsopoulos, N. C. (1977) 'Contribution à l'étude du plan de la ville de Thessalonique à l'époque romaine,' in *Atti del XVI Congresso di Storia dell'Architettura (Athènes, 1969)*, Rome, 187–263.

Muller-Wiener, W. (1977) *Bildlexikon zur Topographie Istanbuls*, Tübingen.

Mundell Mango, M. (2000) 'The Commercial Map of Constantinople,' *DOP* 54, 189–207.

Mundell Mango, M. (2001) 'The Porticoed Street at Constantinople,' in Necipoglu (ed.), 29–51.

Nasrallah, L. (2005) 'Empire and Apocalypse in Thessaloniki: Interpreting the Early Christian Rotunda,' *JECS* 13.4, 465–508.

Nasrallah, L., C. Bakirtzis and S. J. Freisen (eds.) (2010) *From Roman to Early Christian Thessalonikē*, Cambridge, MA.

Necipoglu, N. (ed.) (2001) *Byzantine Constantinople: Monuments, Topography and Everyday Life*, Leiden – Boston – Cologne.

Neff, K. (ed.) *Die Gedichte des Paulus Diaconus. Kritische und erklärende Ausgabe*, Munich 1908.

Neiss, R. (1984) 'La structure urbaine de Reims antique et son évolution du Ier au IIIe s. ap. J.-C.,' in *Les Villes de la Gaule Belgique au Haut-Empire (Revue archéologique de Picardie 1984, 3/4)*, 171–79.

Niewöhner, P. (2007) 'Archäologie und die "Dunkeln Jahrhunderte" im byzantinischen Anatolien,' in Henning (ed.), vol. 2, 119–57.

Niewöhner, P. (2011) 'The Riddle of the Market Gate: Miletus and the Character and Date of Earlier Byzantine Fortifications in Anatolia,' in Dally and Ratté (eds.), 103–22.

Nikšić, G. (2011) 'Diocletian's Palace – Design and Construction,' in Bülow and Zabehlicky (eds.), 187–202.

Nock, A. D. (1947) 'The Emperor's Divine Comes,' *JRS* 37, 102–16.

Nongbri, B. (2013) *Before Religion: A History of a Modern Concept*, New Haven.

Noreña, C. (2011) *Imperial Ideals in the Roman West: Representation, Circulation, Power*, Cambridge.

Oenbrink, W. (2006) 'Shahba / Philippopolis – Die Transformation einer safaitisch-arabischen Siedlung in eine römische Colonia,' in Johne, Gerhardt and Hartmann (eds.), 243–70.

Olivier, A. and A. Rebourg (1985) 'Un portique monumental le long du cardo maximus à Autun,' *Revue archéologique de l'est et du centre-est* 36, 334–38.

Olmo Enciso, L. (2000) 'Ciudad y procesos de transformación social entre los siglos VI y IX: de Recópolis a Racupel,' in Mateos Cruz and Caballero Zoreda (eds.), 385–99.

Olmo Enciso, L. (2007) 'The Royal Foundation of Recópolis and the Urban Renewal in Iberia during the Second Half of the Sixth Century,' Henning (ed.), vol. 1, 181–96.

Olmo Enciso, L. (2008) 'Recópolis: una ciudad en una época de transformaciones,' in L. Olmo Enciso (ed.), *Zona arqueológica Recópolis y la ciudad en la época visigoda*, Alcalá de Henares, 41–63.

Orselli, A. M. (2006) 'Epifanie e scomparse di città nelle fonti testuali tardoantiche,' in Augenti (ed.), 17–25.

Ortalli, J. (1991) 'L'Edilizia abitativa,' in Carile (ed.), *Storia di Ravenna* II.1, 167–92.

Ousterhout, R. (1999) *Master Builders of Byzantium*, Princeton.

Pani Ermini, L. (2009) 'Evoluzione urbana e forme di ruralizzazione,' *Settimane del CISAM* 56, 659–93.

Parsons, D. (1973) 'The Pre-Romanesque Church of St-Riquier: The Documentary Evidence,' *Journal of the British Archaeological Association* 130, 21–51.

Patlagean, E. (1977) *Pauvreté économique et pauvreté sociale à Byzance, 4ᵉ-7ᵉ siècles*, Paris.

Peduto, P. (2011) 'Quanto rimane di Salerno e di Capua longobarde (secc. VIII–IX),' in P. Roma (ed.), *I Longobardi del sud*, Rome, 257–78.

Petković, S. (2011) 'Gamzigrad-*Romuliana* in der Zeit nach dem kaiserlichen Palast,' in Bülow and Zabehlicky (eds.), 113–28.

Piccirillo, M. and E. Alliata (eds.) (1999) *The Madaba Map Centenary, 1897–1997*, Jerusalem.

Pietri, C. (1961) 'Concordia apostolorum et Renovatio Urbis,' *Mélanges d'archeologie et d'histoire* 73, 275–322.

Pietri, C. (1976) *Roma Christiana: Recherches sur l'église de Rome, son organisation, sa politique, son idéologie, de Miltiade à Sixte II (311–440)*, Rome.

Pirenne, H. (1937) *Mahomet et Charlemagne*, Brussels.

Poccardi, G. (1994) 'Antioche de Syrie. Pour un nouveau plan urbain de l'île de l'Oronte (Ville Neuve) du IIIᵉ au Vᵉ siècle,' *MEFRA* 106.2, 993–1023.

Poccardi, G. (2001) 'L'île d'Antioche à la fin de l'Antiquité: histoire et problème de topographie urbaine,' in Lavan (ed.) 2001, 155–72.

Popović, I. (1990) 'Les activités professionnelles à Caričin Grad vers la fin du IVᵉ et le début du VIIᵉ siècle d'après les outils de fer,' in Bavant, Kondić and Speiser (eds.), 269–306.

Popović, I. (2011) 'A Residential Complex in the South-eastern Part of Late Antique Sirmium: Written Sources and Archaeological Evidence,' in Bülow and Zabehlicky (eds.), 177–85.

Popović, V. (1971) *A Survey of the Topography and Urban Organization of Sirmium in the Late Antique Period*, Belgrade.

Porena, P. (2003) *Le origini della prefettura del pretorio tardoantica*, Rome.

Posamentir, R. (2008) 'Ohne Mass und Ziel? Bemerkungen zur Säulenstrasse von Anazarbos im Ebenen Kilikien,' in I. Delemen et al. (eds.), *Euergetes. Festschrift für Prof. Dr. Haluk Abbasoglu zum 65. Geburtstag*, Istanbul, 1013–33.

Posamentir, R. (2011) 'Anazarbos in Late Antiquity,' in Dally and Ratté (eds.), 205–24.

Potter, D. S. (2004) *The Roman Empire at Bay AD 180–395*. London and New York.

Poulter, A. (ed.) (2007) *The Transition to Late Antiquity on the Danube and Beyond*, Proceedings of the British Academy 141, Oxford.

Prigent, V. (2010) 'La Sicile de Constant II: l'apport des sources sigillographiques,' in A. Nef and V. Prigent (eds.), *La Sicile de Byzance à Islam*, Paris, 157–87.

Pullan, W. (1999) 'The Representation of the Late Antique City in the Madaba Map: The Meaning of the Cardo in the Jerusalem Vignette,' in Piccirillo and Alliata (eds.), 165–71.

Raimondo, C. (2006) 'Le città dei *Bruttii* tra tarda antichità e altomedioevo: nuove osservazioni sulla base delle fonti archeologiche,' in Augenti (ed.), 519–58.

Ramallo Asensio, S. F. (2000) 'Arquitectura doméstica en ámbitos urbanos entre los siglos V y VIII,' in Caballero Zoreda and Mateos Cruz (eds.), 367–84.

Randsborg, C. (1991) *The First Millennium AD in Europe and the Mediterranean: An Archaeological Essay*, Cambridge.

Rapp, C. (2005) *Holy Bishops in Late Antiquity: The Nature of Christian Leadership in an Age of Transition*, Berkeley – Los Angeles.

Rautman, M. (2011) 'Sardis in Late Antiquity,' in Dally and Ratté (eds.), 1–26.

Rebourg, A. (1998) 'L'urbanisme d'Augustodunum (Autun, Saône-et-Loire),' *Gallia* 55, 141–236.

Renfrew, C. (2004) 'Towards a Theory of Material Engagement,' in DeMarrais, Gosden and Renfrew (eds.), 23–31.

Rey, R. (1963) 'Un grand bâtisseur au temps du roi Dagobert. Saint Didier, évêque de Cahors,' *Annales du Midi* 65, 287–93.

Rich, J. (ed.) (1992) *The City in Late Antiquity*, London.

Ripoll, G. and J. M. Gurt (eds.) (2000) *Sedes regiae (ann. 400–800)*, Barcelona.

Rizos, E. (2013) 'Keszthely-Fenékpuszta and the Danube from Late Aantiquity to the Middle Ages,' *JRA* 26, 898–903.

Roberts, M. (2001) 'Rome Personified, Rome Epitomized: Representations of Rome in the Poetry of the Early Fifth Century,' *AJP* 122, 533–65.

Rodríguez Colmenero, A. and I. Rodá de Llanza (eds.) (2007) *Murallas de Ciudades Romanas en el Occidente del Imperio. Lucus Augusti como Paradigma*, Lugo.

Rogers, A. (2011) *Late Roman Towns in Britain: Rethinking Change and Decline*, Cambridge.

Romano, D. G. (2003) 'City Planning, Centuriation, and Land Division in Roman Corinth,' in Williams and Bookidis (eds.), 279–301.

Rothaus, R. R. (2000) *Corinth: The First City of Greece. An Urban History of Late Antique Cult and Religion*, Leiden – Boston – Cologne.

Rotili, M. (1986) *Benevento romana e longobarda. L'immagine urbana*, Benevento.

Roueché, C. (1984) 'Acclamations in the Later Roman Empire: New Evidence from Aphrodisias,' *JRS* 74, 181–99.

Roueché, C. (1999a) 'Looking for Late Antique Ceremonial: Ephesos and Aphrodisias,' in H. Friesinger and F. Krinzinger (eds.), *100 Jahre Österreichische Forschungen in Ephesos: Akten des Symposions Wien 1995*, Vienna, 161–68.

Roueché, C. (1999b) 'Enter Your City! A New Acclamation from Ephesos,' in P. Scherrer, H. Taeuber and H. Thür (eds.), *Steine und Wege. Festschrift für Dieter Knibbe zum 65. Geburtstag*, Vienna, 131–36.

Roueché, C. (2004) *Aphrodisias in Late Antiquity: The Late Roman and Byzantine Inscriptions*, revised online edition 2004: http://insaph.kcl.ac.uk/ala2004 (*JRS* Monograph 5, London, 1989).

Roueché, C. (2006) 'Written Display in the Late Antique and Byzantine City,' in E. Jeffreys (ed.), *Proceedings of the 21st International Congress of Byzantine Studies*, Aldershot, 235–54.

Roueché, C. (2007) 'Late Roman and Byzantine Game Boards at Aphrodisias,' in I. Finkel (ed.), *Ancient Board Games in Perspective*, London, 100–05.

Roueché, C. (2009) 'The Kuretenstraße: The Imperial Presence in Late Antiquity,' in Ladstätter (ed.), 155–69.

Saghy, M. (2000) '*Scinditur in partes populus*: Pope Damasus and the Martyrs of Rome,' *EME* 9, 273–87.

Saliou, C. (2000) 'À propos de la ταυριανή πύλη: remarques sur la localisation présumée de la Grande Église d'Antioche de Syria,' *Syria* 77, 217–26.

Saliou, C. (2005) 'Identité culturelle e paysage urbain: Remarques sur les processus de transformation des rues à portiques dans l'antiquité tardive,' *Syria* 82, 207–24.

Saliou, C. (2009) 'Le palais impérial d'Antioche et son contexte à l'époque de Julien. Réflexions sur l'apport des sources littéraires à l'histoire d'un espace urbain,' *AnTard* 17, 235–50.

Samson, R. (1994) 'Populous Dark-Age Towns: The Finleyesque Approach,' *Journal of European Archaeology* 2, 97–129.

Saradi, H. (1995) 'The Kallos of the Byzantine City: The Development of a Rhetorical Topos and Historical Reality,' *Gesta* 34, 37–56.

Saradi, H. (2006) *The Byzantine City in the Sixth Century: Literary Images and Historical Reality*, Athens.

Saradi, H. (2008) 'Towns and Cities,' in E. Jeffreys (ed.), *The Oxford Handbook of Byzantine Studies*, Oxford, 317–27.

Šašel-Kos, M. and P. Scherrer (eds.) (2002) *The Autonomous Towns of Noricum and Pannonia: Noricum (Situla 40)*, Ljublijana.

Saunders, G. (2003) 'Recent Developments in the Chronology of Byzantine Corinth,' in Williams and Bookidis (eds.), 385–99.

Sauvaget, J. (1934) 'Le plan de Laodicée-sur-mer,' *Bulletin d'Études Orientales* 4, 81–114.

Sauvaget, J. (1947) *La mosquée omeyyade de Médine. Études sur les origins architecturales de la mosquée et de la basilique*, Paris.

Sauvaget, J. (1949) 'Le plan antique de Damas,' *Syria* 26, 314–58.

Schädler, U. (1998) 'Mancala in Roman Asia Minor?,' *Board Games Studies* 1, 10–25.

Schaller, D. (1976) 'Das Aachener Epos für Karl den Kaiser,' *Frümittelalterliche Studien* 10, 134–68.

Scherrer, P. (1995) 'The City of Ephesos from the Roman Period to Late Antiquity,' in H. Koester (ed.), *Ephesos Metropolis of Asia*, Cambridge, MA, 1–25.

Schindel, N. (2009) 'Die Fundmünzen von der Kuretenstraße 2005 und 2006. Numismatische und historische Auswertung,' in Ladstätter (ed.), 171–245.

Schütte, S. (1995) 'Continuity Problems and Authority Structures in Cologne,' in A. Ausenda (ed.), *After Empire: Towards an Ethnology of Europe's Barbarians*, San Marino, 163–69; discussion at 170–75.

Scranton, R. L. (1957) *Corinth XVI: Mediaeval Architecture in the Central Area of Corinth*, Princeton.

Sears, G. (2007) *Late Roman African Urbanism: Continuity and Transformation in the City*, BAR International Series 1693, Oxford.

Segal, A. (1988) *Town Planning and Architecture in Provincia Arabia: The Cities along the Via Traiana Nova in the 1st – 3rd Centuries C.E.*, BAR International Series 419, Oxford.

Segal, A. (1997) *From Function to Monument: Urban Landscapes of Roman Palestine, Syria and Provincia Arabia*, Oxford.

Selzer, W. (1955) *Das karolingische Reichskloster Lorsch*, Kassel – Basel.

Semmler, J. (1973a) 'Die Geschichte der Abtei Lorsch von der Gründung bis zum Ende der Salierzeit (764–1125),' in F. Knöpp (ed.), *Die Reichsabtei Lorsch: Festschrift zum Bedanken an die Stiftung der Reichsabtei Lorsch 764*, vol. 1, Darmstadt, 75–173.

Semmler, J. (1973b) 'Chrodegang, Bischof von Metz 747–766,' in F. Knöpp (ed.), *Die Reichsabtei Lorsch: Festschrift zum Bedanken an die Stiftung der Reichsabtei Lorsch 764*, vol. 1, Darmstadt, 229–45.

Seston, W. (1946) *Dioclétien et la Tétrarchie*, Paris.

Settis, S. (2001) 'Roma fuori di Roma: periferie della memoria,' *Settimane del CISAM* 48 (2001), 991–1013.

Sewell, J. (2010) *The Formation of Roman Urbanism, 338–200 B.C.: Between Contemporary Foreign Influence and Roman Tradition*, Portsmouth, RI.

Shear, T. L. (1973) 'The Athenian Agora: Excavations of 1972,' *Hesperia* 42, 359–407.

Sivan, H. (2008) *Palestine in Late Antiquity*, Oxford.

Slater, T. (ed.) (2000) *Towns in Decline AD 100–1600*, Aldershot.

Slootjes, D. (2006) *The Governor and His Subjects in the Later Roman Empire*, Leiden – Boston.

Smith, J. (2005) *Europe after Rome: A New Cultural History 500–1000*, Oxford.

Smith, R. B. E. (2007) 'The Imperial Court of the Late Roman Empire, *c.* AD 300–*c.* AD 450,' in A. Spawforth (ed.), *The Court and Court Society in Ancient Monarchies*, Cambridge, 157–232.

Smith, R. B. E. (2011) 'Measures of Difference: The Fourth-Century Transformation of the Roman Imperial Court,' *AJP* 132, 125–51.

Smith, R. R. R. (1999) 'Late Antique Portraits in a Public Context: Honorific Statuary at Aphrodisias in Caria, A. D. 300–600,' *JRS* 89, 155–89.

Smith, R. R. R. (2002) 'The Statue Monument of Oecumenius: A New Portrait of a Late Antique Governor from Aphrodisias,' *JRS* 92, 134–56.

Spanu, M. (2002) 'Considerazioni sulle *plateae* di Antiochia,' in T. Drew-Bear, M. Taslianan and C. M. Thomas (eds.), *Actes du Iᵉʳ Congrès International sur Antioche de Pisidie*, Lyon, 349–58.

Speiser, J.-M. (1984) *Thessalonique et ses monuments du IVe au VIe siècle*, Paris.

Speiser, J.-M. (2001) *Urban and Religious Spaces in Late Antiquity and Early Byzantium*, Aldershot – Burlington.

Speiser, J.-M. (2004) 'L'art impérial et chrétien, unité et diversités,' in Morrison (ed.), 277–300.

Spiegel, E. M. (2006) 'Im Schutz der römischen Stadtmauer. Das Gebiet des Clarenklosters in römischer Zeit,' in W. Schäfke (ed.), *Am Römerturm. Zwei Jahrtausende eines kölner Stadtviertels*, Köln, 8–22.

Srejović, D. (ed.) (1993) *Roman Imperial Towns and Palaces in Serbia: Sirmium, Romuliana and Naissus*, Belgrade.

Srejović, D. (1993) 'Felix Romuliana. The Ideological Testament of Emperor Galerius,' in Srejović (ed.), 31–53.

Srejović, D. and C. Vasić (1994) 'Emperor Galerius' Buildings in Romuliana (Gamzigrad, Eastern Serbia),' *AnTard* 2, 123–41.

Stephanidou-Tiberiou, T. (1995) *To mikro toxo tou Galeriou stē Thessalonikē*, Athens.

Steuer, H. (1980) *Die Franken in Köln*, Cologne.

Stiegemann, C. and M. Wemhoff (eds.) (1999) *Kunst und Kultur der Karolingerzeit. Karl der Große und Papst Leo III in Paderborn. Beiträge zum Katalog der Ausstellung Paderborn 1999*, Mainz.

Stöger, H. (2011) *Rethinking Ostia: A Spatial Enquiry into the Urban Society of Rome's Imperial Port-Town*, Amsterdam.

Strobel, K. (1993) *Das imperium Romanum im "3 Jahrhundert". Modell einer historischen Krise?*, Stuttgart.

Tabaczek, M. (2008) 'Conception, construction et entretien des rues à colonnades au proche-orient romain,' in Ballet, Dieudonné-Glad and Saliou (eds.), 101–08.

Thonemann, P. (2011) *The Maeander Valley: A Historical Geography from Antiquity to Byzantium*, Cambridge.

Torp, H. (1991) 'The Date of the Conversion of the Rotunda at Thessaloniki into a Church,' in Ø. Andersen and H. Whittaker (eds.), *The Norwegian Institute at Athens: The First Five Lectures*, Athens, 13–28.

Torp, H. (1993) 'Thessalonique paléochrétienne. Une esquisse,' in L. Rydén and J. O. Rosenqvist (eds.), *Aspects of Late Antiquity and Early Byzantium*, Stockholm, 113–32.

Torp, H. (2003) 'L'entrée septentrionale du palais impérial de Thessalonique: l'arc de triomphe et le vestibulum d'après les fouilles d'Ejnar Dyggve en 1939,' *AnTard* 11, 239–72.

Tjäder, O. (1955–82) *Die nichtliterarischen lateinischen Papyri Italiens aus der Zeit 445–700* (2 vols., Acta Instituti Romani Regni Sueciae, Series in 4°, XIX:1–2.), Lund – Stockholm.

Trombley, F. R. (1985) 'The Decline of the Seventh Century Town: The Exception of Euchaita,' in S. Vryonis, Jr. (ed.), *Studies in Honor of Milton Anastos*, Malibu, 65–90.

Tsafrir, Y. (1999) 'The Holy City of Jerusalem in the Madaba Map,' in Piccirillo and Alliata (eds.), 155–63.

Tsafrir, Y. and G. Foerster (1997) 'Urbanism at Scythopolis-Bet Shean in the Fourth to Seventh Centuries,' *DOP* 51, 85–146.

Uggeri, G. (1998) 'L'urbanistica di Antiochia sull'Oronte,' *Rivista di Topografia Antica* 8, 179–222.

Untermann, M. (1999) '"*opere mirabili constructa*" Die Aachener "residenz" Karls des Großen,' in Stiegemann and Wemhoff (eds.), 152–64.

Urbano, A. (2005) 'Donation, Dedication, and *Damnatio Memoriae*: The Catholic Reconciliation of Ravenna and the Church of Sant'Apollinare Nuovo,' *JECS* 13:1, 71–110.

Van Deman, E. (1923) 'The Neronian Sacra Via,' *AJA* 27, 383–424.

Vasić, C. (1990) 'Le plan d'urbanisme de la ville haute: essai de reconstitution,' in Bavant, Kondić and Speiser (eds.), 307–15.

Vasić, M. (2007) 'Felix Romuliana (Gamzigrad) – Palast und Gedenkmonument des Kaisers Galerius,' in U. Brandl and M.Vasić (eds.), *Roms Erbe auf dem Balkan. Spätantike Kaiservillen und Stadtanlagen in Serbien*, Mainz, 59–79.

Velázquez, I. and G. Ripoll (2000) '*Toletum*, la construcción de una *urbs regia*,' in Ripoll and Gurt (eds.), 521–78.

Velázquez, I. and G. Ripoll (2012) 'Recopolis: *Urbs Relicta*? An Historico-Archaeological Debate,' in Christie and Augenti (eds.), 145–75.

Vercauteren, F. (1959) 'La vie urbaine entre Meuse et Loire du VIe au IXe siècle,' *Settimane del CISAM* 6, 453–84.

Verhulst, A. (1999) *The Rise of Cities in North-West Europe*, Cambridge.

Verslype, L. and R. Brulet (eds.) (2004) *Terres noires. Dark Earth, Actes de la table ronde de Louvain-la-Neuve (2001)*, Louvain-la-Neuve.

Verzone, P. (1966) 'Ipotesi di topografia ravennate,' *CARB* 13, 433–43.

Veyne, P. (1976) *Le pain et le cirque: sociologie historique d'un pluralisme politique*, Paris.

Vickers, M. (1973) 'Observations on the Octagon at Thessaloniki,' *JRS* 63, 111–20.

Vives, J. (1963) *Concilios visigóticos y hispano-romanos*, Barcelona – Madrid.

Vives, J. (1969) *Inscripciones cristianas de la España romana y visigoda*, Barcelona.

Volpe, G. (2006) 'Città apule fra destrutturazione e trasformazione: i casi di *Canusium* ed *Herdonia*,' in Augenti (ed.), 559–87.

von Falkenhausen, V. (1989) 'Die Städte im byzantinischen Italien,' *MEFRM* 101.2, 401–64.

von Petrikowitz, H. (1971) 'Fortifications in the North-Western Roman Empire from the Third to the Fifth Centuries A.D.,' *JRS* 61, 178–218.

Wacher, J. (1995) *The Towns of Roman Britain*, 2nd ed., London.

Wagner, P.-É. (1987) 'Le paysage urbain de Metz,' in X. Barral i Altet (ed.), *Le paysage monumental de la France autour de l'an Mil*, Paris, 510–16.

Wallace Hadrill, A. (2008) *Rome's Cultural Revolution*, Cambridge.

Walmsley, A. (2007) *Early Islamic Syria: An Archaeological Assessment*, London.

Walmsley, A. (2011a) 'Trends in the Urban History of Eastern *Palaestina Secunda* during the Late Antique – Early Islamic Transition: Documenting and Explaining Continuities and Discontinuities in North Jordan in the Post-classical Period,' in Borrut et al. (eds.), 271–84.

Walmsley, A. (2011b) 'Pella, Jarash and 'Amman. Old and New in the Crossing to Arabia, ca. 550–750 C.E.,' in Holum and Lapin (eds.), 135–52.

Walmsley, A. (2012) 'Regional Exchange and the Role of the Shop in Byzantine and Early Islamic Syria-Palestine: An Archaeological View,' in Morrison (ed.), 311–30.

Walmsley, A. and K. Damgaard (2005) 'The Umayyad Congregational Mosque of Jarash in Jordan and Its Relationship to Early Mosques,' *Antiquity* 79, 362–78.

Ward-Perkins, B. (1984) *From Classical Antiquity to the Middle Ages: Urban Public Building in Northern and Central Italy A.D. 350–800*, Oxford.

Ward-Perkins, B. (1996) 'Urban Survival and Urban Transformation in the Eastern Mediterranean,' in Brogiolo (ed.), 143–53.

Ward-Perkins, B. (1997) 'Continuitists, Catastrophists and the Towns of post-Roman Northern Italy,' *PBSR* 65, 157–76.

Ward-Perkins, B. (1998) 'The Cities,' *CAH* 13, 371–410.

Ward-Perkins, B. (2005) *The Fall of Rome and the End of Civilization*, Oxford.

Ward-Perkins, B. (2009) 'The Lombard City and Urban Economy,' in Ausenda, Delogu and Wickham (eds.), 95–105.

Watson, A. (1999) *Aurelian and the Third Century*, London and New York.

Weidemann M. (1986) *Das Testament des Bischofs Bertram von Le Mans vom 27 Marz 616*, Mainz.

Westphalen, S. (2006) '"Niedergang oder Wandel?" – Die spätantike Städte in Syrien

und Palästina aus archäologischer Sicht,' in Krause and Witschel (eds.), 181–97.

Whitcomb, D. (2006) 'The Walls of Early Islamic Ayla: Defence or Symbol?,' in H. Kennedy (ed.), *Muslim Military Architecture in Greater Syria from the Coming of Islam to the Ottoman Period*, Leiden – Boston, 61–74.

White, R. (2000) 'Wroxeter and the Transformation of Late-Roman Urbanism,' in Slater (ed.), 96–117.

Whittaker, C. R. (2004) *Rome and Its Frontiers: The Dynamics of Empire*, London and New York.

Whittow, M. (2001) 'Recent Research on the Late-Antique City in Asia Minor: The Second Half of the 6th-c. Century Revisited,' in Lavan (ed.), 137–53.

Whittow, M. (2003) 'Decline and Fall? Studying Long-term Change in the East,' in Lavan and Bowden (eds.), 404–23.

Wickham, C. (1984) 'The Other Transition: From the Ancient World to Feudalism,' *Past and Present* 103, 3–36.

Wickham, C. (2005) *Framing the Early Middle Ages: Europe and the Mediterranean 400–800*, Oxford.

Wightman, E. (1970) *Roman Trier and the Treveri*, London.

Wilkes, J. J. (1993) *Diocletian's Palace, Split: Residence of a Retired Roman Emperor*, 2nd ed., Sheffield.

Williams, C. W. and N. Bookidis (eds.) (2003) *Corinth XX: Corinth, the Centenary 1896–1996*, Athens.

Williams, S. (1985) *Diocletian and the Roman Recovery*, London.

Wolper, E. S. (2003) *Cities and Saints: Sufism and the Transformation of Urban Space in Medieval Anatolia*, University Park, PA.

Wood, I. (1994) *The Merovingian Kingdoms 450–751*, London – New York.

Wood, I. (2007a) 'Review Article: Landscapes Compared,' *EME* 15, 223–37.

Wood, I. (2007b) 'Theoderic's Monuments in Ravenna,' in S. J. Barnish and F. Marazzi (eds.), *The Ostrogoths from the Migration Period to the Sixth Century: An Ethnographic Perspective*, Woodbridge, 249–63.

Woolf, G. (1996) 'Monumental Writing and the Expansion of Roman Society in the Early Empire,' *JRS* 86, 22–39.

Woolf, G. (1998) *Becoming Roman: The Origins of Provincial Civilization in Gaul*, Cambridge.

Wulf-Rheidt, U. (2011) 'Die Entwicklung der Residenz der römischen Kaiser auf dem Palatin vom aristokratischen Wohnhaus zum Palast,' in Bülow and Zabehlicky (eds.), 1–18.

Yegül, F. K. (1986) *The Bath-Gymnasium Complex at Sardis*, Cambridge, MA.

Zanini, E. (1998) *Le Italie Bizantine*, Bari.

Zanini, E. (2003) 'The Urban Ideal and Urban Planning in Byzantine New Cities of the Sixth Century AD,' in Lavan and Bowden (eds.), 196–223.

Zanini, E. (2007) 'Technology and Ideas: Architects and Master-Builders in the Early Byzantine World,' in Lavan, Zanini and Sarantis (eds.), 381–405.

Zanker, P. (2000) 'The City as Symbol: Rome and the Creation of an Urban Image,' in Fentress (ed.), 25–41.

Zavagno, L. (2009) *Cities in Transition: Urbanism in Byzantium between Late Antiquity and the Early Middle Ages (AD 500–900)*, BAR International Series 2030, Oxford.

Zirardini, A. (1762) *Degli antichi edifizi profani di Ravenna*, Faenza.

INDEX